3ds Max Design

Architectural Visualization

For Intermediate Users

Brian L. Smith

Focal Press is an imprint of Elsevier
225 Wyman Street, Waltham, MA 02451, USA
The Boulevard, Langford Lane, Kidlington, Oxford, OX5 1GB, UK

Notices

Knowledge and best practice in this field are constantly changing. As new research and experience broaden our understanding, changes in research methods, professional practices, or medical treatment may become necessary.

Practitioners and researchers must always rely on their own experience and knowledge in evaluating and using any information, methods, compounds, or experiments described herein. In using such information or methods they should be mindful of their own safety and the safety of others, including parties for whom they have a professional responsibility.

To the fullest extent of the law, neither the Publisher nor the authors, contributors, or editors, assume any liability for any injury and/or damage to persons or property as a matter of products liability, negligence or otherwise, or from any use or operation of any methods, products, instructions, or ideas contained in the material herein.

Library of Congress Cataloging-in-Publication Data
Application submitted

British Library Cataloguing-in-Publication Data
A catalogue record for this book is available from the British Library.

ISBN: 978-0-240-82107-8

For information on all Focal Press publications visit our website at www.elsevierdirect.com

11 12 13 14 5 4 3 2 1

Printed in the United States of America

Credits

Contributing Authors
Brian Zajac
Padhia Romaniello
Chris Bullen
Alexander Gorbunov
Nadiya Tarasyuk
Volodymyr Kvasnytsya
Konstantin Kim
Ximo Perez

Technical Reviewer
Mark Gerhard

Compositor
Dina Quan

Cover Image Designer
SPINE3D

3D Models Provided by
Alex Gorbunov, Intero Visuals

The inspiration for everything I do in the 3D world has always been my wonderful wife Shari and our two kids Laken and Kegan. I would not be doing what I do without their support.

Contents at a Glance

About the Author

Brian Smith began his 2D and 3D CAD studies in the early 1990s and worked as an animation specialist in architectural, engineering, and landscaping firms in southwest Florida. He started his own company in 2001, specializing in the production of architectural animations and renderings, and a few years later cofounded the production company 3D Architectural Solutions (3DAS) in Sarasota, Florida. In 2006, he founded the publishing company 3DATS and in 2008, 3DATS teamed up with CGarchitect and Spine3D to form CGschool—the world's leading visualization training company. He divides his time between production and training, and in his free time looks for big mountains to climb.

Brian graduated from the U.S. Military Academy at West Point with a major in Aerospace Engineering. He served on active duty, including two years as a Battery Commander, responsible for a short range air defense battery of over 100 soldiers. Following 9/11, he served in Washington, D.C. as an Air Defense Artillery Fire Control Officer, working closely with the U.S. Secret Service, the U.S. Air Force, and the FAA to provide air defense coverage of our nation's capitol. In August of 2011, Brian completed a one-year assignment at NORAD where he served as an Army Liaison to the Air Force. He is currently a Major in the Florida Army National Guard.

About the Contributing Authors

Brian Zajac received his B.F.A. from Bowling Green State University in Ohio and began working in the field of 3D in the mid 1990s. At that time, a typical workstation cost as much as $100,000 and ran at a fraction of the speed of today's computers. He left 3D and turned his sights toward a career in web design where he wouldn't have to wait so long to see the fruits of his labor. In 2002, Brian started his own company, EyeMagination (www.eyemagination.us) with the goal to build the best possible web-based solutions and Internet marketing for small businesses. Brian has worked with several hi-profile organizations, such as the PGA, American Golf and the New York Yacht Club.

After establishing his web-based business, Brian noticed that the 3D world of technology had become much faster, produced better results, and was finally cost-effective. So, along with his business partner, Brian Smith, he formed 3DAS (www.3das.com)—a 3D architectural visualization facility that creates stunning photorealistic renderings and animations. With his other business partner, Jeff Mottle (CGarchitect.com), Brian developed CGschool—the world's leading visualization training company.

Padhia Avocado Romaniello is an artist who had the fantastic fortune of stumbling upon the 3d world in 1997. Although originally starting off in character modeling and animation using Maya, she has worked for the last several years in architectural visualization using 3ds Max and V-Ray. In 2001 she founded Avocado Digital Design Inc., and has worked on the 3d production, branding, web design, and collateral materials of many projects across the U.S. and abroad. Seeking to improve her 3d skills, she completed some advanced training with Brian Smith and later formed a partnership with 3DAS and 3DATS. Padhia just recently relocated to Hollywood, CA to work as a 3d artist in the film industry.

Chris Bullen is the founder of True Dimensional Studios Inc. He has pioneered new visualization paradigms, has a commanding grasp of a wide variety of programs, and continually seeks out and uses emerging technologies. After receiving his degrees in Pure and Applied Mathematics, he embraced 3D as his primary focus and applied his passion and experience as a traditional artist over to the digital realm. Chris has over 15 years of experience in architectural visualizations and continues to write articles and technical manuals for the industry. In recent years, Chris has focused his attention toward training others in mental ray. He has taught at many levels in both the private and public sectors. Driven by his passion, he is dedicated to improving the learning experience within the visualization community.

Konstantin Kim was born in USSR in 1981 and began working in the CG industry as a freelancer in 2003. In 2004 he graduated from South Ural State University in Chelyabinsk with a degree in Nuclear Physics. His main interest lies in architectural visualization, with specialties in animation, compositing, and the design of digital plants models. He currently lives in Russia and continues to work as a freelancer.

Alexander Gorbunov began using 3d Studio for the first time in 1996 when he started his Bachelor of Fine Arts degree at the Ukraine State Maritime Technical University in Nikolaev, Ukraine. At that time, it was 3D Studio 4 for DOS. He was immediately fascinated with 3D graphics and decided that it would be his lifelong hobby. After finishing his education in 2001, he turned his hobby into a small business and began a freelancing career by producing small visualizations for companies all over the world.

Concentrating mostly on interior scenes, Alex noticed an ever increasing demand for custom furniture and accessories. As more time passed, he found himself more and more interested in the creation of furniture and invested a great deal of personal time honing his craft.

In 2005, he moved to Tampa, FL, just a short drive from 3DAS. Soon after, Alex took his work to the next level and founded Intero Visuals; a company dedicated to the creation of fine 3D furniture and accessories. His collections are the absolute finest the crew at 3DAS has ever come across, and so recognizing his unique skills and dedication, 3DAS entered into a strategic partnership with Alex and has found him to be an invaluable asset to their production. His work can be seen at www.interovisuals.com.

Nadiya Tarasyuk graduated from the Lviv Academy of Art with a Master's Degree in Interior Design and later from the Lviv Academy of Commerce with a Master's Degree in Economics. She began her visualization career soon after in 2001, teaching herself 3ds Max while working as an interior designer for a construction company in Lviv, Ukraine. After 3 years of self-teaching, Nadiya had produced several outstanding visualizations and made a name for herself in her area. She received an offer to work as project manager in the 3D department of a software development company. After several great years of working for this company, she felt that she received the management experience she needed to start her own company. She joined forces with Volodymyr Kvasnytsya and together they founded Visarty Inc.

Today, Visarty is one of the leading companies working in the field of 3D visualization and interior design, not only in Ukraine but throughout the world.

Volodymyr Kvasnytsya graduated from Lviv University with a Master's Degree in Theoretical Physics and began working in the computer graphics industry shortly after, landing a position with the TV and radio company "Lux" in 2001. There he worked as a 2D animator and before long learned 3D well enough to receive a position as a 3D animator with a local architectural company.

When the time was right, he decided to start his own firm and co-founded Visarty with Nadiya Tarasyuk and together they have produced an incredible portfolio of visualization work. Today, Visarty produces visualizations for projects all around the world.

Ximo Peris initially trained as an architect before moving into architectural visualization in 1997. He lived in Holland for 3 years, teaching at TU Delft and working at DPI Animation House before moving to London and joining Hayes Davidson. Since 2000 he has been employed at Smoothe where he has worked on many large scale animation and film projects across the UK and worldwide. Most notably, Ximo liaised with the London 2012 bidding team, coordinating an extensive team tasked with creating imagery and film sequences that very simply yet effectively communicated the Olympic vision to a global audience.

Other projects Ximo has delivered include works for Mercedes Benz, to launch the new Mercedes Benz World at Brooklands Museum in the UK, the Orchid House, which was featured in BBC2's design show, and several large scale productions that incorporated green screen studio shoots for projects in the Middle East. Ximo regularly lectures and presents to students and architects on the language and techniques of visualization in the construction industry.

About the Technical Reviewer

Mark Gerhard is a 3ds Max guru. He is currently employed by TurboSquid, as Director of the Artist Division.

He has worked with 3ds Max since its inception as 3D Studio in 1990 and was one of the first artists hired to test the software while collaborating with the original development team including Gary Yost, Tom Hudson, and Dan Silva. He was one of the first 3D Studio instructors, training most of the original resellers and educators around the world. While working for Autodesk, he served as product manager for the 2D Animation program, Animator Studio, and was one of the first Autodesk Application Engineers devoted to 3ds Max. He spent 6 years as a Senior Technical Writer, and was the lead writer for the 3ds Max tutorials for versions 3 through 6.

In addition to his work at Autodesk, he has been a technical editor for numerous books on 3ds Max including the *Inside 3ds Max* series for New Riders, the *Mastering Visually* series for Wiley/Sybex, and each architectural visualization book by 3DATS. He has authored chapters in books on 3ds Max, including Focal Press' Foundation series, *Learning 3ds Max 2008*. Along with Jeffery M. Harper, he is co-author of the official Autodesk Certification guide, *Mastering 3ds Max Design 2011*.

He holds a degree in painting and sculpture from UC Berkeley and has worked in the field of design visualization, graphic design, and commercial art for over 30 years. He has taught countless individuals 3D animation at institutions such as Napa Valley College, Santa Rosa Junior College, Academy of Art University, and Sonoma State University. He is also the author of the children's book, *The Elf of the Shelf Sees Himself* (Push Press, 1983).

He lives in California with his wife Rhonda, the joy of his existence for the last 26 years. He has four delightful children and two grandsons.

Acknowledgments

THIS BOOK IS THE COMBINED effort of 9 individual authors from around the world and several other individuals mentioned below. Each played an invaluable role in seeing this book through to completion and without their help, it simply wouldn't exist.

Thanks to Dina Quan for once again, single-handedly taking on the role of compositor and laying out the design of this book.

Thanks to Mark Gerhard for once again tearing into our work as technical reviewer and making us all look so much smarter.

A special thanks again to my good friends Nadiya and Volodymyr of Visarty. They are two of the best in the business and for many years now they have provided unwavering 3D production support through many difficult projects. We're still trying to find time to visit you both in your neck of the woods.

Thanks to Alexander Gorbunov for providing many of the models used in this book as well as writing an amazing tutorial on furniture creation. Alexander is arguably the best furniture modeler in the world and has become an invaluable asset to our business. You can see his work at www.interovisuals.com.

Thanks to Chris Bullen for taking on the challenge of writing four chapters on mental ray.

Thanks again to my mom for beating proper English into me and for serving as the final proofreader of this book. You would be hard-pressed to find many English errors in a book if she has anything to say about it.

Brian L. Smith

Foreword

I'VE WORKED IN THE ARCHITECTURAL VISUALIZATION industry for about 16 years now, in a variety of different capacities, and started CGarchitect.com about half way through my career. Although starting this site has been rewarding on many levels, the opportunity to meet and interact with people from all walks of life within the computer graphic industry has by far been the most rewarding. In that time I can honestly say I can count only a handful of people who are truly dedicated to the advancement of our industry. Brian Smith is without a doubt one of those people, so it was indeed an honor to be asked to write the foreword for this, his third of what undoubtedly will be one of many books to come.

It all started with an email from Brian on February 17, 2006 that started with: "Jeff, My name is Brian Smith". An email not unlike the thousands I receive each year, but upon reading the email in its entirety and discovering in his bio that he was a West Point graduate, I knew there was something more to this guy. First and foremost I found it pretty intriguing for an Aeronautical Engineer, one who graduated from West Point no less, to have somehow found his way into the field of Architectural Visualization. Second, I knew how thankless a job writing a book could be. Right away I sensed Brian was the real deal and by virtue of writing a book, was obviously committed to sharing knowledge and advancing our industry. Naturally drawn to people who shared my same passion for the industry, I replied.

I'm glad to say that my instincts were right. Not only is his character beyond approach and his commitment to the industry as sincere as it comes, I think I finally met someone else as crazy as I am about promoting and advancing our industry. One only has to work with Brian for a few hours to get a true sense of this. Thousands of emails later, countless hours of online chats and phone calls and many projects that we have now worked on together, I count Brian as one of my inner circle of friends in the industry. It goes without saying that I don't take lightly putting my endorsement on a book, but gladly and proudly do so for this one.

You only need to spend a bit of time searching for resources that are dedicated to Architectural Visualization to appreciate the need for a book like this in our industry. Training centers, publishers and industry websites abound in the gaming and entertainment industries, but are few and far between in the field of Architectural Visualization. What is exceptionally refreshing about Brian's philosophy is that despite spending inordinate amounts of time writing, he still dedicates a great deal of his time working in the trenches. Many times authors and instructors have never worked in production or have not worked in the "real world" for so long; they have lost touch with what is really going on around them. What makes the contents of this book so valuable is that the tips and techniques outlined come from years of hands-on experience and a true understanding of what it means to work for clients and deliver a quality product.

Now you might be thinking to yourself, could a book really be that good? The answer is quite simply, yes! I find myself in a unique position through my connection to the community with CGarchitect, and with my work at CGschool, that I am privy to a great deal of customer feedback and industry opinion. Over the past five years I've seen comments from hundreds of people who have read Brian's books or tutorials, taken his live training classes or watched the hours of videos he has created, and without fault the response has always been overwhelmingly positive. It's pretty amazing to see how much people's work improves, how more efficient and productive they become

when someone, pardon the pun, turns on the light for them. Even I found it hard to believe someone's training could be that good, but take my word for it, what you are about to read is literally going to change how you work.

Brian and his crew have done an exceptionally good job and have most definitely raised the bar for what it means to teach within a community. But enough chit-chat already, get reading! I promise you'll not be disappointed.

Jeff Mottle
President/Founder
CGarchitect Digital Media Corp. (CGarchitect.com)

Who Is This Book For?

THIS BOOK IS THE FOLLOW-UP companion to the book entitled *3ds Max 2008 Architectural Visualization – Beginner to Intermediate*. That book was written primarily for beginners and was designed to take 3ds Max users to an intermediate level and provide the basics needed to land a job with a visualization company. *3ds Max Design Architectural Visualization — For Intermediate Users* takes the next logical step and is designed to take intermediate 3ds Max users to the advanced level, not just by teaching more advanced features but also by teaching practical application and time-saving techniques of the tools covered in our *Beginner to Intermediate* title.

Having taught 3ds Max for many years now, we (CGschool) can say with some degree of authority that one of the biggest problems 3ds Max users have when seeking instruction in the visualization industry is gauging their own skill level accurately enough to find an appropriate class. An even greater problem, however, is that there is just not much real-world instruction to be found at the intermediate and advanced levels. One of the goals of this book was to help with this last problem.

Like the *Beginner to Intermediate* title, this book has been published by CGschool, which gave us complete control over every facet of its design and structure. We spared no expense in printing the highest quality book, both in terms of physical appearance and technical instruction. Just as we did with our other title, in this book we went to great lengths to simplify the instruction. But unlike our other title, which focused on explaining the technical side of 3ds Max, *Intermediate* is geared toward teaching great techniques to use with the program. It is assumed that by choosing this title, you have progressed beyond the fundamentals and are at least familiar with a large majority of the tools that top production firms use every day. Although this book should provide insight to a wealth of new features that you may not yet have stumbled upon, it will also build upon many of the features you should already be familiar with, by teaching great techniques with which to implement those features in a production environment.

Finally, this book is written for the 2012 version of 3ds Max; however, with the exception of some critical mental ray upgrades and the occasional change in interface, this book is completely suitable for use with many earlier versions of 3ds Max. All files are provided in the 3ds Max 2011 format, with the exception of some mental ray files that were necessary to provide as 3ds Max 2012. Although it's impossible to gauge what lies ahead for the program, we believe that this book will be completely relevant for many years to come.

Introduction

I GOT MY FIRST TASTE of the computer graphics world back in the early 1980s with the ground breaking Atari system, to which I, like so many other kids of my generation, were hopelessly addicted. To this day, I kick myself for giving away that and my next great system, the Commodore 64; another piece of hardware that had a profound effect on my eventual decision to make a career out of computer graphics.

I don't imagine many very young game players could relate, but I find it a bit sad to see the types of games found in the few arcades still around today and the demise of the great old classic games of the 1980s, to which countless thousands of my quarters went by the wayside. OK, mostly my parents' quarters, but who was counting.

Back then, I was quite sure that if I didn't become an astronaut, a professional ball player, a secret agent or some other cool dude that all boys envision themselves becoming, I would be making video games. I never would have imagined that I would eventually find myself creating architectural visualizations and loving what I do. Nor did I imagine that somewhere along the way I would find myself waking up to the sound of Reveille and marching, quite literally, to the beat of a completely different tune.

After surviving more years in the military than I care to recall, I landed a job with an aerospace firm; which I thought was appropriate since I had dedicated so much time earning an aerospace degree in school. It wasn't long before I realized that, short of being that astronaut I once thought I might be, the aerospace industry isn't as glamorous and appealing as it seems from the outside. While on occasion very interesting, most of my time was spent designing, quite literally again, nuts and bolts to tolerances of 1/10,000th of an inch. That got old quite quickly and I started looking at the architectural field.

I got lucky and landed an architectural drafting position, not because of my experience in architecture, but because the employee was a former Army officer who wanted to see what I could do. Unfortunately, I was so unskilled in the field that I literally couldn't pick out a door from a window on a floor plan. My employer also found it odd that I was placing dimensions on floor plans that were written to 1/256th of an inch, which made some of his contractors laugh. But I'm a fairly quick learner and it wasn't long before I knew all I needed to know about architectural drawings. It also wasn't very long before I was teaching myself all I needed to know to turn a set of architectural drawings into a 3D visualization, using the old 3d Studio DOS version of the program we all use today.

From the time I began teaching myself 3D, I was always frustrated with the lack of practical visualization material and having to create the really useful techniques on my own. I decided that if a decent book dedicated to visualization wasn't written before I had the opportunity, I would write one myself. Thus, the idea of writing the *Beginner to Intermediate* book was born.

Even more frustrating than a lack of a decent visualization book was the lack of intermediate or advanced level training; regardless of the industry. To this day, you would be hard-pressed to find such training anywhere. So the idea for this more advanced book began about the same time as the beginner book, and now after another two years of laboring, another title is realized. With the help of 8 other individuals directly responsible for writing some of the material presented in this book, and with the help of countless others in less conspicuous roles, I believe we have put

together a book that is a first of its kind. One that presents advanced visualization techniques that have been time-tested in production for maximum speed and efficiency. And what we believe makes our writing valid is that we use these techniques in production every day.

A tremendous amount of time and effort was put into determining the best possible content to present in this book as well as the order in which it would be presented. Since the first days that work began on this book, the table of contents was changed, revised, massaged, and edited more times than any of us can recall. In the end, we believe that a great mixture of practical application and real-world experience was achieved and presented in the most logical order. We hope you agree.

Tutorial and Layout Conventions

All of the tutorials within this book are carefully designed to maximize the amount of features and techniques presented while at the same time minimizing the time needed to complete the tutorials. Some of the tutorials contain several hundred steps because, in some cases, a large number of steps were needed to provide a thorough demonstration of a particular workflow. Nonetheless, great care was taken to craft the tutorials in such a way that minimized the total number of steps needed to complete the demonstration and to minimize the unnecessary repetition of duplicate commands. The result, we believe, are tutorials that maximize the transfer of knowledge in a minimal amount of time.

To keep this book as clear and easy to follow as possible, the following text conventions are used throughout:

Bold text is used to draw your attention to on-screen elements in the 3ds Max interface and the first appearance of important words or concepts.

Menu commands are written in the form **Menu > Submenu > Submenu**.

Support Files for Exercises

The files needed to complete the exercises in this book can be found at http://www.thecgschool.com/books.

Reader Feedback

An enormous amount of effort went into checking this book for errors and to validate the material and exercises presented herein. Nevertheless, it would be impractical to think that a book of this size and complexity is completely free of any errors. If you find errors of any kind, we kindly ask that you let us know so we can remove them on future printings. Please send all comments to cgsupport@thecgschool.com. Your feedback is greatly appreciated!

1st-Person Perspective

This book is written in the 1st-person perspective. However, because this book was written by so many individuals, and because it is not practical to mention who wrote each part, any reference to 'I' is simply a reference to one of the authors.

This book is powerful! As a fan of Einstein and the law of relativity, I wanted to know how much energy this book could release if its mass were completely converted to useable energy. Knowing that $E=mc^2$, this 1.8kg book represents 162 trillion joules, or 45 million kilowatt hours, which is enough energy to power the city of New York for roughly 4 hours.

Working with Architectural Drawings

Preparing AutoCAD linework properly can be a time-consuming process, but it's an important process that when done effectively can save a tremendous amount of time and grief in the long run.

Understanding Architectural Drawings

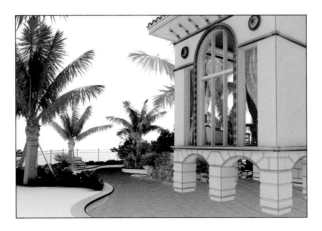

THE FOUNDATION OF ANY 3D visualization is the linework found in its architectural drawings. Just like a contractor needs drawings to erect a building, a 3D artist needs drawings to create a visualization. Understanding a set of architectural drawings is critical to efficient and accurate work in 3ds Max, and without knowing exactly how drawings are put together and what each component of a drawing indicates, a 3D artist is likely to spend a great deal of time trying to make sense of the madness that can be a set of architectural drawings.

Today, nearly all building projects use CAD to create architectural drawings, and more specifically, AutoCAD. However, many visualization projects begin long before the final construction drawings are generated. Construction drawings are the final set of drawings submitted to a city or county building department and supplied to contractors who intend to bid on the project. These 'final' drawings often lead to addendums and on-site adjustments, but construction drawings will always have a certain acceptable level of quality and engineering. The same cannot be said for the drawings those of us in the 3D world are often forced to work with. Since our work often begins at the design development stage or before final construction drawings are generated, we often face the challenge of working with incomplete drawings containing numerous errors or conflicting data. Whatever the case may be, architectural drawings can be difficult for many 3ds Max users to grasp, especially for those who haven't had the benefit of working as an architect, engineer, or draftsman.

I decided to make the first few chapters in this book a discussion on architectural drawings and AutoCAD because many intermediate level users in 3ds Max do not have a solid background in architecture or a fundamental level of knowledge of AutoCAD, yet both of these areas are so critical to our work. Not being able to create a roof plan, interpret a door schedule, or how to recognize the difference between a block and an xref in AutoCAD are just a few examples of the countless difficulties many talented 3ds Max users face when working in the visualization industry. Many students find learning 3ds Max quite simple compared to the difficulties of learning the fundamentals of architecture, and of course, many talented 3ds Max users from other industries have migrated to the visualization industry in recent years. There is very little documentation to guide users in their progression, and so these chapters are an attempt to help 3ds Max users understand

the very important stage of working with architectural drawings. As mentioned in the introduction, much of what is discussed about the architectural industry in this book can be applied to the building industry as a whole, including other sectors such as civil engineering, structural engineering, and landscape architecture.

The Architectural Design Process

Architectural drawings undergo a long and often tumultuous journey before landing in the hands of a contractor who wants to bid on the project. While no two projects follow identical paths during this journey, there are common phases most projects go through, as well as common roadblocks and obstacles most projects will encounter. This section aims to illustrate the evolution of architectural drawings from the time a project is conceived, up to the point where the drawings are government approved and ready for use.

All projects start with an owner who approaches an architectural firm with a concept in mind. The architect's primary job is to take the owner's concept and design a structure with all the appropriate engineering in place to satisfy local, state, and federal guidelines. When a design is complete, architects then submit a set of construction drawings to local building departments for review and approval. Figure 1-1 shows an example of a complete set of construction drawings for a commercial building. Once approved and once a contractor has been selected, the project can proceed with construction under the careful watch of the architect who makes sure the construction conforms to the guidelines specified in the architectural drawings. That is, in a nutshell, the process of architectural design. Needless to say, the actual process involves a little more work, and the following sections briefly illustrate some of the most important details of this process. By knowing the basics of the architectural design process, you will be much better prepared for the 3D design process, and many of the obstacles and pitfalls that can hamper your workflow.

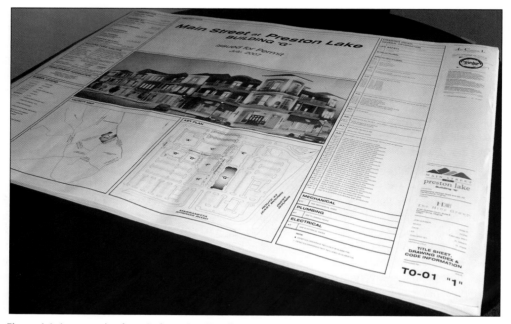

Figure 1-1. An example of a set of construction drawings.

When a 3D artist receives a project from an architect or an owner, it is critical for the artist to know exactly what phase an architectural project is in. Without knowing the phase, the artist has little chance of knowing just how likely a design is to change. Clients often leave out this very important piece of information, and when asked directly, some clients may not always provide a complete answer. If you at least know what phase a project is in, and understand what each phase entails, then you at least have a good understanding of how likely you are to see changes coming. If you don't iron out the specifics of how changes will be billed in your contract, it's only a matter of time before you run into a difficult situation. Fortunately, the sample contract provided with this book provides the necessary protection against project changes. Feel free to adopt the wording in this contract as your own.

According to AIA, the American Institute of Architects, there are five major phases of the architectural design process:

- Schematic Design (SD)
- Design Development (DD)
- Construction Drawings or Construction Documents (CD)
- Bidding and Contract Negotiation (BID)
- Construction Administration (CA)

Schematic Design

The first phase of architectural design is the **Schematic Design** phase, or **SD** for short. The primary objective of this phase is to develop a clearly defined, feasible concept and present it in a form the client can understand and accept. Secondary objectives include clarification of the project's program, exploration of alternative designs, and estimations of construction costs.

During this phase, an architect works closely with the client to determine the appropriate **program**, or set of needs a building must fulfill. The program includes the project's functions, goals, design expectations, budget, and site requirements (such as building code, zoning, and accessibility issues). Preliminary construction costs are also estimated during this phase so the client can know as early as possible if the project is feasible from a financial standpoint.

In the first part of the SD phase, the architect researches the project to determine what its current problems are and what kind of problems might develop in the future. Once a program has been established through this research, the architect's focus shifts from figuring out what the problems are to how the problems can be solved. In the course of solving a project's problems and fulfilling a project's need, a more practical schematic design is born. Architects often provide multiple versions of a design that reflect different options the client may or may not be willing to pay for, based on preliminary cost estimates. Minor details are ignored in the SD phase, and instead, the architect focuses on the overall big picture, making sure no major problems exist in the project's design before continuing with work in the next phase.

During SD, architects usually provide their clients with concept sketches, either by hand or CAD, as well as feasibility studies based on site and building code restrictions. It is quite rare for an architect or owner to request 3D work this early in the architectural design process, simply because the architect can very quickly hand-draw low detail 3D perspective renderings that would satisfy the clients' need for visual representation. Even if architects sub 3D work out to an outside source and 3D work is desired during the SD phase, many architects can still produce this type of low quality mass modeling 3D work in house at this point.

In recent years, city and county officials throughout the U.S. (and I presume other countries) have placed a greater emphasis on the need for architects to provide more accurate illustrations of

their designs as early as possible, so officials can provide the architects with preliminary approval or denial of a design, and prevent unnecessary work on a project that has no hope of being approved in its current design. These preliminary illustrations usually include such details as landscaping because of its impact on the overall look of a project. Regardless, few 3D firms are used in the SD phase for the reasons just mentioned. If approached by an architectural firm, 3D artists must understand exactly what the client wants and be careful not to waste time on details the client does not need.

The typical documentation developed by the end of the SD phase includes:

- A site plan
- All floor plans
- All exterior elevations
- Building sections of critical areas
- Landscape plans
- Preliminary construction cost estimate
- Hand or CAD renderings

The final step in the SD phase, or any phase for that matter, is to obtain formal client approval of the provided documents. Once an architect receives approval, the next phase of the design process can begin.

If a client approaches you with a request for 3D services on a project in the schematic design phase, you should make absolutely certain that both of you come to a clear understanding about the level of detail to be provided and the cost of making 3D changes during later phases.

Design Development

The second phase of the architectural design process is **Design Development**, or **DD** for short. During this phase, the design is refined into a clear, coordinated set of drawings covering all aspects of the design. This set of drawings typically includes fully developed floor plans, exterior elevations, building sections, and a fully developed site plan. For critical areas of a project, architects may choose to develop interior elevations, reflected ceiling plans, roof plans, wall sections, and details. These drawings may or may not include dimensions and notes, and even when they do, they typically see a great detail of refinement until the point at which the drawings are submitted to the building department for approval. The drawings produced during DD become the basis for the construction drawings submitted for government approval.

In the SD phase, most of the work is performed by the architect(s) because almost all of the work is design-oriented and above the normal qualifications of a draftsman. During the DD phase, however, the work is fairly evenly split between the architect(s) and draftsman. At the beginning of the DD phase, an architect will create what's known as a cartoon set of drawings, which is usually nothing more than a set of hand-drawn letter size sheets of paper with a tentative layout of the full working set of construction drawings, as shown in Figure 1-2. Once that cartoon set is created, the drafter will spend a great deal of time setting up the DD drawings per the cartoon set and adding all the generic information required, such as dimensions, scales, sheet titles, and building/wall section callouts.

Figure 1-2. An example of a cartoon set drawing.

In the SD phase, architects do not always use the services of engineers because at such an early stage in the design, an architect is usually more than capable of determining the feasibility of the overall design. For example, if the design calls for a 100-foot roof span without any supporting columns in place, the architect may not know what the ideal beams to use are, but would know enough to know that a sufficient and affordable type of beam *can* be used to allow the design to progress. Once the DD phase begins, numerous engineers are usually needed for all but the smallest and simplest of projects. Even though architects are experts in the design of buildings, with the exception of these simplistic projects, they are usually not legally permitted to *sign and seal* a set of architectural drawings without the subsequent signature and seal of the appropriate subcontractors. These subcontractors usually include civil, structural, mechanical, plumbing, electrical engineers, as well as landscape architects. Depending on the type of project being built and its location, a project may require a certified approval from one or more of these subcontractors. When architects or engineers certify a set of drawings, they stamp or press their seal into each drawing and sign on top of that seal, as shown in Figure 1-3.

Figure 1-3. An example of a 'signed and sealed' drawing.

During the DD phase, architects usually provide these subcontractors with CAD files in their most up-to-date form, and then based on these CAD drawings, the various subcontractors develop an accurate design for their specific areas of responsibility and provide the architect with enough guidance to proceed with construction drawings. Before developing construction drawings, the architect must ensure that no major design flaws or issues exist that could lead to a redesign.

For many architectural firms, the typical documentation developed by the end of the DD phase can appear very similar to the final construction drawings, although the DD drawings will typically not contain as many details, dimensions, and notes. Unlike the SD drawings, the DD drawings will also include initial material and color selections, selections for engineering systems (such as sprinkler systems), and preliminary engineering drawings with all the information the architect needs to move into the construction drawings phase. For example, structural engineers will include on their version of the floor plans, the sizes of all beams needed to support the floors or ceiling above. Without this information, the architect cannot finalize the sizing of the wall components surrounding the beams or the space between walls containing those beams.

The final step in the DD phase is to obtain formal client approval of the provided documents. Once an architect receives approval, the next phase of the design process can begin.

Beginning a 3D project in the design development stage can be quite risky – even more so than in the schematic design phase. In the SD phase, there's usually no doubt on anyone's behalf that the project is going to undergo numerous and major design changes and that continuing 3D work into future phases can easily require starting from scratch. In the DD phase, however, there is usually sufficient detail provided to allow for a complete visualization, and clients often don't understand how even small changes in a building or site design can lead to enormous amounts of work, or in many cases, starting over from scratch. Furthermore, the number of hours needed to achieve the level of detail shown in the DD drawings is always going to be far greater, which means that starting from scratch will require far more work. If a client approaches you with a request for 3D services on a project in the design development phase, you should make absolutely sure that the

client knows the costs and implications of making changes to the 3D visualization that are certain to come in the design development or construction drawings phase. Depending on what the visualization is to be used for, the client may elect to use the visualization provided in the DD phase, rather than paying for changes made in the construction drawings phase. If the visualization is to be used for marketing purposes, then a DD visualization will often suffice. However, if the client needs to present the final building design to the city or county for its approval, the visualization will usually need to be a highly accurate reflection of the final design.

Construction Drawings

The third phase of the architectural design process is the **Construction Drawings** phase, or **CD** for short. This phase is often referred to as the Construction Documents phase, but for the purpose of this book, I will usually refer to this phase as Construction Drawings. During this phase, additional design issues emerge and the architectural team works to address these issues. There are numerous reasons why a project may undergo significant design changes during the construction drawing phase. These can include city or county officials denying certain aspects of a project's design, the realization that the cost of construction was underestimated, a lack of funding for the design as it currently stands, and the client simply deciding that he doesn't like the design any more. It is often this last example that best illustrates how the design process never really stops, but rather continues through construction and the everyday use of the buildings and facilities developed.

Construction drawings (CDs) must include all details required per city, county, and federal guidelines. Every aspect of how a project is to be put together must be included in the CDs. These are the documents to which the architect, owner, and/or government officials will hold the contractor responsible. Likewise, these are the documents that contractors use to determine construction cost, so the importance of these documents being accurate cannot be underestimated. This does not mean that changes to designs cannot occur after CDs are submitted. If changes are required, addendums are simply added to the CDs and those addendums are submitted to the building department for approval. In most cases, changes at this point are usually quick to fix, even when the scope of the change is large. For example, even with something as significant as a roof changing from concrete tile to shingle, a few small changes to the notes found on the elevations and sections will usually suffice.

It is extremely important to remember, however, that some design changes that appear at first to be simple, can in fact take much longer to correct than the example of the roof. In the rush to meet deadlines, drafters or architects often decide to cut corners, and a perfect example of a change that can take an enormous amount of time to make properly, and one that is often corrected with a quick fix instead, is a change to the length of a wall. If, for whatever reason, an architect or drafter has to change the length of a wall by even a few inches, that change might be seen on every major drawing to include one or more floor plans, interior and exterior elevations, sections, the foundation plan, and so on. The quick fix would be to simply change the dimension on the floor plan without actually changing the linework the dimension annotates. For small changes in length, this might not be a big deal, especially since contractors are required to build per the dimensions anyway, and other drawings like elevations are supposed to be for reference only. However, if the change to the length of the wall is a little more substantial, then even an experienced 3D artist is likely to not know that the linework is erroneous and the resulting 3D models might be inadequate.

Bidding and Contract Negotiation

The next phase in the architectural design process is **Bidding and Contract Negotiation**, or **BID** for short. When an architect submits a set of construction drawings to the building department, his work is usually far from over. Although contractors are often pre-selected before a project even begins, most construction projects go through a bidding process, whereby the architect will serve as the manager of the bidding. When contractors are invited to bid on a project, they pick up a set of CDs and any addendums that may have developed, they study the project closely to determine their cost of construction, and they place a bid on the project. Sometimes the project owner looks only for the lowest bidder, but in many cases being the lowest bidder doesn't ensure winning the project. If an owner has a preference toward one firm and the bids are close enough, the lowest bidder might not win the project.

Construction Adminstration

The last phase in the architectural design process is **Construction Adminstration**, or **CA** for short. Between the time CDs are submitted to the building department and the project is fully constructed, numerous changes can be made to the design. As an example, many cities and counties have a certain minimum type of landscaping that must be provided for a project. Landscape architects will often create landscape drawings that satisfy minimum landscaping code, but when it comes time to actually plant that vegetation, the landscape architect may, at the request of the owner, completely change the landscaping. There are numerous reasons for this, such as the owner not wanting to decide until the last possible moment how much money he wants to spend, how much he can spend, or the owner simply not knowing what he would like to see planted until he sees the project nearing completion. As a 3D artist, it is very important to understand how concrete a project's landscaping drawings are, and what the client wants. Even though landscaping is usually not the focus of a project, it is nonetheless a critical component of a realistic 3D scene. The real landscaping an architect or owner has in mind or the real landscaping that actually gets planted on site is often so drastically different from the original landscape drawings, if one creates a 3D scene using these original landscape drawings without the client's express consent, problems are bound to arise. Many clients are not experienced enough with 3D to know to volunteer this type of information. Therefore, you should always get clarification on such details.

Another example of a change that is often made after CDs are submitted, and one that can greatly affect the progress of a 3D visualization, is the changing of a building's colors. Architects or owners often change their minds at the very last minute after having the opportunity to test real color samples on a building as it nears completion. Figure 1-4 shows a commercial development nearing completion and a newly developed paint scheme being tested with the benefit of real world conditions. The paint colors being tested are relatively unorthodox for the location and without the ability to apply actual paint samples like this, an architect or owner is often unsure about the selection. By using the services of a 3D visualization company, clients can often identify poor color schemes before it's too late, and so it is because of our work that clients often change design characteristics like this at the last minute. During the design development phase of the project shown in Figure 1-4, an initial color scheme was submitted by the architect and approved by the city planning board, but it was not until the building was almost completely finished that the architect and owner determined that the chosen color scheme was not appropriate. As always, you should try to determine as early as possible how much something like a color scheme is likely to change, and you should reflect the consequences of such changes in the project's contract.

COLORS:

- ▦ - Fusion: SW6919 + 4 additional same color with increased values

- ▦ - Venture Violet: SW6970 (accent as shown)
 - Heron Plume: SW6070 (use on 4' band same as before)
 - Reprose Gray: SW7015 (general building color plus cmu wall in window system)
- ■ - Tricon Black: SW6258 (all steel columns)

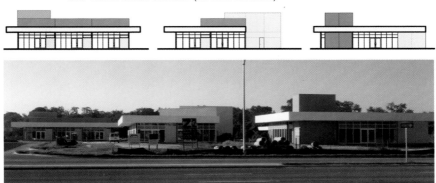

Figure 1-4. A paint scheme created after CD submission.

One of the biggest responsibilities an architect has for most projects is monitoring the progress of a building during its construction, hence the true meaning behind the term Construction Administration. Throughout the entire construction process, there will always be questions or problems that arise that require the architect's attention. Besides having to deal with these questions, architects are paid to ensure that the project is being built according to the plan. Architects make site visits to observe the progress and quality of construction and notify the owner when problems arise.

When a project is complete to the satisfaction of the architect, the architect will issue a **Certificate of Substantial Completion**, and at that point the architect's responsibility is usually over.

The Anatomy of Architectural Drawings

If you have never worked in an architectural office before, or never had formal training in the architectural field, a full set of architectural drawings can be quite intimidating. Even for small projects a full set can easily contain over 100 individual sheets. For a very large project, several hundred are not unusual. The drawings shown earlier in Figure 1-1 were over 120 sheets in all and that was for a relatively small building. The image in Figure 1-5 shows an example of **Specifications** that often accompanies a set of construction drawings. Specifications clarify in words many of the important details shown in the architectural drawings. As you can see from the image on the cover, the building is quite small, yet the specifications for this building are over 200 pages in length.

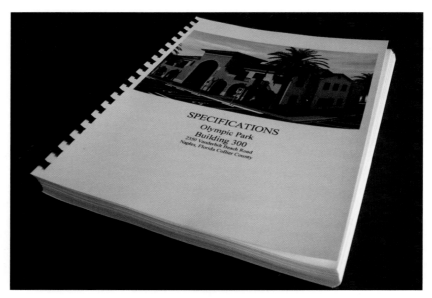

Figure 1-5. A typical set of specifications for an architectural project.

Receiving this much information to decipher at the beginning of a visualization project can be extremely difficult. Unfortunately, the flip side isn't much better. Receiving too little information usually leads to even more problems. Fortunately, for the majority of what we do, we only need to rely on a few critical drawings to do our work.

As I mention several times throughout this book, you should never price a job without seeing the architectural drawings you will have to work with. At the very least, you should price very conservatively to account for the numerous different ways that poor drawings and missing information can hinder your work. This is discussed more in later chapters. But unlike a contractor who needs every drawing to know exactly how to put the project together inside and out, a 3D artist only needs to focus on the drawings that depict the physical structures that will actually be seen. This usually means that the drawings most critical to a visualization are:

- Elevations
- Floor plans
- Sections
- Site plans
- Landscape plans
- Roof plans
- Reflected ceiling plans

Of course, in a perfect world you would receive all of these drawings in complete CD form, but as is often the case, much of this information will either be lacking or incomplete. Notwithstanding the precautions mentioned earlier about beginning a project before receiving all the necessary information, once the necessary drawings are received and you decide to begin your work, the first step in the 3D creation process is the preparation of AutoCAD linework for importation into 3ds

Max. Obviously many 3ds Max users choose to model in other programs like Architectural Desktop and Revit, in which case preparing this linework is not really a necessary step. If you do choose to model in other programs, I highly recommend to at least explore the benefits of modeling solely in 3ds Max. Regardless, the first step in the 3D creation process is preparing the AutoCAD linework. But before beginning a discussion on this subject, I want to delve into an in-depth discussion on the various drawing types 3D users typically work with during a visualization project. The remainder of this chapter looks closely at how architects and drafters put each of the critical drawings together so you can better understand what you're looking at when inside one of these drawings, and better understand how to handle the linework. In Chapter 2, we will explore the basics of AutoCAD for those who have little or no experience in the program, so they may become familiar enough with the program to follow the procedures and techniques outlined in many of the remaining chapters. However, the focus of Chapter 2 is preparing AutoCAD linework for importation in 3ds Max, and this subject will be covered thoroughly in Chapter 2 as well as many of the tutorials throughout this book.

Every architecture and engineering firm has its own standards for creating drawings, and working with so many different standards can be difficult and time consuming for even experienced artists. What's more is that even when firms create their own standards, they don't always follow them. If you assume the worst when you receive drawings, you will probably be more likely to find any problems and inconsistencies that exist.

Most of what is discussed in the remainder of this chapter deals with problems you might run into when working with architectural drawings and things you should always be on the lookout for. Having spent several years as a drafter in architectural firms, I am aware of the numerous challenges that drafters and architects face when trying to get a set of drawings out the door. These challenges, if not dealt with properly in the architectural office, tend to migrate over to the desk of the 3D artist trying to make sense of what is sometimes an apparent mess of linework. So in the remainder of this chapter, I will attempt to make understanding architectural drawings a little easier for the less experienced 3ds Max user.

Sheet layout

Before discussing each of the important drawing types, I want to make a quick mention about the paper architectural drawings are printed on and the way sheets are ordered.

An individual piece of paper on which an architectural drawing is printed is usually referred to as a sheet. In the U.S., five standard sizes are used for the vast majority of all sheets printed in architecture:

- ARCH A – 9"x12"
- ARCH B – 12"x18"
- ARCH C – 18"x24"
- ARCH D – 24"x36"
- ARCH E – 36"x48"

As you can see from the dimensions shown, each larger drawing is exactly twice the size of the previous drawing. Sizes A, B, and C are usually reserved for addendums, for showing small areas of a project, or for showing large areas at a small scale. Very large projects often make use of the E size drawings, but the most commonly used drawing size is the D size drawing.

For all but very small projects, a set of construction drawings will contain drawings grouped together in different sections. The drawings an architect creates in-house will be together in one area of the set (usually toward the very top of the set), the structural engineering drawings will be grouped together in another area, and the electrical, mechanical, landscape drawings, etc., will be grouped together as well, as shown in Figure 1-6.

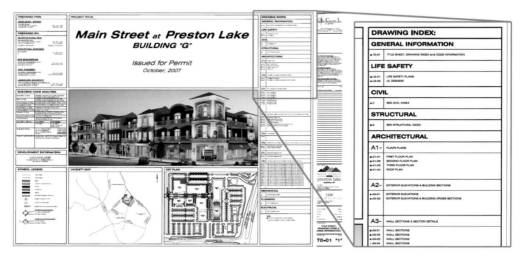

Figure 1-6. The title sheet of a set of construction drawings.

Much of the information presented in the architectural drawings simply reiterates what is discussed in other drawings and many times the architect will simply make annotations on a drawing telling the reader to refer to another drawing. For example, if an architect decides that a column should go in a certain location, he is usually not allowed by law to select a column without the approval of a structural engineer. Not knowing what column type or size the engineer will ultimately decide to use, and not wanting to worry about updating his plans if the engineer decides to change the structural drawings, the architect will often just place a note on his floor plan that reads something like, "Column – See Structural Drawings". The architect still needs to show a column on his floor plan and foundation plan, but he is not required to specify any pertinent information about it. Understanding this relationship between the architect and all of the subcontractors who work for him makes reading a set of architectural drawings much easier.

Elevations

Elevations provide viewers a better understanding of the scope and complexity of a project than any other drawing type. If this weren't true, then you wouldn't see elevations sitting in front of a project site, as shown in Figure 1-7; you would see other drawing types, such as floor plans or sections. Although I always recommend reviewing all the important CAD drawings firsthand before quoting a project, it is not difficult to estimate a project based on what is visible in the elevations alone. An elevation is one of the 1st drawings created for a new project, if not the very 1st, because with it an architect can show a building's style, size, and complexity all at once. If an architect or owner does not approve of the 1st elevation, then a new elevation can be generated without having had wasted time working on floor plans or any other drawings.

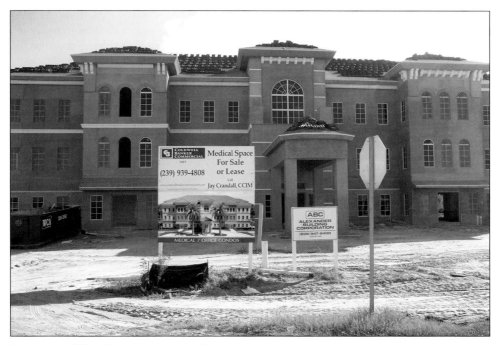

Figure 1-7. A 3D rendering used to advertise a project under construction.

When working on a building, a contractor can only use elevations as a visual aid. The contractor will never take measurements from an elevation and use that to determine things like window sizes, wall lengths, and door types. Because of this, some architects place a minimal amount of information on elevations and specify the critical dimensions and notes on other drawings such as floor plans and wall sections.

Since architectural drawings are printed in black and white, the only way to delineate differences in all of the lines on paper is by adjusting the line weight, or line thickness. In all drawings, heavier line weights usually indicate more important features in a project. For example in the left image in Figure 1-8, the outline of the standing seam roof is shown in heavier line weight than the thin vertical lines that indicate the standing seams. But in some drawing types, such as an elevation, heavier line weights can also indicate objects that are closer to view. Since all elevations show orthographic views, such as the left image in Figure 1-8 (rather than perspective views, such as the right image), line weights are the only way to show the viewer that objects are in the foreground or background. For example, notice that in the left image of Figure 1-8, there is a column just to the left of the building entrance on the 1st floor. The lines that delineate the outside of the column are thicker than the lines that delineate the same column just to the right of the door, because the column to the right is farther away from the viewer. Without this change in line weight for the two columns, there would be no way to know from just this one view that one column was farther away than the other. Regardless of what you perceive in this type of situation, if there is any doubt in your mind whatsoever, a quick check of the floor plan should confirm or refute what you visualize in the elevations.

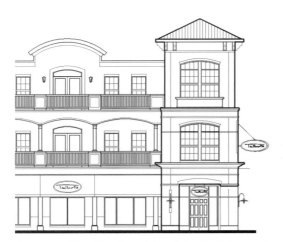 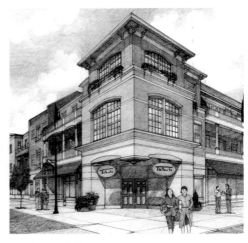

Figure 1-8. The difficulty in determining depth in an orthographic image (left).

As mentioned, elevations provide the viewer with the best overall look and feel for a project. But just like all drawings, they have to be scaled down to fit within a sheet of paper, and because of this, the elevations cannot show every little detail that goes into a building's construction. For example, the window elevations shown in Figure 1-9 only show one line to indicate window mullions. This is because at the scale that elevations are printed, drawing lines for every bend or corner in a window's profile would only result in one very thick solid line being shown. It is common practice among veteran 3D users to limit the amount of detail placed in a structure to that which is shown in the elevations. In other words, if it's an important enough feature for the client to want to see it in 3D, then it is usually important enough to place in the elevations. In fact, the contract that 3DAS sends out with every job indicates that all details shown in the architectural elevations will be included in the 3D model, and any detail not shown in the elevations will not be included in the 3D model unless expressly requested by the client. This kind of practice leaves little doubt for both the 3D user and client as to what will be included in the 3D model.

Obviously, this way of thinking requires some common sense. For example, if the architectural drawings show a single line to represent the mullions, then you clearly have to do a little research into the section details of the windows to determine what the mullion thickness should be. Likewise, when an architect cannot draw all of the lines for every bend and corner of a window's profile, it's a good indication that it's not necessary to model every bend and corner. In the left image of Figure 1-9, you can just barely distinguish separate lines indicating two major components of the window frame. Seeing these separate lines would be a good indication that the window frame you create in 3D should have at least one bend in its profile, i.e., two different parts at different depths.

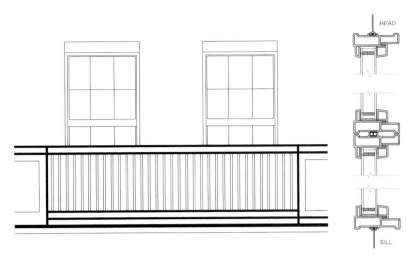

Figure 1-9. A typical elevation of a window (left) and the more detailed section view (right).

Elevations often provide clues about an object's structure that might at first go unnoticed. For example, in Figure 1-10, it might at first appear that the vertical bars in the railing are *completely* vertical, when in fact they are curved in two different places along their length. You cannot see the curvature in this single orthographic view, but a clue to their true shape can be found in the tightly spaced horizontal lines that run up the length of the bars. These lines indicate some sort of bend or corner and since there cannot be that many corners in such a small area, the only logical reason those lines exist is to denote a curve to the shape of the bars. What makes these lines even more important is that another elevation from the side may not even show these curves because they might be hidden from view by other parts of the building. In fact, the corresponding floor plan probably won't give any indication of these curves either, and therefore, whenever you see these types of clues, it would be wise to look at the railing details or any building or wall section that shows a section cut of these railings.

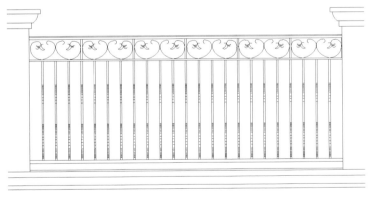

Figure 1-10. An elevation that reveals a clue that there's more than meets the eye.

An additional point I would like to make about the railings in Figure 1-10 is that unless you look at a detail drawing of the railing, there's simply no way to know whether the various parts of the railing have a square or circular cross section. In reality, it usually shouldn't matter because even if you know the cross section is circular, you shouldn't add the extra polygons if you don't need to, and unless your camera is extremely close to the railings, you would never be able to tell anyway. For railings that are completely straight (i.e., do not contain bends and curves), it wouldn't be too detrimental to build the railings with a circular cross section. But the railings in Figure 1-10 clearly have a significant amount of curvature, especially the intricate design in the top section. Adding a circular cross section to these railing could easily increase the polygon count 5-fold or more. Simply put, knowing how much detail to build into your objects is a critical part of scene optimization.

Floor plans

The heart of any set of architectural drawings is the floor plan. From the drafter who labors over its creation, to the engineer who uses it as a template for his or her drawings, to the builder who methodically erects the building to its specifications, no other drawing type receives as much attention and analysis as the typical floor plan. Floor plans show and delineate important building components of a single floor as seen from a top view and as seen from a particular vertical position between the floor and ceiling. The primary responsibility of a floor plan is to show precisely where walls, windows, and doors are located, and depending on the type of project and drawing practices of the architectural firm, may include other critical building components such as beams, columns, roof overhangs, and floor and wall finishes (or surfaces).

When a builder starts the construction process, the drawing the builder will be most focused on is the foundation plan, because you can't erect walls, windows, doors, etc., without a foundation in place. On very small projects, the information usually placed on a foundation plan might be incorporated in the floor plan, but in most construction drawings, the foundation plan is a self-contained drawing that delineates important structural information. This critical information including footing sizes, slab thickness, beam and column locations, etc., comes from a structural engineer, but that information starts with a floor plan. During the design development stage, an architect will provide the structural engineer with a floor plan, and using that floor plan as a template the engineer can design the structural components of the building. If the structural engineer decides that walls have to be moved or columns have to be changed, architects will then adjust the floor plan within the construction drawings to accommodate the necessary structural design change. The same kind of process is repeated with each of the engineers (mechanical, electrical, plumbing) involved in the design, so it should be easy to see how the floor plan serves as a central authority from which all other drawings are generated.

On a floor plan, lines representing the exterior of a wall usually do not actually indicate the exterior surface but rather the outside surface of the load bearing component within the wall. This means that even if the exterior side of a wall contains a 1-inch trim feature running along the bottom of the wall, as shown in Figure 1-11, the floor plan will still reflect where the main load bearing part of the wall is (in this case the concrete block). The line on a floor plan representing the exterior of a wall will still almost always represent the outside surface of the concrete block, or whatever load bearing component the wall is made from. When you begin setting up your linework for importation into 3ds Max, I recommend aligning all the available elevations to the floor plan in this manner. If drawn correctly, both sides of the elevation will align to the floor plan as shown in Figure 1-11.

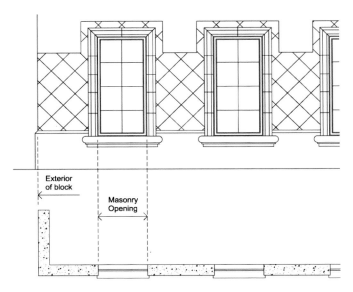

Exterior
of block

Masonry
Opening

Figure 1-11. Projecting a floor plan onto an elevation.

If a project involves creating an exterior visualization only you don't need to be concerned with anything inside the building, except for those elements you want to see through the windows. Therefore, you usually don't have to be concerned with something as insignificant as the exact location of the interior surface of an exterior wall. When preparing the CAD linework for importation into 3ds Max, in most cases I will simply trace the linework representing the exterior surface of the walls, and offset these newly created lines 8 inches. Tracing the existing linework ensures that the linework I import is flawless, and offsetting the linework 8 inches ensures that I have a sufficient wall thickness to house all windows and doors. The fact that the walls may actually be 8.5 inches, 9.25 inches, 10.1 inches, etc., really is an irrelevant thing that will never be noticed. Perhaps if the wall thickness were as large as 12 inches, I would then offset the exterior lines 12 inches.

This same type of mentality should also apply to a project where all you need to create is an interior visualization. For an interior scene, you would obviously need to use the linework on a floor plan that represents interior walls; however, every architect has his or her own unique way of representing interior walls. Some choose to depict walls with two lines showing a rough approximation of the actual wall thickness, while some choose to show two lines representing stud thicknesses along with an additional line on either side depicting a particular wall finish. Some choose to dimension their walls and others choose to label their walls with an annotation that directs viewers to look at a wall schedule to determine the exact wall thickness. Regardless of how interior walls are depicted on a floor plan, 3D artists should not be concerned with what's inside a wall, but rather that the linework is located in an approximately accurate location. Accuracy in 3D is a difficult concept for many users to prioritize, and it's important to understand how to prioritize the accuracy of the linework you prepare for 3ds Max. For example, if you have a tiny one-quarter-inch gap showing between two walls that should be perfectly joined, that is a really bad thing, because light can easily seep through and the viewer will almost always see this kind of inaccuracy. However, if your wall thickness is off by that same amount or if your wall placement is off by that same one-quarter of an inch, the viewer will never know or care.

Checking floor plans against elevations is an important part of preparing the CAD drawings for use in 3ds Max. In Figure 1-11, notice that in addition to the side of the building being aligned properly, the masonry openings are also aligned. If this were not the case, then the client will usually want you to build per the elevations, since they best reflect what the client understands the building will look like. One more point I would like to make about this image is that the windows have a substantial trim feature around the top, left, and right sides of each window. It would be impossible to know for sure what the cross-section of this trim feature looks like without referring to a section drawing or a detail drawing that includes a section cut through the window.

Perhaps the most important feature found on a floor plan is the dimension. Engineers will always use a floor plan's dimensions to design their elements, and builders will always use dimensions to guide their construction. 3D artists have little need for dimensions, however, because as just mentioned, the linework used in 3D doesn't need to be as accurate as the linework used by the actual builder. For example, if a drafter modified a floor plan dimension at the very last minute without adjusting the linework properly, which happens all the time, this should be of no concern to the 3D artist. So after receiving a drawing from an architect, one of the very first things I will do is remove all of the dimensions. Floor plans tend to also contain a great deal of notes, and while some of these notes may provide important reference information that would be useful further along the 3D creation process, much of what is found can be removed along with the dimensions. The idea is to remove everything from all drawings that is simply not going to prove useful in 3ds Max. Importing hundreds of dimensions, notes, hatch patterns, etc., will only slow your work in 3ds Max.

Sections

Section drawings provide a cutaway view of a building from the side to reveal what lays beneath the surface of each building element the section cuts through. In a set of architectural drawings, there are usually one or two building sections that show a complete section view of the entire length of the building, and several wall sections that provide a partial section view of areas that need special emphasis, as shown in Figure 1-12.

The main purpose of a section drawing is to illustrate information that cannot be easily derived from other drawings. For example, the left image of Figure 1-12 shows part of an elevation, but it cannot be determined from this elevation alone or any other drawing type (beside a section) where the roof of the building is located. If the elevation contained an elevation marker indicating that the roof is located, for example, 15'-0" A.F.F. (above finish floor), then you would not need to refer to a building or wall section. However, as mentioned, every architectural firm has its own way of creating drawings and this is not something you are guaranteed to find on a drawing. If such a note does exist on an elevation, then that would be an example of a note that is worth keeping for later reference when the time comes to create the roof. So if you want to determine where the roof is positioned in the elevation of Figure 1-12, simply refer to drawing B on sheet A5.1 and you would see the appropriate section and the true location of the roof.

Figure 1-12. A section drawing revealing the location of the roof - information missing from the elevation.

It's important to note that while every firm has its own unique way of creating drawings, there are some general guidelines that most firms follow in the creation of section drawings. First, when a section view cuts through an object, that object is usually shown with a hatch pattern. In the right image of Figure 1-12, notice that the roof that was just discussed contains numerous horizontal and vertical lines. This is nothing more than a hatch pattern to indicate that the roof is not just some object in the background of the section but rather is an object being cut by the section. Notice also in this image that two rectangular areas contain a solid hatch. This type of hatch is usually reserved for beams or areas where concrete is poured into place.

As 3D artists, we shouldn't be too concerned about what the inside of a wall looks like or what materials make up the floor or ceiling of our visualization. However, it is important to understand what each component of a section drawing is depicting, so we know where to find the missing information we cannot find on other drawings.

As an additional note about section drawings, they are often very helpful in the creation of lofts or sweeps. As a matter of preference, I always create walls using the loft or sweep feature rather than extruding splines or using the Edit Poly feature some users prefer. If you want to ensure that the shapes you loft or sweep contain the highest level of detail possible, you might need to generate your shapes using the section drawings. Due to the large scale that elevations are usually printed, such as 1/8"=1'-0", there is only so much detail that architects want or need to put into the elevations. Earlier I mentioned that if the detail is not shown in the elevations then it typically does not need to be seen in 3D (except for close-up views). While this is a good rule of thumb, when detail *is* needed, you might simply have no choice but to build your shape from a section drawing. In Figure 1-13, you can see an elevation that doesn't contain as much detail about the soffit and fascia as the section drawing. By using the section drawing as a guide, rather than the elevation, you can trace a much more detailed shape to use for your loft or sweep, as shown on the right side of the image.

Figure 1-13. A section drawing used to create a more detailed shape than what the elevation can provide.

Site plans

I believe that if there is any drawing type that 3D artists struggle with understanding more than any other, it would have to be the site drawing. This is primarily because site drawings are convoluted with far more information than a 3D artist would ever care to see or know about and while the information is important and necessary to the contractor building the project, the majority of information found on most site plans only makes understanding the linework more difficult. Figure 1-14 illustrates this problem quite clearly. The top image shows a large site drawing over 300 acres and the bottom left image shows a close-up of one area. As you can see, there is an enormous amount of linework that is simply unnecessary for the 3D artist. The bottom right image shows the same close-up with all the unnecessary information removed. Taking this 'dirty' site plan, as I call it, and turning it into a 'clean' site plan can be quite a challenge for even an experienced 3D artist if he or she does not understand some basic principles about how site plans are created.

Figure 1-14. An example of a 'dirty' and 'clean' site drawing.

As mentioned earlier, architectural drawings reiterate a great deal of information presented by the subcontractors. In the case of a site drawing, architects will usually always include their own watered down version of a site plan that contains a fraction of the information provided by the civil engineer who creates the master site plan. The primary reason for this is so the building department and the other subcontractors involved in the project can see and understand the overall site concept without needing a degree in civil engineering. If an architect presented the more convoluted site plan to the building department some of the members deciding whether to approve the project might have no clue as to what they were looking at. So the architect's job is to take the civil engineer's drawing and remove all but the most important features that are critical to winning approval by the building department, and critical to helping the other subcontractors design their respective areas of the project. Figure 1-15 shows an example of an architectural site plan with just the most important information, such as setbacks, property lines, retention areas, new walkways, etc. In this particular drawing, the fire protection plan is combined with the site plan because of the simplicity of both individual drawings.

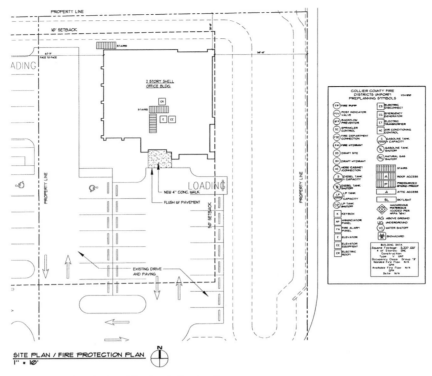

Figure 1-15. A typical architectural site drawing.

Civil engineers use a different scale than architects and because of this, the drawings you receive from an architect may need to be scaled properly before they can be superimposed with the drawings used to create the buildings in your project. Civil engineers use decimal units with 1 unit equaling 1 foot. Architects, on the other hand, use architectural units with 1 unit equaling 1 inch. It should be mentioned here, however, that in most countries besides the U.S., architects and engineers both use the metric system. Regardless, civil engineers in the U.S. create their drawings with 1 unit equaling 1 inch, which means that the drawings are created at 1/12th the scale of the drawings that an architect creates. This means that if you want to superimpose a building's linework on the site drawing, you will need to scale the site drawing up 12-fold for the footprints to match.

Another thing that makes understanding site plans difficult for some users is that when an architect sends a site plan for a project, it usually does not come with such details as the one shown in Figure 1-16. Many architects don't think to send this type of drawing to the 3D artist and many 3D artists don't think to ask for it. But without this kind of detail, the 3D artist is left to guess at the details of key features. In this image, you can see a particular type of curb profile, and in this drawing it's actually given the callout, 'Type F'. This means that somewhere in the civil engineering drawings, there's a detail drawing entitled 'Type F' and if the 3D artists creates anything other than this curb type, there is a good chance that the owner or architect will have something to say about it. Whenever you work on a drawing (such as a site plan) where it's impossible to know exactly what is going on, it's better to ask the client for more drawings or more information. Otherwise, the consequences could be costly and time-consuming.

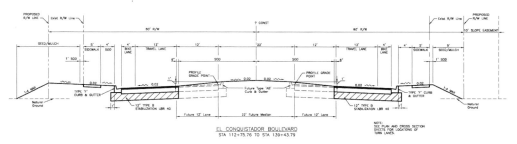

Figure 1-16. An example of a site drawing detail.

Landscape plans

In the previous discussion about site plans, I stated that *"I believe that if there is any drawing type 3D artists struggle with understanding more than any other, it would have to be the site drawing."* I certainly believe this to be true, but if there is one drawing type users actually struggle with conforming to, it would without a doubt be landscape drawings. Landscape drawings present a challenge to many users because vegetation is one of the most difficult, if not *the* most difficult type of visualization content to create realistically. Just like poor lighting can ruin a perfectly modeled and textured scene, poor landscaping can ruin a perfectly illuminated exterior. In my experience, I have found that landscaping is rarely a focal point of a project. However, when not created realistically, it quickly becomes the most distracting component of a visualization.

There are numerous reasons why landscaping is such a difficult part of architectural visualization. One is that many clients don't have a landscaping plan prepared at the time they ask for your services, and when asked about the landscaping, their typical answer might be, "just throw in something that looks nice" or "just make it tropical looking". But because most of us aren't landscape architects, these requests are easier said than done. Another reason is that there are tens of thousands of plant and tree species in the world and if the client wants the same vegetation that is specified in the landscape drawings, it is often very difficult to find a suitable match in one's library. Even if you own an extremely large library or own a plugin that allows you to create vegetation from scratch, it is often very difficult to replicate the look of the actual vegetation specified in the landscape drawings.

Before accepting or quoting a project, I highly recommend asking the client exactly what he wants to see for landscaping. Specifically, it would be wise to ask the following questions at a minimum:

- Are there landscape drawings? If so, are the drawings just temporary and made only to satisfy code or will there be a new landscape plan designed down the road?

- How closely does the vegetation in 3D have to match the vegetation that will actually be planted? Can I, for example, use a Foxtail palm in lieu of a Queen palm.

- Do you want to see fully matured vegetation or younger vegetation like the kind that will actually be planted?

- Are the hardscape elements (pavers, coping, etc.) finalized? If not, when will they be?

The answers to these questions can greatly affect the amount of rework you have to perform so it would be wise to cover yourself by stating in the contract what the consequences are of the different possible answers you might receive. For example, if there are no landscaping plans, and the client wants you to play the role of landscape architect, are you going to charge extra for this work and what happens if the client doesn't like your design?

As indicated in the last question, landscape architects are usually responsible for designing hardscape elements like pavers, coping, pool decks, walkway patterns, etc. If you do not see these details on the architect's site plan, which in my experience is rare, don't assume that they will not be needed. One of the great marketing advantages of working with a client on a 3D visualization is that you will often be asked by the client to contact the various subcontractors directly to obtain the information or drawings you need. Take advantage of this opportunity and place a call to the landscape architect (or any sub) and ask the type of questions just mentioned. You will often find the landscape designer giving you significantly different and more accurate information than the project architect. Of course this is true for any sub contractor you deal with, so it's always good to ask questions.

Landscape architects usually delineate their vegetation selections in one of two ways; by plac-ing annotations next to groups of plant and tree symbols, as shown in the left image of Figure 1-17, or by creating a legend of symbols and using those different symbols in the landscape plan to indi-cate the different types of vegetation, as shown in the right image. In the left image, notice that there is a callout for 4 Foxtail palms and that the callout is pointed to only one symbol. Since the annotation refers to 4 Foxtail palms, you should see 3 other identical symbols close by, as the image shows. Underneath each callout in the left image and under the Specification header on the right image is the information for the size of the vegetation to be planted. It is obviously impor-tant to create your vegetation at the correct size; however, I find it easier and sufficient to just import the vegetation symbols and use their canopy sizes to scale the vegetation to proper size.

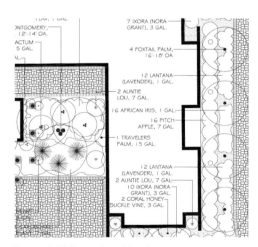

PLANTING SCHEDULE

Palms

Plant Sym	Botanical Name	Common Name	Specification
●	Roystonea elata	Royal Palm	4'-6' gw; 24' oa matching
✳	Wodyetia bifurcata	Foxtail Palm	8' ct. 14'-16' oa
⊛	Ptychosperma elegans	Alexander Palm	10'-14' ct, triple - staggered 16'-18' oa
◉	Chrysalidocarpus lutescens	Areca Palm	5'-6' oa, triple - staggered
◉	Cocs nucifera	Malayan Coconut Palm	6'-8' - wood - 24' oa, full
⊛	Veitchia winin	Winin Palm	8'-10' ct, double staggered 12'-14' oa.
❀	Phoenix roebelini	Pygmy Date Palm	5'6' oa, triple staggered

Trees

Plant Sym	Botanical Name	Common Name	Specification
⊗	Tabebuia Impetiginosa	Purple Tabebuia	10'-12' oa - 6'-8' spr. 4'ct 2' cal.
⊗	Tibouchina granulosa	Purple Glory	6'-8' oa - spr. 3' ct. 1 1/2' cal.
⊛	Bucida buceras	Black Olive	14'-16' oa. 8' spr. 6' ct. 3' cal.

Figure 1-17. Examples of landscape annotations.

As a final note about landscaping, the larger the vegetation, the more important it is to create correctly. In the left image of Figure 1-17, for example, it is far more important to make sure the large Foxtail palms look like Foxtail palms than it is to make sure the very small African Iris plants look correct. You should obviously try to match vegetation as well as you can, but when you simply don't have the correct model in your library or don't have the time to create it from scratch, it is far better to sacrifice accuracy on the smaller vegetation. In fact, as long as your camera isn't too close to the vegetation in question, you can use the **Scatter** feature to quickly create vegetation that has the general look you need to achieve. For example, if you want to create a large number of small hibiscus plants with white flowers, simply scatter an individual face with an appropriate image of a green leaf around a volume that represents the location of the plants and then scatter a face with an image of a white flower. By controlling the number of duplicates you can easily control the density of the green leaves and white flowers, and by controlling the size of the individual faces that get scattered, you can control the quality (or accuracy) of the vegetation and the shadows that get cast. Techniques like these are discussed throughout the rest of this book.

Roof Plans

Except for flat, simple roof designs, a roof can be another extremely difficult object type for 3D artists to create. With some programs like Revit or Architectural Desktop, you can create simple roofs in just a few seconds. However, with complicated roof designs, these programs simply don't always make things any easier. Once you start introducing curves, changes in elevation, or unique frame structures, creating a 3D roof in 3ds Max becomes much more practical and efficient.

I think it would be safe to say that before you can create a roof in 3D, you must know how to create one in 2D, and unless you've worked in an architectural office doing such a thing, this might be quite a difficult undertaking. Having spent several years as an architectural draftsman, I've probably drawn over 100 roof plans for all types of buildings, but for very complex roof structures I still find myself struggling today. Unfortunately, roof plans are not always available when a client approaches you for a 3D visualization, and when this is the case, your only choice is to wait on the architect to provide one or create one yourself. Regardless, unless you know how to draw a plan in 2D, you probably won't have much success creating one in 3D.

Relatively speaking, roof plans do not usually contain a great deal of linework because there are really only a few critical things the architect needs to delineate. The most important thing to show is the location of roof ridges, hips, and valleys, but other important things include roof pitches, gutter locations, roof surface materials (e.g., tile, shingle), and exterior wall locations, all of which can be seen in the example in Figure 1-18.

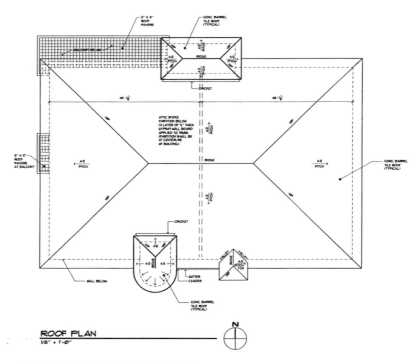

Figure 1-18. An example of a roof plan.

Unless a unique roof design is called for, two adjacent roof planes 90 degrees apart in orienta-tion will always meet to create a hip at exactly 45 degrees, as shown in Figure 1-19. When one roof structure joins into a completely separate roof, a valley will be created, also shown. Notice also in this image that the apex of this roof is labeled ridge and that the slope of the roof, known also as pitch, is labeled as 4:12. The 4:12 is also known as the rise-over-run because the roof rises 4 feet for every 12 feet it runs horizontally. The only reason the hip lines would not be exactly 45 degrees in orientation is if the adjoining roof surfaces were not at the same slope. Because of the annotation **TYP** (short for **typical**) in Figure 1-19, we can clearly see that all three roof surfaces have the same 4:12 slope.

Knowing this basic information, you can quickly create the 2D linework for many simple roof designs by drawing lines representing the roof overhangs (the distance from the exterior walls to the edge of the roof), and connecting the various roof surfaces with straight 45 degrees lines and horizontal/vertical lines representing the ridges.

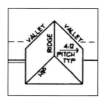

Figure 1-19. An example of a hip and valley connection.

Figure 1-20 illustrates some other features commonly found on a roof plan. Notice that the top side of this image shows a horizontal line for the roof's edge rather than two valley lines where one roof joins another. This is a clear indication that this particular roof is completely separate from the main roof and in fact stands well above it. If this small roof ran into the larger roof, we would see two valley lines at 45 degrees. Another indication that this smaller roof is independent of the larger roof is the dashed line representing the exterior wall surfaces below. Dashed lines are used to delineate structures below or above the view of whatever is being displayed. In this case, we can see a completely separate set of lines for this roof, which would only be shown if this roof was rising through and above the main roof. Yet another indication that this roof is elevated above the main roof is the annotation of a building element known as a cricket. A cricket is a structure that redirects rain water so it runs off the roof rather than collecting behind a wall that rises through a roof. Because we see a cricket callout on the roof plan, we know that there is a wall coming up through the main roof.

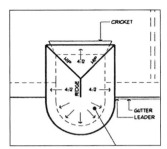

Figure 1-20. An example of a cricket.

This section has highlighted just a few things to help make understanding roof plans a little easier. Later in this book, we'll look at various methods used to create 3D roofs from this 2D linework.

Reflected Ceiling Plans

The last drawing type I want to discuss is the reflected ceiling plan. This drawing type, shown in Figure 1-21, gets its name from the idea that if you look straight down on a mirror lying on a floor, you would see the reflection of the ceiling in the mirror. This drawing is usually only needed for interior scenes, but without it, you would probably find yourself playing the role of an architect designing the layout of important building elements such as light fixtures, ceiling fans, suspended ceilings, soffits, etc., all of which are found on the reflected ceiling plan.

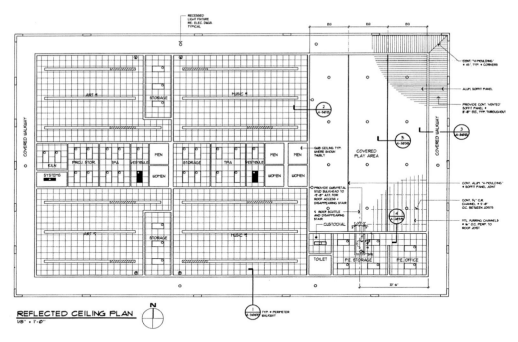

Figure 1-21. An example of a reflected ceiling plan.

Like a floor plan, the reflected ceiling plan shows certain building elements cut through. But unlike a floor plan, where the cut plane usually exists about half way between the floor and ceiling, the cut plane for the ceiling plan occurs just below the ceiling, thereby excluding windows and doors from the cut. Notice in Figure 1-21 that no doors or windows are shown. However, the magnified image in Figure 1-22 gives a clear indication of columns along the covered walkway being intersected by the cut plane. The columns are shown with a bolder line weight while beams that run between them are shown in a lighter line weight. This allows the architect to highlight the location of important building elements (like beams) that might be excluded from the floor plan. The architect *could* show the cut running through windows and doors, but this would serve no purpose and would only convolute the drawing with unnecessary linework. Notice also in Figure 1-22 that other important features like soffit panels can be detailed. With the exception of a section drawing, this kind of information could not be found anywhere else. One other important piece of information commonly found on reflected ceiling plans is ceiling height. The plan shown in Figure 1-22 does not show ceiling height because there is only one ceiling height used throughout the entire building and this was noted on the floor plan; however, the reflected ceiling plan is often the main reference point for specifying ceiling heights.

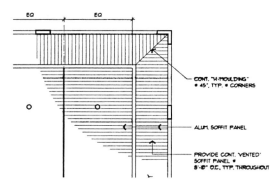

CONT. "H-MOULDING"
@ 45°, TYP. @ CORNERS

ALUM. SOFFIT PANEL

PROVIDE CONT. 'VENTED'
SOFFIT PANEL @
8'-0" O.C., TYP. THROUGHOUT

Figure 1-22. An example of a reflected ceiling plan.

Summary

The purpose of this chapter is to help 3D users understand the process of creating architectural drawings and some of the important characteristics of the most important drawing types for work in 3D. Many visualization artists migrate from other industries, and understanding architectural drawings can be quite difficult. Unfortunately, being an expert in 3ds Max doesn't help much when it comes to reading architectural drawings or understanding how they are put together. Without knowing how to read drawings, there's really no way to create what you need to in 3D, and without knowing the process of creating architectural drawings, you are far more likely to run into some of the many problems mentioned in this chapter that can come up along the way. Hopefully, before continuing on with the remainder of this book you have a thorough understanding of concepts discussed in this chapter. If so, the techniques described throughout this book will be much easier to understand.

Preparing AutoCAD Linework for 3ds Max

AT THE BEGINNING OF CHAPTER 1, I stated that the building block of any architectural scene is linework and that the vast majority of architectural visualization projects begin with AutoCAD drawings. Whether you model in 3ds Max or choose what I would call the more difficult approach of modeling in other programs such as AutoCAD, Revit, or Architectural Desktop, linework is where our work will always begin. Unlike users in other industries who can start with a simple primitive and use an endless number of tools to change the primitive into a highly complex character or some other free-formed model, those of us in the visualization industry cannot simply build architectural elements without the same drawings used to build the structures in real life.

This chapter demonstrates techniques that can be used to prepare this AutoCAD linework for importation into 3ds Max. If you choose to do the majority of your modeling in a program other than 3ds Max, then unfortunately, some of the techniques outlined in this chapter won't apply. However, if you take my advice and conduct the majority (if not all) of your modeling in 3ds Max, then one of the most important phases of the 3D design process is the preparation of AutoCAD linework for 3ds Max. Simply put, knowing how to use the CAD linework found in a set of architectural drawings is a critical factor in fast, efficient work in 3ds Max. So in this chapter you will see how good preparation of linework in AutoCAD can allow the 3ds Max user to model many complex scene elements in just a few seconds. In reality, the techniques discussed in this chapter can be applied to any CAD program on the market. But because AutoCAD is by far the most widely used 2D CAD program in the world, this chapter is catered toward AutoCAD users.

The steps this chapter outlines to help you prepare AutoCAD linework for 3ds Max are as follows:

- AutoCAD setup
- Explore and examine AutoCAD drawings
- Consolidate drawings
- Clean linework

- Orient linework
- Create new linework as necessary

After reading this chapter, you should have a thorough understanding of the process used to prepare AutoCAD linework for 3ds Max. Parts 2 and 3 of this book continue where this chapter leaves off by describing techniques for importing this newly prepared linework and using it to create various building and site elements.

AutoCAD Setup

After a few years of teaching 3ds Max, it occurred to me that an enormous number of intermediate level 3ds Max students have little or no working knowledge of AutoCAD. I imagine the biggest reason for this is that many 3ds Max users import linework in a different way than the way described in this chapter. Specifically, rather than spending time in AutoCAD cleaning the drawings and preparing the linework for a streamlined workflow, many users elect to import *all* of the linework from AutoCAD drawings and use this linework as a guide with which to create their models. For example, in Figure 2-1, you can see four elevations around the model of a house. Many users import drawings like this and model the various building elements with the appropriate elevation serving as a background and a guide. There is nothing wrong with this approach if it works for you, but I personally don't believe it can compare to the speed and efficiency of the method outlined in this book, which uses the Loft command and/or Sweep modifier. However, before either of these features can be used efficiently, the AutoCAD linework must be properly prepared, and the best place to make these preparations is inside AutoCAD itself.

Figure 2-1. Imported AutoCAD elevations used as a guide for modeling in 3ds Max.

Since this discussion is based on the idea of maximizing speed and efficiency while preparing AutoCAD linework for 3ds Max, I thought it would be appropriate to first mention some fundamental concepts that deal with how the AutoCAD user interacts with the program. If you started using 2D

or 3D software in the days of DOS based software, before icons and toolbars were available and when computer displays were much smaller, you probably have a much better appreciation for keyboard shortcuts and maximizing screen real estate. Whichever is the case, let's take a few moments to look at a few things that might make working in AutoCAD much faster.

Customization

I don't normally recommend customization to anyone who isn't already very familiar with a program; however, since there are a few very simple customization changes you can make that can greatly improve your efficiency in AutoCAD, I feel that a short discussion about these changes is warranted here.

When you first install AutoCAD, you are presented with numerous toolbars and program settings that are not optimized for maximizing speed and efficiency, as shown in Figure 2-2. This image shows the default layout for AutoCAD version 2004, but the layout is very similar to even the latest release of the program. Incidentally, at 3DAS, we use 2004 because we don't need any of the features in later releases, and Autodesk recently removed the 3DSOUT command. As you'll see later, this command is critical to our workflow.

Figure 2-2. The default AutoCAD 2004 layout.

To maximize screen space you can simply right-click any toolbar and deselect those you don't want to use, or click and drag them to the center of the screen and then close them one at a time. The only toolbars we keep on our screens at 3DAS are the **Layers** and **Properties** toolbars.

By typing **Config**, you can enter the **Options** dialog box, shown in Figure 2-3, and do a few more things that can speed up your work in AutoCAD. Within the **Display** tab, I recommend turning off the **Screen Menu** and scroll bars, both of which take up valuable screen real estate. The Screen Menu is the large menu interface directly to the right of your viewport. At the bottom of this tab is an option to increase your crosshair size and whether you use AutoCAD for 2D drafting or for importing into 3ds Max, this option should be set to 100% so the crosshairs stretch to the entire length of your screen window, thereby allowing you to use the crosshairs as a tool to check the alignment of lines on opposite ends of the screen.

Figure 2-3. The AutoCAD Options dialog box.

If you make the changes described, your AutoCAD screen would look like the image in Figure 2-4, and you would have a substantial increase in viewport area.

Figure 2-4. AutoCAD with an increase in viewport area.

Inside the **User Preferences** tab of the Options dialog box is a button that allows you to customize the right-click button of your mouse. Whether you use keyboard shortcuts or icons to enter commands in AutoCAD, the **Right-Click Customization** button is an important feature to customize properly because doing so allows you to execute commands even quicker than using keyboard shortcuts with your free hand. In AutoCAD, there are three different modes you can be operating within, and how you customize this dialog box determines what happens when you press the right mouse button in each of these three different modes. I recommend setting up this dialog box as

shown in Figure 2-5. In default mode, when no objects are selected, I recommend having a right-click mean **Repeat Last Command**. In Edit Mode, when one or more objects are selected, I recommend having a right-click mean **Shortcut Menu**. Finally, in Command Mode, when a command is in progress, I recommend having a right-click mean **Enter**. Configuring your right mouse button this way allows you to very quickly start the same command over again, open a shortcut menu and end a command in progress, which are perhaps the most commonly executed commands in AutoCAD, with the possible exception of the zoom and pan features, which should without a doubt be performed with the middle mouse button...once again a type of mouse configuration.

Figure 2-5. The AutoCAD Right-Click Customization dialog box.

Units

Another thing to keep in mind with every AutoCAD drawing you open is the drawing's units. Unlike the previous configuration settings mentioned, units are stored with each drawing rather than the program itself. Before importing the linework from any drawing into 3ds Max, it would be wise to ensure that you know at what scale your drawing was created. Otherwise, you might find that your floor plans don't fit properly into your project's site drawing. In the U.S., architects create drawings so that 1 unit equals 1 inch. Civil engineers, on the other hand, create drawings so that 1 unit equals 1 foot, which means that before you import site drawing linework into 3ds Max, you determine whether you need to scale your drawings up twelve-fold to match the architectural drawings. As mentioned in Chapter 1, many architects create their own properly scaled version of the site drawing, using the civil engineer's linework as a guide.

To change or inspect a drawing's units, type **units** at the command prompt. Doing so opens the **Drawing Units** dialog box, shown in Figure 2-6. As an additional note, the precision specified in this dialog box has no effect on the accuracy of linework in AutoCAD or imported into 3ds Max.

Figure 2-6. The AutoCAD Drawing Units dialog box.

Command Alias Editor

As mentioned constantly throughout this book, keyboard shortcuts provide a great way to increase speed and efficiency with 3ds Max. The same holds true with AutoCAD even if you use the program for nothing more than preparing linework for importation into 3ds Max. Keyboard shortcuts can drastically reduce the time it takes to interact with AutoCAD and considering that you might need to spend up to 25% or more of your total project time preparing linework in AutoCAD, the time savings can be enormous.

Keyboard shortcuts in AutoCAD are stored in a file labeled **acad.pgp**, and as of release 2004, this file is saved in the following location:

C:\Documents and Settings\Administrator\Application Data\Autodesk\AutoCAD 2004\R16.0\enu\Support

If you want to edit your shortcuts, you can do so by opening this file with a simple text editor such as Wordpad or Notepad. However, an easier way to do this would be through the **Command Alias Editor** dialog box found in the **Express** > **Tools** menu, and shown in Figure 2-7.

As an additional note, Figure 2-8 provides a list of important AutoCAD commands for anyone needing to prepare linework for 3ds Max. As with any 2D or 3D program, the most widely used commands in AutoCAD will undoubtedly be the pan and zoom commands, which are not shown in this list because they are best accessed with a middle wheel mouse button. If you have a solid understanding of just these 30 commands, there won't be much you can't do to efficiently prepare linework for importation.

Figure 2-7. The AutoCAD Command Alias Editor dialog box.

A	Arc	LO	Layon
C	Copy	M	Move
CC	Circle	MI	Mirror
D	Dist	O	Offset
E	Erase	OS	Osnap
EL	Ellipse	PE	Pedit
EW	Extend	PL	Pline
F	Fillet	PP	Pasteclip
FF	Filter	R	Rectang
FR	Layfrz	RE	Regen
I	Imitate	RT	Rotate
IS	Layiso	S	Scale
L	Line	ST	Stretch
LA	Layer	T	Trim
LI	List	X	Explode

Figure 2-8. The top 30 AutoCAD commands suggested for learning with preparing linework.

Explore and examine AutoCAD drawings

One of the first questions a potential client will ask about 3D visualizations is how much does it cost. Pricing your work is arguably the most difficult and important part of your job if you are the owner or manager of a 3D visualization firm. As hard as it is, it would be far more difficult, and certainly more risky, to provide someone a quote on a project before ever looking at the project drawings. At 3DAS, we learned long ago, and sometimes the hard way, to never speak a word about prices before seeing a project's drawings. There are numerous reasons for this, besides the obvious problem of quoting too low before realizing the true scope of work that lies ahead. One is that you don't give yourself the opportunity to learn more about your client and the project he needs you to work on, both of which can influence the final price you set. Another is that without seeing the drawings, you should estimate high for a worst case scenario, and though you may tell the client you are in fact estimating high, he/she may be completely turned off by your over-inflated proposal.

But the biggest reason you should thoroughly examine AutoCAD drawings before quoting a future project is that there are numerous ways drafters and architects can put a drawing together that will add an enormous amount of time to your work. We will look at most of these ways a little later, but suffice to say, you should avoid quoting a project before you are able to receive a complete, or nearly complete, set of architectural drawings.

The next part of this discussion deals with consolidating and cleaning your AutoCAD drawings, but before you can do either, you have to first examine all of the drawings your client provides so you have all of the linework needed to properly create all parts of the project. Our clients usually don't know much about what we do or how we do it. Sometimes they just don't care. Sometimes, the person we deal with is an architect, a real-estate agent, the owner of a construction company or some other person who is simply representing the owner who is actually paying the bill. Sometimes these contacts don't even want or endorse the 3D visualizations we produce and only work with us on a project because they are forced to by the owner who insists on using 3D. Whatever the case may be, we sometimes have to beg, plead, and holler to get all the necessary drawings from our contacts, while other times our contacts simply throw us everything they have and tell us to find what we need.

Figure 2-9 shows an example of a list of AutoCAD drawings an architect provided us, perhaps not knowing or caring what we needed to do our work. As you can see, the list includes floor plans, site plans, elevations, and sections, the heart of what we need to do our work.

Name ▲	Size	Type
071LOT4	478 KB	AutoCAD Drawing
A-01 SITE	221 KB	AutoCAD Drawing
A-02 1ST FLOOR PLUMB	221 KB	AutoCAD Drawing
A-03 1ST FLOOR NOTE	223 KB	AutoCAD Drawing
A-04 1ST FLOOR ELECT	247 KB	AutoCAD Drawing
A-05 2ND FLOOR NOTE	228 KB	AutoCAD Drawing
A-06 2ND FLOOR STRUC DIM	215 KB	AutoCAD Drawing
A-07 2ND FLOOR INT DIM	204 KB	AutoCAD Drawing
A-08 2ND FLOOR ELECT	246 KB	AutoCAD Drawing
A-09 3RD FLOOR NOTE	229 KB	AutoCAD Drawing
A-10 3RD FLOOR STRUC DIM	211 KB	AutoCAD Drawing
A-11 3RD FLOOR INT DIM	203 KB	AutoCAD Drawing
A-12 3RD FLOOR ELECT	247 KB	AutoCAD Drawing
A-13 4TH FLOOR NOTE	226 KB	AutoCAD Drawing
A-14 4TH FLOOR STRUC DIM	217 KB	AutoCAD Drawing
A-15 4TH FLOOR INT DIM	203 KB	AutoCAD Drawing
A-16 4TH FLOOR ELECT	244 KB	AutoCAD Drawing
A-17 ROOF DECK NOTE	221 KB	AutoCAD Drawing
A-18 ROOF DECK STRUC DIM	212 KB	AutoCAD Drawing
A-19 ROOF DECK INT DIM	204 KB	AutoCAD Drawing
A-20 ROOF DECK ELECT	238 KB	AutoCAD Drawing
A-21-24 ELEVATIONS	2,212 KB	AutoCAD Drawing
A-25 ROOF PLAN	204 KB	AutoCAD Drawing
A-26 SECTIONS	1,737 KB	AutoCAD Drawing
A-27 POOL PLAN	237 KB	AutoCAD Drawing
BASE 1	289 KB	AutoCAD Drawing
BASE 2	407 KB	AutoCAD Drawing
BASE 3	366 KB	AutoCAD Drawing
BASE 4	400 KB	AutoCAD Drawing
BASE ROOF DECK	314 KB	AutoCAD Drawing

Figure 2-9. The AutoCAD drawings provided for a past visualization project.

As thorough as the list was, and as many unnecessary drawings as we were provided, there were numerous other drawings, which we didn't receceive but needed to complete our work, to include landscaping, interior elevations, and furniture plans. All of these drawings were important to

our project, and though we may provide a fairly accurate proposal without them, it's an example of missing information that must be discovered early on so you can account for this lack of information in the proposal/contract to your client.

Equally important and often equally as difficult as calculating the pricing of a project is the calculation of a project's schedule. In your proposal/contract, you should never specify a product delivery date if you don't have 100% of the information you need to complete your project. Instead, you should provide your delivery date as a number of days from the time you receive all the necessary information. For example, Figure 2-10 shows a project schedule as specified in the PSA (Professional Services Agreement) for a particular project. Notice that it states that we have been provided with all architectural drawings, yet we still did not have other information we needed to complete our work. Because we had all of the architectural and site drawings, and because the information we lacked had only a minimal impact on the total amount of work to be performed, we were comfortable in providing a proposal. But we did not specify a product delivery date. Instead we stated that the product would be delivered in a certain number of days after all the information was provided.

Project Schedule:

3.1 Provided by the CLIENT:

All architectural and site drawings	Provided
Signed contract and deposit	To be provided
Color scheme for all architectural elements	To be provided
Furniture plan, furniture and material selections	To be provided

3.2 Provided by 3DAS, LLC:

Draft renderings for review of architectural correctness	NLT 3 weeks (21 calendar days) after CLIENT provides all items listed in project schedule 3.1
Draft renderings for review of furniture and materials	NLT 6 weeks (42 calendar days) after CLIENT provides all items listed in project schedule 3.1
Draft animation	NLT 2 weeks (14 calendar days) after CLIENT provides final approval of furniture and material selections
Final animation	NLT 2 weeks (14 calendar days) after CLIENT provides final approval of draft animation

Earliest delivery of final animation: 70 calendar days

Figure 2-10. A suggested format for contractually displaying a project schedule.

As an additional note about the exploration and examination of AutoCAD drawings, after the next few sections of this chapter we will look at the basics of how to import AutoCAD linework. When we do, I will make a suggestion to import linework piecemeal, which simply means, import small parts of your linework, one at a time. There is a very good reason for doing this. Although you can certainly import an entire drawing into 3ds Max all at once, doing so will only convolute your screen, slow down your viewports and increase the time it takes to select and isolate certain objects. More importantly, however, if you import your linework piecemeal, it allows you to spend more time in AutoCAD figuring out what's going on before you rush into the creation process in 3ds Max. When teachers administer a test in school, they often recommend to their students to answer the easiest questions first. This same philosophy works in the 3D world. By creating the easiest 3D elements first, you give yourself extra time to examine drawings and identify problems before spending valuable time creating something with incorrect linework.

Consolidate drawings

The next major step in preparing AutoCAD linework for 3ds Max is to consolidate all the pertinent drawings into one single drawing. This doesn't mean that you have to or even should consolidate the drawings for numerous different buildings into one single drawing; but when you need to build a single major component of your project, like a single building, you should consolidate each of the pertinent drawings for that individual building into one single drawing file. There are 2 major reasons why this is a good practice to get into. First, it allows you to clean each of your drawings all at once, rather than repeating the same steps over and over for each drawing. Second, it allows you to find contradictory information and linework by having all of the drawings visible in one easy to see space and by allowing you to align different drawings together to see how each drawing compares to the next.

The process of consolidating drawings is simple. Open one of the drawings, copy all of the linework to the clipboard, paste that drawing's linework from the clipboard into a new, blank master drawing, and repeat the process for each drawing that needs to be consolidated, which is usually the floor plans, elevations, and sections. Since many drawings use xrefs, you need to make sure that the drawing you open really contains the linework you need, rather than just an xref of the linework. In addition, always unhide and unfreeze all layers so you know that when you select and copy linework to the clipboard, you've actually copied all of the linework and not left any hidden or frozen linework behind. Figure 2-11 shows an example of linework from a three-story house consolidated from several different floor plans, elevations, and section drawings.

Figure 2-11. An example of a consolidated set of architectural drawings (elevations, floor plans, and sections).

Clean linework

Once linework is consolidated into one master drawing, the next major step is to clean all of the linework by the simple but often time-consuming process of isolating and deleting the linework on individual layers that contain unnecessary information. Sometimes you can select and isolate multiple layers at one time and delete all of the linework at once; however, you must be careful not to delete necessary linework that was placed on an inappropriate layer. It is not uncommon for drafters to place linework on the wrong layer, and while it may not negatively affect their ability to

produce good construction documents, it certainly can be a problem for 3D users who expect to see a particular type of linework and all of that linework on a layer when that layer is isolated. For example, if you isolate the dimension layer of a drawing and don't realize that the drafter carelessly placed critical wall lines on that layer, you might inadvertently delete those wall lines when you delete all of the dimensions. One way to avoid this problem in AutoCAD is to learn to use the **Filter** command so that instead of isolating layers, you can isolate (or filter) certain types of linework, such as dimensions. Refer to AutoCAD's help files if you are not familiar with this command.

The previous image from the three-story house in Figure 2-11 showed an example of a 'dirty' drawing full of information we simply don't need to do our work, such as dimensions, notes, electrical and plumbing fixtures, just to name a few. Figure 2-12 shows the cleaned version of the drawing. Notice that the section drawings in the upper-right corner of the image show notes of some sort; however, these sections are only for reference and never need to be imported into 3ds Max. They are just placed in the consolidated drawing so the 3D user can refer to them as needed.

Figure 2-12. An example of a cleaned AutoCAD drawing.

I use the term 'dirty' to indicate drawings that contain not only information that's useless for producing visualizations, as in Figure 2-11, but also to indicate drawings that contain linework that is not ideally suited for use in 3ds Max. What you don't see in the 'dirty' image of Figure 2-12 is some of the many things that make the linework difficult to work with in 3ds Max. I use the term 'clean line' to indicate a line or spline that is free from any defects that would cause problems or errors in 3ds Max, and I use the term 'dirty line' to indicate a line or spline that is created or modified in some way that prevents its use 'as is' in the creation of 3D objects. There are several reasons why a line may be 'dirty', and hence, not usable when imported into 3ds Max. The following is not a complete list, but explains the majority of the reasons why linework is unusable when imported into 3ds Max.

Overlapping lines

This occurs when a line crosses over itself, as shown in the top-left image in Figure 2-13. When converted to 3D, this type of line often results in a solid that appears hollow or is missing a top and bottom.

Figure 2-13. An example of overlapping lines producing improper results (top) and proper results (bottom).

Broken lines

This occurs when lines that should be continuous are broken into 2 or more individual segments, as in Figure 2-14. These segments may have endpoints close together, or they may be separated by a significant distance. If the end points are close enough together, they may be automatically welded when imported into 3ds Max; however, it is usually far more effective to identify these broken lines and weld them in AutoCAD. Waiting to fix this problem in 3ds Max will almost certainly take longer because of 3ds Max's slower and less efficient line editing capabilities. Perhaps more importantly, if you leave the linework 'dirty' in AutoCAD, you may have to repeat the cleaning process in 3ds Max if you need to re-import for any reason.

Figure 2-14. An example of a broken line that would need to be repaired before use in 3ds Max.

Different layers

This occurs when lines that should be on the same layer are placed on separate layers, as shown in the multi-layered lines that represent the curbs in Figure 2-15. When isolating individual layers, this problem can lead to the user not realizing that he or she has just hidden information (on the wrong layer) and the result can be disastrous.

Figure 2-15. An example of linework on the wrong layer.

Varying elevations

One of the most frustrating things about working with drawings that somebody else creates is the eventual occurrence of line segments existing on varying elevations. From a top view, these lines may appear to be otherwise 'clean', but the truth soon comes out when you view your linework from a perspective view, as shown in the right image of Figure 2-16. In the left image, one cannot possibly know that the walls are actually created in 3D, which means that if you import this linework, you will actually be importing solids. Furthermore, if you decide to trace the existing linework (using snaps) rather than using the linework as is, you might find that the vertices of your newly created line exist at different elevations because one vertex may have snapped to the bottom of a wall and the very next vertex may have snapped to the top of the wall. You can fix this problem a few ways, such as with the Flatten command in AutoCAD, or within 3ds Max by aligning all the in vertices to the same elevation. Regardless, any method will take time and for large projects with numerous such occurrences, the total amount of time needed to clean the drawings properly could be enormous. This is yet another thing to keep in mind when inspecting drawings and providing a quote.

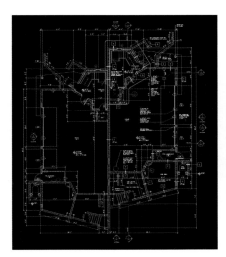
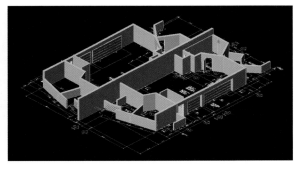

Figure 2-16. A 2D CAD drawing that is, unfortunately, not completely 2D.

The cleaning of these types of drawings may take several hours, and for very large projects, might take several days, but once cleaned, the linework can often be turned into complete 3D models in just minutes. This would not be possible, with any reasonable amount of accuracy, if the linework is not properly cleaned prior to import into 3ds Max. This process of cleaning linework will help you reduce unnecessary information on your screen and improve viewport navigation, and further provide you time to explore and examine your scene which can only help you identify problems early and reduce your chances of incorrect 3D models.

Orient linework

Once the master drawing has been cleaned, the next major step of the process is orienting the linework. The very first thing that should be done when beginning this step is to locate the origin. The linework you prepare, and therefore the model you construct in 3ds Max, should always be centered on the origin because 3ds Max is less accurate the farther away objects are from the origin. So start the orienting process by centering the site or the first floor plan of a building directly at the origin of a drawing.

If you are working on the construction of a site, then once you center the site, your work in the orientation of linework may very well be finished. You do need to ensure that your site plan is scaled properly, and knowing that most site plans originate from civil engineering drawings, I would always make sure to scale my site plan properly before importing the linework into 3ds Max. If you are constructing a building, however, then the process of orienting drawings is far more complicated and time-consuming. As with site drawings, you should always center all of your linework at the origin so that modeling in 3ds Max is done with the highest possible accuracy. The image in Figure 2-17 shows the same three-story house seen earlier in the chapter with all of the floor plans, elevations, and sections consolidated into one drawing and cleaned of all unneeded information. However, the drawings are not arranged in a manner suitable for importation into 3ds Max.

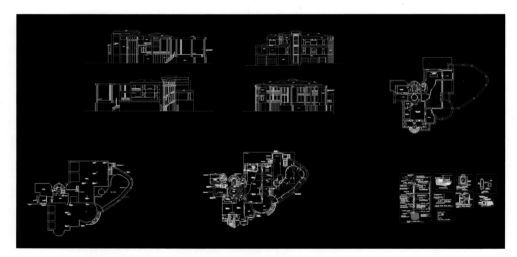

Figure 2-17. A cleaned AutoCAD drawing ready for proper orientation

The image in Figure 2-18 shows the same drawing with all the linework oriented in a way that makes working in future steps of this process (i.e., creating and importing linework) much easier. Notice that each elevation is oriented around each side of the first floor plan and rotated so that lines from the elevations can be projected against the floor plan to check for conflicts. All other floor plans are aligned in a row to the side for reference, as are sections and details.

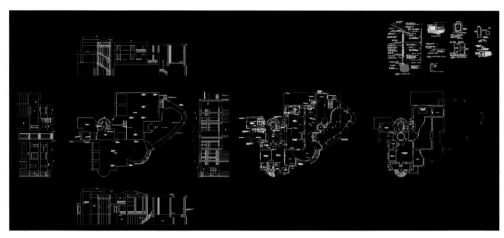

Figure 2-18. An example of a properly oriented AutoCAD drawing.

So now that we've analyzed one project and how linework was prepared for 3ds Max, let's take a quick peek at another project. Figure 2-19 shows a rendering of a building...

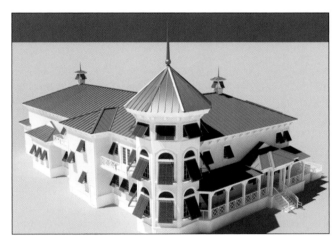

Figure 2-19. The rendering of the building shown in Figure 2-20.

...and Figure 2-20 shows the cleaned and oriented linework. As you can see, the elevations are again oriented around the first floor plan. One additional note about theses elevations – notice that there is an additional copy of each side elevation. These copies were created to prevent the need to turn one's head 90 degrees to see the side elevations properly. Doing this makes working in this drawing a little easier.

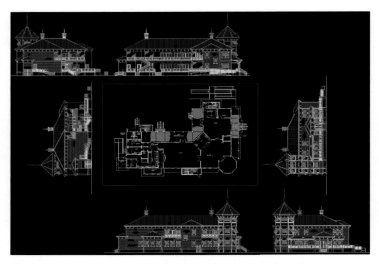

Figure 2-20. Another example of a cleaned and oriented drawing.

Create new linework as necessary

Once the linework is cleaned and oriented the next step is to either import the linework into 3ds Max as is, or create new linework to facilitate the construction process in 3ds Max. If you use the Edit Poly approach of building your models, also known as the box modeling method, then you may decide at this point to simply import the linework as a reference against which to build your models, as shown earlier in Figure 2-1. While this approach has its advantages, at 3DAS we greatly prefer to use the powerful and versatile loft and sweep features to create a large portion of the building and site elements of a project. In the next chapter, we'll begin to import linework and look at techniques of using it to create various building and site elements.

At this point, we will look a little farther into this preparation process that uses the loft/sweep method by looking at how a drawing was arranged for another project. Figure 2-21 shows a rendering of the building we'll be looking at.

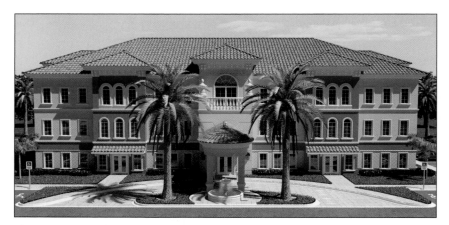

Figure 2-21. A rendering of the 2D drawing shown in Figure 2-22.

And Figure 2-22 shows the linework as it appeared after it was consolidated and cleaned. However, the drawing still needed to be oriented, and since we always use the loft and sweep tools to create our buildings, additional linework needed to be created. Creating this new linework is the critical last step before the linework is imported into 3ds Max. Again, the process of importing linework and using it to create 3D objects will be discussed many times throughout the chapters that make up Parts 2 and 3 of this book.

Figure 2-22. The cleaned and consolidated AutoCAD linework for the rendering in Figure 2-21.

Figure 2-23 shows the same drawing with the next two steps completed. Here you can see that the linework is oriented properly, but notice all of the other newly created linework. In the bottom-center of the image is a copy of each window and door. This linework is used to guide the creation of the 3D windows and doors within 3ds Max, and this process will be discussed in Chapter 4. Figure 2-23 also contains several horizontal lines running from the left elevation to the left side of the floor plan and several vertical lines running from the left half of the front elevation to the front of the floor plan. These lines were created to serve as a guide by which to place the windows and doors once created in 3ds Max. By importing these lines into 3ds Max and aligning a copy of the appropriate 3D window or door, you can precisely locate the position of each of these object types along the length of a wall.

Figure 2-23. The same drawing with oriented linework and newly created linework.

There are numerous other lines created besides those previously mentioned. In the bottom-middle of the drawing are lines that were used as profiles for the lofts created in 3ds Max. The lofts were used to create the walls of this building and the paths that these profiles were lofted around are co-located with the floor plan. In fact, the paths were created by tracing the existing linework, so the paths actually occupy the same space as the existing linework. By isolating the layers of just the newly created linework, you can see all of the linework that was created to build the walls for this project (Figure 2-24). Notice that each path is a different color. This helps distinguish one path from another once they are imported into 3ds Max.

Figure 2-24. The newly created paths and profiles used to create the walls of this building.

Now let's take a look at what this project looked like a little down the road. Figure 2-25 shows this building after lofts were created for the walls and after copies of the various windows and doors were placed in their proper location along the walls. Notice the lines that were used as a reference to place these copies. Once they were placed properly along the length of the walls using these lines, we needed to refer back to the AutoCAD drawings to determine the height of the

windows and doors off the ground. Once they are in their final position, we can just explode all of these groups we copied and use the ProBoolean feature to subtract these objects that represent the volume of the windows and doors, from the lofts, thereby leaving behind a void in which those windows and doors are shown. This process is discussed at length in upcoming chapters.

Notice one other thing in this 3D scene. Only the left side of this building is being created. This is because the building is symmetrical and once the left side is created, a simple mirror routine will allow us to quickly duplicate the left half into the right half.

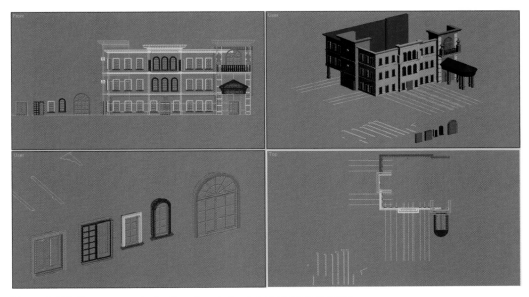

Figure 2-25. The same project with walls, windows, and doors in position.

Now this is just our preferred way of creating these fundamentally important objects - walls, windows, and doors. As mentioned, there are a few other methods some veteran modelers use to create these objects. Some use the box modeling method whereby the edit poly feature is used to carve out the windows and doors, sometimes using an XRef set of linework as a reference in a viewport. Some who use this method also incorporate lofts and sweeps to form their walls while others simply extrude the linework to do the same thing. While we feel strongly about our chosen method of creation, which method is best is a matter of opinion and based on the little nuances of how we all work. But what no veteran user will deny is that linework that's not prepared properly in AutoCAD will lead to less efficient and less accurate modeling in 3ds Max. By taking the time to clean up drawings properly in AutoCAD, not only can you work faster and more accurately in 3ds Max, you have one other big advantage as well. The longer you spend in AutoCAD, the more time you have to examine the drawings and figure out how the project is being put together in real life. Not all drawings are easy to read, either because of the complication of the design or the lack of skill on the part of the drafter creating the drawings. But if you model your projects one component at a time (i.e., import the linework for the walls, build the walls, import the linework for the windows and doors, build these objects, etc.), you can identify and address drafting errors early on, rather than importing all the linework early on and realizing down the road that you have to recreate something because the linework was improperly created. And by importing clean linework piecemeal, you also don't have to look through a mess of linework in 3ds Max to see the lines you actually need to work with.

Additional Notes

Up to this point, we've only looked at the preparation of linework for buildings, and while I would argue that the loft and sweep features are the best tools in 3ds Max to model a building, I know that other veteran users would want to make the case for their own methods. This is especially true when you consider that many users prefer to model using B.I.M (Building Information Modeling) capable programs such as Revit. But when it comes to creating sites, I would argue that the way we have figured out to create sites is truly the fastest possible. That's a pretty bold statement, but after trying every conceivable way of creating site elements, we've found that nothing else even comes close.

So let's just look at how some site linework was prepared for some past projects and see how that linework can be used in 3ds Max to quickly create the various site objects. Figure 2-26 shows an example of a very dirty drawing. This is a site drawing that was created by a civil engineering firm and as is typical with civil drawings, there is an enormous amount of information unnecessary to visualization work. Cleaning a drawing this large with this amount of unnecessary linework could take half a day, but the time spent preparing the linework properly here in AutoCAD is well worth it because once this linework is prepared properly, you can easily model the entire site in less than 30 minutes.

Figure 2-26. A very 'dirty' site drawing.

Figure 2-27 shows what the drawing looks like once the linework is cleaned and prepared for import.

Figure 2-27. The 'clean' version of the site drawing.

Notice that if I select and isolate the linework representing the roads, as shown in Figure 2-28, it is in fact just one continuous closed polyline. If I import this polyline in 3ds Max, I could simply add the Edit Mesh or Edit Poly modifiers and right away the roads would be completely modeled. The same line could also be used as the path for a loft or a sweep, and thus used to create the curbs along the side of the roads. If I were to isolate the lines that represent the mulch beds, retention ponds, sidewalks, pavers, or any number of site elements, you would see the same kind of good, clean, closed polylines that are shown in Figure 2-28. Each of these could be turned into renderable mesh or poly objects or used to cut out these various site elements from other site elements. Each of these different site elements can usually be created in less than a minute once the linework is properly prepared.

Figure 2-28. Isolating the roads of the site reveals one continuous spline.

As one final example of the speed of creating 3D objects with clean linework, notice the clean site drawing in Figure 2-29. This image shows the linework representing a shopping center. In the parking area around all of the buildings you can see hundreds of parking lines and road lines. When you receive a site drawing with these lines, they are shown as just that – lines. However, if you turn these objects into polylines with a width of 6 inches, the typical real world width of parking lines, you can quickly turn these polylines into a renderable object in 3ds Max.

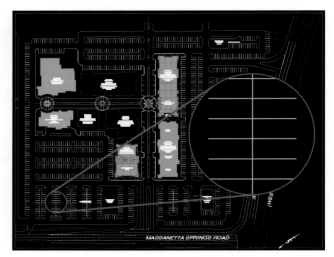

Figure 2-29. A 'clean' site drawing with hundreds of parking lines that can be modeled in seconds.

If the road lines are continuous lines in AutoCAD, as opposed to the dashed lines you see on many roads in the real world, then you can simply import a drawing file of those lines and turn them into a renderable object. However, if you do have dashed lines anywhere in your drawing, such as in the lines shown in Figure 2-30, you can use a unique characteristic of the 3ds file type to have those areas with dashed lines also imported.

Figure 2-30. Dashed road lines that can be exported as a 3ds file and quickly modeled in 3ds Max.

This is a really great thing because if you couldn't have these dashed lines accounted for automatically, it would be very time consuming to manually build these breaks into the linework, especially if they occurred in the bend of a road. Each of the dashed segments is not an individual line but rather one line with a dashed linetype style. If I isolate these lines and export them as a **3ds** file, when I import them into 3ds Max, the dashed linetype style will automatically generate an editable spline with these dashed segments built-in. By adding the Edit Mesh or Edit Poly modifiers, I could turn these splines into a renderable object. Remember, if I just imported this **dwg** file, I would lose these spaces that give these lines their dashed appearance.

As an additional note about this technique, there is a command in AutoCAD called **LTSCALE**, which stands for linetype scale. If you use this command, you can increase or decrease the segment lengths of these dashed lines as well as the spacing in between them. The LTSCALE value you set will ultimately determine what the imported spline will look like.

And there's one final point that should be mentioned here about the workflow described in this chapter. If you're wondering why we don't recommend linking linework as opposed to using the techniques outlined in this chapter, it's because file linking uses the AutoCAD DWG file type rather than the Legacy file type. Because of this, you experience the same problems as you would if you import with the AutoCAD DWG file type. Specifically, vertices are often converted unintentionally from Bezier to Bezier Corner vertices.

Summary

This chapter provided a general overview of how to prepare AutoCAD linework for 3ds Max but it really only scratched the surface of the entire process. With each year seeing improvements in CAD software, we are getting closer to a perfect software package that allows the user to build great projects in 3D, while concurrently using the same software to produce construction documents, which is a process coined by the term BIM (Building Information Modeling). However, no matter how great the software is, I think that we will never see the day when these programs can out-do the speed, efficiency, and accuracy of these fundamental modeling techniques outlined in this chapter. Certainly you can create a building in literally seconds with these software packages today; however, you can't do the same with buildings of any real complexity. Even if you could, you'd have to spend a great deal of time creating all of the unique wall, window, door, and roof styles before you can even start creating your models. The ability to create precise site plans in 3D is really not even possible using the same BIM method that some people use to quickly generate buildings. The bottom line is, preparing AutoCAD linework properly can be time-consuming, but it's an important process that when done effectively can save a tremendous amount of time and grief in the long run.

PART 2

Creating Building Elements

Like most areas of modeling, there are usually numerous ways to arrive at the same result. However, this particular method of work, I believe, is an example where there is clearly a best solution.

Creating Walls, Windows, and Doors (Part I)

IT SEEMS THAT SINCE THE first days of 3D visualization, no other architectural element has garnered more attention than the 'wall'. One of the most commonly asked questions between fellow 3D visualization artists is, "How do you create your walls in 3D?" The question is bound to be answered a number of different ways depending on who you ask and their experience level, but the question is so important to so many of us because the walls are usually the first part of a building that we create, and arguably the most important. It is, in some ways, the real foundation on which other building elements are added. And unlike other critically important scene elements like vegetation, cars, backgrounds, etc., walls leave no room for artistic interpretation, and neither do the objects we place in or on our walls. Extraneous objects, like cars, are certainly important but are usually not the focus of a project. In most cases, a building is the focus of a project and although our choice in cars may not appeal to our clients, it is certainly understood that these types of objects are open for some degree of artistic interpretation, and as such, disapproval is usually not considered an error. Walls, on the other hand, need to be created with precision and any deviation from the data provided in the architectural drawings *is* usually considered erroneous. It's no wonder then why so many 3D artists are interested in the techniques with which others create these critically important object types.

But the creation of walls is of great interest because of their importance to a scene and the attention to detail that's needed to make them, and because of the time needed to make them properly. Depending on the type of building being created, the walls may consume more than half of the time needed to complete the entire building. So the various techniques available to create this type of object are, and probably always will be, of great interest to others. The next chapter, which is Part II of this discussion, is dedicated to illustrating what I believe to be the best, fastest, and most efficient way of creating walls; using the Loft and ProBoolean commands. But because there are other widely used methods for creating these object types, I thought it would be appropriate to discuss these other methods many veteran users prefer. Throughout both of these chapters, I will

draw comparisons between all of these widely used techniques so you can decide for yourself which method works best for you.

There are four primary methods 3D artists use to create walls for a 3D scene. Some artists use a combination of two or more of these methods, but the four primary methods of creation are as follows:

- BIM software
- The Extrude modifier
- Edit Poly modifier
- The Loft and ProBoolean commands

Creating Walls with BIM Software

In the early days of 3D visualization, a few software titles appeared that used a modeling technique known as **BIM**, or Building Information Modeling. The term is used to describe software that allows a user to create structures in 3D while simultaneously allowing the generation of key building information for construction drawings. For example, after placing 20 different doors in a building, the software would allow the user to click a few buttons and create a door schedule that would automatically list the details of all 20 doors, such as masonry openings, door heights, paint color, etc. This door schedule could then be easily placed in the construction drawings and used by the contractor creating the real building. Examples of this kind of software include Architectural Desktop and Revit.

If you work in an architectural office or if you're in the business of creating construction drawings (in addition to 3D visualizations), then using BIM software to generate building models that can be imported into 3ds Max is certainly a worthy approach. Many 3ds Max users rely on the flexibility of design changing and the ability to quickly generate construction drawings that BIM provides. As long as you are aware of the powerful modeling tools available in 3ds Max and their own inherent flexibility toward change that they offer, then you can make an informed decision as to how much to rely on your BIM software to generate your building models. But if you are not aware of what these 3ds Max tools can do, the speed at which they can do it, and their ability to accommodate design changes it would probably be a good idea to look closely at the techniques outlined in this chapter.

In the first few years of introduction, BIM software did not receive a warm welcome. It was widely looked upon as weak, slow, and difficult to understand by even the most receptive users – myself included. During my years as a draftsman, I spent an incredibly large amount of time week after week trying to make the BIM software work in an efficient and cost-effective manner. But no matter how hard I tried, the software simply wasn't capable of supporting our office's needs to produce good working construction drawings while simultaneously allowing us to create our drawings in 3D. After a very long and painful trial period, our office abandoned our BIM software, as did many other offices in the same position. Today the outlook for BIM is far more promising, and the ability to generate accurate models and import them into 3ds Max is quite effective. Figure 3-1 shows a screen shot of Architectural Desktop 2005 and provides a small peek at the power and flexibility available with the software. Incidentally, the inset rendering was not created in Architectural Desktop.

Figure 3-1. Architectural Desktop 2005 with its powerful BIM features.

Although it's quite advantageous to use and import models already constructed with BIM software, there are some definite drawbacks to this approach. One of the most frustrating aspects of working with imported models is the need to keep reapplying the same mapping coordinates over and over. Another is that random faces are often facing the wrong direction for no apparent reason, and the result is a building that appears to have holes in it. Even if you render with 2-sided materials, this doesn't make viewing your models in a viewport any easier. Imported parametric models also tend to consume more RAM and be more of a strain on the graphics card, because of the inherent nature of the BIM software to create faces on an object that could not possibly be visible. Yet another frustrating aspect of using BIM is the ever increasing complexity of the software and the greater time needed to learn the additional features that come with each new release. The techniques of modeling in 3ds Max outlined in this chapter, on the other hand, have changed very little year to year. And perhaps the most frustrating aspect of using BIM is the time it takes to generate all the unique window and door styles when it seems that no two projects ever use these same styles without some degree of tweaking.

So if you are aware of all the advantages and disadvantages of modeling with 3ds Max and BIM software, you can at least make a good decision as to which is best for you. If you decide to start or continue using BIM, you can still take advantage of the 3ds Max tools to add certain details to your buildings, such as trim, banding, or roof tiles.

Creating Walls with the Extrude Modifier

The **Extrude** modifier has been a staple in the diets of many 3D users since the first days of the software. While not as powerful as many other modeling tools, it is still a favorite among many 3ds Max users today because of its simplicity and ease of use. In the DOS days of 3d Studio, this feature was used to some degree by virtually everyone needing to construct a building in 3D. Today its use is far less widespread, but many users still rely on it solely or in conjunction with one of the other techniques outlined in this chapter. At 3DAS, we still use this technique quite regularly, because under certain situations this technique itself cannot be rivaled. An example of just such a situation is the wall shown in Figure 3-2.

When used to create walls, this modifier is usually implemented by creating closed splines that mimic the outline of some part of an elevation, and extruding those splines along the X or Y axis. By creating the linework for door and window openings, you can simultaneously add these features to your walls with very little additional work. Even creating rounded windows and doors, curved arches, or any number of complex wall styles is quite simple and straightforward using this method. Figure 3-2 shows an example of this modifier at work. The top-left image shows the original Auto-CAD linework, the top-right image shows the isolated closed spline created for one of the walls, the bottom-left image shows the same spline imported into 3ds Max and extruded 8 inches, and the bottom-right shows the completed 3D rendering of the same project. Once the main wall component is in place, you can use the Extrude modifier to add other elements such as trim, banding, medallions, and even the windows and doors that fit within the initial extrusion. For example, if you want to add the trim along the bottom of the arch entry walls, simply create a rectangle in top view by snapping end points to the newly extruded wall, add the Edit Spline modifier, create an outline of approximately 1-inch in Spline sub-object mode and extrude the spline to the necessary height.

Figure 3-2. Building walls piecemeal with the use of the Extrude modifier.

So by using the Extrude modifier alone, you can construct a building in a relatively short amount of time. And while for *most* walls it doesn't offer the speed that can be achieved with the Loft and ProBoolean features, the Extrude modifier is very simple, highly accurate, and moderately flexible. When used in conjunction with the Loft and ProBoolean, its use becomes even more practical.

Creating Walls with the Edit Poly Modifier

The **Edit Poly** modifier is arguably the single most important tool in 3ds Max for many users in many different industries. For some, this modifier is the backbone of the modeling portion of every project, and for others it is nothing more than a tool used to do a few quick things here and there. Whatever your choice, the Edit Poly is certainly one of the most powerful features available for modeling and you should at least be familiar with what it can do.

The Edit Poly modifier is also the backbone of a multi-industry wide technique known as **box modeling**. Box modeling is simply the technique of modifying a lowly detailed object into a highly detailed object. In fact, the term 'box modeling' comes from the technique of crafting intricate models out an ordinary box. The primary function of this technique is the extruding and scaling of the edges and polygons that make up an object, while a secondary function of this technique is the subdividing of these edges and polygons. With these two functions, the box modeler can create just about any object imaginable. This technique is used in the entertainment industry to model such objects as characters and vehicles, and in many cases, the user starts with nothing more than this simple primitive. In the architectural industry its use is just as far reaching and it is widely lauded in the creation of numerous architectural elements. In Figure 3-3, you can see how using this feature allows the user to start with a single polygon and end up with a highly detailed towel.

Figure 3-3. The Edit Poly feature used to turn a single polygon into a highly detailed towel.

In the upcoming chapters, you will see demonstrations and tutorials where this tool is used in the creation of everything from furniture to roofs to 3D sites. In the remainder of this chapter, however, its coverage is limited to a discussion on walls, windows, and doors.

So just how fast and easy is it to model these object types using the Edit Poly command? Well, if you rely on the Edit Poly for the majority of your modeling rather than just using it on occasion to make a few modifications here and there, then I would argue that you aren't working at top speed and you're doing things the hard way. In this chapter and the next are two exercises that help demonstrate the benefits and drawbacks of using the Edit Poly command for wall modeling versus using the Loft and ProBoolean commands. In the first exercise, found in the remainder of this chapter, we will use the Edit Poly command as the primary modeling tool. In the second exercise, found in the next chapter, we will use the Loft and ProBoolean commands. After conducting both exercises, you should have a fairly good idea of how each method works and which method is the most efficient.

As you have undoubtedly already read, AutoCAD drawings are a very important part of most 3D visualization projects. However, not all 3ds Max artists have AutoCAD and not all want to be forced to purchase this additional software. Because of this, there are two very different ways that 3ds Max artists use AutoCAD drawings to help guide their modeling in 3ds Max.

The best method, I firmly believe, is to prepare and import the necessary linework in AutoCAD as described in Chapter 2. This method allows you to immediately use the 2D linework to create 3D models rather than having to create new linework inside 3ds Max. It also means that you can carefully inspect and edit the linework inside AutoCAD using many of the program's features that make this type of work so much easier than inside 3ds Max. This method of course requires you to own

the software, but the bottom line is that if you do, you can take advantage of the many techniques described throughout this book that you would otherwise not be able to do without additional work inside 3ds Max.

The second method in which many 3ds Max artists use AutoCAD drawings is to import, link, or XRef drawings into 3ds Max so you can use the linework as a background with which to trace new linework, or with which to guide how you model your individual objects. These drawings can be elevations (as shown in Figure 3-4), floor plans, or any other drawing that provides useful information about the structure you are modeling. With this method you have an exact visual reference that shows you exactly where each window should be placed, exactly where each reveal line should be located, or exactly where the top of each roof extends. By using the Edit Poly tool on an object, you can enter a sub-object mode and move, rotate, or scale individual sub-objects until they are lined up exactly with the background linework. Many 3ds Max artists use this method even when they have AutoCAD at their disposal, but as a matter preference, I believe this method is best suited for checking the work you do with other methods and for small occasional edits.

Figure 3-4. An example of using imported, linked, or XRef'd linework as a background for modeling.

So let's run through the first exercise and see how the Edit Poly can be used to model walls. To provide a fair demonstration of the two methods of using AutoCAD linework as just described, the exercise will incorporate steps for using both methods. As an additional note, as mentioned in the previous chapter on preparing linework, many of the exercises in Parts 2 and 3 of this book will pick up where the last chapter left off. This means that many of the exercises will start by importing AutoCAD linework that has already been prepared using the techniques discussed in the last chapter. In the case of this first exercise, we will use cleaned and prepared AutoCAD linework for both methods of using AutoCAD linework, as just described.

Wall, Window, and Door Modeling – Part I (The Edit Poly)

In Part I of this two-part wall modeling exercise, we will use the Edit Poly as the primary modeling tool to create walls, as well as the windows and doors that lie within them. **If you do not have AutoCAD, simply read step 1 for reference and proceed to step 2.**

1. Open the AutoCAD file, **ch03-01.dwg**. This is a drawing of the medical office building shown in the next illustration called Olympic Park, whose linework has already been prepared by the guidelines specified in Chapter 2. You will be asked to refer to this drawing on a few occasions to complete this exercise properly.

 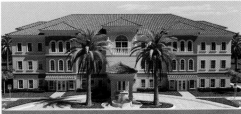

2. Reset 3ds Max.

3. Change the units of this new scene to **U.S. Standard, Feet w/ Decimal Inches** and with **Default Units** set to **Inches**. If you do not wish to work in U.S. standard you will have to convert the units prescribed in this exercise.

4. In the **System Unit Setup** dialog box, ensure that the **System Unit Scale** is set so that **1 unit = 1.0 inches**.

5. Import the file **ch03-01.dwg** using the **AutoCAD DWG** file type and the option to derive objects by **Entity**, as shown in the next illustration. In most tutorials in this book, you will be asked to use the **Legacy AutoCAD** file type because the AutoCAD DWG file type will often, and inexplicably, replace Bezier vertices with Bezier Corner vertices, thereby ruining the linework. This does not always happen but when it does, you can simply use the Legacy AutoCAD file type and curves will import properly. The downside to the Legacy AutoCAD file type is that it can take a long time to import a large drawing. Another very important thing to note is that the Entity option needs to be used, regardless of which file type is imported. This allows all of the individual lines, or entities, to be imported as individual objects rather than being grouped together. Because of this, the individual elevations can be repositioned, as we will see in an upcoming step. However, the **Entity** option comes with a warning that can actually be seen in the 3ds Max help files. In the help files, it says **Warning**: *This option has the potential to create an enormous number of objects in your scene*. It is only because of this side effect of using this option that the Legacy AutoCAD file type may be difficult to use. With small drawings it is not a problem, but in large drawings, using the Entity option with the Legacy file type can be very slow.

6. Execute the **Zoom Extents All** command. You should see the three floor plans and three elevations, as shown in the next illustration.

7. Save your file. If you wish to continue from this point with an already prepared scene, open the file **ch03-01.max**. Initiating a save early on is important so an automatic backup file can be generated from the start and used in the event of a computer or program crash.

8. Select all of the front elevation linework and create a group called **Elevation-Front**.

9. In the **Hierarchy** panel, click on **Affect Pivot Only** and use the Align command to align the pivot point of the group to the very bottom of the group; i.e., the blue ground line. You will need to make sure that the line you click on in the viewport to open the **Align Selection** dialog box is the actual line that represents the ground.

10. Close the **Affect Pivot Only** command.

11. Click on the **Select and Rotate** icon and then select the **Use Pivot Point Center** found on the **Use Center flyout** (2nd icon to the right of the Select and Rotate icon).

12. Rotate this group **90** degrees along the **X-axis** so it's completely visible from the **Front** view.

13. Create a group called **Elevation-Rear** and **Elevation-Side** from the respective elevation linework.

14. Adjust the pivot points and rotate both of these groups the same way you did the first group, so you have all three elevations oriented, as shown in the next illustration.

15. If you wish to continue from this point with an already prepared scene, open the file **ch03-02.max**.

At this point, the scene is set and we are ready to begin modeling. Since the building is completely symmetrical, only one half of the building needs to be modeled and the other half can be a mirrored copy. Due to the limitations of printing such a complex and lengthy exercise as this, we will only model one of the walls in this building. However, the same procedure used to create the first wall can be used on all other walls.

The wall we are going to create is the main wall on the left side of the building. Although you could start by using the existing linework on the floor, it is always better to leave this linework as is for reference, and create your own new linework on top of the existing linework. This ensures that the linework used is properly constructed. Let's start by creating a new line on top of the floor plan where the exterior surface of this block wall lies.

16. If you have not already done so, switch the **Perspective** view to an **Orthographic** view. This makes zooming in and out and panning around much easier.

17. Use the keyboard shortcut **Alt+W** to switch from a 4-viewport configuration to a single viewport configuration. This allows you to see your work better, and prevents 3ds Max from having to refresh 4 separate viewports.

18. From the **Tools** menu, select **Grids and Snaps > Grid and Snap Setttings**. Prior to 3ds Max 2009, this dialog box used to be found in the Customize menu.

19. Click the **Clear All** button to clear all previous snap modes.

20. Enable **Endpoint** mode and close the dialog box.

21. Enable 3D snaps (hotkey=S) and disable the home grid (hotkey=G).

22. Zoom into the front left-hand side of the floor plan and create a line from the endpoint of the exterior side of the main wall seen on the left elevation, to the corner of the same main wall, to the end of the wall on the front of the building. The next illustration shows this line highlighted so you can see exactly where it needs to be created.

With this first line in place, we need to extrude it to the height of the wall we are modeling. First we need to measure the height of this wall.

23. Name this new line **Bldg-MainWall**. As a matter of good practice, I recommend labeling all building elements with some type of prefix, such as Bldg-. This keeps all the building objects listed together inside the various object display dialogs.

24. If you wish to continue from this point with an already prepared scene, open the file **ch03-03.max**.

25. If you have AutoCAD, return to the file **ch03-01.dwg** and use the **DIST** command to measure the distance from the blue ground line to the top of the wall, as shown in the next illustration. If you do not have AutoCAD, use the tape-measure tool in 3ds Max to measure this same distance using the **Elevation-Front** group. The distance should be measured as **38'-4"**.

26. Return to the 3ds Max scene and use the **Extrude** modifier to extrude the 1st line you created **38'-4"**. Note that if you created your line by clicking on the 3 endpoints in a counterclock-wise manner, you should see an extruded line as shown in the following illustration. If you created your line in a clockwise direction, then the polygons of the extrusion will be facing toward the inside of the building, and you will have to flip the normals of this object.

27. Add the **Shell** modifier. This will allow us to apply thickness to the wall.

28. Within the Shell modifier, change the **Outer Amount** to **0.0**, the **Inner Amount** to **8.0**. Changing the Outer Amount to 0.0 ensures that the outer surface doesn't move and changing the Inner Amount to 8.0 makes the wall 8 inches thick.

29. At the very bottom of the Shell modifier, enable the **Straighten Corners** option. This ensures that the shell remains 8 inches thick throughout the entire length of the spline.

30. Use the keyboard shortcut **Alt+Q** to isolate the wall object you are creating and the **Elevation-Front** group. This will allow you to see how the wall object you are creating matches the front elevation without the distraction of all the other linework.

31. Switch to a Front view and enable **Smooth + Highlights** mode. Notice that the new wall matches the elevation. The first modification we are going to make to this wall is to add the trim feature along the bottom of the wall, as shown in the following image. This trim feature is not something that is ever depicted on a floor plan, which is why it sticks out beyond the new wall we created. To create this trim feature we must divide the existing polygons we have, and create new vertices at the top of the trim.

32. If you wish to continue from this point with an already prepared scene, open the file **ch03-04.max**.

33. Add the **Edit Poly** modifier to the **Bldg-MainWall** object.

34. Open **Edge** sub-object mode and inside the **Edit Geometry** rollout click on the **Slice Plane** button. When you click this button a yellow slice plane is created at the home grid.

35. Use the transform gizmo to move the slice plane up to the top of the trim that runs along the bottom of the main wall we are trying to create. Zooming in very close will allow you to make this placement more accurate than you would ever need it to be, although you could refer to the AutoCAD drawings and take a distance measure to find out exactly where it needs to be placed. Toggle between Wireframe and Smooth + Highlights mode as necessary.

36. Switch to an **Orthographic** view and zoom into the **Bldg-MainWall** object so you can see exactly what is going on with the slice plane. Notice that it is creating temporary edges as a visual guide, as shown below.

37. Click the **Slice** button. If you move the transform gizmos up now you will see the new set of edges created when you clicked this button.

38. Click on the **Slice Plane** button again to turn off the slice plane. When you do, the new edges are shown.

39. Switch to **Polygon** sub-object mode, and using a **Window** selection, select the 2 polygons at opposite ends of the wall bottom.

40. Hold down the **Ctrl** key and select the 2 polygons that represent the front-bottom portion of this wall. With these 4 polygons selected, we can now extrude this trim feature.

41. Zoom in closely to the bottom corner of the front and side of this wall object.

42. Inside the **Edit Polygons** rollout, click the **Settings** icon immediately to the right of the **Extrude** button. This opens the **Extrude Polygons** caddy. If you refer to the AutoCAD drawing or the imported Elevation-Front group, you would see that the trim needs to be extruded 2 inches.

43. Type **2** inside the **Extrusion Height** field and click **Apply and Continue** (the plus sign). The Apply and Continue button in all these features tends to be overly sensitive, and you should be careful not to enable the command more than once. Notice that the extrusion appears to occur in an undesirable direction. This is because with the **Group** option enabled as the **Extrusion Type** (first option in caddy), the extrusion takes place along the average normal of the group of polygons selected. To extrude these polygons properly, we need to extrude along the local normal of each polygon.

44. Select the **Local Normal** option as the **Extrusion Type**, and click **OK** (the checkmark) to close this command. The trim feature is now 2 inches thick along the length of both sides of the wall object, as shown in the next illustration.

Now that the trim is extruded, it needs to be tapered, as shown in the AutoCAD drawings. You could certainly go into vertex sub-object mode at this point, select the necessary vertices and move them down the required 2 inches. You could also take advantage of the **Chamfer** feature inside the Edit Poly modifier, which is what we will do now.

45. Enter **Edge** sub-object mode and select any of the top outer edges of the trim feature you just extruded.

46. In the **Selection** rollout, click the **Loop** button. This expands the number of edges selected as far as possible through four-way junctions, as shown in the next illustration. When the expansion reaches a three-point junction, as it does on the back side of these walls, no more edges will be selected. This is simply a quick way to select multiple edges.

47. In the **Edit Edges** rollout, click on the **Settings** icon immediately to the right of the **Chamfer** button. The **Chamfer Edges** caddy opens.

48. Type **2** in the **Chamfer Amount** field and click **OK**. The selected edges are now chamfered and the result is a tapered look to the top of the trim feature.

49. Switch to a **Front** view and zoom in closely to the top of the trim feature on the left side of the wall. As you can see in the next illustration, the tapered portion of the trim feature doesn't match the original AutoCAD linework. The angle is much steeper than the 45-degree taper called for in the drawings. Why would this be?

It's because when the polygons were extruded, they were extruded 2 inches along the average normal, meaning that the corner vertices were pushed out 2 inches, as shown in the next illustration. The polygons, however, were only pushed out about 1.5 inches. In order for the polygons to have been pushed out 2 inches perpendicularly, we would have had to have used an extrusion value of about 2.8 inches. This demonstrates one of the many frustrating quirks of box modeling and one of the many limitations of using this technique. Knowing that a value of 2 inches wouldn't suffice a veteran user would probably have switched to Front view in the first place and dragged up and down on the extrusion amount sliders until the extrusion matched the linework in the AutoCAD drawings. At this point, we have no choice but to fix this problem manually.

50. While still in **Front** view, enter **Vertex** sub-object mode, select the farthest left vertices that make up the trim, and move these vertices so they mimic the profile of the trim, as shown in the next illustration.

51. Unhide the **Elevation-Side** group, switch to **Left** view and repeat the previous step with the vertices making up the front of the wall object. When finished making the change, hide the side elevation again.

The next component of the wall that we're going to craft is the double banding feature that runs along the top of the 1st floor, as shown in the next illustration. Just as before, we have to create additional edges within the structure, and this time we will use a different tool within the Edit Poly to do it.

52. If you wish to continue from this point with an already prepared scene, open the file **ch03-05.max**.

53. Switch to an **Orthographic** view, select the **Bldg-MainWall** object and enter **Edge** sub-object mode.

54. Select the 3 vertical edges on the outside surface of the wall object, as shown in the next illustration.

55. In the **Edit Edges** rollout, click on the **Settings** icon immediately to the right of the **Connect** button. The **Connect Edges** caddy opens.

56. Type **3** in the **Segments** field and click **OK** to end the command. The edges you had previously selected are now *connected* with 3 new edges running horizontally along the outside surface of the wall object, as shown in the next illustration. This is a quick and easy way to add edges to your object.

57. Switch to a **Front** view and reposition the 3 edges, so they are aligned vertically with the 3 lines that make up the banding feature we are trying to create. Switching back to Orthographic view makes it easy to select the 2 edges you need to move separately from the rest.

58. Refer to the AutoCAD drawing or the front elevation linework in 3ds Max and measure the depth of both parts of the banding feature. The distance should be measured at **3.25** and **4 inches**.

59. Switch back to **Orthographic** view, and if you haven't already done so, enable **Smooth+High-lights** and **Edged Faces** for this view. This will make it much easier to see the results of the next few steps.

60. Go to **Polygon** sub-object mode and carefully select the bottom 2 polygons that will form the bottom part of this banding feature.

61. Zoom in close to the corner of the banding feature, as shown in the next illustration.

62. Inside the **Edit Polygons** rollout, click on the **Settings** icon to the right of the **Extrude** button. The **Extrude Polygon** caddy opens. We will use this feature again but with a different option.

63. Select the **By Polygon** option and in the **Extrusion Height** field type **3.25**, as shown in the next illustration. Click **OK** to close this command. This new option causes each polygon to be extruded along its respective normals, not as an average of a group of selected normals, or as if the vertices were being pushed out a specified amount. Because of this, the value entered in the Extrusion Height field will reflect the true extrusion amount. The problem, however, is that since the 2 polygons were extruded independently of each other, a section of the banding is now missing. To fill in this section, we can simply reposition the 4 vertices that make up this corner.

64. Switch to **Vertex** sub-object mode, and with the **Move** transform active, select the top left vertex, as shown in the next illustration. Notice that the X position of the vertex is displayed within the transform type-in field at the bottom of the screen. We need to apply this value to the X position of the vertices on the right-hand side to make them move to the proper location.

65. Copy the X value for this vertex, as shown in the left image, and paste this inside the X field value for the 2 vertices on the right-hand side. This causes these 2 vertices on the right to move to the same X position as the 1st vertex, as shown in the right image.

66. Use this same technique to reposition the 2 vertices on the left, so they occupy the same Y position as the 2 vertices you just moved.

67. Extrude the top portion of this banding feature using the same extrusion and vertex repositioning technique. The result should look like the next illustration.

The many different trim features on this wall can be created in this same fashion as the 2 previous features, so at this point we won't create any more. However, we haven't yet created any windows and doors. Windows and doors both work the same way regardless of which method you choose to create, meaning that they can both be treated as the same type of object and should be created in the same way. For the purpose of this exercise, let's create the 2nd floor windows on the front of the wall object we have been working on.

68. If you wish to continue from this point with an already prepared scene, open the file **ch03-06.max**.

69. Change to a **Front** view and zoom out to the extents of the **Bldg-MainWall** object. At this point we need to make edges for the windows we want to create. We will start with the vertical edges and then create the horizontal. The reason for creating the vertical edges before the horizontal ones will become apparent shortly.

70. Enter **Edge** sub-object mode and click on the **Slice Plane** button.

71. Rotate the slice plane **90** degrees about the **Z-axis** so it is vertical rather than horizontal.

72. Move the slice plane so it's at the left edge of the masonry opening of the farthest left window, as shown in the next illustration. The masonry opening is the same as the outer edge of the window frame, which is always the same as the opening indicated on a floor plan.

73. Click the **Slice** button to create the new edges.

74. Move the slice plane to the right side of the window and create a slice at the right side of the masonry opening of this window.

75. Repeat this for each of the remaining eight windows on the front of the **Bldg-MainWall** object. The result should look like the next illustration.

76. Rotate the slice plane **90** degrees about the **Z-axis** so it is horizontal once again. On the 2nd floor, there are 2 different window types at slightly different heights, and in the next few steps we need to create slices at the top and bottom of both types.

77. Create a slice at four different elevations, as shown in the next illustration. For the square shaped window, the slice needs to occur at the top and bottom of the masonry opening. However, on the window with the curved top we need to place the top slice at the top of the square frame, not at the top of the arch. The reason for this will be apparent in just a moment.

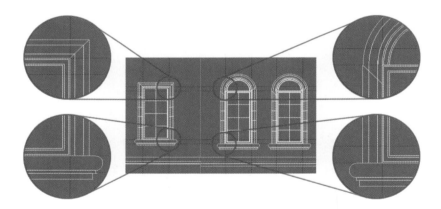

78. Create one final slice at the very bottom of the trim feature directly above the 2nd floor windows, as shown in the next illustration. We need to add this slice to separate the work we are going to do on the 2nd floor window from the windows on the 3rd floor. Had we already created this trim feature, this step would not be necessary.

79. Close the **Slice Plane** command.

80. If you wish to continue from this point with an already prepared scene, open the file **ch03-07.max**.

Because of the slice plane we created for the top of the windows with the arch, we have unnecessary edges running through the windows on both sides. These should be removed.

81. Select the edges running through the top part of the 3 windows on the left-hand side of the front elevation, as shown in the next illustration. **Note:** Since this needs to be done for both sides of the wall object, do not simply click on the edges. Use a **Window** selection to select the edges on the front and back of the wall at the same time.

82. Inside the **Edit Edges** rollout click the **Remove** button. This simply removes the unnecessary edges without deleting any polygons in the process. You cannot delete edges because doing so would also delete the polygons on both sides of the deleted edge.

83. Remove the additional edges running through the top of the 3 windows on the far right of the front elevation.

The 3 windows in the middle of the 2nd floor also have unnecessary edges running through their tops and bottoms. These will also have to be removed.

84. Remove the top-most edge running through the arched portion of these 3 windows, and the edge running through the bottom portion, as shown in the next illustration. Don't forget to select these same edges on the back side of the wall object before removing.

85. If you wish to continue from this point with an already prepared scene, open the file **ch03-08.max**.

86. Switch to an **Orthographic** view and rotate your view to a perspective showing both the front and side of the wall object.

87. Switch to **Polygon** sub-object mode and select the 9 polygons that represent the 2nd floor windows you just created edges for, as shown in the left side of the next illustration.

88. Rotate the view to show the back side of the wall object and select the 9 polygons in the same location on the back side, as shown in the right side of the next illustration.

89. In the **Edit Polygons** rollout click on the **Bridge** button. The polygons you selected are deleted and new polygons are created for the sides of the new openings, as shown in the next illustration.

We've created 9 window openings on the 2nd floor of this wall object. We need to change the top portion of the 3 center windows to an arched window, but before we can do this we have to remove some extra edges we no longer need. Without removing the unnecessary edges around these 3 center windows, we cannot modify the windows as needed without extra polygons being left behind.

90. Switch to **Edge** sub-object mode and zoom into the 3 center windows.

91. If you have not already done so, switch to a **Wireframe** view.

92. Carefully select the 8 edges shown in the next illustration. These 8 edges serve no purpose because they are not part of the edges that make up the border of any window opening. Leaving them behind will cause problems with the next part of this exercise, which is turning these rectangular window openings into arched window openings at the top.

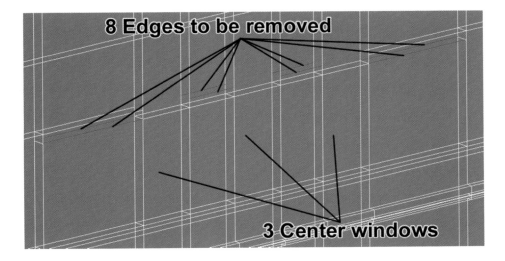

93. In the **Edit Edges** rollout, click the **Remove** button. These 8 edges are removed. Again, you cannot simply delete the edges by pressing the delete key on your keyboard, because doing so will delete any polygons connected to the deleted edges. Removing is more like optimizing.

Now we are going to add edges to the polygons immediately above the window openings, so we can curve the top portion of the openings to match the architectural drawings.

94. Select the 12 edges shown in the next illustration. These edges make up the top and bottom of the 2 outside and inside polygons directly above each of the 3 window openings.

95. In the **Edit Edges** rollout, click the **Settings** button immediately to the right of the **Connect** button. The **Connect Edges** caddy opens.

96. Type **25** inside the **Segments** field and click **OK** to end the command. This adds 25 additional edges to the area immediately above each window opening, as shown in the next illustration.

97. Switch to a **Front** view and zoom into the area above one of windows you just added edges.

98. If you wish to continue from this point with an already prepared scene, open the file **ch03-09.max**.

99. Using a **Window** selection mode (not Crossing), select all of the edges immediately above one (and only one) window opening, as shown in the next illustration.

100. While still in **Edge** sub-object mode, add the **FFD(4x4x4)** modifier. By being in Edge sub-object mode with certain edges already selected, you restrict the FFD modifier so it only affects the edges that are selected when the modifier is added.

101. Open the **FFD(4x4x4)** modifier and click on **Control Points**.

102. In **Front** view, create a window selection around the 2 rows of control points positioned in the middle and along the very bottom of the lattice, as shown in the next illustration.

103. Move the selected control points upward so the top of the newly formed arch aligns to the top of the arch defined in the architectural drawings, as shown on the left side of the next illustration.

104. With the same 2 rows of control points selected, perform a non-uniform scale along the **X-axis** so the 2 rows move away from each other, thereby making the model conform to the architectural drawings, as shown on the right side of the next illustration.

105. Repeat the last few steps to add curvature to the 2 remaining arched windows. To do this, you will have to add a new **Edit Poly** modifier and a new **FFD (4x4x4)** modifier to the 2 remaining arched windows. The result of modifying all 3 windows should look like the next set of images.

106. If you wish to continue from this point with an already prepared scene, open the file **ch03-10.max.**

The last thing we will do in this exercise is create the window frames for these 9 windows.

107. Switch to an **Orthographic** view.

108. Add an additional **Edit Poly** modifier to the modifier stack and switch to **Polygon** sub-object mode. When you do, the polygons that make up the inside of the window openings should be automatically selected because when you performed the bridge command earlier, those were the polygons that created the bridge and they remain selected until you deselect them. If you had inadvertently deselected them, you will have to reselect these same polygons.

109. In the **Edit Polygons** rollout click the **Settings** icon to the immediate right of the **Inset** button.

110. In the **Inset Polygons** caddy enter **2.0** and click **OK** to complete the command. This creates new edges 2 inches from the outer edge of the windows, and means that our window frames will be 4 inches thick, as shown in the next illustration. If you want a different thickness to your frames, simply use the necessary inset amount at this time.

111. With these newly created polygons selected, click the icon to the right of the **Extrude** button.

112. Select **By Polygon**, type **2** in the **Extrusion Height** field and click **Apply**, as shown in the next illustration. By clicking Apply, you can execute the extrusion (to see if it works properly) without closing the command and since the command is still active you can revert to a front view to determine exactly how far you need to extrude the polygons.

Close inspection of the window frames from Front view will indicate the extrusion should really be set to 0.5 inches, as shown in the next illustration.

At this point, you could complete all of the walls, windows, and doors for this building using the same features and procedures discussed so far. By continuing use of the **Inset** and **Extrude** features, you can quite easily form all of the window and door frames all at once, as well as the door and glass objects that lie within those frames. The exercise ends at this point, because continuing from here would only be repetition of the same steps already covered.

Summary

This chapter explained the many differences between the most commonly used methods of creating walls, windows, and doors. Through the use of a practical exercise, we focused specifically on how to create these objects using the box modeling method. In reality, the majority of the exercises in this chapter focused on creating walls and the window and door openings that lie within those walls. The actual door and windows that lie within those openings can be created with the box modeling method by just continuing with the same procedures and commands discussed.

While the box modeling method has a few inviting qualities about it, I would argue that it simply cannot compare to the speed and efficiency that can be achieved using the Loft command to create walls and the ProBoolean command to create window and door openings. At 3DAS, we do not endorse the box modeling method to create walls, windows, and doors on a large scale. However, the method was discussed at length because it is still a great solution for making modifications to existing objects, and all of the settings and procedures covered in this exercise will be applicable to countless other object types you need to create throughout the course of modeling a complete architectural scene. It was also discussed because many veteran users choose this method as the backbone for all their modeling. Furthermore, a complete understanding of all of the commonly used methods for doing a particular type of work in 3D is necessary, if you want to create an objective opinion about which method works best for you.

In the next chapter, we will look closely at how to create walls, windows, and doors using the Loft and ProBoolean features.

Creating Walls, Windows, and Doors (Part 2)

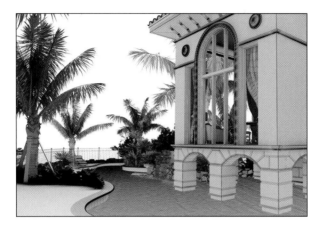

IN THE LAST CHAPTER, WE discussed the four primary methods veteran 3ds Max artists use to craft their walls and the various objects that are built onto or within those walls. The exercise focused on use of the Edit Poly feature, also known as the box modeling method. While this method has some distinct advantages and is heavily favored by a decent percentage of veteran 3ds Max users, I believe that it simply does not offer the speed and versatility available with the Loft and ProBoolean combination. This chapter is a demonstration of that speed and versatility.

It should be mentioned at this point that many veteran users prefer the Edit Poly feature over the Loft and ProBoolean, because at one time it may have been the only method they were familiar with to perform their work. Over time, we all become comfortable using certain commands and techniques, and with enough practice, we can become so familiar that we eventually find out how to squeeze every last bit of speed and efficiency out of the commands and techniques we use. When that happens, switching to a totally different method of work might not actually be faster in the short term, and therefore, a less appealing alternative.

Before beginning the 2nd part of this 2 part exercise, it should also be understood that while many users prefer the Loft and ProBoolean combination, the Sweep and Boolean features are also suitable alternatives that work in similar ways. The Sweep offers the same lofting power but does not respect the very important pivot point of an object. Also, since it's a modifier, the original spline used for the path is lost when the Sweep modifier is added. For these simple reasons, the Loft is my preferred choice.

The Boolean feature is also a possible choice for subtracting the voids used for window and door openings; however, it does not offer the same flexibility of the ProBoolean. The primary difference between the two is that before the ProBoolean performs its subtraction, it subdivides the object to allow for more accurate cuts, and once the cut has occurred, it optimizes the geometry to the way it was before. The Boolean does not do this. When the Boolean and ProBoolean commands are used for identical objects, you often end up with the exact same model, but because the Boolean has a tendency to display internal edges, the result is a dirtier looking mesh, even when

both mesh versions are identical in terms of face count and placement. An additional, and equally annoying difference, is that with the ProBoolean you can subtract multiple objects without ever worrying about missing faces. With the Boolean feature, you have to subtract *all* of your Boolean objects at once, or run the risk of seeing missing faces on the inside surface of a wall opening.

And perhaps the biggest reason many users achieve erratic results with the Boolean command is that the feature does not work well with long and skinny faces. Since the ProBoolean subdivides an object before cuts are made, long skinny faces are not a problem. As you will see in Chapters 7 and 8, which deal with creating sites, the Boolean is actually an invaluable command when used properly and one that provides something the ProBoolean cannot. But because the Boolean is not needed in the creation of walls the same way it is needed in the creation of sites, use of this feature with this object type is far less appealing.

Wall, Window and Door Modeling – Part 1 (Lofts and ProBooleans)

In Part 2 of this two-part wall modeling exercise, we will use the Loft and ProBoolean features as the primary modeling tools to create the same wall created in Part 1 of this exercise. Unlike Part 1, this exercise will include the creation of each component of one of the two window types found on the 2nd floor of this wall. It is important to note that while the first portion of this exercise is conducted in AutoCAD, the same steps can be performed within 3ds Max. As mentioned throughout this book, preparing linework in AutoCAD before importing has numerous advantages. Perhaps the biggest advantage is the faster and more efficient line editing tools available with AutoCAD. Another is that if you do not use AutoCAD, you *might* need to import the entire drawing rather than just a few simple polylines, and delete all the imported linework when you're finished creating your new splines from the linework. Regardless, these same steps performed in AutoCAD can be performed in 3ds Max.

1. Open the AutoCAD file, **ch04-01.dwg**. This is the same drawing that was used at the beginning of Part 1 of this exercise.

2. Create a new layer called **0-Profiles**, set its color to **magenta**, and set the current layer to this new layer. This will be the layer all wall profiles will be placed on. Using the prefix **0-** helps with the organization of your layers, because it forces all the layers you create to appear together and at the beginning of the layer manager.

3. To the left of the front elevation, create a closed polyline representing the cross section of the main wall, as shown on the left in the next illustration. Since the exterior walls of a building are typically 8 inches thick, create the polyline 8 inches wide. You can either trace over the existing front elevation linework, or make a copy of the linework off to the side and use the various line editing features in AutoCAD to turn this copy into the closed polyline needed.

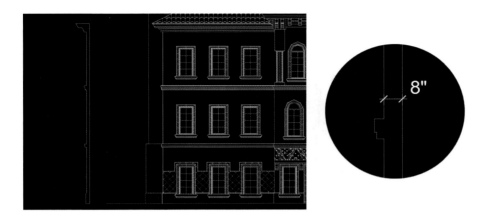

4. Create a new layer called **0-Paths**, set its color to **yellow**, and set the current layer to this new layer. This will be the layer all wall paths will be placed on.

5. On the existing 1st floor plan, create a polyline representing the location of the exterior surface of the main wall, as shown by the 3 points in the next illustration.

At this point, we can import these 2 polylines into 3ds Max and create the main wall. Since there are 2 different file formats we can import, we have to decide which one will be used. If we use the **AutoCAD DWG** file type, we can simply import by layer and import only the 2 new layers we created. However, as mentioned several times in previous chapters, this format type often removes curves, and is therefore not always an option to be considered. The **Legacy AutoCAD** file type is always reliable and will therefore be the format type used here. Since we cannot import by layer with this option, and since we don't want to import the entire architectural drawing every time we want to import new linework, we need to create a new drawing that only contains these 2 newly created polylines. There is a very quick and easy way to do this. Again, if you do not have AutoCAD these steps would not be necessary, as you will have already created your new linework directly in 3ds Max.

6. Select the 2 polylines you created in AutoCAD.

7. Right-click inside the viewport and select **Copy with Base Point**.

8. In the command line, type **0,0** for the base point. These last 2 commands copy the selected polylines to the clipboard using the origin as a base point.

9. Start a new AutoCAD drawing.

10. Type **pasteclip** in the command line, and type **0,0** for the base point. This pastes the 2 polylines into the new drawing.

11. Zoom to the extents of the drawing to insure that the new linework is in the drawing and save the drawing using the name **wall_path&profile.dwg**. This file would normally contain all of the paths and profiles that need to be created.

12. Close the file **wall_path&profile.dwg** and save the original AutoCAD file to the new name **ch04-02.dwg**. It is good practice to save your files incrementally so you can return to previous configurations of the same scene.

13. Reset 3ds Max.

14. Change the units of this new scene to **U.S. Standard, Feet w/ Decimal Inches** and with **Default Units** set to **Inches**. If you do not wish to work in U.S. standard you will have to convert the units prescribed in this exercise.

15. In the **System Unit Setup** dialog box, ensure that the **System Unit Scale** is set so **1 unit = 1.0 inches**.

16. Import the file **wall_path&profile.dwg** using the **Legacy AutoCAD** file type with the derive by layer option, and use the **Zoom Extents All** command to see the 2 polylines (now to be called splines) as shown in the next illustration.

Before we can create the loft that will represent the wall we want to build, we have to set the pivot point of the wall profile spline. Since all splines we create or import have pivot points automatically created at their center, and since lofts use an object's pivot point to determine the positioning of the loft, if we do not move the pivot point of the wall profile spline, we will end up with a loft half-buried in the ground. So at this point, we need to align the pivot point of the profile to the point that represents where the exterior surface of the wall meets the ground. But as mentioned in previous chapters, since the linework on our floor plan does not depict the trim that runs along the base of the walls but instead just the

8 inch concrete block, the true pivot point we need to establish would be where the exterior surface of the concrete block meets the ground.

17. Activate the **Top** view, and switch to a single viewport configuration of the Top view and perform a zoom extents.

18. Select the wall profile spline, and click and activate the **Move** transform.

19. Within the **Hierarchy** panel, click the **Affect Pivot Only** button.

20. Change your snap settings so **Pivot** and **Endpoint** are the only 2 snap options enabled. Using these 2 particular snap options makes it easy to align pivot points.

21. Enable snaps and place your cursor over the wall profile until the symbol for **Pivot** appears, as shown in the next illustration.

22. With the **Pivot** snap symbol shown, click and drag on the transform gizmo, and move your cursor to the very bottom-right corner of the wall profile spline, releasing the mouse button when the endpoint snap is shown on that corner (left side of next illustration).

23. Using the transform type-in, move your pivot point **8** inches in the **negative X** direction. If you made your wall spline 8 inches wide as directed in a previous step your pivot point should now be positioned exactly where the concrete block wall meets the ground, as defined by the exterior line you traced on the floor plan, and as shown on the right side of the next illustration.

24. Click the **Affect Pivot Only** button to end this command.

25. Change the snap settings so only the **Endpoint** option is enabled. This is the only option you will need for the majority of the time snaps are needed. When other snaps are needed, as in the example with the positioning of the pivot point, you can easily change your options when needed.

26. Disable snaps and switch to a **Perspective** view.

27. If you wish to continue from this point with an already prepared scene, open the file **ch04-01.max**.

28. Select the wall path spline and loft the wall profile along its path. The result should look like the next illustration. If you created the wall path in the opposite direction from what was indicated in an earlier step your loft will be inside out. You will need to either go into spline sub-object mode of the wall path and reverse the direction of the spline, or create the loft again and hold down **Ctrl** when picking the wall profile in the viewport.

29. Switch to an **Orthographic** view and zoom to the extents of the loft. Switching to an Orthographic view makes viewport navigation much easier.

The first thing that needs to be corrected is the inappropriate smoothing 3ds Max automatically generates.

30. Go to the **Modify** panel and open the **Surface Parameters** rollout.

31. Disable the **Smooth Length** and **Smooth Width** options. With these options disabled, 3ds Max doesn't try to automatically smooth corners and the shading looks more natural.

32. Enable **Edged Faces** mode for this viewport (hotkey=F4). This shows just how many unnecessary polygons are created by default.

33. Switch to a **Front** view and zoom closely to the fascia and trim at the top of the wall loft, as shown in the next illustration. Notice that one area contains curves and everywhere else there are straight segments. These additional polygons are necessary to display the curved areas properly, but they are not at all necessary anywhere else. Because of this, it would be very wise to remove these additional segments created automatically, and manually tell 3ds Max where to place the additional vertices to make curves look smooth.

34. Within the **Skin Parameters** rollout, reduce the **Shape Steps** and **Path Steps** to **0**. Notice that this causes the curved portion of the loft to no longer be curved.

35. Switch to a **4-viewport** configuration and within the **Top** view zoom in closely to the top of the wall profile, as shown in the next illustration.

36. Select the wall profile and enter **Segment** sub-object mode.

37. Select the 2 curved segments (as shown in the next illustration) and within the **Modify** panel scroll to the bottom of the **Geometry** rollout.

38. Click the **Divide** button. Notice that the loft shown in Front view reflects the division of these 2 segments by adding additional polygons.

39. Click the **Divide** button two more times. Now the curved portion of the loft is quite smooth, as shown in the next illustration.

40. Repeat this process with the other curved segments found in the trim feature that runs between the 2nd and 3rd floors. Since each curved segment is different, consider dividing each segment a different amount. When finished, your trim should look similar to the following illustration.

Now your loft is perfectly optimized, with no more polygons than is necessary to create a great looking wall. You could reduce the polygon count even farther by removing the very bottom line segment in the profile, since no one would ever see this part of the loft. But for the few extra polygons you would remove, it's hardly worth the trouble. You could even delete the inside wall segment, if the inside of the loft would never be seen, but again, the reduction in polygons would be insignificant.

One of the great things about the loft feature is how you can quickly incorporate trim, banding, and joint features into your loft by just including these details in the wall profile spline. We just accomplished in a few steps what took a very large number of steps to do in the previous exercise in Chapter 3. But before moving on to creating the windows for the 2nd floor of this wall, let's make one more modification to the wall profile spline.

In the front elevation is a diamond shaped score pattern that runs along the wall and around the windows. If you analyze the building section, you will see that this is nothing more than a pattern set into the stucco that gets applied to the 8 inch concrete wall. Because it's just a pattern, and not something like a banding feature that comes out from the main part of the wall, we can accommodate this pattern by simply using a different material for this portion of the wall. To add a different material to just this section of the wall, we have to first create the edges in the wall object so we can have separate polygons for the separate materials. And although we could use the Slice feature to add these edges as we did in the last chapter, we would have to add the Edit Mesh or Edit Poly modifier, and that would essentially break the link between the wall path and profile.

Instead of adding the Edit Mesh or Edit Poly here, we can again just modify the wall profile spline. This time, we simply need to add a vertex at the point along the wall profile that matches the same point on the front elevation where the change in material is indicated, as shown in the next illustration.

41. Refer back to the AutoCAD drawing and create a single line between the two vertical extremes of the portion of the wall that you need to add the edge, as shown in the next illustration.

42. Take a distance measure from the midpoint of this new line and the top of the scored wall feature. The distance should be **3.5 inches**.

43. Go back into your 3ds Max scene, and while still in Segment sub-object mode of the wall profile spline, divide the appropriate segment once, thereby creating one new vertex in the very middle of the segment, as shown on the left side of the next illustration. Since we know that the top of the wall scoring occurs 3.5 inches below the midpoint of this segment, we can place this new vertex properly by moving it 3.5 inches in the negative Y direction.

44. Go to **Vertex** sub-object mode and move the newly created vertex **3.5** inches in the **negative Y** direction. If you look at the loft from a Front view, you will now see the additional edge created, as shown on the right side of the next illustration.

45. Close out of sub-object mode.

46. Save the file using a new name.

I always recommend saving incrementally and saving often, and before adding an Edit Poly modifier or creating a ProBoolean from the wall loft, it would be wise to save a copy of the scene first so you can come back to the scene in its current state, and pull objects like the wall loft out and modify them while the loft is still linked to the path and profile.

And speaking of linked objects, one of the great things we can do to our loft, because of its link to the wall profile spline, is quickly assign material IDs to the various polygons that make up the loft. By assigning material IDs to the various segments that make up the profile spline, the corresponding polygons on the loft receive the same material IDs. This means that we can quickly assign different materials to the loft or, at the very least, break the loft into separate objects by just selecting polygons by their different material IDs.

47. If you wish to continue from this point with an already prepared scene, open the file **ch04-02.max**.

48. Open the **Material Editor** and create a **Multi/Sub-Object** material with **4** sub-materials. By looking at the elevations, you can determine how many different materials will be needed for the entire loft object. In this case, there are 4 distinct materials, as shown in the next illustration. Often you may not even be provided this information, at the modeling phase of a project, but it is nonetheless helpful to assign different material IDs to the different parts of a building so that when the time comes, you can easily assign those different sub-object materials or easily select polygons by their material IDs and detach the polygons to separate objects.

49. Assign different colors to each sub-material, as shown in the next illustration, so that the different parts of the loft stand out from each other when the material is assigned.

50. Assign the names shown in the next illustration to the 4 different sub-materials that will be applied to the loft. Any names will do of course, but I always like to stress to taking the extra few seconds to name objects and materials properly so scene navigation is as simple as possible.

51. Assign this new material to the wall loft. When you do, the entire loft should appear as sub-material color #1.

52. Select the wall profile spline and go to **Segment** sub-object mode.

53. Scroll to the very bottom of the **Modify** panel and open the **Surface Properties** rollout.

54. Create a window selection around the entire wall profile spline so all of the segments are selected. In the **Set ID** field of the **Surface Properties** rollout, you should see that all of the segments in the selected spline have material ID 1 assigned. This means that they will all receive sub-material 1 when a multi/sub-object material is assigned. If there is anything but the number 1 in this field, change it to read **1**.

55. Change the material ID of the scored stucco region to **2**, depicted by the green portion of the next illustration. Change the material ID of the rest of the stucco wall to **3**, as depicted by the blue portion. Change the material ID of the 3 different trim features to **4**, as depicted by the purple.

56. Close sub-object mode and save your scene.

Now that the different parts of the wall contain different material IDs, assigning different materials or breaking the wall into separate objects is quick and easy.

At this point, we need to continue with the creation and placement of windows and doors. This phase of modeling is best started once all of the walls are in place, because with all the walls created it's easy to spot errors in your work, and fixing those errors won't take as long as it would if you had already placed windows and doors inside the walls and broken the link between the loft and its supporting path and profile. So assuming that all walls are created at this point, we need to refer back to the AutoCAD drawings and prepare the necessary linework to create the windows and doors. Again, if you do not have AutoCAD, the same basic steps can be performed in 3ds Max.

As an additional note, it's worth mentioning that while this chapter is dedicated to a demonstration of the Loft and ProBoolean combination, there is nothing preventing users from using the Loft and Edit Poly together or the Edit Poly and ProBoolean together. So if you feel that the Edit Poly is your best way to build walls, you can still make use of the ProBoolean to create the window and door openings and still use the procedures outlined in the remainder of this chapter to create the windows and doors that go in those openings.

57. Return to the AutoCAD drawing and make a copy of the rectangular window found on the 2nd floor and place the copy off to the side, as shown in the next illustration. Normally, this would be a copy of every door and window in the building, but since we are only concentrating on creating one window type, we only need to create this one copy here.

In time and with practice, all visualization artists refine what they feel to be an acceptable level of detail for the objects shown in a set of architectural drawings, but as mentioned before, if it's important enough and sizeable enough to be shown in a set of elevations, then it probably needs to be shown in 3D. Likewise, if it's not visible in the architectural elevations it's usually safe to leave out of the visualization. Your contracts should even reflect this way of thinking.

So in the case of this window, the lines shown in the elevations can be used to determine the level of detail we need to create. And without even looking at a window section or a window detail drawing, an experienced artist can take one look at the linework for the window and immediately determine what each line represents. To help facilitate your understanding of what the linework really indicates, the next illustration is provided as a reference.

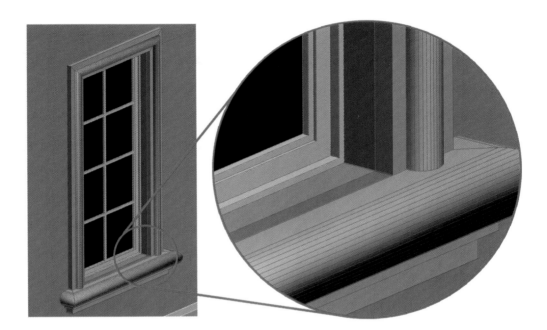

In the real world, window and door assemblies are usually made up of dozens of different components, but in the 3D world, there are usually 4 major components that make up a window or door assembly. They are: frames, glass, trim, and the actual door or window. An additional object that will need to be created is the Boolean object with which to subtract the necessary void. If you break each window or door down to these separate elements, they are quite simple to create. In most cases, each component can be created by simply extruding or lofting splines.

One important note that goes back to what was said a moment ago about the level of detail needed, is that the drawings of these windows have, like most drawings do, the need for separate window components at different depths. What you should be able to discern from the last illustration is that very distinct parts of the window need to be created separately. The window frame is not just a couple of extrude splines, but rather a group of 3 distinctly separate components that once created are attached together. They are most easily created by extruding 3 separate sets of closed splines. Once extruded and positioned at their respective depths into the wall, they should be attached together because they will always require the same material.

Both the glass and the Boolean objects can also be easily created with extruded splines, while the window sill and trim features of this window can be easily created with lofts. So let's continue now with the creation of these 2 windows with this basic understanding of the linework that makes up the window elevations.

The first element we will create the linework for is the window frame. First, let's create the mullions and the 3 different parts of the frame that support them. If you do not have AutoCAD, use the equivalent 3ds Max features to perform the same steps.

58. Offset the single vertical line **0.5** inches to the left and right sides of the line. These 2 lines will be used to create a vertical mullion 1.0 inches thick. You can refer to a building's section drawings to verify a mullion's thickness, but a 1.0 thickness is a common thickness that seems most applicable to a window of this size. Even if the mullions needed to be less than 1.0 inches, I wouldn't create them any smaller because mullions any smaller than this can begin to disappear at a distance and would often appear thinner than an individual pixel. It is common practice to thicken or enlarge certain object types to allow them to display better when rendered.

59. Offset the 3 horizontal lines **0.5** above and below just like you offset the vertical line. The linework should change from that shown on the left side of the next illustration to that shown on the right.

60. Create a new layer in AutoCAD called **0-Frame-1** and select the color **magenta** for the layer. This is the layer we will create the 1st frame linework on. The -1 suffix simply reminds us that this is the 1st part of the frame we are creating.

61. Make layer **0-Frame-1** the current layer, and using endpoint snaps, draw two rectangles that define the outermost frame component, as shown on the left side of the next illustration. If you do a distance measure of these 2 lines, you would see that they are 0.5 inches apart.

62. Create a new layer in AutoCAD called **0-Frame-2** and select the color green for the layer. This is the layer we will create the 2nd frame linework on.

63. Make layer **0-Frame-2** the current layer, and draw two rectangles that define the next frame component that lies just within the 1st linework you created, as shown on the right side of the next illustration. If you do a distance measure of these 2 lines, you will see that they are 1.5 inches apart.

0-Frame-1 **0-Frame-2**

64. Create a new layer in AutoCAD called **0-Frame-3** and select the color **red** for the layer. This is the layer we will create the 3rd and final set of linework on, which in this case is the mullions.

65. Make layer **0-Frame-3** the current layer and draw a single rectangle that represents the outer edge of the mullions as shown by the outer most red rectangle in the next illustration.

66. Using the extra linework you offset to create the mullions, and intersection snaps, create **8** additional rectangles defining the space between the mullions and the mullion frame. The result should be 9 total rectangles on this layer, as shown in the next illustration.

0-Frame-1

You should have just created 3 sets of lines on 3 different layers, and with 3 different colors (as a visual aid). In a moment, this linework will be imported into 3ds Max, extruded in different amounts and placed at varying depths.

67. Create a new layer in AutoCAD called **0-Glass** and select the color **blue** for the layer. This is the layer we will create the glass linework on.

68. Make layer **0-Glass** the current layer, and draw a single rectangle that represents the location where the glass will be visible. This rectangle will be imported into 3ds Max and extruded a small amount. There is no need to create 8 individual rectangles for the glass even though there are clearly 8 window panels where the glass is visible. In the real world the glass would run through the mullions anyway, and we can allow this to happen in the 3D world as well since it saves time. The rectangle should look like the one shown in the next illustration.

0-Glass

69. Create a new layer in AutoCAD called **0-Boolean** and select the color **cyan** for the layer. This is the layer we will create the Boolean object linework on.

70. Make layer **0-Boolean** the current layer, and draw a single rectangle that represents the outermost extent of the outer window frame. This rectangle represents the area that will be cut out of the wall, so this also needs to be co-located with the outermost rectangle you created for the window frame.

0-Boolean

The next window object we'll create is the window sill, and the method we'll use is the loft. The only thing we don't know about the sill's structure by looking at the elevation is the depth of the sill; i.e., how far out from the wall it extends. Sometimes a section or detail drawing of these types of objects is not available, as was the case with this project. When information is lacking, an educated guess based on the rest of the building design can help, as can a call to the client. We can always change the depth later, but a good depth to start with is about 4 or 5 inches.

71. Create a new layer in AutoCAD called **0-WindowSill-profile** and select the color green for the layer.

72. Make layer **0-WindowSill-profile** the current layer, and draw a line down from the bottom left corner of the window trim to the bottom of the window sill, as shown on the left side of the next illustration. This will be the back of the sill that rests against the wall.

73. Using the line editing tools in AutoCAD (or 3ds Max), create a closed polyline from this new line and the existing sill linework, as shown on the right side of the next illustration. We won't need the existing window linework anyway, so you can delete the unnecessary lines.

0-WindowSill-profile

The last window object we'll create is the window trim, and again, the method we'll use is the loft. Like the window sill, there was no section or detail available for the trim. Unlike the window sill, we don't even know for sure what the cross section looks like, but the light gray lines indicate that it is probably one of 2 different types; a curved or stair-stepped cross section.

74. Create a new layer in AutoCAD called **0-WindowTrim-profile** and select the color **red** for the layer.

75. Make layer **0-WindowTrim-profile** the current layer and use the existing linework to create the closed polyline shown on the left side on the next illustration. Rather than creating the curved portion shown in the illustration, we could have elected to create a stair-step shape with sharp corners, but based on the style of the rest of the building and the improved look the curve provides, creating the profile with this curvature is probably a good idea.

76. Move the newly created polyline off to the side of the window linework so that when imported into 3ds Max, it doesn't interfere with our view of the other window linework we've created.

77. Save your AutoCAD or 3ds Max file.

0-WindowTrim-profile

At this point, you would be finished with linework preparation of this window, whether your work was performed in AutoCAD or 3ds Max. If you were preparing the linework for every window and door in this building, the steps would be the same for every new window and door, and each assembly would be lined up in a row. For a larger building with far more window and door types, your lineup might look as long as the one in the next illustration, but if you perform the same steps for each assembly at the same time, you can dramatically reduce the total time needed to build each.

So with the linework for this single window completed, let's complete this exercise by importing the linework into 3ds Max, turning the 2D linework into 3D models, and placing copies of the window in their appropriate locations around the wall we created.

78. Return to your 3ds Max scene (if you have preparing linework in AutoCAD).

79. If you wish to continue from this point with an already prepared scene, open the file **ch04-03.max**.

80. Hide all of the objects in your scene.

Unlike the last time we imported linework, this time we will try using the **AutoCAD DWG** file type, since it allows you to only import the layers you want, rather than the entire drawing. If for whatever reason you lose curves in your linework to the import process, you can always use the procedure demonstrated earlier whereby you copy and paste specific linework to a completely new drawing and use the **Legacy AutoCAD** file type to import the entire drawing. If you use the AutoCAD DWG file type, the next illustration shows the specific layers you need to import.

81. Using the AutoCAD DWG file type, import the linework on the 7 new layers you created. Make sure to use the option to derive objects by **Layer**, so all lines on the same layer become part of the same object. If you wish to use an already prepared AutoCAD file, import the drawing named **ch04-02.dwg**.

After importing, you should have the linework shown on the left side of the next illustration. The names of the linework should have the prefix Layer:, but for the purpose of calling out these new objects, this prefix will not be used in the naming of the objects.

82. Except for the 2 profile splines, rotate all of the window linework **90 degrees** along the **X-axis**, as shown on the right side of the next illustration.

We now need to extrude each part of the frame, as well as the glass and Boolean objects. The amount that each needs to be extruded should be based on visual appeal when information about the true thickness is not available. Building and wall sections are not always available at the time our work needs to begin, as was the case with this project. Rather than bugging the client every time information is missing make an educated guess based on what simply looks best in a given situation. Asking a client too many questions can make you appear indecisive and inexperienced.

83. Extrude **0-Frame-1** in the amount of **4 inches**, as shown in image 1 of the next illustration. This needs to be the largest extrusion amount since it will house the other parts of the frame. Knowing that our walls will be the normal 8 inches thick, you should make the largest frame component be at least a few inches thinner than the wall, but a few inches thicker than the smallest frame component; i.e., the mullions. 4 inches is the amount I always use here unless there is a definitive reason to use some other thickness.

84. Extrude **0-Frame-2** in the amount of **2 inches**, as shown in image 2 of the next illustration. I always reduce each inner frame component to half the thickness of the next outer frame component, because it helps to show the separation between the two.

85. Extrude **0-Frame-3** in the amount of **1 inch**, as shown in image 3 of the next illustration. Since we made the width of each individual mullion 1 inch earlier in this exercise, extruding this object 1 inch makes the mullions the same thickness in both directions. This is something to think about when you're creating the mullion linework earlier in the process.

86. Extrude **0-Glass** in the amount of **0.25 inches**, as shown in image 4 of the previous illustration. You could always just convert this single rectangle to an editable mesh or poly; however, this might cause problems if you need to view this glass from the inside and do not make the glass 2-sided. Glass obviously has thickness in the real world, so there's no real reason why you can't give the glass thickness in the 3D world. The 0.25 value used here is a good arbitrary amount to use for glass.

87. Extrude **0-Boolean** in the amount of **24 inches**. This object only needs to be as thick as the thickest wall it will penetrate, but having it a bit thicker means that you don't have to be as careful in its placement into the wall (in terms of depth).

88. With all 5 objects created, switch to a **Top** view and center each piece on each other along the **Y-axis** as shown in the next illustration.

89. Switch to an **Orthographic** view.

90. Hide the **0-Boolean** object. This will allow us to see the other window objects.

91. Select **0-Frame-1** and attach the other 2 frame components to it (**0-Frame-2** & **0-Frame-3**).

92. Rename this window frame object **Bldg-Frames**. Renaming an object like this at this point is a good way to indicate that the object is structurally finalized and needs no other modeling work. You can use whatever prefix you like, but you should use some type of prefix that forces 3ds Max to list certain types of objects together. For example, when naming objects that make up a building, I always use the prefix Bldg-. This ensures that my frames, walls, glass, trim, and every other building object are listed together. If you had multiple buildings you would not have the frames of one building attached to the frames of another. In this case, I would name the frames of one building as Bldg1-Frames and the frames of another building as Bldg2-Frames. This makes scene navigation more efficient. When we create site objects in upcoming chapters, you will see that I recommend using the prefix Site-.

93. Rename the glass object **Bldg-Glass**. Incidentally, we do not need to rename the 0-Boolean object since it will disappear shortly when we use it with the Boolean command to create the openings in our wall.

94. In **Orthographic** view, draw a single spline around the very outside edge of the window frame beginning at the bottom left and ending at the bottom right, as shown in the next illustration.

95. In **Top** view, change the pivot point location of both the **0-WindowTrim-profile** and **0-WindowSill-profile** objects, as shown in the next illustration.

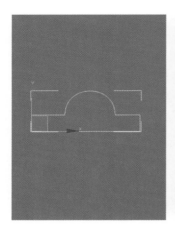
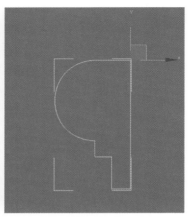

96. Divide the curved segment in each spline enough to allow for smooth curves in the loft.

97. Loft the **0-WindowTrim-profile** around the spline you just created around the window.

98. Disable **Smooth Length** and **Smooth Width** and reduce the **Shape Steps** and **Path Steps** to **0**. Your loft and its placement should look like that shown in the next illustration.

99. With this object being structurally finished, rename it to **Bldg-Trim1**.

100. Using the bottom of the newly created loft as a guide, create a spline with 4 vertices, starting from the top left and ending at the top right as shown in the next illustration.

101. Loft the **WindowSill-profile** along this newly created spline.

102. Disable **Smooth Length** and **Smooth Width** and reduce the **Shape Steps** and **Path Steps** to **0**. Your loft and its placement should look like that shown in the next illustration.

103. With this object structurally complete, rename it as **Bldg-Sills**.

104. Move the **WindowSill** and **WindowTrim** objects 2 inches in the negative Y direction, as shown in the next illustration. Since the window frame is 4 inches thick and the wall it lies within is 8 inches thick, there should be 2 inches between the window frame and the outside surface of the wall, which is where both the trim and sill will be placed.

With this last step, our window is complete and ready for placement around the wall.

105. Unhide the **0-Boolean** object.

106. Select the **0-Boolean** object, right-click inside the active view, and within the **Object Properties** dialog box, enable the **See Through** option to make the 0-Boolean object transparent.

107. Create a group named **Window-A** containing all of the window objects (**Bldg-Frames**, **Bldg-Glass**, **Bldg-Sills**, **Bldg-Trim1**, and **0-Boolean**). Since you would normally be creating multiple window types, this type of name will help you quickly distinguish the group from other window types (if necessary).

108. Save the file.

109. Return to your AutoCAD file (if using AutoCAD). You can also just use the file name **ch04-02.dwg**.

110. Create a new layer called **0-Window&DoorGuides** and select the color **red** for the layer.

111. Make **0-WindowDoor&Guides** the current layer and using the front elevation, draw vertical lines from the center of each 2nd floor window we are placing, upward through the front wall on the floor plan. You should create a total of 6 vertical lines, as shown in the next illustration.

112. Using the left elevation, draw horizontal lines from the center of each 2nd floor window we are placing, to the right, until you cross the left side wall on the floor plan. You should create a total of 3 horizontal lines as shown in the next illustration.

113. Save the file.

114. Return to your 3ds Max scene or continue with the file named **ch04-04.max**.

115. Import the **0-WindowDoorGuides** layer. You can also import this linework from the file **ch04-03.dwg**. These 9 lines can now serve as a guide by which to place copies of the window you created.

116. Using **Top** view, make an instance of the 3D window assembly you created and position it inside the wall loft, as shown in the next illustration, using the linework you just imported as a guide. The window frame should be approximately 2 inches from the inside and outside wall surfaces. If you import the linework using the **Entity** option (so that each spline is a separate object), you can use the Align command to position each window to its exact position. However, this type of object does not need to be placed with such precision along the length of a wall. Eyeballing it is perfectly acceptable in this type of situation. However, since the trim and window sill needs to be not floating in mid-air, you must ensure that it is positioned against the outer face of the wall or just slightly inside, as shown in the blow-up of the next illustration.

Now we have to position the window at its correct elevation. Before we can do so, we should align the very bottom of the window sill with the ground and then measure the distance the assembly needs to be elevated.

117. Using **Front** view, move the window assembly so that the very bottom of the sill object is aligned with the ground, as shown in the next illustration.

118. Refer back to the AutoCAD drawing and measure the distance from the ground to the very bottom of the window sill, as shown in the next illustration. The distance should be measured at **14'-8.5"**.

119. Switch back to your 3ds Max scene and move the window assembly up **14'-8.5"** in the **Z direction** (as seen from a Top view).

120. Create **8** additional instances of this window group and use the window guidelines to position them in their proper locations, as shown in the next illustration.

121. Save the file and save it again under an additional name. Since the window groups were created as instances, if you need to change the window design you can change one and have each update automatically. Saving the file to an additional name means that you can continue working on the building, but come back to the building in this current state to modify the windows while they are still instances and then merge them into a later version of the scene.

122. Select all **9** window groups and ungroup them.

123. Deselect all of the objects and select any one of the **9** window frames.

124. Collapse this object to an editable mesh or editable poly. This is very important, because if you don't the next step won't work.

125. Attach all of the other **8** window frames to this object. In this exercise, we are only working with 1 window type, but normally, all window frames from each window type would now be one single object.

126. If the name is not already correct, rename the window frame as **Bldg-Frames**. When instances of the object were made, a suffix was added.

127. Repeat the process of attaching similar objects together and renaming them. Do not forget to attach the Boolean objects together.

At this point, we need to subtract the Boolean objects from the wall loft to create the window openings.

128. Select the wall loft and use the **ProBoolean** command to subtract the **0-Boolean** object from the loft. The result should be a wall loft with 9 openings in it, as shown in the followng illustration.

129. Save the file. If you wish to see a completed version of this scene, open the file **ch04-05.max**. This concludes the exercise.

Wall Materials

Since this chapter and the previous ones were a discussion on creating walls, now would be a good time to say a few words on material selections for these objects. Advanced material creation will be discussed in later chapters that deal with mental ray, but I want to mention a few things that come up constantly in discussion forums and intermediate level classes we teach.

There are just a few types of wall materials you will need to simulate in a typical visualization; concrete, brick, stone, and aluminum or wood siding. There are a few other less commonly used wall surfaces you might need to simulate on occasion, such as the logs of a log cabin, but the majority of wall surfaces you will need to simulate fall into one of these 4 categories (not withstanding the use of glass as a primary building surface material). Some of these wall surface types should clearly be created with maps loaded in the **Diffuse Color** channel, while others should be created by use of maps loaded in the **Bump** channel. In addition, under certain conditions, the **Displacement** channel can be used to enhance the 3D appearance of a material type.

Use of the Bump channel

When concrete is the visible exterior surface material of a wall, it usually comes in the form of stucco or **CMU** (concrete masonry unit). When stucco or some other poured type of concrete is needed, rather than applying an image in the **Diffuse Color** channel of a material, you should simulate the material with a map loaded in the **Bump** channel and leave the diffuse color channel empty so you can quickly change your wall color without having to update an image. The left image in Figure 4-1 shows an image of a beige stucco wall. This image could certainly be loaded into the Diffuse Color channel, but if you or the client wants to change the color of the wall stucco to green, then you would need to use Photoshop or some other photo editor to change the color and resave the file, or save to a new file and load the new bitmap in 3ds Max. This can get old quite fast. There are other difficulties you might also run into, such as the image appearing too tiled or too blurred when viewed up close.

Figure 4-1. Images of stucco manipulated in Photoshop to allow for color changes.

Rather than simulating stucco this way, you should use a map loaded in the Bump channel to simulate the texture you want and change the wall color with the Diffuse Color channel. The stucco texture shown in the left image of Figure 4-2, for example, was created by loading the black and white image shown on the right into the Bump channel. This allowed us to quickly change the color of the wall as well as create multiple wall colors, as shown in the rendering, without ever having to leave 3ds Max or manipulate the original image used. Creating a texture like this makes it possible to zoom in very close to the wall without creating a blurring effect for the image's lack of resolution. It also becomes easier to prevent a tiled appearance using an image in the Bump channel.

Figure 4-2. Different stucco colors created with a single black and white image loaded in the Bump channel.

Creating wall texture this way has another unique advantage. Because the image loaded in the Bump channel is a bitmap, which is a 2D map (as opposed to a procedural 3D map), you have to

control its scale through the use of a UVW Map modifier. However, you can control the strength of the wall texture (i.e., its roughness) by adjusting the bump amount. This is something you cannot do if you load an image of stucco (or any other wall surface image) in the Diffuse Color channel.

In addition to creating stucco this way, you can quickly create patterns in your wall surfaces, such as the diamond-shaped pattern shown on the wall in Figure 4-2, which was created by the left image shown in Figure 4-3. The right image of Figure 4-3 could be used to simulate an exposed CMU wall.

Figure 4-3. More black and white images that can be used in the Bump channel to create a unique wall pattern.

In addition to creating stucco this way, you can quickly create patterns in your wall surfaces, such as the diamond-shaped pattern shown on the wall in Figure 4-2, which was created by the image shown in Figure 4-3.

Use of the Diffuse channel

When you need to create a brick, stone, or wood wall surface, such as those shown in Figure 4-4, you simply cannot avoid using an image of such a material in the Diffuse Color channel. You can certainly enhance its 3D appearance with the use of an image in the Bump channel, but there is simply no getting around the need for these types of images. This is especially true if you're trying to simulate additional material qualities such as chipped paint, rust, or other weathered appearances.

Figure 4-4. A brick, stone, and wood image that would be suitable for use in the Diffuse Color channel of a material.

Use of the Displacement channel

Many types of material surfaces can be given a noticeable 3D enhancement through the use of displacement. This type of enhancement, however, often comes with an expensive price tag. Using

displacement to make the material on a wall appear more 3D can dramatically increase rendering time, but unless the view is extremely close to the wall with the displaced material, it's rarely worth it. The siding shown on the building in Figure 4-5, for example, was created using the black and white striped image shown in the upper left corner of the image. Had displacement been used, there would be no discernible improvement in the 3D look of the siding. However, if the view were much closer, say from the patio, then the use of displacement might be noticeable, and therefore, justified. In reality, even if the use of displacement were justifiable, I would prefer creating the 3D appearance of the siding manually by physically building the relief into the walls. The loft is a great way to do this with little effort.

Figure 4-5. An example where the use of displacement would be unjustified to enhance siding on walls.

Using displacement on a brick wall would be even more difficult to justify, because unlike siding, the displacement would run both horizontally and vertically. And unless you are using an advanced render engine such as V-Ray, you are going to need to have the polygons in place ahead of time to allow for displacement. With V-Ray, you can create a great-looking displacement for a brick wall (or any other material), even when you only have 1 polygon in place. With most other render engines, you have to have many thousands of additional polygons in order to create a good looking displacement. For all of these reasons, the need for displacement on walls is rare.

Summary

This chapter was a demonstration of the power and efficiency of the Loft and ProBoolean combination. Like most areas of modeling, there are usually numerous ways to arrive at the same result. However, this particular method of work, I believe, is an example where there is clearly a best solution. With good linework in place, regardless of whether the linework is prepared in AutoCAD or 3ds Max, creating walls can be quick and easy. If you save your work incrementally and often, you can also return to an earlier version of your scene to recover your wall lofts or window Booleans in their original state, and use the power and flexibility of both features to make drastic modifications with ease. Creating walls is not difficult, but because it can be so time-consuming, this is one area of scene creation that you should make sure you are maximizing efficiency.

Creating Roofs

AFTER WALLS ARE ERECTED AND windows and doors are in place, the next logical object to create for a building is the roof. If you rely on BIM software to create your roofs, you can literally create a roof with a few clicks of the mouse, but while this can seem like an appealing feature for this type of software, creating complex roof structures with BIM software can often be more of an annoyance than a pleasure. This is because of the somewhat limited capability of today's software to try to interpret what you try to direct. While the methods described in this chapter will not afford you the opportunity to create a roof in literally just a few seconds, they will allow you to create one with ease and precision.

In this chapter, we'll start by looking at different ways to create the generic roof structure, meaning the individual surfaces defined by a roof plan, and then we'll focus on the different finishes you will typically need to apply to your roofs. With the exception of the most simplistic flat roofs, all 3D roof models must start with a roof plan. If you are fortunate enough to have worked in an archi- tectural office creating roof plans in 2D you will undoubtedly find less difficulty with the creation of roofs in 3D because half of the challenge is interpreting what you are looking at, even when the roof plan is drawn correctly and all elevations are present. Oftentimes, roof plans are not available at the time your work must begin, and while you can certainly insist on receiving a solid roof plan from your client before you begin working, you might be asked to create one yourself when one doesn't yet exist. Not being able to create a roof plan can be a handicap, but not being able to interpret one is a show-stopper. This chapter does not attempt to teach the understanding of roof plans, but rather how to turn one into a 3D model.

Terminology

Before beginning a discussion on the creation of 3D roofs, an overview of some key terminology is in order. The following is a brief description of the most important roof elements you need to know when working with architectural drawings. They are almost always referenced at some point in a set of architectural drawings. Figure 5-1 illustrates each of the important elements listed.

Key Elements

Eave – the part of a roof that overhangs a wall
Soffit – the underside of an eave
Fascia – the vertical, outermost edge of an eave
Ridge – the horizontal high point between two sloping roof surfaces
Ridge cap – the weather proofing cover that sits on top of a ridge to seal two adjacent slopes
Pitch – the slope of a roof usually defined by a rise over run (rise/run)
Rise/Run – the ratio between vertical rise and the horizontal run of a roof
Hip Roof – a roof that has a sloping end and sloping sides
Gable Roof – a roof that has slopes only on its sides and forms a triangular-shaped wall at its end

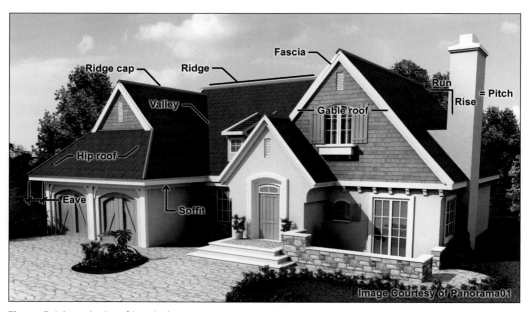

Figure 5-1. Important roof terminology.

The Generic Roof Structure

Before you can apply a roof material in your scene, you have to first create a generic roof structure. This is simply the individual polygons, as shown on the left side of Figure 5-2, on which a roof material is placed, such as the concrete tiles shown on the right side.

Besides BIM software, there are two primary methods with which to create this generic roof structure. You can either use the existing CAD roof plan linework to create the necessary polygons and then move those polygons to the proper height, or you can reverse engineer the roof plan linework using the existing 3D walls you've already created. As a matter of preference, always prefer to reverse engineer a roof plan, even when one already exists, but both methods will be discussed here along with their benefits and drawbacks. For the sake of familiarity, we will continue working with the same building that was used in the last few chapters.

Figure 5-2. The polygons that make up the generic roof (left) and the concrete tiles placed on the roof (right).

Working with an existing roof plan

Turning an existing roof plan into a generic 3D roof structure is a rather simple process of creating a series of closed splines, either in AutoCAD or 3ds Max, and turning those splines into editable mesh or editable poly objects. As mentioned throughout this book, AutoCAD is far better at line editing than 3ds Max, so if you can prepare this roof linework in AutoCAD, I highly recommend it. Just like every other area of modeling, you should spend a little time analyzing the roof plan linework to ensure that the roof plan is correct and matches the elevations, and that the linework is clean. By clean, I simply mean that lines meet with coincident endpoints, horizontal lines are perfectly horizontal, vertical lines are perfectly vertical, 45-degree lines are perfectly 45-degrees, and so on. The linework for the exercises in this chapter is already cleaned per the guides in Chapter 2 so we can avoid this initial cleaning process. As with previous chapters, the same basic steps outlined in AutoCAD can be performed with imported linework in 3ds Max.

1. Open the AutoCAD file **ch05-01.dwg**.

2. Move the roof plan linework so that instead of being positioned on top of the 3rd floor plan, as shown on the left of the next illustration, it is instead positioned on top of the 1st floor plan, as shown on the right. A quick way to do this would be to enable endpoint snaps, select and isolate the layer the roof plan is on (**Roof-plan**), select all the roof linework, turn all layers back on, execute the **Move** command, use the **P** option to select all previously selected linework (i.e., the roof linework), select any corner on the 3rd floor plan and select the same corner on the 1st floor plan to complete the move.

3. Isolate the **Roof-plan** layer so we can work on creating new linework without having to see through the existing floor plan linework. You should see only the roof plan linework shown on the left side of the next illustration.

4. Create a new layer called **0-Roof**, set the layer color to **red**, and make this the current layer.

5. With endpoint snaps enabled and using the right image in the next illustration as a guide, draw a closed pline in the shape of a triangle from the top-left corner of the main roof to the apex, down to the bottom-left corner of the main roof, and back to the starting point. This pline must be closed in order to be converted to an editable mesh or poly in 3ds Max.

6. Repeat the last step by creating closed splines for each individual roof surface, as shown in the next illustration. Do not create any plines for the first floor overhang roof because we will create this particular roof type with a different method that suits this type of roof better.

7. Save this file.

8. Switch to 3ds Max and open the file **ch05-01.max**. This scene contains all of the walls, windows, and doors that would (or should) be completed by the time a roof is created.

9. Using the **AutoCAD DWG** file type, import the **0-Roof** layer from the drawing you just saved, and derive objects by **Layer**. You can also import this layer from the file called **ch05-02.dwg**. Since the roof plan was drawn on the home grid (i.e., an elevation of 0), the imported linework lies at the base of the walls, as shown in the next illustration.

10. Switch back to the AutoCAD and take a distance measure from the ground to the very top of the main roof's fascia. The distance should be measured at **40'-2"**, as shown in the next illustration.

11. Return to the 3ds Max scene and elevate the roof linework **40'-2"**. When you do, notice that the corners of the main roof plan linework do not perfectly lie on the corners of the 3D fascia. This will almost always be the case unless you reverse engineer a roof plan, as we will do in the next exercise. The solution at this point would be to enter vertex sub-object mode and individually adjust the location of each vertex. The main problem with this approach is that it results in an inaccurate roof plan, meaning that ridges and valleys will not exist perfectly between their respective eaves and roof pitches do not perfectly match what is shown in the elevations. This does not mean that this inaccuracy is unacceptable. In fact, it would be nearly impossible for the viewer to notice this type of inaccuracy.

12. With endpoint snaps enabled and with the **Layer:0-Roof** object selected, enter **Vertex** sub-object mode and move the **4** corner vertices of the main roof plan so they snap to the 4 corners of the fascia, as shown in the next illustration.

13. Select the **12** vertices that make up the 2 hip roofs on each side of the building, as shown in the next illustration.

14. Using endpoint snaps, move all **12** vertices to their proper height by snapping any single vertex to its exact proper location, as shown in the next illustration. Having done this, 2 of the 12 selected vertices on these 2 hip roofs are now properly positioned; the one you snapped to and the one next to it. Now, let's move other vertices on these two hip roofs to their proper location.

15. Select the **2** vertices shown selected in the left image of the next illustration and snap them to their proper location using the corner vertex. Repeat this step with the other 2 sets of 2 vertices shown in the middle and right images. When this is done, all of the outside (eave) vertices will be properly positioned.

16. Select the **12** vertices that make up the 2 outside hip roofs on the front of the building, as shown in the next illustration.

17. Snap these **12** vertices to their proper height by snapping one vertex to its exact proper location.

18. Repeat the earlier step of snapping the remaining outside (eave) vertices to their exact proper location.

19. Select and position the 6 vertices that make up the front center hip roof and position them as you have all the previous hip roofs thus far, and as shown in the next illustration.

Now that the eave of each roof is located properly, the last step in creating the generic roof structure is to elevate the vertices that represent the ridge of each roof.

20. Switch to the AutoCAD file and measure the distance from the eave of the main roof to the ridge of the main roof, as shown in the next illustration. This distance should be measured as **18'-1.75"**. This is the distance the ridge vertices of the main roof need to be elevated.

21. Return to the 3ds Max scene, or if you wish to continue from this point with an already pre-pared scene, open the file **ch05-02.max**.

22. Select the **2** vertices that represent the ridge of the main roof and elevate these vertices **18'-1.75"**.

23. Switch back to the AutoCAD file and measure the distance from the eave of one of the side hip roofs to its ridge. This distance should be measured as **6'-6.25"**. This is the distance the ridge vertices of the side hip roofs need to be elevated.

24. Return to the 3ds Max scene, select the **4** vertices that represent the 2 ridges of the 2 side hip roofs and elevate these vertices **6'-6.25"**.

25. Switch back to the AutoCAD file and measure the distance from the eave of one of the outer hip roofs on the front of the building to its ridge. Just like the last roof, this distance should be measured as **6'-6.25"**. In fact, because every one of the small hip roofs is exactly the same width and has the same pitch, they have the same change in rise.

26. Elevate the ridge vertices of all remaining roofs **6'-6.25"**. Once this is done, all of the vertices of the generic roof structure will be in place.

27. Add the **Edit Mesh** or **Edit Poly** modifier to the roof object. The linework is converted into a renderable 3D roof structure, as shown in the next illustration.

The generic roof structure might appear at first to be complete; however, there are a few remaining problems.

28. Switch to **Front** view and notice how the side hip roof runs into the main roof structure, as shown in the next illustration. Because of this, there is no gap between the side roofs and the main roof.

29. Switch to **Left** view and notice how the front hip roofs do not run into the main roof structure, as shown in the next illustration. Because of this, there is a gap. This is a very common occurrence that is often caused by inaccuracies in the roof plan and/or elevations, or conflicts between them.

30. While in **Left** view, select and move the vertices that make up the back side of these hip roofs so they run into the main roof, as shown in the next illustration.

31. Close sub-object mode. It is important to note at this point that while you can certainly place these vertices well within the main roof, to create a roof on which you intend to place 3D tiles, I highly recommend positioning these vertices so they lie right on the surface of the main roof. This is so that when you place the 3D valley caps at these intersecting surfaces, you have vertices to snap to. Otherwise, placing valley caps can be very tedious.

The roof structure is now complete and ready for a roofing material. However, there is one final problem with the roof that needs to be corrected. The fascia on the 2 outer hip roofs on the front side of the building do not run into the main roof structure, as shown in the highlighted area of the next illustration. This is because these objects were created with the loft feature and were once part of the walls they rest on. The fascia was detached from the wall lofts but because the walls did not run any farther into the center of the building, neither did the fascia. The simple fix is to adjust the end vertices of the fascia objects so they do run into the roof like the rest of the fascia.

32. Select the **Bldg-Fascia** object and enter **Vertex** sub-object mode.

33. For both of the roofs in question, select the vertices that make up the back side of the fascia and move them into the main roof, as shown in the next illustration.

On the front of the building are 2 more roof types that need to be created. The small roof high-lighted on the left side of the next illustration can be created quite easily by extruding a closed spline, and the overhang roof highlighted on the right can be created with a loft. For the purpose of this exercise, the necessary linework has already been prepared.

34. Merge the **3** objects inside the file **ch05-roof_linework.max** into your current scene. These objects represent the linework needed to create the 2 new roof types just mentioned.

35. Select the object **Bldg-Roof-Small** and extrude it **20'-0"**. This is the width of the small roof shown in the next illustration. Once this extrusion is made, you can add detail to the roof as you like, but this roof is complete per the details shown in the elevations. In a moment, we'll add roof tiles to this and the other roofs.

36. Select the object **Bldg-Roof-path** and create a loft from it using the object **Bldg-Roof-profile** as the profile.

37. Reduce the **Shape Steps** and **Path Steps** to **0**. When you do, you should see a loft created as shown in the next illustration. This technique is very handy for creating these types of roofs because you can create the actual roof structure at the same time you create the beams that support the roof. The only problem is that no matter how precise you try to make your path and profile, you will always have a gap at the ridge of the roof or an overlap where one end of the loft wraps itself, as is the case here. A quick fix is to weld the problematic vertices.

38. Add the **Edit Mesh** modifier.

39. Go to **Vertex** sub-object mode and select the vertices at the front apex of the roof, as shown on the left side of the next illustration.

40. Weld the selected vertices using a threshold distance of **1'-0"**. This causes all of the vertices to weld into 1 vertex, as shown on the right side of the next illustration. When this is done, the roof appears normal.

41. Rename the loft **Bldg-Roof-Overhang**. As mentioned in earlier chapters, renaming objects after they are structurally completed or after materials have been applied is a good way to keep track of which objects are finished and which objects still need work.

42. Save your scene for use in the third exercise in this chapter. The completed roof should look like the next illustration. If you wish to see the completed scene at this point, open the file **ch05-03.max**. This is the end of this exercise.

Reverse engineering a roof plan

Another alternative to creating a roof as outlined in the previous exercise is to reverse engineer the roof plan. This simply means that instead of using the roof plan linework you receive and building your roof directly from this linework, you instead build or modify a roof plan using the already created walls as a guide.

In the following exercise, we will start with the same scene we started the 1st exercise in this chapter with, but instead of using the roof plan as is, we will create new linework in 3ds Max, export that linework to AutoCAD, create or modify an existing roof plan, and import this new roof plan back into 3ds Max. The result will be a roof plan whose endpoints are, without a doubt, located precisely where they need to be. This method is not always necessary, but there are a few reasons why it might be.

Roof plans are not always available at the time we begin our work, so if you can create linework to help guide the creation of an accurate roof plan as just described, then reverse engineering might be the best option. Also, many roofs are extremely complicated and quite difficult to understand, even for experienced 3D artists. When this is the case, creating linework from existing 3D walls can serve as a useful visual aid to ensure that your roof plan is drawn with precision, and that it's accurate in the first place. For complicated roofs, it's not unusual for experienced drafters or even architects to trim or extend a line in the wrong place. Creating linework from existing 3D walls has a way of facilitating the understanding and modification of an existing roof plan. Finally, if you have any desire to build your roofs with accuracy, meaning no irregularities such as gaps between the roofs and fascia, then you are undoubtedly going to have to modify your 3D roof once it's created, to make endpoints on the roof match the endpoints on the fascia. Therefore, doing this step prior to roof creation doesn't really add any work and if it can facilitate the entire process it is a worthwhile alternative.

1. Open the 3ds Max scene, **ch05-01.max**. This is the same scene we used in the previous exercise.

2. Create a closed spline in the shape of rectangle whose endpoints are snapped to the 4 top-most corners of the main roof, as shown in the next illustration.

3. Create another **4-point** rectangle on the very top of the fascia found on the center roof of the front elevation.

4. Repeat the last step with the other remaining roofs. There should be a closed 4-point spline created at the very top of each individual fascia. These splines will now be imported into AutoCAD and compared with the roof plan provided for this project. If you do not have Auto-CAD, you can still perform the same basic steps in 3ds Max using the roof plan you imported into 3ds Max.

5. Select all **6** splines and export them as a **3ds** file.

6. Switch to AutoCAD and open the file **ch05-02.dwg**.

7. Import the **3ds** file you just created. When you do you should see the 6 splines come to rest on top of the existing roof plan, as shown in the far left image of the next illustration. However, if you zoom in closely to any of the roof corners, you will see that there is a substantial misalignment between the linework you imported and the existing roof plan. Furthermore, if you change to a perspective view, you will see that the imported linework is positioned at a much different elevation than the existing roof plan, as shown in the far right image in the next illustration. The linework you just imported exists at the exact proper location and can

now be used to correctly modify the position of the existing roof plan. If you didn't have a roof plan at all, this would also be a great way to start. Because of the great line editing capabilities of AutoCAD, creating or modifying a roof plan like this is a fast and efficient way to work. You can, of course, do the exact same thing without the use of AutoCAD, but you will certainly take longer to do it.

8. Correct the original roof plan using this imported linework as a guide.

9. Once the existing roof plan linework has been corrected, import the corrected linework into 3ds Max and create your roof as outlined in the previous exercise. This is the end of this exercise.

Applying Roofing Materials

Most roofs we work on in the 3D visualization world can be classified as one of three types: **tile**, **standing seam**, or **shingle**. Each of these 3 categories also contains a wide array of subcategories that might sometimes seem more varied than certain species of trees. For example, in the category of tile, you might be asked to provide clay tile, Spanish tile, barrel tile, metal tile, concrete tile, cement tile, ceramic tile, and so on. The list of standing seam and shingle roof variations is just as dramatic. But while we should always strive to give our clients a great product, this doesn't mean that we need to provide exactly what is specified in the architectural drawings. For example, when a tile roof is specified, we certainly need to provide a tile roof. However, when the drawings call for Spanish tile, we will almost always be able to use a Straight Barrel style or a Mediterranean style or anything similar.

Figure 5-3. An example of a tile, standing seam, and shingle roof.

The application of the three different types of roof materials shown in Figure 5-3 requires 3 completely different approaches. The final section of this chapter discusses these 3 different approaches.

Tile Roofs

In the 1st decade of 3D visualization, very few artists attempted to place 3D tiles on a roof, relying instead on textures. The difference in realism between the two is profound, and today textures are simply unacceptable in most projects. While 3D tiles can dramatically increase the polygon count in a scene, there are a few things you can do to minimize the count and keep viewport refresh rates up and render times down.

Placing 3D tiles on a roof requires a good amount of time and until a ground-breaking plugin or script comes along, there's really no way around it. As mentioned, the exact style you decide to use is usually irrelevant and what's more important is how you place the tile. To facilitate the placement, you should create a 3ds Max scene that contains a large sample of your tile that can be placed and copied over the length of your various roof surfaces. Figure 5-4 shows such a sample. The entire sample is comprised of just one object and that object contains a multi-sub-object material with 4 different sub-materials. Incidentally, many tile roofs use only 1 color throughout the entire roof, but by building a sample such as this with several different sub-materials applied, you can decide at any time whether to use just 1 or several different colors.

Figure 5-4. A large expanse of 3D tile to be placed on the various surfaces of a roof.

Since 3D tiles can have a detrimental effect on system resources, one of the things you should always make sure you do is use tile that does not have a back to it. For example, Figure 5-5 shows the same tile sample as shown in Figure 5-4, only this time from behind. Notice that the only faces visible from behind are the edges of the tiles. Placing polygons on the backside of this type of roof will essentially double the polygon count of the roof and would be a complete waste because these polygons would never be visible.

Figure 5-5. The tile sample shown in Figure 5-3 as seen from behind.

To place 3D tiles on a generic roof structure efficiently ensure that the pivot point of your tile sample is located at the very bottom edge of your sample, as shown in Figure 5-6. This allows you to place your sample at the very edge of your roof and then rotate your sample so it never has to be repositioned. If you align the bottom of your tiles to the edge of the roof but don't place the pivot point at the bottom of your tiles as well, when you rotate your tiles to match the roof pitch, the bottom of the roof will no longer be aligned to the edge of the roof.

Figure 5-6. Aligning the pivot point of a tile sample to the very bottom of the sample.

At this point, let's run through an exercise that demonstrates the placement of 3D tiles on the generic roof structure created during the 1st exercise of this chapter.

Placing 3D Roof Tiles

This exercise demonstrates how to place 3D tile on a generic roof structure.

1. Open the 3ds Max file, **ch05-generic_roof.dwg**. This scene contains only one object; the generic roof structure created in the 1st exercise of this chapter.

2. Merge in the 3 objects from the file **3D_tile_roof_sample.max**. One object is the large roof sample, and the other two objects are the ridge and valley caps that will be placed on the generic roof.

3. Hide the objects named **Ridge Sample** and **Valley Sample**.

4. Select the **Tile Sample** object and align the very bottom left corner of the object (as seen from **Front** view) to the very bottom left edge of the main roof. The result should look like the next illustration. Since this object has such a high polygon count, using only one viewport or disabling unnecessary viewports can speed placement.

5. If you have not already done so, switch from a **4-viewport** layout to a **single** viewport layout.

6. Switch to **Left** view and zoom to the extent of the object.

7. Rotate the object about the **Z-axis** (as seen from **Left** view) until the tiles are placed squarely on the front surface of the roof, as shown in the next illustration. Zooming in to the apex of the main roof will help place the tiles properly. The tiles need to be rotated exactly **-15.27** degrees (about the Z-axis using Offset:Screen mode or the X-axis using Absolute:World mode) to be perfectly positioned, so you can use this value if you want.

8. Enter **Element** sub-object mode and delete all of the tiles from the apex of the roof and above.

9. Switch to a **Top** view.

10. Select and isolate the **Bldg-Roof** object.

11. Draw a closed spline with **8** vertices as shown in the next illustration. This spline is going to be used to trim away that part of the Tile Sample object that overlaps the front surface of the main roof. Therefore, it needs to be drawn accurately with points 5 through 8 being as close as possible to the corners of the roof surface in question. That being said, it can be a few inches off because we are going to place a roof cap over the tiles. You can always just snap to these vertices; however, you will then have to move them later so they are all at the same elevation. I prefer to simply zoom in and 'eyeball it'.

12. Extrude this object **100'**. Since the roof tiles are elevated about 40' above the home grid, this causes the resulting extrusion to run directly through the tiles.

13. Exit Isolation Mode and use the **Boolean>Subtract** feature to cut away the excess tiles, as shown in the next illustration. With an object that contains as many polygons as the roof tile object, performing the **Boolean** operation can take 2 or 3 minutes, depending on the speed of your computer. Many users prefer the **ProBoolean** feature; however, one of the downsides to this feature is that it can take far longer to finish than the Boolean operation. For an object like the roof tiles, the wait may be extremely long.

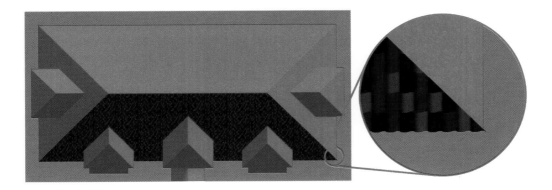

As an additional note, you can add the **Edit Mesh** or **Edit Poly** modifier to the **Tile Sample** object and create a slice plane that cuts through the tiles directly where the tiles need to be trimmed, as shown in the next illustration. Once the tiles are sliced, you have to manually select and delete all the unnecessary tiles. The biggest problem with this method is the sluggish rate at which 3ds Max refreshes your display, which of course is caused by displaying such a high poly object. If you use this method you will have to do a lot of panning and zooming, and the result can be a painfully slow trimming operation. You can always use a temporary aid such as **Fast View Nth Faces** so that only every Nth face has to be refreshed, but I still prefer the Boolean technique over any other.

Now that the first roof surface is finished, you can quickly and easily mirror these first tiles so they are duplicated on the back side of the main roof. Depending on your render engine and your workflow, you might want to make a decision at this point, whether or not to create the mirrored object as a copy or an instance. If you create an instance, then of course your file size won't increase. I would suggest doing this at the very least. You can also create an **XRef** of your roof tiles so the data is stored in another file. If you use **mental ray** or **V-Ray**, I would suggest creating your entire roof as one object and turning that object into a proxy. This will cause the roof tile data to be stored in a separate file (like an XRef) and cause the roof tiles to be rendered as dynamic geometry. This means that the data is loaded and unloaded on the fly during the rendering process rather than being all loaded at once at the start of the rendering and staying in memory until the rendering is complete, which is how static geometry is treated. The result is that you can render much larger scenes without running out of RAM so easily.

At this point, there is no need to continue with the placement of tiles in this exercise because doing so would simply be repetition of the commands already used. Once all of the various roof surfaces have been finished with tiles, we would need to unhide the Ridge Sample and Valley Sample objects and place each of these objects in the same manner outlined in this exercise thus far.

Standing Seam

Unlike a tile roof, which requires the meticulous and time-consuming placement of individual tiles, standing seam roofs are relatively quick and simple to create and are usually best created by carving detail into the generic roof structure. In the real world, this kind of roof comes in a seemingly endless variety of types, just like the variety found in tile roofs. However, just like tile roofs, you can usually get away with using one type and not worry about duplicating the exact detail found in a real metallic roof. For example, Figure 5-7 clearly shows a standing seam roof; however, unless you were very close to the roof, you would never be able to tell which of the varieties shown on the right are being used. Because of this, we can create these types of roofs very quickly using a very simple technique.

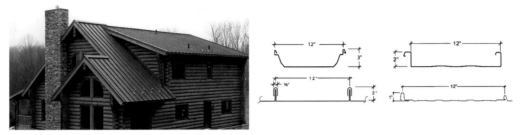

Figure 5-7. An standing seam roof with an indistinguishable seam style.

Just like the tiles on a roof shouldn't be represented by a texture, standing seams shouldn't as well. This is even truer when you consider how quick and easy it is to physically create the seams, as compared to placing 3D tiles. To create the seams in a roof, simply use the **Boolean>Cut>Split** feature to create cuts in the roof and the **Edit Mesh** or **Edit Poly** modifiers to elevate the newly created polygons. The following exercise demonstrates this.

Creating standing seams in a roof

In this exercise, we will start once again with the same roof we started with in the last exercise. Instead of placing 3D tiles on the roof, this time we will cut seams into the various roof surfaces and push those new polygons upward to create the look of standing seams.

1. Open the 3ds Max scene, **ch05-generic_roof.max**. This is the same scene we used in the previous exercise. The only object in this scene is the generic roof structure we created in the first half of this chapter.

2. Select the object **Bldg-Roof**, go the **Modify** panel and enter **Polygon** sub-object mode. Before we can cut the seams into the roof, we have to separate the polygons that are going to have the seams running in different directions. We need to create 2 separate objects from the roof object. One will contain all the polygons where the seams run vertically (as seen from Top view) and the other will contain all the polygons where the seams run horizontally.

3. Select all of the polygons that will have seams running horizontally, as shown in the next illustration.

4. Detach these polygons and name the object **Seams-Horizontal**.

5. Close sub-object mode and give the current roof object a new color to help distinguish its polygons from the polygons you just detached. You should have something similar to what's shown in the next illustration.

6. In **Top** view, create a box of any size directly above the roof (as seen from Top view), as shown in the next illustration.

7. In the **Modify** panel, change the **Length** to **0'-3"**, the **Width** to **200'-0"**, and **Height** to **100'-0"**. A length of 3" means that the seams will be 3" wide. A width of 200' simply allows the box to span the roof, and a height of 100' simply means that the box will run up through the roof and allow us to perform the Boolean>Cut>Split operation.

8. Move the box so it is just beyond the back side of the roof, as shown in the next illustration.

9. In the **Tools** menu, select **Array** and use an **Incremental Y Move** of **-1'6"** and a **1D Count** of **75**. Enable the **Copy** option as the type of object to be made. This makes 75 copies of the box in the negative Y direction, as shown on the right side of the next illustration. A value of 1'-6" was used because that is going to be the distance between seams.

10. Attach all the seams together so they become one object.

11. Select the object called **Seams-Horizontal** and in the **Create** panel select **Geometry Compound objects > Boolean**.

12. Select the **Cut>Split** option, click the **Pick Operand B** button, and click on the horizontal boxes you just attached together. The resulting object should have new edges created, as shown in the next illustration.

13. Add the **Edit Poly** modifier, go to **Polygon** sub-object mode and extrude the selected polygons **3** inches. A great characteristic of the Boolean>Cut>Split feature is that cut polygons are automatically selected when you go to polygon sub-object mode. The ProBoolean feature does not do this, which is why it shouldn't be used in this way.

A very important consideration before creating the 1st box is how wide the seams are going to be and how far apart they should be placed. As the next illustration shows, there are 3 standard distances that U.S. manufacturers use between seams in a roof; **12"**, **16"**, and **18"**.

But unfortunately, due to the limitations with computer displays, the appearance of a standing seam roof is negatively affected by the parallelism of the seams when viewed at a low angle or too much from the side. In the next illustration, you can see that the warping affect of the seams increases toward the left because the viewing angle is increasing. Because of this, it is usually beneficial to increase the thickness of the seams as well as the distance between them. In the real world, most seams are barely 1-inch thick, and as shown in the previous illustration, the largest distance between seams is usually 18 inches. This doesn't mean that you can't significantly increase these amounts to reduce the warping affect. As we have done in this current exercise, we made the thickness of the seams 3 inches to make the seams appear more substantial. Otherwise, they might appear extremely thin and unnatural when seen from a reasonable viewing distance. In this current exercise, I elected to keep the spacing between the seams at 18 inches because this roof would not be viewed from hundreds of feet, or from such an angle that would exacerbate the warping effect. With very large roofs viewed from a great distance or at poor angles, I have used spacing as much as 5 feet. In many cases, the viewer simply cannot tell that this has been done, and as I say several times in this book, it is usually far better to make your visualizations look good rather than accurate. This does not mean you shouldn't be accurate when accuracy is needed. It simply means accuracy is not always needed or beneficial.

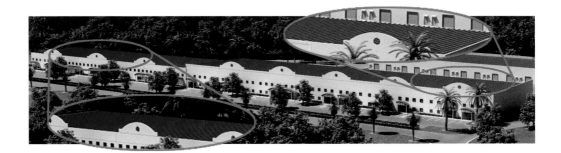

The seams for the remainder of the roof surfaces should be created in the same manner outlined thus far. Once these seams are in place, you can move on to the final step in the creation of your roof. The final step is the creation of ridge and valley caps. The process is fairly straightforward and uses the **Sweep** modifier to create all of the caps from paths and profiles. For the sake of simplicity, we will only create ridge caps for the main roof.

14. In **Top** view, and with endpoint snaps enabled, draw a line from the bottom left corner of the front roof surface to the apex of the roof, as defined by the numbers on the left side of the next illustration.

15. Draw 3 additional lines for the other 3 corners of the main roof and draw a 5th line from one end of the ridge to the other. The direction in which you draw your lines does not matter. The results of the 5 lines you draw should look like the right side of the next illustration.

16. Attach all 5 lines together to make one object and rename the object **Roof-Caps**.

Next, we need a shape or profile to sweep along the length of these lines that were created. Rather than recreating the wheel each time, you should have this type of object stored in some sort of library.

17. Merge the 2 objects in the file labeled **roof_cap_profiles.max**. These are the ridge and valley cap profiles.

18. Select the **Roof-Caps** object and add the **Sweep** modifier.

19. Click the **Use Custom Section** button followed by the **Pick Shape** icon (directly to the right of the Pick button).

20. Select the object **RidgeCapProfile** and click the **Pick** button to complete the Sweep command. The result should look like the following illustration.

You can adjust the sweep pivot alignment to make the ridge caps move up or down on the roof if necessary. To create the valley caps, repeat the last few steps and use the object **ValleyCapProfile** as the custom section. As mentioned earlier, creating the lines for the valleys can be tricky if you have not placed the endpoints of the small hip roofs directly on the surface of the main roof. If you have you can easily snap to these endpoints to create the linework needed to loft the valley caps.

This concludes the exercise.

Shingle Roofs

The final roof type that needs to be discussed is shingle roofs. Like the other roof types, shingle roofs come in a wide variety, but because shingles are very thin, textures will usually provide the necessary look. Some shingles are quite thick, in which case you may want to resort to placing the shingles in the same fashion as you would tiles; however, I have found this to be an exception rather than the norm.

There are two different ways to approach the application of shingle materials to a roof. You can either separate the various roof surfaces into multiple objects, applying a unique UVW Map modifier to each object, or you can apply a multi/sub-object material to the one object and use map channels to apply multiple UVW Map modifiers. I greatly prefer the first approach partly because it is a little quicker to set up, but more importantly, it allows for much quicker changes.

In this approach, you simply detach all of the coplanar faces into single objects and apply a single UVW Map modifier to each separate object. In Figure 5-8, you can see 5 separate object colors, which indicate that there are 5 separate objects. Each surface with the same color is coplanar, or very close to being coplanar. Because of this, the shingles that are applied to them should be oriented in the same fashion, and because the shingles are oriented the same way, they can all use the same UVW Map modifier. The round section of the roof shown at the bottom of the illustration would need spherical mapping applied, but all other surfaces would only need the default planar mapping.

Figure 5-8. An example of breaking a roof apart into separate objects of coplanar faces.

In Figure 5-9, you can see an example of one object receiving a shingle material. All of the coplanar (or nearly coplanar) polygons receive the same material and mapping. Also, notice in the right image that the UVW Map gizmo has been rotated so it becomes aligned to the surfaces receiving the material. Sometimes, the benefit of this is minimal, while other times it can be quite dramatic.

Figure 5-9. All of the coplanar faces of a roof attached together as one object receiving the same mapping.

As a final note, when creating shingle roofs, don't forget to apply ridge and valley caps as shown in the previous exercise with standing seam roofs. You can even use the same profiles used in the last exercise. Excluding this kind of detail can really hurt the realism of a visualization.

Summary

This chapter provided an in-depth look at the creation of the generic roof structure and the application of the three main types of roofs we typically need to create for visualizations. Someday, we might be fortunate enough to have a tool available that will allow us to quickly place 3D tiles on our roofs, but until then, there is simply no way to get around the fact that the placement of tiles is a meticulous and often time-consuming endeavor. Standing seam and shingle roofs are much easier to create by comparison and certainly don't put the same kind of strain on your computer's resources. Nevertheless, with an object as big and prominent as a roof usually is in a visualization, you should take whatever time necessary to ensure that this important building element is created as effectively as possible.

Creating Furniture

By Alexander Gorbunov (Introduction by 3DATS)

Introduction

People ask us from time to time, 'What do you look for in a 3D user?' Our usual answer is, 'Someone who can produce realistic exteriors.' We say this because it appears to us that far more users struggle with the realism of exterior scenes than interior scenes. While new users are often able to produce beautiful interior visualizations, their exteriors often lack the same believability and realism. There are numerous reasons for this, including a lack of understanding of site plans, not knowing how to create proper landscaping (especially in the absence of a landscaping plan), the usually larger scene size unforgiving of inefficient workflow, and so on. And although it's apparent to us that exterior scenes are far more difficult for users to make believable, it also seems clear that interior scenes have their own unique problems that make them more agonizing to work on.

What makes interior scenes so painful for so many users is the difficulty in helping the client make good furniture and material selections. Unlike modeling from architectural drawings, interior design is more of an art than a science. If a hundred 3D users from all corners of the world receive the same set of architectural drawings, they should all produce nearly identical models, assuming of course the drawings are complete and well-built. But the moment you start working on furniture and material selections, everyone and his or her brother has something to say about the selections made. The drapes are too yellow, the couch is too contemporary, the table is too shiny, the flooring is too boring, and the list goes on. With most interior jobs we've worked on, the clients don't have a decent interior design planned out and often have no idea what they want. When they see your attempt at interior design they can be quick to tell you that they don't like your selections, but getting them to make sound decisions of their own can be a monumental undertaking. Having pained our way through the process of creating interior scenes for so long, we learned long ago to adapt our workflow to accommodate the most difficult clients.

When you present your proposal for interiors to a client, you need to decide whether your client needs or wants custom furniture or if stock furniture is the better choice. If you try to present your client with stock furniture, you of course have to have a large enough selection of high quality furniture and materials from which the client can pick. Unfortunately, many clients don't want to spend the time sifting through hundreds or even thousands of different images of furniture and material selections to find something suitable for their project. Even if they are willing to give it a try, many cannot see past the default colors or materials on the stock furniture and envision different materials or colors on a piece of furniture that might otherwise make a suitable choice. And even if you have an enormous library of furniture and materials, if you don't present those libraries in an easy to navigate manner, the client might quickly give up in frustration. Because of all the potential difficulties in working with clients on these selections, you should always budget for the unexpected.

Figure 6-1 shows one example of a project where the client changed the furniture and materials over and over again, first trying to use stock selections, but in the end relying entirely on custom furniture and materials. Fortunately for us, we always anticipate this possibility on all projects and cover ourselves in our proposals by making it clear to the client from the start the types of changes that incur added cost. This particular client ended up paying more for changes to furniture than what was originally allotted for in the entire project. The bottom line is that you have to know your clients and determine if they are willing to endure the work of choosing custom furniture and materials. If not, you should do everything you can to sell them on custom furniture without scaring them away with too much added cost. If custom furniture is the chosen course, then the only other thing to decide is how to go about creating the furniture. If you would like to see an example of how we work with our clients to create custom furniture, refer to the tip in Appendix A that discusses the selection of furniture. In it we show what we actually send to our client when the determination is made to create custom furniture.

Figure 6-1. An example of the transformation interior projects often undergo.

Furniture creation is a very specialized skill and while many of us can create furniture, creating it fast and detailed is a completely different issue. Unless furniture creation is a specialty skill you possess, you would probably be doing yourself a favor to contract custom furniture creation to someone who specializes in it. Otherwise, you might spend several times longer creating furniture that is of far less quality. If you have a need to contract out this important part of your interior scene, we recommend the author of this chapter, Alexander Gorbunov from Intero Visuals (www.interovisuals.com). His skill in furniture creation is truly amazing and we are delighted to have him write a chapter for us on the creation of furniture.

Creating a Sofa

One of the most difficult challenges of a 3D interior project is providing the client with suitable 3D furniture. Many times the client does not want to use stock furniture or take the time to look through so many sample images. When this is the case, creating custom furniture is the only alternative. But if not done wisely, creating custom furniture can be a very time-consuming process and can end up taking longer than the entire rest of the project.

The following is a pictorial-based tutorial that demonstrates how to quickly and efficiently create the sofa shown in Figure 6-2 starting with nothing more than a simple image. The image on the left is a photograph of the real sofa and the image on the right is the sofa this chapter explains how to create. Using the tools and methods highlighted here, you can create almost any type of furniture you want.

Figure 6-2. The sofa to be modeled in the following exercise.

Creating a Sofa

In this exercise, we need to start by analyzing the left image of Figure 6-2, which will be our only reference in creating the sofa. Try to picture in your mind the parts of the sofa that are not visible from this vantage point and then build a plan of how to model this object. For example, we cannot see the back of the sofa, but it is easy to picture what this part would look like. Most likely, it's just a bridge that connects the left and right armrests, although we can certainly use artistic liberty to modify as we see fit.

Think about what parts should be modeled first and what techniques should be used. Think about what parts should be modeled precisely as shown in the reference image and what parts can be simplified.

So let's come up with the plan of how we would model this sofa part by part. A logical progression might look something like this:

1. Prepare the 3ds Max environment
2. Modeling the armrests
3. Modeling the bottom and back
4. Modeling the seat cushions
5. Modeling the back pillows
6. Modeling the throw pillows
7. Modeling the decorative trim piping

8. Modeling the wooden feet

9. Texturing

10. Assigning materials.

Now that we know the order in which we will build our sofa, we can begin the creation process.

1. Preparing the work environment

In this step, we are going to bring the reference image into the 3ds Max environment so we can use it as a visual reference anytime we need it, and then we are going to model the two armrests of the sofa.

1. Reset 3ds Max.

2. Set your units to **U.S. Standard** and **Fractional Inches** and precision to the default **1/8**. Having chosen this particular unit of measure, it is extremely important to note at this point that care must be taken when typing in fractional units inside 3ds Max. On architectural drawings, 1.5 inches would be written as 1-1/2". However in 3ds Max, you must replace the dash with a space. Therefore, 1.5 inches would be written as 1 1/2", with a space after the first number.

3. Disable the **Show Grid** option in all 4 viewports.

4. In **Front view**, create a simple plane with a width and length of **70** inches and with 1 length and width segment.

5. Switch to **Perspective** view and move the plane **36** inches in the positive **Y** direction, which is away from your current view. The plane needs to be pushed back in the scene so it doesn't block the view of new objects created at the home grid, as seen from Front view.

6. Enable **Edged Faces** mode in **Perspective** view.

7. Activate **Front** view and switch from a 4-viewport configuration to a single viewport configuration.

8. Enable **Smooth+Highlights** as well as **Edged Faces** mode.

9. Disable selection brackets in each viewport (shortcut = **J**). This makes working in segment sub-object mode a little easier because it doesn't obstruct the view of selected edges.

10. Zoom to the extents of the Front view.

11. Using the **Material Editor**, apply the image **couch.jpg** to the plane you just created. The plane should look like the next image. If you are using 3ds Max Design 2009, you will have to disable the **Real-World Map Size** option within the **Command** panel and the **Use Real-World Scale** option within the **Coordinates** rollout of the bitmap applied. Both of these are enabled by default and prevent the mapped image from displaying properly without mapping adjustments.

12. Save the scene.

2. Modeling the armrests

In this step, we are going to model the two armrests using the Edit Poly method known as box modeling. This will be the initial element of the sofa model and will help us establish the proportions of all other objects we create. Also, since the couch is symmetrical, we do not need to model both armrests. After creating one, we will simply create a mirrored copy of the other.

13. Continue from the previous step or open the file **ch06-01.max**.

14. In **Front view**, create a plane that covers the entire front surface of the right armrest, as shown in the left image of the next illustration.

15. In the **Modify** panel, set the length segments to **5** and the width segments to 1.

16. Press the shortcut **Alt+X** to make the plane object transparent. Note that if you are using 3ds Max 2009 with the default configuration, you will have to first change the object's display properties so they aren't set to the **By Layer** option.

17. Add the **Edit Poly** modifier to the plane.

18. Go to **Vertex** sub-object mode and move each individual vertex along the **X-axis** to make the shape of your object roughly match the shape of the front surface of the armrest, as shown in the right image of the next illustration.

19. Press the shortcut **Alt+X** again to make the object no longer transparent.

20. Go to **Perspective view**, apply the **Shell** modifier, and set the **Inner Amount** to **31"** and **Outer Amount** to **0"**. The result should look similar to the next image.

21. Add the **Edit Poly** modifier.

22. Go to **Edge** sub-object mode, select any edge that is parallel to the **Y axis**, as shown in the left image of the next illustration, and click the **Ring** button in the **Selection** rollout. This causes the selection to grow around the first edge selected.

23. In the **Edit Edges** rollout, click the **Settings** icon immediately to the right of the **Connect** button. This opens the **Connect Edges** dialog box.

24. Enter a **Segments** value of **2** and a **Pinch** value of **87**. Click **OK** to complete the command.

25. Select any edge that is parallel to the **X axis** and click the **Ring** button.

26. Click the **Settings** icon immediately to the right of the **Connect** button and enter a **Segments** value of **1** and a **Pinch** value of **0**. Click **OK** to complete the command.

27. Rotate the Perspective view to see the object from the right-hand side, as shown in the next illustration.

28. Select the two edges shown in the left image of the next illustration. These are the middle edges at the top-right and bottom-right corners of the object.

29. Click the **Loop** button to extend the selection of edges to the ends of the object.

30. Click the **Settings** icon to the right of the **Chamfer** button. This opens the **Chamfer Edges** dialog box.

31. Enter a **Chamfer Amount** of **1"** and click **OK** to complete the command.

32. Close **Edge** sub-object mode.

33. Switch to **Front view** and add the Mirror modifier.

34. Enable the Copy option and use the Offset feature to align the left armrest, as shown on the left side of the next illustration.

35. Switch to **Perspective** view, apply **MeshSmooth** modifier to the object and set the **Iterations** value to **2**. We do not need to keep the armrest in this smoothed configuration right now. We applied this modifier just to take a quick look at the model in smoothed mode, as shown on the right side of the next illustration. Once we are sure that everything is OK with the model, we can remove the modifier.

36. Remove the **MeshSmooth** modifier.

37. Save the scene.

38. We just modeled the initial elements of our sofa. All other objects we model will be created while using the armrests as a reference. The armrests are properly scaled and placed at right distance from each other and this helps us understand proportions of the remaining elements.

3. Modeling the bottom and back

In this step we are going to model the bottom and the back of the sofa, which will connect the left and right armrests. You might notice that because some of the features have been repeated so many times before, a description of how they are executed will become more and more abbreviated as the exercise continues.

39. Continue from the previous step or open the file **ch06-02.max**.

40. With the object selected, switch to **Top view**, add another **Edit Poly** modifier, and enter **Edge** sub-object mode.

41. Using the left image of the next illustration as a guide, select the middle edges that run parallel to the **Y axis** and connect the front and rear parts of the armrests.

42. Click the **Settings** icon to the right of the **Connect** button and use a **Segments** value of **1**. Click **OK** to complete the command. This will insert an extra loop of edges within the selection.

43. Move the newly created edges toward the back end of the armrests, which in Top view would be upward. Place the edges approximately one-quarter away from the back end of the armrest, as shown in the right image of the next illustration.

44. Switch to **Perspective** view, enter **Polygon** sub-object mode and carefully select the inner polygons on both armrests as shown in the left image of the next illustration. You will need to navigate around in Perspective mode to select the polygons properly.

45. In the **Edit Polygons** rollout, click the **Bridge** button. This creates a connection bridge between the selected polygons that represents the bottom and back parts of the sofa, as shown in the right image. If your bridged polygons appear twisted, rather than the way shown in the following image, undo the **Bridge** command, click on the **Settings** icon next to Bridge, and use the **Twist** settings to remove the twist applied.

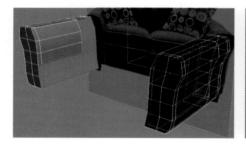 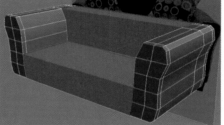

46. Switch to **Top** view, enter **Edge** sub-object mode and select all middle edges that run parallel to the **X axis** and connect the front and rear parts of the armrests, as shown in the left image of the next illustration.

47. In the **Edit Edges** rollout, click the **Connect** button to add 1 set of edges running around the middle of the selected edges.

48. Move the newly created edges toward the back of the sofa, as shown in the right image of the next illustration.

49. Switch to **Perspective** view and select any edge that connects the left and right armrests, such as the one selected in the left image of the next illustration, and click the **Ring** button. All the edges that connect the right and left halves of the couch are selected.

50. Click the **Settings** icon to the right of the **Connect** button and enter a **Segments** value of **2** and a **Pinch** value of **94**. Click **OK** to complete the command. The pinch value pushes the selected edges 94% away from their initial location. This places these new edges relatively close to the armrests. This allows the curvature applied with the MeshSmooth modifier to be confined closer to the armrests rather than extending far out into the middle of the couch.

51. Temporarily apply the **MeshSmooth** modifier with an **Iterations** value of **2** to check the appearance of your model. If your model looks similar to the one shown in the following illustration you are on the right track.

52. Remove the **MeshSmooth** modifier.

53. While still in **Perspective** view, zoom in to the left side of the model.

54. Enter **Edge** sub-object mode and select the edge shown in the left image of the next illustration.

55. Click the **Ring** button to grow the selection completely around the sofa, as shown in the middle image of the next illustration.

56. Click the **Settings** icon to the right of the **Connect** button.

57. Enter a **Segments** value of **1** and a **Pinch** value of **0**. Click **OK** to complete the command. One additional set of edges is created around the sofa, as shown in the right image of the next illustration.

58. Switch to **Vertex** sub-object mode and select the **3** vertices shown in the left image of the following illustration.

59. Move the selected vertices 3/8" in the positive Y direction (inward to the sofa), as shown in the right image.

60. Repeat the previous 6 steps to add and move these same vertices on the right side of the sofa. You can add the MeshSmooth modifier again at this point if you want to check the effect of pushing these 6 vertices inward toward the center of the couch.

In the real world, the back of a sofa will undoubtedly be narrower than the front, and now would be a good time to make this modification.

61. Switch to **Top** view and select all of the middle edges that run parallel to the **Y axis** and connect the front and back parts of the object, as shown in the left image of the following illustration.

62. Using the **Connect** feature, create **1** new set of edges around the sofa. These new edges are necessary to help control the effect of the next modifier that will be added.

63. Go to the **Hierarchy** panel, click the **Affect Pivot Only** button, and then click the **Center to Object** button. We cannot apply the next modifier properly without first centering the pivot point on the object like this.

64. Apply the **Taper** modifier to the object using the following settings: **Amount = 0.086**, **Curve = 0.111**, **Primary = Z**, **Effect = X**, **Limit effect = Enabled**, **Upper limit = 4"**, **Lower limit = -16"**. The result should look like the right image in the following illustration.

To properly finish the parts of the sofa we've created thus far, we need to do some fine tweaking. Toward the end of the exercise, we are going to apply the MeshSmooth modifier to the sofa, but the results will look much better if we first make the sofa look less uniform and more erratic. By building more bulges into the structure of the sofa, the MeshSmooth modifier can make the final sofa appear much smoother and less chiseled.

65. Switch to **Perspective** view and add another **Edit Poly** modifier.

66. Enter **Vertex** sub-object mode and use all three transforms to symmetrically modify the vertices so the sofa takes on a more natural shape and doesn't look too perfect. The top left image of the following illustration shows the sofa before modifying the vertices and the top right image shows the result after.

67. Temporarily apply the **MeshSmooth** modifier to see the result of modifying the vertices.

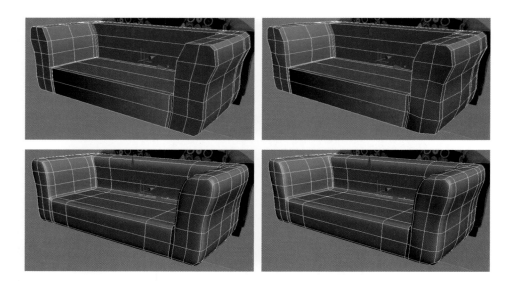

68. Remove the **MeshSmooth** modifier.
69. Save the scene.

4. Modeling the seat cushions

In this step, we are going to model one seat cushion and copy it to create another. We will then apply tools to make the two copies appear unique.

70. Continue from the previous step or open the file **ch06-03.max**.
71. Go to **Top** view and enable **Smooth+Highlights** and **Edged Faces** mode.
72. Create a box object with a **Length** and **Width** of **22"**, a **Height** of **8"**, and **3** length, width, and height segments.
73. Position the box so it rests approximately where a cushion would rest on a sofa in the real world. If the size of your cushion needs to be adjusted a few inches so it better fits the sofa, do so at this time. You should see something similar to the next illustration.

74. Isolate the box so you can work on it without being distracted by the other geometry.
75. Add the **Edit Poly** modifier.

76. Enter **Edge** sub-object mode and select the edges as shown in the next illustration. All horizontal edges on the right third of the box should be selected.

77. Use the **Connect** feature with a **Segments** value of **1** and a **Slide** value of **50**. The Slide value causes the newly created edges to move 50% toward one end of the edges that had previously been selected, as shown in the left image of the next illustration.

78. Repeat the previous step with the other 3 sides of the cushion. You will have to use a -50 value on the left and bottom sides of the box. The result should look like the middle and right images in the following illustration.

79. Switch to **Front** view, enable Wireframe view, and zoom to the extents of the cushion.

80. Enter **Vertex** sub-object mode and create a window selection around the vertices shown in the left image of the following illustration. Since **Ignore Backfacing** is disabled, all of the vertices behind those shown should be selected.

81. Use the **Non-Uniform Scale** feature to scale the selected vertices **200%** along the **Y axis** only, as shown in the right image. This pushes the selected vertices away from each other and closer to the top and bottom of the cushion so that when curvature is applied to the cushion, the effect is confined more to its perimeter.

82. Switch to **Top** view, select all corner vertices and use the **Non-Uniform Scale** feature to scale the selected vertices **5%** inward (along the **X** and **Y** axis only) to the center of the cushion. An easy way to do this is to open the **Scale Transform Type-In** dialog box and enter an **X** and **Y** value of **95**. The result should look similar to the right image of the following illustration. The illustration is shown in Wireframe mode for ease of display.

83. Switch to **Perspective** view and zoom to the extents of the cushion.

84. Enter **Polygon** sub-object mode and select the polygons shown in the left image of the following illustration.

85. Move the selected polygons **1/4"** upward along **Z axis**.

86. Select the polygons shown in the middle image and move them upward another **1/4"**.

87. Select the center polygon shown in the right image and move it upward another **1/2"**.

88. Repeat the previous 4 steps to the bottom of the cushion to make the cushion appear symmetrically inflated.

89. Exit **Polygon** sub-object mode and apply the **MeshSmooth** modifier with an **Iterations** value of **2**.

90. Switch to **Front** view, add another **Edit Poly** modifier to the cushion, and enter **Polygon** sub-object mode.

91. Select the polygons shown in the left image of the following illustration.

92. Apply the **Relax** modifier with a **Relax Value** of **0.5** and an **Iterations** value of **48**. The selected polygons should look like those shown in the right image.

93. While still in **Front** view, disable **Edged Faces** mode.

94. Add another **Edit Poly** modifier.

95. Apply the **Smooth** modifier and enable the **Auto Smooth** option. The result should look similar to the right image of the following illustration. Giving the cushion a stronger edge like this is necessary because we need to apply a decorative trim to the cushion and doing so with a smoothed edge would look strange.

96. Exit isolation mode.

97. While still in **Front** view, re-enable **Edged Faces** mode.

98. Adjust the position of the cushion object so it appears to be in the correct position on the sofa.

99. Apply the **FFD (box)** modifier. Click on the **Set Number of Points** button and enter a **Length** and **Width** value of **6** and a **Height** value of **4**.

100. Open the **FFD** modifier and click on the **Control Points** category inside the modifier stack.

101. Move individual control points to deform the cushion so it looks more natural and less rigid. Refer to the before and after images in the following illustration and close the FFD modifier when you're finished. A before and after version might look like the following illustration. Subtle variations in the pillow's 'perfect' structure can do a lot to make the pillow look more natural.

102. Make a copy of the left cushion and place it in the right cushion position.

103. Slightly modify the control points of the 2nd cushion to make the two cushions appear unique. Close the modifier when you are finished.

104. Save your scene.

5. Modeling the back pillows

In this step, we are going to model one of the back pillows and then copy it to create the other.

105. Continue from the previous step or open the file **ch06-04.max**.

106. Hide all objects in the scene.

107. Go to **Front** view and create a plane with a **length** of **20"**, a width of **28"**, **4 length** segments and **5 width** segments, as shown in the left image of the following illustration.

108. Add the **Edit Poly** modifier to the object.

109. Go to **Vertex** sub-object mode and use the **Move** and **Scale** transforms to position vertices similar to those shown in the right image. This shape will serve as the basis for the outer profile of the back pillows.

110. Select the **4** corner vertexes.

111. Click the **Settings** icon to the right of the **Chamfer** button and apply a **Chamfer Amount** of **1 1/4"**. The result should look similar to the left image, of the next illustration.

112. Switch to **Polygon** sub-object mode and select all of the polygons in the object.

113. Click the **Settings** icon to the right of the **Inset** button and apply a **Group** inset value of **1/8"**. An additional line of vertices is created 1/8th of an inch away from the outer perimeter of the object, as shown in the middle and right images of the next illustration.

114. Apply a **non-uniform scale** amount of **80%** along the **X axis** and **75%** along the **Y axis**. The result should look like the left image of the next illustration.

115. While still in **Front** view, switch to **Wireframe** mode.

116. Switch to **Vertex** sub-object mode, select the **2** vertices shown in the left image of the next illustration and scale them **200%** away from each other so they move twice the distance away from each other than they currently are.

117. Repeat the previous step with the other 3 groups of vertices shown highlighted in the right image.

118. Switch to **Perspective** view.

119. Switch to **Polygon** sub-object mode, select the inner polygons shown in the far left image of the next illustration and move the selected polygons **1 1/2"** in the **negative Y direction** (i.e., toward your view).

120. Select the polygons shown in the middle-left image and push these polygons an additional **5/8"** in the **negative Y direction**.

121. Select the polygons shown in the middle-right image and push these polygons an additional **7/8"** in the **negative Y direction**.

122. Switch to **Edge** sub-object mode, select the very center edge shown in the far right image and move the single edge an additional **1/4"** in the **negative Y direction**.

123. Use the **Ring** feature to quickly select all of the edges shown in the left image of the next illustration and use the **Connect** feature with a **Segments** value of **1** and a **Slide** value of **-38**. The result should look like the image on the right. As we've seen before with other objects in this exercise, creating an additional set of edges close to the border of an object helps confine the MeshSmooth curvature more to the area around the perimeter of an object.

124. Close out of sub-object mode and create a mirrored copy of the pillow along the **Y axis** to create the back half of the pillow.

125. Use endpoint snaps to align the back side copy to the front side copy and attach the two pillow objects together as one object, as shown in the left image of the next illustration. Do not weld endpoints together, because that will remove the border of the two halves, which will be needed later to create a decorative trim.

126. Apply **MeshSmooth** modifier with **2** iterations of smoothing. The result should look similar to the middle and right images of the next illustration.

127. Unhide all objects in your scene and position the pillow properly on the couch as shown in the left image of the next illustration. You should position the pillow so the bottom corners are buried slightly in the cushions. This will be fixed with the next modifier.

128. Rotate the pillow backward so it's resting on the back of the sofa, as shown in the middle image.

129. Apply **FFD (box)** modifier and deform the pillow to achieve a more natural and relaxed look as described earlier in this exercise. The right image shows one example of making this type of modification. Notice that the pillow doesn't look so rigid anymore.

130. Create a mirrored copy of the pillow and adjust the FFD modifier's control points to make the 2nd pillow appear unique. To achieve a more realistic look, I suggest making the 2nd pillow slightly overlap the 1st pillow, either in front or behind. I also suggest taking the extra few seconds to rotate the front pillow so it appears to be leaning on the pillow behind it. The next illustration shows how your pillows might appear. As an additional note, if you created your initial plane too large and the two pillows do not fit properly, a simple adjust to scale should suffice.

131. Save your scene.

6. Modeling the throw pillows

132. Continue from the previous step or open the file **ch06-05.max**.

133. Make an additional copy of the last pillow you created and hide all other objects in the scene.

134. Delete the **MeshSmooth** and **FFD** modifiers from the modifier stack.

135. Add another **Edit Poly** modifier, enter **Polygon** sub-object mode and delete the middle polygons, as shown in the left image of the next illustration.

136. Switch to **Vertex** sub-object mode and move all of the vertices in the right half of the pillow to the left so that the 2 parts are connected in the very center vertex. Use Endpoint snaps to snap the two center vertices together. The result should look like the middle image.

In the next step, we need to weld the left and right halves of the pillow together. But before this can be done, the same vertices on both halves of the pillow have to occupy the same space. There is a very easy way to make this happen. By applying a non-uniform scale of 0% along an axis, all vertices will be brought together to occupy the same axis.

137. Select all of the vertices that make up the middle row of vertices for both the left and right halves of the pillow, right-click the **Non-Uniform Scale** transform, and type a value of **0** in the **X axis** field. The result should look like the right image of the next illustration.

138. Weld the selected vertices together. This is an important step, because if the vertices are not welded together there will be 2 borders around the 2 halves of the pillow and when we use Border sub-object mode later to apply a decorative trim, the trim would be created around both halves rather than around the entire pillow.

139. Since the color of this throw pillow is the same as the back pillows, apply a new object color to the throw pillow.

140. Apply the **MeshSmooth** modifier with **2** iterations.

141. Switch to **Perspective** view.

142. Apply an **80% Uniform Scale** to the throw pillow. In the original reference image, the throw pillows appear to be about 20% smaller than the back pillows. Reducing the size of the throw pillow is in order, and if you unhide the plane with the reference image, as shown in the left image of the next illustration you can get a better idea about exactly how much to scale the size down. Depending on how you created your original plane, you may need to scale your pillow a different amount.

143. Unhide all objects and use the **Move** and **Rotate** transforms to position and orient the pillow properly on the left side of the couch as shown in the middle image of the next illustration. Notice that this pillow should be leaning backward and slightly to the side. Like the previous pillows, it should be buried a small amount into the cushions.

 Just like the back pillows, the throw pillows should have a small amount of deformation applied. Since applying a decent FFD modifier can be a tedious task, you might want to try borrowing the modifier from another object.

144. Select the right back pillow, right-click the **FFD** modifier in the modifier and select **Copy**.

145. Select the newly created throw pillow and on top of the MeshSmooth modifier you just added, right-click and select **Paste**. The FFD modifier you applied to the right back pillow is now applied to the left throw pillow, as shown in the right image of the next illustration. It's a good idea to apply the FFD modifier of the right back pillow to the left throw pillow to prevent two adjacent pillows from appearing too similar. Nonetheless, you will probably need to tweak the control points of this throw pillow to make it fit the sofa properly.

146. As before, create a mirrored copy of the throw pillow, position it on the right side of the sofa, and copy the **FFD (box)** modifier from the left back pillow to the new throw pillow. Your scene should now look similar to the next illustration.

147. Save the scene.

7. Modeling the decorative trim piping

In this step, we are going to model the decorative trim piping that runs along the edges of the seat cushions, back pillows, throw pillows, and some edges of the sofa base.

148. Continue from the previous step or open the file **ch06-06.max**.

149. Use the **Edit Poly** modifier to attach the seat cushions to the base of the sofa to combine the three objects into one and then attach the back pillows and throw pillows together to combine the four pillows into one object.

150. Select and isolate the pillows.

151. Go to **Border** sub-object mode and click once at the edge of each pillow to select the border of each, as shown in the left image of the next illustration.

152. In the **Edit Borders** rollout, click the **Settings** icon to the right of the **Create Shape** button, accept the default **Linear** option and click **OK** to create a new shape with a generic name. A shape is created with 4 splines, as shown in the right image.

153. Close sub-object mode and select the newly created shape.

154. Open the **Rendering** rollout, activate the **Enable in Renderer** and **Enable in Viewport** options, and enter a **Thickness** value of **5/16"**.

155. Exit isolation mode.

156. Select and isolate the base and seat cushions object.

157. While still in **Perspective** view, zoom in to the left side of the object as shown in the left image of the next illustration.

158. Switch to **Wireframe** mode. When you do, notice how busy the view is with so many edges visible. This is because when we attached the objects together a moment ago, the Edit Poly modifier must display all the edges that were previously hidden by the algorithms of the MeshSmooth modifier. We can alleviate this problem by changing a display setting.

159. In the Display panel, enable **Backface Cull**.

We need to create a trim feature as shown in the left image of the next illustration. To do this we will use the Create Shape feature again, but instead of clicking on a border, which we don't have for this object, we need to select edges. And instead of selecting each individual edge we want included, we will use the Loop feature to quickly select multiple edges. However, when we do this, we will be selecting additional edges that shouldn't be involved in the process. So once we use the Loop feature, we will have to deselect certain edges to make a shape similar to the left image of the next illustration.

160. Select the **2** edges shown in the left and middle images of the next illustration and use the **Loop** feature to expand the selection around the couch in two different directions, as shown in the image on the right.

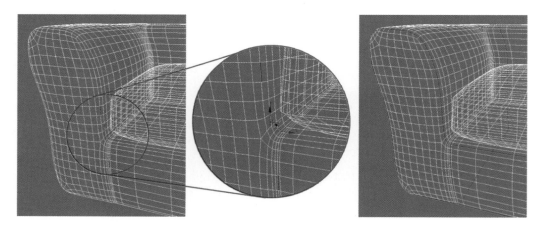

161. Use the **Create Shape** feature to create a shape from these edges with the default **Linear** option. When you do, the shape should automatically be created with a visible thickness.

162. Select and isolate the newly created shape as shown in the left image of the next illustration.

163. Temporarily disable the **Enable in Viewport** option.

164. Delete all of the segments of the spline we do not need, leaving the spline as shown in the left image of the following illustration.

165. Enter Vertex sub-object mode and delete the additional vertices that cause the spline to make a sharp corner as shown in the middle image. Delete as many or as few vertices as you want to create a nice spline for which the decorative trim will follow. In the image on the right you can see the result of deleting 5 vertices. Be careful not to delete too many, as this will cause the trim to not lay flush with the couch.

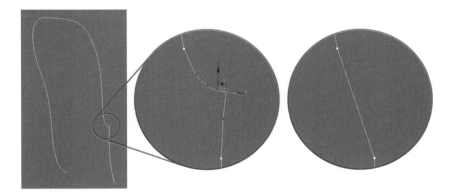

166. Enable the **Enable in Viewport** option again and make the trim thickness **3/8"**.

167. Exit isolation mode and switch to **Smooth+Highlights** mode.

Notice that at the bottom of the sofa the trim does not look realistic because the end appears to be cut off. We need to make it sink into the surface of the sofa to look more natural.

168. Select the **2** vertexes at the ends of the spline and move them **1/8"** in the **positive Z direction** and **1/8"** in the **positive Y direction**, as shown in the left image of the following illustration.

169. Create a mirrored copy of the trim about the **X axis** and position it precisely on the right side of the sofa, as shown in the right image of the next illustration. Temporarily disabling the **Enable in Viewport** option in the **Rendering** rollout will help you place the shape better.

170. Select the **4** edges shown in the left image of the next illustration and use the **Loop** feature to grow the selection completely around the top and bottom of both cushions.

171. Just as before, create a shape from these edges and use the same settings to turn the spline into a renderable object, as shown in the right image.

172. Add the **Edit Poly** modifier to the newly created object and attach all other trim piping to it.

173. Save your scene.

8. Modeling the wooden feet

174. Continue from the previous step or open the file **ch06-07.max**.

175. Create a **ChamferBox** object with a **length** and **width** of **2 1/8"** a **height** of **4 1/4"**, and a **fillet** of **1/8"**.

176. Apply the **Taper** modifier with an **Amount** value **0.87**, as shown in the left image of the next illustration.

177. Position the object underneath the sofa in the appropriate place where you would expect the feet to be positioned.

178. Create **3** additional copies of the object and position them in their proper location at the other 3 corners of the sofa bottom, as shown in the right image.

179. Add the **Edit Poly** modifier and attach all **4** feet together.

180. Save the scene.

9. Texturing

In this step, we are going to assign material IDs to our model and then apply UVW mapping.

181. Continue from the previous step or open the file **ch06-08.max**.

182. With the exception of the background object, attach all scene objects together to make one object.

183. Apply the following material IDs to the following sofa elements: Material ID 1 – Wooden Feet; Material ID 2 - Base, seat cushion and back pillows; Material ID 3 - Decorative trim; Material ID 4 - Throw pillows.

184. With the model selected, go to the **Utilities** panel, click the **Reset XForm** button followed by the **Reset Selected** button.

185. Open the **Material Editor** and load the image **numbers.jpg** into the **Diffuse Color** channel of a material. This material will help us understand the size and positioning of the texture.

03	13	23	33
02	12	22	32
01	11	21	31
00	10	20	30

186. Apply the material to your sofa object and enable the **Show Map in Viewport** option. You will see that right now the texture is heavily distorted, as shown in the left image of the next illustration, which is a sign that the object does not have proper mapping.

Now we are going to apply UVW mapping to each element. Although we just attached all of the objects together to simplify the assigning of material IDs and the resetting of the XForms, we now need to detach the individual elements to make mapping easier.

187. Detach the wooden feet from the sofa, apply the **UVW Map** modifier with Box mapping and with a length, width, and height of **60"**. This will be the size that the image we apply to the wooden feet represents in the real world.

188. Detach the sofa base and back and armrests (which are one element), and then select and isolate the detached object.

189. Switch to a **Front** view, select the detached object and enter **Polygon** sub-object mode.

190. With the **Ignore Backfacing** option disabled, use a crossing window to select the two middle rows of polygons that make up the base and back of the sofa, as shown in the left image of the next illustration.

191. In the **Selection** rollout, click the **Grow** button until all of the polygons that make up the front, back, and bottom are selected. As you can see in the right image, you should not select any of the polygons that make up the armrests.

The following illustration shows the image that we need to apply to the couch base, cushions, and back pillows. This image is a very close representation of the material in the original image; however, you can always use Photoshop to carefully piece together parts of the original image to

create an even more accurate material. The image is seamless so we can tile it as much as we want, and because the image is perfectly square, we can apply box mapping with minimal chance of distortion. The image appears to represent a real world size of about 16 inches, so this will be our mapping size.

192. Switch to **Perspective** view and apply the **UVW modifier** with **Box** mapping and with a **length**, **width**, and **height** value of **16"**. Notice that the texture is not mapped properly along the front of the couch, as shown in the left image of the next illustration. This is not a good place to show poor mapping.

193. Open the **UVW Map** modifier and move the gizmo in the positive Y direction until the numbers line up at the front of the couch, as shown in the image on the right. The numbers will not align properly on the back part of the couch where the pillows rest, but because this area will not be seen, it is not necessary to adjust any further. Note also that disabling Wireframe mode will allow you to see the map change in real time as you move the gizmo.

194. Add the **Edit Poly** modifier and return to **Polygon** sub-object mode. When you do, you should see the previously selected polygons still selected.

195. Press the keyboard shortcut **Ctrl+I** to invert the selection. This causes all of the polygons in the armrest to be selected.

196. Apply a **UVW Map** modifier to the selected polygons with **Box** mapping and a **length**, **width**, and **height** of **16"**. The result should look similar to the left image of the next illustration.

197. Open the **UVW Map** modifier and transform the gizmo until you are satisfied with the mapping applied.

198. Exit isolation mode.

199. Detach the cushions and then select and isolate the cushions.

200. Apply a **UVW Map** modifier with **Box** mapping and a **length**, **width**, and **height** of **16"**. Since the cushions have the same material as the couch base, we need to use the same mapping size we used a moment ago. Transform the mapping gizmo as necessary to achieve a seamless appearance to the cushions.

201. Exit isolation mode.

202. Detach the decorative trim and then select and isolate the trim.

203. Apply a **UVW Map** modifier with **Box** mapping and a **length**, **width**, and **height** of **16"**. Since the trim is such a thin element and any fabric texture would be hard to recognize, we could really just apply a color to it rather than applying another UVW Map modifier. However, it only takes a moment to apply it and since 16" is as good as any size right now and since it matches the size applied to the rest of the couch, that is the size we are using here.

204. Exit isolation mode.

205. Select and isolate the back pillows.

206. Apply the **UVW Map** modifier with **Planar** mapping and with a **length** and **width** of **16"**. As you can see from the original reference image, the back pillows have the same texture as the rest of the couch, so we need to use the same mapping size. Notice, however, that the material is not oriented properly on the pillows, as shown in the left image of the next illustration.

207. Rotate the **UVW Map** gizmo around the **X axis** to align the gizmo with the front of the pillows, as shown in the middle image.

208. Add another **Edit Poly** modifier and rotate your view to see the back side of the pillows. Notice that the texture is flipped on the back side of the object, as shown in the right image.

209. Go to **Element** sub-object mode and select the two elements that represent the back side of the pillows.

210. With the two elements selected, apply the **UVW XForm** modifier and in the modifier's rollouts enable the **Flip** option for the **U Tile**. This will flip the texture. Adding another UVW Map modifier would not have worked as well because you would have had to reorient the gizmo and adjust the mapping size all over again. The UVW XForm modifier is a great tool that allows us to modify the existing mapping without completely removing it beforehand.

211. Add another **Edit Poly** modifier to the object.

212. The next step involves the use of one the most widely adored tools in 3ds Max; the **Unwrap UVW** modifier. This modifier allows you to create complex mapping on an object and will be used to help bend the texture in the same way the structure bends. It will be discussed in much greater detail in Chapter 15.

213. Apply the **Unwrap UVW** modifier and click the **Edit** button within the **Parameters** rollout. This opens the **Edit UVWs** dialog box. You can zoom out within the dialog box to see the pillows in their entirety if you want. If you did not apply the Edit Poly modifier before this step, then the Unwrap UVW modifier would be applied to the last selected polygons, which we don't want right now.

214. Press the keyboard shortcut **Ctrl+A** to select all of the vertices in the viewports. All of the vertices in the Edit UVWs dialog box are also selected.

215. From the **Tools** menu select **Relax**. This opens the **Relax Tool** dialog box. This feature will help bend the texture along the contours of the pillows.

216. In the **Relax Tool** dialog box, use the **Relax by Face Angles** option along with an **Iterations** value of **1000**, an **Amount** value of **0.5**, and a **Stretch** value of **0.2**. Click the **Apply** button to complete the command. The before and after results should look similar to the next illustration.

217. Close the **Relax Tool** and **Edit UVWs** dialog boxes.

218. Exit isolation mode.

The Relax feature is a great way to bend a texture along the structure of an object, but a downside to its use is that it always affects the texture size. In this case, the texture was enlarged about 30%, which is apparent when you compare the back pillows to the mapping on the couch. As before, we don't want to do away with the mapping already applied, so we cannot add another UVW Map modifier. Instead, we will use the UVW XForm modifier again.

219. With the back pillows selected, apply the **UVW XForm** modifier with a **U Tile** value of **1.4**, a **V tile** value of **1.4**, and with the **Apply to Entire Object** option enabled. The before and after result should look similar to the next illustration.

220. Select and isolate the throw pillows.

221. Detach the left pillow from the right pillow and isolate the selection.

The next illustration shows the image created in Photoshop by piecing together parts of the original reference image. This image needs to be stretched over the entire length and width of the throw pillows, so the mapping gizmo needs to be set to match the size of the pillow once it has been oriented properly.

222. Apply **Planar** mapping to the pillow and rotate the planar gizmo to the surface of the pillow.

223. Increase the length and width of the gizmo so it covers the entire surface of the pillow, as shown in the left image of the next illustration.

224. Add the **Edit Poly** modifier and enter **Element** sub-object mode.

225. Rotate your view to see the back side of the pillows and select the back element of the pillow.

226. Keeping the selection active, apply the **UVW XForm** modifier and enable the **Flip** option for the **U Tile**. The back side of the pillow should now be oriented properly.

227. Add another **Edit Poly** modifier.

228. Apply the **Unwrap UVW** modifier and click the **Edit** button within the **Parameters** rollout.

229. Press the keyboard shortcut **Ctrl+A** to select all of the vertices in the object, and from the **Tools** menu, select **Relax**.

230. Use the **Relax by Face Angles** option with an **Iterations** value of **500**, an Amount value of **0.5**, and a **Stretch** value of **0.2**. Click **Apply** to complete the command. The result should look similar to the right image of the next illustration. Although the size of the mapping was increased slightly, it is relatively insignificant and decreasing it here should not be necessary.

231. Close the **Relax Tool** and **Edit UVWs** dialog boxes.

232. Exit isolation mode.

233. Use the same technique to texture the right pillow.

234. Attach all objects together into one model. The result should look similar to the next illustration.

235. Save the file.

10. Applying materials

236. Continue from the previous step or open the file **ch06-09.max**.

237. Open the Material Editor and load the material library called Sofa.mat. This material library contains two materials; a standard material and a V-Ray version of the standard material. Both are multi/sub-object materials.

238. Apply the material named Sofa to the sofa in your scene. Because the material is a Multi/Sub-object material and because you have already created material IDs, each unique part of the sofa should now be textured properly. The next illustration shows the couch rendered in Scanline with no lights. The right image of Figure 6-2 shows the couch rendered in V-Ray.

239. This is the end of the exercise. If you want to view a completed version of the scene, open the file **ch10-10.max**.

PART 3

Creating Site Elements

It probably won't be too many more releases before Autodesk makes 3D site creation even easier with more dedicated tools, but in the meantime, we must rely on our imaginations more than the tools that they created specifically for our type of work.

Creating 2D Sites

In the last four chapters, we covered the creation of building elements such as walls, windows, doors, and roofs. This chapter begins a four chapter series discussing the creation of objects that can be generally classified as site elements, such as roads, sidewalks, curbs, backgrounds, and vegetation. In this 1st chapter, we'll look closely at some of the best techniques for creating 2D sites, and in the next chapter we'll use many of the same tools and numerous others to create 3D sites. The remaining two chapters deal with the challenges of creating realistic backgrounds and vegetation.

Creating a 3D site plan can seem like a daunting challenge and can easily frustrate experienced users. For many years, 3DAS has experimented with virtually every possible way to create site plans, and if you've been frustrated with a particular plan of attack, there's a good chance that we have probably experienced a similar frustration when trying the same thing. We now find ourselves using the same steps and the same tips and tricks on just about every site we work on, with minor variations in site elements specific to each piece of work. With a little practice using these routines, anyone can breeze through constructing a solid 2D site in minimal time.

This tutorial covers the creation of some of the most prevalent types of objects found in site drawings. Specifically, each of the following object types are included:

- Grass
- Roads
- Curbs
- Sidewalks
- Pavers
- Paver bandings
- Road lines
- Mulch
- Parking stops

Obviously, any given scene may need to be populated with miscellaneous object types such as cars, people, signs, etc.; however, these objects should be pulled from your pre-existing libraries and not created from scratch. Vegetation and backgrounds can also be considered site objects but will be discussed in depth in Chapters 9 and 10.

In this tutorial, we wanted to demonstrate as many tips, tricks, and routines as possible, spending minimal time on repetitive steps that waste time without teaching anything new. Therefore, the site plan used in this tutorial may appear overly simplified. For example, lines that represent streets are often poorly constructed and contain countless breaks, rather than being continuous lines. Rather than giving you lines that require hours of editing and welding to fix, we have provided nearly perfect AutoCAD linework, with only a few imperfections that allow us to demonstrate problems usually commonplace to site drawings. This will allow the tutorial to progress rather quickly in comparison to real-world site creation, and therefore speed up and optimize learning considerably.

One additional note about this and all future chapters is that by this point in the book, many of the commands featured have been discussed numerous times before. Because of this, most of the chapters from this point on will usually explain previously discussed commands only once at the 1st instance of the command and will assume that you know how to find and implement those commands after the 1st instance.

The Metro Professional Complex

For this exercise, we return to a past project that, at the time of the writing of this chapter, is still under construction in the business district of downtown Fort Lauderdale, Florida. This project is a medium-sized modern commercial building development and the final product called for two high resolution renderings with views of the front and rear of the building, as shown in Figure 7-1. This project consists of a single 3-story contemporary building, with a parking lot that extends around and underneath the building, and a courtyard in the front containing a fair amount of vegetation.

Figure 7-1. Two finished images of the Metro Professional Complex.

I always like to visit a project's site whenever possible to get a feel for the property and its surroundings at the time of day I think I would like to create the images. A helpful tool in the study of a site, especially when you cannot visit it in person, is aerial and/or satellite imagery, such as the left image shown in Figure 7-2. Any photographs the client can provide, such as the right image, are also invaluable.

Figure 7-2. A old satellite image and new street level photo of the project site just before construction.

Some of the best satellite imagery can be found through **Google Earth** and **Microsoft Virtual Earth**. If you haven't already investigated these applications, as well as professional versions of both you would be doing yourself a favor to do so. One particularly useful feature in Microsoft Virtual Earth is the ability to view aerial imagery from a perspective view. Figure 7-3 shows an example of this. If you're lucky enough to have your project located in one of the areas where such library photography is available, you can truly enhance your ability to visualize the surrounding environment.

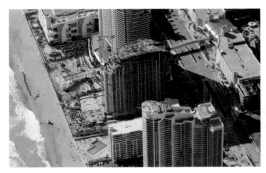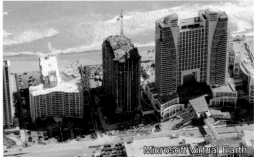

Figure 7-3. An example of Microsoft Virtual Earth.

So the first step in the creation of a 3D site plan is to 'clean' the drawing and prepare it for use in 3ds Max per the guidance outlined in Chapter 2. The original site drawing, shown in the left image of Figure 7-4, was actually one of the cleanest site drawings I have ever worked on, yet it still contained most of the problems discussed in Chapter 2, which required about 1 hour to clean. There was extraneous information that needed deletion, such as setbacks, dimensions, survey lines, etc., and most of the useful linework consisted of individual lines rather than continuous polylines. Nearly every line needed attention, but nonetheless, the linework was overall simple to use and easy to understand. Once completed, our cleaned site drawing looked like the right image in Figure 7-4.

Figure 7-4. The 'dirty' and 'clean' AutoCAD site drawing for the Metro Professional Complex.

An important note to make about the cleaned site drawing is that some liberties were taken in the creation of linework not shown in the original site drawing. Notice in the cleaned version that there are two rectangles placed around the outside of the property. The outside rectangle represents the terrain (referred to in this exercise as the grass) and is the limit of what will be seen in any view. The second rectangle is a line we will use to create curbs. Although this rectangle does not appear in the original site drawing either, and although curbs would never enclose a property in the real world, it was placed here for two reasons. First, we know that we will need a single rendering of the front and back of the property and that our vantage points will not show the fact that the curbs are completely surrounding the property. Second, this same line will be used to cut out the roads from the surrounding grass object created by the first rectangle. I also wanted to show some road lines in the rendering that did not appear in the original site drawing. This is why you can see the three green lines in the cleaned drawing that do not appear in the original. The ultimate goal in adding this additional linework is to create a reasonable grass, road, road line, and curb object as shown in the final renderings in Figure 7-1. For these reasons, we can take the liberty of creating linework in a manner that would not be practical in the real world.

Since the 2D linework is prepared, we can begin the creation process for each of the elements that will make up the 2D site. It is important to note at this point that the linework to be imported into 3ds Max can be imported all at once or one layer at a time. In this tutorial, I chose to import all linework at the same time; however, this is a matter of personal preference and in more complex sites I recommend importing one layer at a time. This will allow you to work on one site element at a time and not clutter your view and workspace with linework you are not currently working on. More importantly, it gives you time to get a 'feel' for the project and to think about how to create the more difficult elements later while working on some of the easier elements.

Before going any further, I would like to reiterate a point made in Chapter 2 about the origin of a file. If you look in the original drawing, **metro_initial.dwg**, you'll notice that the origin is located a great distance away from the linework of this project. In the cleaned drawing I moved all of the linework in the project so it is centered on the origin. This is important because, unlike AutoCAD, the accuracy of 3ds Max is greatly dependent on where you operate in the world-space coordinate system. If you are not familiar with why this is or are not completely confident with how to set up the 3ds Max work environment, please refer to the discussion in Chapter 2.

Import the linework

When you prepare linework in CAD, it is important to figure out ahead of time which scene elements are going to be combined into the same scene objects. Minimizing the number of object types will reduce the number of times you have to perform the same 3D operations in 3ds Max and can greatly improve speed and efficiency. For example, if you had dozens of parking lines on several different layers, it wouldn't make sense to import those lines and apply the same commands to each of those separate objects in order to turn them into renderable meshes. It would be better to place all of the parking lines on the same layer so you only have to prepare the one object.

In this project, I have simplified the AutoCAD drawing so that only 13 unique layers exist besides the default **0** layer, as shown in Figure 7-5. This makes turning the linework into a finished site much easier. I like to retain very strict layer management to aid efficiency and workflow. I give all my layers very descriptive names so there is no doubt what is contained on them and I go to great lengths to ensure that all linework is placed on the appropriate layer. Notice also that all the layers are preceded with the prefix **0-**. This is a personal technique I use to keep my own layers at the top of the layer manager. When the site is completely cleaned of any unnecessary layers, it's a mute point; however, during the cleaning process, this is a very useful technique that helps navigating around what is sometimes hundreds of layers. I also categorize my layers by giving them an additional prefix, such as **Site** or **Bldg**, which allows me to quickly and easily locate and isolate all my building or site linework in AutoCAD as well as in 3ds Max.

Figure 7-5. The project layers created in AutoCAD.

Now that everything possible has been done to streamline our work in 3ds Max, let's go ahead and import the linework.

1. Reset 3ds Max.

2. Set units to **U.S. Standard**, **Feet w/ Decimal Inches**, and **Default Units** to **Inches**.

3. Make sure the **System Unit Setup** dialog box shows that **1 Unit = 1.0 Inches**.

4. Import the file **metro_clean.dwg** using the **Legacy AutoCAD** file type and the default options, **Derive Objects By Layer** and **Convert to single objects**. The **Group common objects** option should not be enabled.

5. Zoom to the extents in each viewport and turn off the home grid in each. Disabling the home grid makes seeing the linework a little easier.

6. Activate **Top** view and switch from a 4-viewport to a single viewport configuration. The scene should look like the following illustration.

Grass

The first important rule in creating terrain is to 'keep it simple'. Almost no site in the real world is completely flat, and therefore, when you receive a drawing originating from a surveyor or some other type of civil engineering firm, chances are pretty good that you will find notes or topographical lines indicating some variation in the elevation of the terrain. However, when looking through the lens of a camera, whether in the real world or in the virtual world, you will often not see the subtle variations in elevation that would justify the use of 3D terrain. For instance, if a parking lot had a 6 inch downward pitch toward its center to allow for water to flow into a drainage feature, this is something you should never have to worry about modeling. Creating this simple little change in elevation can bring about a number of different problems that would otherwise not have to be addressed if the parking lot were to remain completely flat. In this scenario, one would have to ensure that the parking lines conformed to the slope of the parking lot and that cars were positioned just right so their tires weren't seemingly buried in the pavement or floating a few inches above it. For such small variations in terrain, it is far better to avoid the complication of accommodating this kind of detail. In the next chapter, we'll cover some of the many different ways of creating 3D terrain, but for this particular site we are going to simplify things and create the terrain as a flat piece of land.

7. Enable endpoint snaps and use snaps to draw a rectangle directly on top of the second rectangle from the outside (**0-Site-Curb_B.01**), as shown in the following illustration.

8. Name the object **Site-Grass_Outside.**

9. Add the **Edit Spline** modifier and attach the object named **0-Site-Grass.01** to this new rectangle you created.

10. Add the **Edit Poly** modifier to this object and render **Top** view. Your rendering should look like the left image in the following illustration. This object represents the grass that surrounds the roads.

11. Use snaps to draw a 2nd rectangle in the exact same location as the 1st.

12. Name this object **Site-Roads**. This object will be the foundation of the road that will be created.

13. Add the **Edit Poly** modifier to this object and render **Top** view again. The result should look like the right image of the following illustration.

14. Disable snaps.

15. Save your file.

Curbs

There are numerous types of curbs used in the real world, but in this project only two unique types are called out. For the sake of simplicity, I have labeled these curb types as type A and type B, as shown in Figures 7-6 and 7-7. These two types are perhaps the most widely used in the world and even when a project calls for a slightly different appearance, these two types can usually be relied on to fill your needs.

In this project, type A has an overall cross-section width of 2'-0", which includes a 6-inch wide raised portion that retains the surrounding topsoil. Sometimes referred to as a gutter curb, this type of curb is beneficial for allowing rain water to drain into the various drainage basins. It's used along one side of the main road that runs in front of the property and wraps around the front half of the building in a continuous closed fashion.

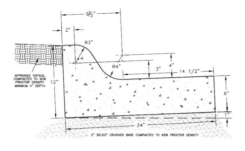

Figure 7-6. Curb Type A.

Type B is a curb with a simple rectangular cross-section and an overall width of 6 inches. This curb type separates the grass from the road in some areas and the pavers from the road in other areas. It is used around the small island under the backside of the building, but will also be used outside of the property limits to improve the appearance of the rendering.

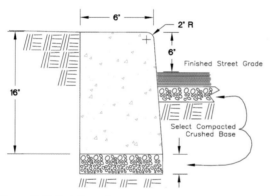

Figure 7-7. Curb Type B.

The first curb we will create is Type A, which runs along the main road in front of the property and around the front half of the building. This type of curb is usually represented by three lines, and the drawings for this project make no exception to this. The inner line closest to the grass represents the back side of the curb, the middle line represents the top outside part of the curb, and the outside line closest to the road represents the point where the curb meets the road.

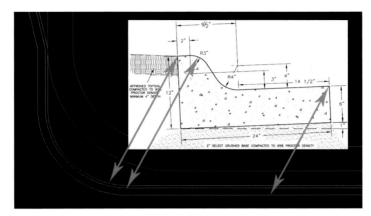

Figure 7-8. A plan and section view of one of the project's curb.

The first thing to decide is what type of method you're going to use to model the curbs. For most curbs, the **Loft** command and **Sweep** modifier cannot be beat. You can always use techniques such as a renderable spline with a 4-sided cross section or an extruded closed spline, but nothing compares to the power and versatility of the Loft and Sweep. With these tools and good linework in hand, you can create curbs for the largest of scenes in just a few minutes. As a matter of personal preference, I prefer the Loft command because of how it respects a profile's pivot point; however, since you cannot loft along a path consisting of non-continuous splines, the Sweep modifier is the better tool for larger scenes. This is a very small scene that will take the same amount of time either way, so in this exercise we will use the Loft.

The first step is to create a shape that represents a cross-section of the curb and a path with which to loft the shape along. The shape I created for this curb, shown in Figure 7-9, is a simplified version of the curb section shown in Figure 7-8. This curb is 6 inches tall, 24 inches wide, and contains two curves with a 2-inch radius.

Figure 7-9. The shape to be lofted with the pivot point centered on the shape.

Before you can use any shape for a loft, you have to adjust the shape's pivot point so that the loft is created in the appropriate place in 3D space. As a rule, I always establish my roads at an elevation of zero (i.e., aligned with the home grid), and most other objects tend to be at an elevation at or above this point. In Figure 7-9, you can see that the pivot point is located at the center of the object. However, this is not an appropriate place with which to align a loft in 3D space because the center of the loft will be aligned with the home grid, and therefore, the bottom half will be below the roads.

So once your shape is created and selected, open the **Hierarchy** panel, select **Affect Pivot Only**, and use the **Align** command to move your pivot point to the bottom left corner of the object, as shown in Figure 7-10. If you wish to use this same shape in creating the curb for this project, use the file named **shape-curb-A.max** when we continue with the exercise in just a moment.

Figure 7-10. The shape to be lofted with the pivot point aligned properly.

As I mentioned before, in the original drawing (**metro_initial.dwg**), there were three lines that represent the structure of the curbs, yet in the cleaned file (**metro_cleaned.dwg**), notice that only one line exists. This is because only one line is needed to loft the shape and anything else brought into 3ds Max would be unnecessary and only serve to clutter your workspace. The line I chose to use as the path for the loft is the inside line where the curb meets the grass. The reason I chose this line is that after we prepare it for lofting, it can be used later to cut the grass out of the road. If we used any other line, then we cannot apply displacement to the grass without having the grass appear to be growing up through the curbs.

Let's continue creating our curb:

16. Continue from the previous exercise or open the file **ch07-01.max**.

17. Merge the curb shape you created or the one found in the file **shape-curb-A.max**. Notice that the shape is merged into your scene at the scene origin. I placed the shape at the origin for convenience in locating it later.

18. Select the object **0-Site-Curb_A.01**. This object will be used to create curb Type A, and be one of the lines used to create the road the curbs run along.

19. In the **Command** panel, select **Create** > **Geometry** > **Compound Objects** > **Loft**.

20. Click the **Get Shape** button and click on the shape you just merged.

21. Switch to a **Perspective** view and then change the view to an **Orthographic** view. Switching to an Orthographic view makes viewport navigation much easier, and switching to Perspective view first is necessary to keep from simply making the Top view an Orthographic view.

22. Enable **Edged Faces**. The Orthographic view should already be set to Smooth+Highlights.

23. Zoom in closely to one of the curved areas of the curb. Notice two things wrong with the object, as shown in the left image of the following illustration. One is that the gutter portion of the curb is on the inside rather than the outside. The other is that the curb appears chiseled rather than smoothly curved. Let's fix the first problem and come back to the second later.

24. Undo the **Create Loft** command.

25. With the object **0-Site-Curb_A.01** still selected, enter **Spline** sub-object mode and within the **Geometry** rollout, click the **Reverse** button. This reverses the direction of the spline, which causes the loft's shape to be projected in the opposite direction.

26. Create the loft again. Having reversed the direction of the path, the curb object is now created so that the gutter is on the outside, as shown in the right image of the following illustration.

The second problem with the object is that it appears chiseled in all of the curved areas. This is because there are not enough vertices in the original path, and not enough default steps used when the loft was created. You could increase the number of steps in the loft above the default value of 5 to achieve much smoother curves, but there are two problems with this strategy. One is that there will be unnecessary faces created in straight segments where additional steps are unnecessary. The second is that by the time you increase the path steps high enough to allow for smooth curves, you will see overlapping faces and erratic shading in corners. Both of these problems can be seen in the following illustration where the path steps were increased to 10. The solution to both of these problems is to globally reduce the number of steps to 0 and manually insert the steps where needed.

Figure 7-11. The curb object lofted with 10 steps.

27. With the loft selected, open the **Skin Parameters** rollout in the **Modify** panel and reduce the **Shape Steps** and **Path Steps** value to **0**. Notice that the loft loses all its curves along both its cross section and along the path. This ensures that there will be no unnecessary faces along portions of the loft that should be completely straight. Now let's add faces where they are needed.

28. Select the object **0-Site-Curb_A.01** and enter **Segment** sub-object mode.

29. Switch to **Top** view and zoom into the top right corner of the object, as shown in the following illustration, and select the two curved segments of the spline.

30. In the **Modify** panel, scroll down to the bottom of the **Geometry** rollout and click the **Divide** button. Notice that the highlighted segments are divided into 2 segments of equal length.

31. Click the **Divide** button again. The 2 segments of each curve are now divided into 4 segments of equal length and a curve is reappearing in the loft. Continue to click the **Divide** button until this portion of the loft achieves a reasonable level of curvature, as shown in the right image of the following illustration.

32. Repeat this same process with each portion of your loft that should be smoothly curved. You can highlight multiple segments of the path and divide those segments at the same time and to better see the segments you want to highlight, delete the loft and recreate it once the path is structured properly.

In addition to the path, the shape needs to contain an adequate number of vertices in the curved segments.

33. Select the shape **Shape-Curb_A**, zoom in closely in **Top** view and enter **Segment** sub-object mode.

34. Select the **two** curved portions of the shape and divide these segments with a segment value of **6**, as shown in the following illustration. This will provide smooth enough curves without too many unnecessary vertices. If this were a much larger project where the typical view would be much farther away from the curbs in your scene, you could easily get by with just a few additional segments added.

35. Close sub-object mode.

After completing the corrections to your path and profile, one final modification you should make to your loft at this point is to improve the smoothing.

36. Switch to **Orthographic** view, select the loft object, apply the **Smooth** modifier and enable the **Auto Smooth** option. To see the effect of this modifier, look around at different parts of the object while toggling this modifier on and off. You will see the shading change significantly in some areas. Although lofts automatically have the Smooth Length and Smooth Width enabled, this is usually a bad thing and results in a bad appearance around corners. The Auto Smooth option fixes this problem.

As a matter of practice, I recommend changing the name of your objects once their structure has been finalized, and having finalized the structure of this object, now would be a good time to rename it.

37. Change the name of your loft to **Site-Curb_A**.

38. Save your file.

Now we need to create curb type B, which surrounds the small island at the rear of the property and is also used around the roads that surround the property. Because of the structure of this particular curb type and how the linework was developed, this curb should only take a few quick steps to create.

39. Continue from the previous exercise or open the file **ch07-02.max**.

40. Select the object **0-Site-Curb_B.01**.

Since we used the loft command last time and since this 2nd curb object consists of more than one spline that would have to be lofted individually, here we're going to use the Sweep modifier. Knowing this, we should prepare our curb linework ahead of time. I always prefer to divide the segments before creating a loft or sweep so the spline can be seen without being obscured.

41. Switch to **Top** view and zoom to the extents of the scene.

42. Enter **Segment** sub-object mode and divide the curved portions of the curb object into an adequate number of segments, just as we did with curb Type A. Exit sub-object mode when you are finished.

Now we need to create a shape to sweep along the path of this object. After you create this object once, you should save it in a library of objects so you can retrieve it later rather than creating it all over again.

43. Zoom in to the origin of the scene where the **Shape-Curb_A** object is located and draw a rectangle with an approximate length and width of 6 inches, as shown in the left image of the following illustration.

44. Go to the **Modify** panel and change the length and width of the rectangle to exactly **6 inches**.

45. Open the **Interpolation** rollout and change the **Steps** value to **0**. If this is not done the resulting sweep will have all of these additional steps built into its cross-section. When creating sweeps, it is much better to manually create the additional vertices as needed, just as we did with the path.

46. Add the **Edit Spline** modifier.

47. Enter **Vertex** sub-object mode and select the top-right vertex.

48. Within the **Geometry** rollout, type **2** inside the field to the right of the **Fillet** button and press **Enter**. The corner changes to incorporate a 2-inch chamfer, assuming you reduced the interpolation steps of the rectangle to 0 just a moment ago. If you didn't reduce the steps you would see a 2 inch curve, as shown in the right image of the following illustration. To actually get this curve to appear now, we need to divide this segment several times. This will provide the proper look to the top corner of the curbs closest to the roads.

49. Enter **Segment** sub-object mode, select the 2-inch fillet segment (which really looks like a chamfer presently) and divide it with **6** segments. A decent curve should appear.

50. Rename the object **Shape-Curb_B**.

Since we are going to use the Sweep modifier, we don't need to adjust the object's pivot point.

51. Select the object **0-Site-Curb_B.01** and apply the **Sweep** modifier.

52. Within the **Section Type** rollout, enable the **Use Custom Section** option, click the **Pick** button and click on the **Shape-Curb_B** object in the viewport.

53. Switch to **Orthographic** view and zoom in closely to one of the curved portions of the curb object. Notice that this curb is also inside out.

54. Go down in the modifier stack to the **Edit Spline** modifier, enter **Spline** sub-object mode and reverse the direction of the spline with the curved portions. The rectangular shaped spline surrounding the project does not need to be reversed.

55. Close out of sub-object mode and return to the **Sweep** modifier in the modifier stack. Notice that the filleted side of the curb object is now facing outward. Another problem, however, is that the curb has far too many segments within each curved area, as shown in the left image of the following illustration. The reason for this is the interpolation that is automatically applied to all splines that are created or imported.

56. Go down in the modifier stack to the **Edit Spline** modifier, open the **Interpolation** rollout and enter a **Steps** value of **0**.

57. Return to the **Sweep** modifier and notice that the resulting sweep appears to have the proper number of segments in it, as shown in the right image of the following illustration. This interpolation is what gives the spline its curves, but if we add vertices manually it's not needed. That being said, it should also be mentioned that for very large projects where manually creating the additional vertices would take a long time, using interpolation in the original spline and original shape is a great way to quickly create curvature in your resulting sweeps. The best part about interpolation is that it does not add additional vertices in straight segments. You might also want to experiment with the Adaptive option within the Interpolation rollout, because it can intuitively assign what it believes to be the proper number of segments everywhere in your spline.

One final problem with this object is that it's half buried in the road. Unlike a loft, a sweep object does not respect a shape's pivot point location, so adjusting the pivot won't do any good. Instead we have to adjust the alignment within the sweep object.

58. Within the **Pivot alignment** section of the **Sweep Parameters** rollout, select the **bottom left-hand corner** alignment option. This causes the curb object to move upward so the bottom is aligned to the home grid.

59. Switch to **Top** view and zoom in closely to one of the curved areas of the object.

60. Turn the **Sweep** modifier on and off a few times while taking note of the location of the object's alignment relative to the original spline. Notice that because the bottom left hand corner option was selected in the sweep modifier, the inner edge of the curbs (the side without the 2-inch curve) is aligned with the original spline, as it should be. Also, if there appears to be 2 distinct lines on the inside edge of the curb, it is because sweeps incorporate a banking option by default. This option distorts the object and should always be removed in just about all object types.

61. Within the **Sweep Parameters** rollout, disable the **Banking** option. If the sides of the curb were not completely vertical beforehand, they will be at this time.

The last change we should make to this object is improving the smoothing.

62. Apply the **Smooth** modifier and enable the **Auto Smooth** option.

63. Since your curb should now be structurally complete, rename the object **Site-Curb_B**.

64. Save your file.

Roads

Since curbs represent the boundary between the roads and the terrain, we can take advantage of the already prepared curb linework and use it to quickly cut out the roads from the surrounding terrain. Let's start by creating copies of the linework used to create the curbs.

65. Continue from the previous exercise or open the file **ch07-03.max**.

66. If not already selected, select the object **Site-Curb_B**, and create a clone of it using the name **Temp1**. This object will have a short lifespan, so I chose to give it a suitable name. Also, ensure that you use the **Copy** option rather than the **Instance** or **Reference** option.

67. Remove the **Smooth** and **Sweep** and modifiers. This will return the object to its original spline appearance. In a moment, we will attach this spline to the spline used to create curb Type A.

68. Select the object **0-Site-Curb_A.01** and create a clone of it named **Temp2**. We cannot use the original spline used to loft curb A because it will affect the loft we created.

69. Attach the object **Temp1** to this object. The result should be an object containing several different closed splines.

70. Open the **Interpolation** rollout and reduce the interpolation value to **0**. This will prevent any unnecessary vertices from being created when we apply the next modifier.

71. Switch to an **Orthographic** view.

72. Apply the **Extrude** modifier with an amount of **20'** and move it **10'** downward (in the negative Z direction). It should now be a solid object intersecting the road object, as shown in the following illustration.

73. Select and isolate the objects **Site-Roads** and **Temp2**.

74. Switch to **Top** view and enable **Smooth+Highlight**s and **Edged Faces.**

75. Deselect both objects and reselect only the **Site-Roads** object.

76. **This next step is very important**. In the **Edit** menu select **Hold**. This stores a copy of your scene for later retrieval. We will need to retrieve it shortly.

77. Select **Create** > **Geometry** > **Compound Objects** > **Boolean** > **Cut** > **Split**.

78. Click on the **Pick Operand B** button and select the object **Temp2** you just extruded. The object named **Temp2** no longer exists and you should see an outline of the roads cut into the Site-Roads object.

79. Add the **Edit Poly** modifier to the **Site-Roads** object.

80. Enter **Polygon** sub-object mode. You should see the faces selected for the area cut out of the roads. This is one tremendous advantage of using the Boolean feature — it automatically selects the cut polygons. The ProBoolean feature does not do this.

81. Within the **Edit Geometry** rollout, click the Detach button.

82. Close out of sub-object mode and give the **Site-Roads** object a vastly different color from the object you just detached so the two objects can be easily distinguished.

Look closely around different areas of the grass object. You will probably notice that 3ds Max did not do a very good job of cutting the extruded object out of the grass object. There are probably numerous missing and deformed faces along the edge of where the cut took place, as shown in the next illustration. There is a very good reason for this. Boolean operations do not work well when some of the faces that have to be created are long and skinny, as is the case in this scene. The reason the faces are long and skinny is because of the distance and angle between vertices of the road object and vertices of the cutting object. If an operation does not work right the first time, simply increase the polygon density of the object being cut using a modifier such as Subdivide.

83. From the **Edit** menu, select **Fetch** and **Yes** to complete the command. This returns the scene to the pre-Boolean configuration.

84. With the **Site-Roads** object selected, add the **Subdivide** modifier and change the **Size** value to **10'**. Making the maximum face size 10' will make the cuts much more accurate.

85. Select **Create** > **Geometry** > **Compound Objects** > **Boolean** > **Cut** > **Split**.

86. Add the **Edit Poly** modifier and enter **Polygon** sub-object mode. The cut polygons are automatically selected.

87. Press the keyboard shortcut **Ctrl+I** to invert the selection of polygons.

88. Within the **Edit Geometry** rollout, click the **Settings** icon immediately to the right of the **Detach** button.

89. Name the object **Site-Grass_Inside** and click **OK** to complete the Detach command.

90. Close out of sub-object mode, select the new object you just created/detached and give the object a new color. This allows it to be distinguished from the polygons that were just detached.

91. Analyze the cut that was just made. This time you should have clean edges all around your road object, as shown in the next illustration, because 3ds Max doesn't have to create long, skinny faces.

As mentioned earlier, the road object will remain at the home grid; however, the grass object needs to be elevated above it as it would be in the real world. Normally grass is found growing above a curb, sidewalk, and any other similar site element. But because we want the option to apply

displacement to the grass to make it rise above these elements, we will leave it positioned 1 inch below the top of the curbs. Also, since the grass is nothing more than a surface, and since we don't want to have to generate any unnecessary polygons, elevating the grass object above the curb means that there will be a gap between the curbs and the grass. This is obviously unacceptable and for both of these reasons, the grass should be raised so that it's just below the top of the 6-inch tall curbs we created earlier.

92. Exit isolation mode and select objects **Site-Grass_Inside** and **Site-Grass_Outside**.

93. Switch to Orthographic view, zoom in closely to one of the curb areas, and move both objects upward **5 inches** so they are positioned just 1 inch below the top of the curb objects. The following illustration shows what the curbs should look like in a couple of different places.

Now might be a good time to change the background color of your scene to something lighter. Black backgrounds can negatively impact the mood of your renderings and it's best to use a lighter color, even for test renders.

94. Change the background color of your scene to a light blue color, similar to a midday sky color.

95. Render the scene. It should look similar to the following illustration.

96. Save the file.

Sidewalks

Now that we have our roads and curbs created, let's create perhaps the easiest object in the site; the sidewalks.

97. Continue from the previous exercise or open the file **ch07-04.max**.

98. Select the object **0-Site-Sidewalks.01**.

99. Add the **Extrude** modifier and use an **Amount** value of **6 inches**. This makes the top of the sidewalks flush with the top of the curbs, as shown in the following illustration. By extruding the sidewalks 1 inch higher than the surrounding grass, you can add displacement to select areas and make the grass appear to grow over the sidewalks as it would in the real world.

The only other structural modification that should be made to this object is applying joint lines, as you would typically find in the real world. In the real world, these joints would be about 1/4 of an inch wide and deep. However, joints with these dimensions simply will not show up well unless viewed from a very short distance. Because of this, you should always beef up the size of the joints. To create the joints, all we need to do is subtract a volume from the sidewalks as we did when creating window openings in the chapters dealing with walls. To make this exercise flow quickly, an object has already been prepared and is ready to be cut out of the sidewalks.

100. Merge into your current scene the sole object in the file **sidewalk-booleans.max**. The merged object should be a series of boxes, as shown in the left image of the following illustration. The distance between joint lines in the real world is typically 4 to 6 feet, so in this case, a distance of 5 feet was used. As an additional note, the boxes are 1 inch wide and have been placed 1 inch into the sidewalk object.

101. Select the object **0-Site-Sidewalks.01** and select **Create** > **Geometry** > **Compound Objects** > **ProBoolean**.

102. Click the **Start Picking** button and then click the object **sidewalk-booleans** in the viewport. The result should look like the right image in the following illustration. The ProBoolean feature was used here to keep the geometry clean looking and to prevent extra coplanar edges from being displayed automatically, as they would have been with the Boolean feature.

103. Rename the object **Site-Sidewalks**.
104. Save the file.

Pavers and Paver Bandings

The next two object types we need to create for this scene are pavers and the bandings that surround them. Both are usually just bricks arranged in a specific pattern to form a beautiful type of site element often referred to as hardscaping. When created correctly, they can add a wonderful touch of realism to a scene.

Paver bandings provide a great accent to the pavers in any project and 3D artists often make the mistake of not taking the extra step of adding this key element to their work or not orienting the bandings correctly. Whether around a pool, on a sidewalk, or in a street, bandings make a big difference in the look of a hardscape area; when placed improperly, they can stand out like a sore thumb. The images in Figure 7-12 show several different examples of paver bandings oriented in a specific manner around other paver bricks. Imagine how these images would look if the paver bandings didn't exist or if they were all oriented in an inappropriate manner, for example if all the pavers were aligned in the same direction when they should instead be oriented in a radial fashion.

Figure 7-12. Examples of pavers and paver bandings.

In this project, the paver bandings used were nothing more than applications of poured concrete, rather than individually placed bricks. This made creating the bandings for this project very quick and easy. However, for the sake of proper coverage of the subject, I will provide a few tips on how to efficiently create the look of bandings arranged in a specific way around the rest of the pavers.

105. Continue from the previous exercise or open the file **ch07-05.max**.

106. Switch to a **Top** view.

107. Select and isolate the two objects, **0-Site-Pavers_Banding1.01** and **0-Site-Pavers_Banding2.01**.

108. Make a clone of the object **0-Site-Pavers_Banding2.01** and rename it **Site-Pavers**.

109. Extrude this object **6 inches**. The result should look like the left image of the following illustration.

110. Select the object **0-Site-Pavers_Banding1.01** and attach the object **0-Site-Pavers_Banding2.01**.

111. Extrude this object **6.5 inches**. The result should look like the right image of the following illustration. Making this object slightly higher than the pavers it surrounds provides a nice distinction between the two objects.

112. Rename this object **Site-Paver_Bandings**.

113. Exit isolation mode.

114. Save the file.

As mentioned, the bandings for this project are solid concrete poured in place, and therefore, very simple to create in 3D. More often than not, however, bandings require precise orientation around an often complex perimeter, such as an oddly shaped pool. When this is the case, you have two choices to represent the pavers; with a texture or with actual 3D objects representing each individual brick. Because the number of pavers needed for a banding feature is usually relatively small, I would recommend placing 3D pavers rather than a texture. Placing these bricks can be time consuming, but there is a useful tool that can make it much quicker and far more precise than manual placement. If you find that a texture is the most reasonable solution, you will probably have to work equally hard to make the pattern look proper. Whichever your choice, the following exercises demonstrate 2 methods you might want to use to make the job a little easier.

3D Paver Bandings

115. Open the file **paver_exercise01.max**. This file contains 4 objects. One object is a 6x12 inch paver with a thickness of 6.5 inches, which is just thick enough to rise through another object that represents the grout that will be seen through the pavers. A third object is the large interior area inside the banding where the pavers can be mapped, and the fourth object is a spline that will be used as a path for the tool of choice for this exercise; the **Spacing Tool**.

116. Select and isolate objects **3D-Paver01** and **Site-Pavers_Guide**.

117. Deselect both objects and select only the **3D-Paver01** object.

118. Press the keyboard shortcut **Shift+I** to activate the **Spacing Tool**. This tool can also be found in the **Array** flyout of the **Extras** toolbar in 3ds Max 2009. In previous releases, this tool is found in the **Tools** menu.

119. In the **Count** field type **150**, in the **Context** section enable the **Follow** option, and in the **Type of Object** section enable the **Copy** option, as shown in the right image of the following illustration.

120. Click the **Pick Path** button, click on the **Site-Pavers_Guide** object in the viewport, click the **Apply button** and close the dialog box. There should now be 150 copies of the 3D pavers positioned as evenly as possible around the path. As good as this tool is, it can't do miracles and make the spacing between the pavers perfect around sharp corners, so some manipulation will be necessary with the Edit Poly modifier.

121. Delete the original 3D paver off to the side.

122. Exit isolation mode.

123. Select one of the 3D pavers you created, and attach all the other pavers to it.

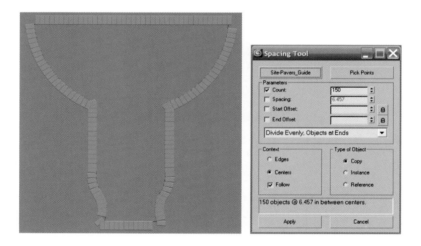

124. Enter **Element** sub-object mode and make copies of the pavers as necessary to fill in the areas where pavers should exist. You will also need to delete a few pavers and reposition others and you will also need to enter **Vertex** sub-object mode and manipulate individual vertices as necessary to produce a proper arrangement. This should take a few minutes, and the following illustration shows a before and after view of one area in Wireframe.

125. Render **Top** view. The result should look similar to the following illustration. If you want to see a completed version of this exercise, open the file **paver_exercise01-completed.max**.

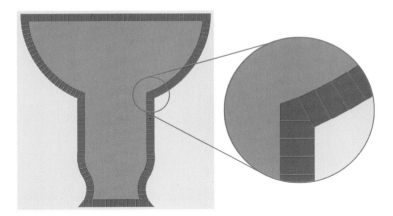

Textured Paver Bandings

If you decide that 3D paver bandings will place too much of a strain on your computer's resources and you want to instead use a texture that simulates the look of what you created in the last exercise, you have a few choices. The first is to loft a shape along the same path used in the last exercise and enable the mapping option unique to lofts. The benefit of this method is that it is a great way to quickly create mapping that follows the path of the banding. This is the method we will use in the following exercise. Another way is to use the new **Spline** mapping feature found in the **Map Parameters** rollout of the **Unwrap UVW** modifier. Yet another way you can create the proper texture is by creating 3D pavers as described in the last exercise, and then rendering a high resolution image to be used as the texture. This is a nice technique, but will of course require you to do all the work of placing the 3D pavers in their proper location and orientation first.

126. Open the file **paver_exercise02.max**. This file contains 3 objects. One object is a 6x12 rectangle that will serve as the loft profile. A second object is the interior object that represents the area where the inside pavers can be mapped, and a third object is the same path used in the last exercise with vertices manually inserted, and with vertex ticks enabled so you can clearly see where the path contains vertices.

127. Create a loft using the object **Site-Pavers_path** as the path and the object **Paver-shape** as the shape.

128. Open the **Material Editor** and apply the lone material you see in the 1st sample slot.

129. Within the **Skin Parameters** rollout of the **Modify** panel, reduce the **Shape Steps** and **Path Steps** to **0**, if not already set from a previous use.

130. Within the **Surface Parameters** rollout, enable **Apply Mapping** (if not already enabled) and type a **Length Repeat** value of **150**. This forces 3ds Max to use the path as a mapping guide so the orientation of the bitmap follows the path. The 150 value specifies how many times the bitmap will be repeated throughout the length of the path, as shown in the next illustration. Incidentally, if you didn't set **Real-World Map Size** to be disabled by default in 3ds Max 2009 you will have to disable it now in order for this step to work correctly.

Unfortunately for this scene, the paver bandings can't be simulated very well using this method because of the sharp corners in the path. Because of the sharp corners, the bitmap gets stretched, bent, and generally distorted, rather than tiling seamlessly as it does along the gradual bends in the path. Nonetheless, this technique is invaluable for many paver bandings because this particular problem is not typical with most projects. Applying this technique to a rounded pool for example will result in perfectly seamless mapping and can be done in seconds.

Road lines

Road lines are a simple yet critical element of many 3D sites. If our road was 3D with varying elevation, the process we would use to create this object type would be similar to the way many of the site elements are created; with the **Boolean** > **Cut** > **Split** feature. Since our road is completely flat, however, the process is much easier and can be completed in much less time. The AutoCAD drawings we started with displayed the road lines as simple **polylines** with a width of 6 inches (the standard thickness for most road lines). When imported into 3ds Max, plines become perfect splines to work with and need only to be turned into mesh or poly objects to be renderable.

131. Continue from the previous exercise or open the file **ch07-06.max**.

132. Select and isolate the object **0-Site-RoadLines.01** and apply the **Edit Poly** modifier.

133. Render **Top** view. Since the lines are imported as closed splines, they can be made to render just by being converted into an editable mesh or poly object. However, notice that the center road line did not import properly. Instead of importing as a dashed line as shown in the site drawing, it was imported as a single closed spline. This is because the DWG file type does not allow linetype patterns to be translated into a similar looking spline as shown in the AutoCAD drawing. There is a way to make this translation happen, but it requires you to do something different inside AutoCAD. If you do not have AutoCAD, you simply can't take advantage of this technique.

134. Return to the AutoCAD file **metro_cleaned.dwg**.

135. Select and isolate the **0-Site-RoadLines** layer.

136. Type the command **3dsout**. You are asked to select the lines you want to export using this command. Sadly, the 3DSOUT feature was removed from a recent release of AutoCAD, which is why I recommend using an older version of AutoCAD that still has this feature, such as 2004. Nevertheless, you can download this feature from the Autodesk support website.

137. Select all of the green road lines and press **Enter** twice to complete the selection.

138. Enter a file name and save the file to your computer.

139. Return to your 3ds Max scene and delete the object with all of the road lines.

140. Import the 3ds file you just saved using the default options. If you don't have AutoCAD, you can import the file **road_lines.3ds**. Notice that the dashed lines are now translated properly.

141. Add the **Edit Poly** modifier to the road lines.

It is important to note that AutoCAD uses whatever linetype scale you have specified to determine the scale of the exported plines. This simply means that whatever you see in AutoCAD is what you get imported into 3ds Max.

142. Exit isolation mode.

143. Move the road lines up **.25 inches** in the **Z direction**. This will elevate the lines just enough above the road.

144. Right-click inside the active viewport, select **Object Properties** and disable the **Cast Shadow** option. This ensures that the lines will not cast shadows and appear to be anything more than paint on the roads.

145. Rename the object **Site-RoadLines** and change the color of the object to something that stands out better against the road object.

146. Render **Top** view. The result should look like the next illustration.

147. Save the file.

Mulch

One of the most important components of a good landscape plan is the layout of mulch. I use this term generally to describe any type of substance immediately surrounding vegetation—wood chips, gravel, rock, etc. Mulch is usually a very simple object to create and can be created very quickly even for very large developments. If you are fortunate enough to have CAD drawings from which to pull mulch linework, then your work may be simplified as long as the linework is well-

created. If the linework is problematic, it might be better to just import it into 3ds Max as is, quickly trace a similar outline and then delete the original linework. If landscape plans are non-existent, you may find yourself having to come up with what you hope your client finds to be good enough. Fortunately, for this project a landscape drawing was available for this project and the layout of the mulch was placed within the site drawing.

148. Continue from the previous exercise or open the file **ch07-07.max**.

149. Select the object **0-Site-Mulch.01** and extrude it **20'**.

150. Move the object down **10'** in the **Z direction** to make it intersect the **Site-Grass_Inside** object.

151. Select the **Site-Grass_Inside** object and apply the **Subdivide** modifier with a maximum face size of **5'**. This will help guarantee that the Boolean operation that will be performed next operates smoothly.

152. Use the **Boolean** > **Cut** > **Split** feature to cut the mulch area out of the surrounding grass object.

153. Add the **Edit Poly** modifier, enter **Polygon** sub-object mode and detach the mulch area using the name **Site-Mulch**.

154. Close sub-object mode, select the **Site-Mulch** object and give it a new color so it stands out from the surrounding grass object. The result should look like the following illustration.

Notice that as a result of the multiple times the subdivide command was used to prepare for Boolean operations, there are numerous interior edges on the road, grass, and mulch objects. You can always leave these edges in your scene, but at times they can become a distraction and make it harder to see other objects. If this is the case, and you want to remove them, you can take advantage of the power of the ProBoolean command.

155. Select and isolate the **Site-Mulch** object.

156. Create a plane inside the mulch object without allowing the plane to touch any portion of the mulch, as shown in the left image of the following illustration. The number of length and width segments is not important.

157. Select the **Site-Mulch** object and apply the **ProBoolean** feature.

158. Click the **Start Picking** button and click on the plane you just created. The result is that all of the interior coplanar edges are removed on the mulch object, as shown in the right image of the following illustration. The **Advanced Options** rollout of the ProBoolean feature contains the option that allows for the removal of all coplanar edges as well as the ability to turn the 3-sided faces into 4-sided polygons. Applying the ProBoolean feature to the small plane we created simply allowed us to take advantage of the ProBoolean's power without having to subtract or cut any part of the mulch object.

159. Exit isolation mode.

160. Repeat this edge removal process on the **Site-Roads** and **Site-Grass_Inside** object.

161. Render **Top** view. The result should look similar to the following illustration.

162. Save your file.

Parking Stops

When its linework is set up properly, the parking stops object can be one of the quickest and easiest site objects to create in 3ds Max. If you refer to the original site drawing, you will notice that there are multiple lines depicting the parking stops in plan view, as shown in the left image of Figure 7-13. The parking stop is 8 inches wide and consists of 2 chamfered corners, as shown in the right image. The easiest way to create this particular object is to replace the multiple lines in the original site drawing with one individual line for each parking stop (center image) and use the Sweep modifier with a proper shape (right image).

Figure 7-13. The original linework for the parking stops (left) and the new linework (center and right).

163. Continue from the previous exercise or open the file **ch07-08.max**.

164. Next to the other 2 shapes located at the origin of the scene, create a rectangle with a length of **6 inches** and a width of **8 inches**.

165. Add the **Edit Spline** modifier, enter **Vertex** sub-object mode and apply a **2 inch** chamfer to the top left and top right vertices, as shown in the right image of Figure 7-13. Since we are going to use the Sweep modifier with this shape, we don't need to adjust the pivot point of the shape.

166. Select the **0-Site-ParkingStops.01** object and apply the **Sweep** modifier using the new shape you just created as the custom section type.

167. Change the alignment of the sweep object to the bottom-center so the bottom of the parking stop object is resting directly on the road object, as shown in the following illustration.

168. Change the name of the object to **Site-ParkingStops**.

169. Save the file.

This completes this 2D site exercise. The final geometry should look similar to the following illustration. If you want to see the completed scene, open the file **ch07-09.max**.

Summary

If you've ever spent much time pursuing the numerous chat forums we have available in our industry, you've noticed that sites are a source of great frustration for so many users. The reasons are numerous, such as the sheer size of some sites, lack of understanding civil engineering data, the inability to manage high poly objects such as trees and cars, and so on. But in reality, the best thing anyone could do to improve his or her workflow for site creation is to better clean and prepare the original linework before it's ever brought into 3ds Max. It should be clear from this exercise that sites can, and probably should, be created with just a few key features. It should also be clear that once linework is prepared properly, you can create a decent site in a relatively small amount of time. By practicing these same techniques over and over again, a site of this magnitude could take well under an hour to create.

Creating 3D Sites

THE CREATION OF 3D SITES offers all the challenges that come with 2D sites but with numerous additional difficulties. When creating 2D sites using the methods described in the previous chapter, you don't have to worry as much about things such as gaps or holes between different elements, facets appearing on the various surfaces, adjacent faces overlapping, or any number of other problems that 3D terrain modelers have to contend with on a regular basis. You also don't have nearly as much site data to interpret, prepare, import, and manage. For moderately sized projects, things like cleaning and preparing poorly constructed topographical lines could add hours to your work.

The goal of this chapter is to demonstrate techniques for creating 3D sites, address some of the most common problems 3D terrain modelers run into, and present some solutions to help solve those problems. To create a 3D site, you have to be able to create a 2D site, and knowing all of the techniques presented in the previous chapter are critical in the creation of 3D sites, as illustrated in this chapter. It will be necessary here to use tools such as the Boolean > Cut > Split, the Loft, the Sweep modifier, and numerous other features discussed in the last chapter. Rather than re-explaining these same features in this chapter, it will be assumed that you have a thorough understanding of all the tools needed to created 2D sites. This will allow the exercises to progress smoothly and quickly.

Elevation Data

Site drawings usually originate from surveyors who provide information about the existing lay of the land to civil engineers, who in turn use that information along with the architect's and owner's intent to create a new design of the land. When a new design is created, perhaps the most critical information is the elevation data, which is provided in one of two ways; either with topographical lines, such as the left image shown of Figure 8-1, or with raw numbers, as shown in the right image.

Figure 8-1. Elevation data through topographical lines (left) and raw numbers (right).

In most cases, when a site drawing only contains raw numbers rather than topographical lines, the changes in elevation are too minimal to warrant going to the trouble of creating the terrain in 3D. Notice in the right image of Figure 8-1 that the various numbers indicate only a few inches of elevation change. So in most cases, when 3D terrain is called for, you will be provided with a site drawing that contains topographical lines. Remember, however, that many architects create their own stripped down versions of site plans based on the civil engineering drawing they're provided, and this type of information is not always placed on an architect's site drawing.

Perhaps the biggest problem 3D terrain modelers face with topographical linework is that it's not created in a way that's suitable for work in 3ds Max. It's usually not suitable because the last thing the civil drafter is considering when working on a drawing is how to help a 3D artist model the terrain in 3D. Notice in the left image of Figure 8-2 that there are structures that block the continuous flow of topographical lines. Trimming the topographical linework like this allows the structures to be displayed better in print, but when those lines are isolated (right image), it's clear that there is a great deal of repair work to be done to prepare the linework for terrain creation. Fixing this problem requires you to connect the linework and weld end points, or to trace the linework instead. Which way you go simply depends on how many breaks there are and how many other ways the linework has been *dirtied*, such as overlapping lines, linework on wrong layers, and all the other things discussed in Chapter 2. Either way, a great deal of time is likely to be involved in preparing topographical linework for use in 3ds Max.

Figure 8-2. 'Dirty' togographical lines with annoying breaks.

Creation Methods

There are numerous ways to create 3D terrain in 3ds Max. Some are very precise, and some are just roughly approximated. Which method you use depends most heavily on the data you have to work with and the time you can afford to spend on linework preparation. If you have good, clean

linework to work with, creating 3D sites can take just minutes. The techniques described in this chapter fall under one of two methods of creation; creation with the use of displacement or creation with the use of topographical linework.

Displacement

Displacement involves the use of a map to elevate select areas of an object's surface. Pure black pixels mapped on the surface of an object will have no effect on the displacement of the object, while pure white pixels cause the maximum amount of displacement as defined by the displacement tool used to apply it.

The left image in Figure 8-3 is the famous Diamond Head Crater in Hawaii, and the right image is a grayscale version of it created in Photoshop and used to displace the mesh shown in the bottom image. Creating this terrain in 3D is quite simple and a far better approach than trying to use topographical lines. Even if you did have very clean linework without all the problems that always seem to exist, creating this terrain with topographical lines is probably not the best approach. The size represented by the aerial image is 1.25 miles, and achieving the same kind of detail provided with image displacement would require so many individual lines with so many vertices that their use would probably overwhelm your system resources. Notice in the grayscale image, all the fine fractal-like detail coming out from the rim of the crater. This is simply not practical to incorporate into a series of splines, and even if you could, you would probably be waiting a lot longer for 3ds Max to complete the displacement.

Figure 8-3. Using displacement to create the famous Diamond Head in Hawaii.

You could, however, use topographical lines as a guide with which to help you create the grayscale image, and in this way their existence would be worthwhile. You could simply load a screen shot of your linework into Photoshop and use the **Magic Wand** and **Paint Brush** tools to select and paint the various spaces between the lines in a way that mimics a CAT Scan. From here you could easily apply other tools to soften the transition and add further details into your image. This technique is very similar to painting maps onto objects using the **Unwrap UVW** modifier.

Figure 8-4. An example of using topographical linework to create a displacement map.

Now let's look at different ways displacements can be applied. The main ingredient of any displacement is a map, and although there are several ways maps can be used to create displacement, some methods are clearly better than others.

Displacement mapping

Displacement mapping is a generalized term that is often used to describe the process of using a map to create displacement, but it actually refers to the use of a map in the **Displacement** channel of a material. There are two downsides to using a map in the Displacement channel. One is that it doesn't automatically update an object in the viewports, and the other is that the displacement amount is guided only be the Amount value in the Displacement channel rather than by a real-world elevation value. Regardless, let's see how it works so it can be accurately compared to the other methods we employ.

Creating terrain with displacement mapping

1. Open the file **ch08-01.max**. This scene contains one object; a plane with the default 4 length and width segments and a length and width of 1.25 miles; the approximate distance represented by the Diamond Head grayscale image that will be used to displace the plane.

2. Within the **Material Editor**, load the bitmap **Diamond_Head_disp.jpg** within the Displacement map channel and apply the material to the plane.

3. Enable the **Show Map in Viewport** option to make it easier to see how the displacement should occur. If you were to render right now, the object would not be displaced because a map in the Displacement channel cannot apply displacement by itself. It needs the **Displace Mesh (WSM)** modifier. This modifier is found in the World-Space Modifier section of the modifier drop-down list.

4. Apply the **Displace Mesh (WSM)** modifier. Notice that the plane is displaced slightly; however, without enough vertices, the displacement is unacceptable.

5. Go down in the modifier stack to the plane object and change the length and width segments to **50**. The plane begins to take shape.

6. Switch to a **Front** view and use the **Tape Measure** tool to measure the total height of the land mass from the lowest point to the highest point. The height should be measured at approximately 817′. The true height of Diamond Head is 762′; however, with the use of displacement mapping, you cannot enter this value anywhere to produce the correct height. The best you could do is calculate the percentage change in height that needs to take place and enter a new value in the **Amount** field of the Displacement channel based on that percentage.

7. In the **Material Editor**, go up to the parent material, click inside the **Amount** field of the **Displacement** channel and type the keyboard shortcut **Ctrl+N** to open the **Numeric Expression Evaluator**.

8. Type **762/817*100** and press **Enter**. The Amount changes to 93, which is the value needed to lower the apex of the terrain to the approximate correct height. Notice, however, that the terrain didn't change. Again, this is one of the shortfalls of displacement mapping.

9. Within the **Displace Mesh Binding (WSM)** modifier, click the **Update Mesh** button. The terrain should update and if you measure the height again, you should find that the apex is approximately 762′.

10. Save your file for use in the next exercise.

The Displacement modifier

Using Displacement mapping is certainly an option, but it provides no advantage over the better form of displacement, implemented through the **Displace** modifier. The continuation of the previous exercise illustrates this.

Creating terrain with the Displacement modifier

11. Continue from the previous exercise or open the file **ch08-02.max**.

12. Disable the **Displacement Map** channel within the **Material Editor**, and within the **Modifier** panel, click the **Update Mesh** button. The terrain should return to a completely flat plane.

13. Remove the **Displace Mesh Binding (WSM)** modifier and in its place, add the **Displace** modifier. The Displace modifier is really the best option for standard 3ds Max displacement. With the Displace modifier, we can now enter an exact value for the displacement height.

14. Enter a **Strength** value of **762′**. Notice that the entire plane is elevated to this height. This is because there is presently no map loaded in the modifier to guide the displacement.

15. Drag an instance of the **Diamond_Head_disp.jpg** map from the **Material Editor** to the **None** button within the **Map** section of the **Displace** modifier. Now the terrain should appear as it did before with the **Displace Mesh Binding (WSM)** modifier applied. However, you can now change the elevation of the terrain in real-time by adjusting the Strength of the Displace modifier.

One important thing to remember with the Displace modifier is that the value you enter for the strength will result in that height when there are pure white pixels somewhere in the map that is applied. In this exercise, the very top of the crater was elevated to 762′ feet because the pixels on the corresponding part of the map were pure white. If the brightest pixels in the map only had a color value of 128 (halfway between pure black and pure white), entering a value of 762′ for the displacement strength would only yield a maximum displacement of 381′.

16. Press the keyboard shortcut **7** to turn on the **Show Statistics** feature. The total polygon count should indicate 5000 polygons. Remember from previous chapters that this is not really accurate. There are actually 2500 polygons and 5000 faces. Nevertheless, this is a relatively small number of polygons and we can certainly afford to use more to create greater detail.

17. Render the **Camera** view so you can compare to the added detail the next step will create. The result so far should look like the left image of the following illustration.

18. Go down to the plane object in the modifier stack and change the length and width segments to **200**. The terrain immediately updates to show much greater detail and the face count now sits at 80,000.

19. Render the **Camera** view again. The terrain should now look like the right image.

Notice that although the terrain now has much greater detail, it isn't necessarily more realistic. The main reason is because of the excessive displacement in some of the sloping ridges that run down from the top. And the reason they exist is because of the drastic changes in color in the grayscale image used to create the displacement.

If you look at a perspective aerial of Diamond Head in the following illustration, you can see that the variance is not quite so dramatic. There is a lot of detail that would be nice to add; however, it would require you to use much greater precision during the manipulation of the original image, which you may or may not be willing to do. If you do, then increasing the face count of the object before the displacement is added might be the way to go. If you are not willing to manipulate the image as required, your next best alternative is to mitigate the variance by using the MeshSmooth or TurboSmooth modifiers. Each has its advantages and disadvantages, but they are minor and both will produce the exact same mesh.

20. Apply the **MeshSmooth** modifier to the terrain. I prefer the MeshSmooth modifier, because it won't increase the face count in the viewport until you turn the object into a mesh or poly object.

21. Render the **Camera** view. Notice that there is no significant change to the terrain. The reason is because the terrain was already smooth and had too many vertices in place to allow for smoothing to occur over a larger area. The only way you can reduce the variance in the terrain is by reducing the original face count in the plane object.

22. Change the length and width segments of the plane to **80**. The result should look like the following illustration. The terrain doesn't have the detail it had before, but it also doesn't show the bigger problem of greater variance. It also uses only about 25,000 faces rather than 80,000.

23. Just so we can finish this exercise with one more touch of realism, load the bitmap **Diamond_Head_diff.jpg** into the **Diffuse Color** channel of the applied material and render the **Camera** view again. The result should look like the following illustration. If you want to see a completed version of this scene, open the file **ch08-03.max**.

As a final note about displacement, you can animate the strength of the displacement to create the effect of an object growing out of the ground, or the effect of the ground itself growing in height.

Topographical Lines

Although displacement provides a quick, efficient, and effective way of creating 3D terrain, projects don't ever come with displacement maps. If you want one, you will need to create one yourself, and in many cases this is just not the most practical approach. The most common approach for creating 3D terrain is through the use of topographical lines.

Topographical lines, also referred to as contour lines or isolines, allow for very accurate terrain creation, but they come with two significant drawbacks. They usually require a great deal of preparation to use and require far more skill than simple displacement. In many cases, the linework is horribly constructed from a 3D artist's point-of-view, because it often contains an enormous number of breaks to help display elevation data or other data critical to a civil engineer. Occasionally, you will find things like endpoints that don't meet properly or poor layer management, but the most common problem, by far, is the break in the linework that civil engineers place in the drawings, as shown in Figure 8-2. The only solution to this problem is to fill in the gaps with your own new linework, and that is often an unavoidable situation that can take an enormous amount of time to complete.

In the following exercises, you will not be required to fill in the gaps of the topographical linework because this requirement, although very common, is a very simple task to complete that can require a great deal of time. Instead, we will jump right into the more difficult tasks of trying to solve the problems that really perplex many 3D terrain modelers. In the 1st exercise using topographical linework, we will work with a large area of land and attempt to create a decent looking terrain with a smooth appearance and with minimal polygons. In the 2nd exercise, we will work with a very small piece of terrain that will be seen up-close and will need to be created with great precision.

Creating large 3D terrain with topographical lines

1. Open the file **ch08-04.max**. This file contains one editable spline consisting of numerous individual splines placed at their proper elevation. The task of filling in gaps, welding endpoints and placing the various splines at their proper elevation was already performed because of the simplicity and time involved.

2. Select the spline and from the **Display** panel enable **Vertex Ticks**. This option allows you to see just how highly dense the vertices in the splines are.

3. Use the **Edit** > **Hold** feature to save the scene in its current state.

4. Select the **Terrain** feature from the list of available **Compound Objects**. Notice that the perimeter of the spline does not conform to the original rectangle that made up the perimeter, as shown in the left image of the following illustration. Also, there is a large amount of erratic shading and the object is plagued with a jagged appearance.

5. Press **F4** to turn on **Edged Faces** mode. Notice the enormous number of faces, as shown in the right image.

6. From the **Simplification** rollout, enable **Interpolate Points * 2**. This improves the appearance of the perimeter of the terrain but worsens the problem of excessive faces. This is not the way you should attempt to improve the look of the terrain.

7. Use the **Edit** > **Fetch** feature to restore the object to its spline configuration.

8. Add the **Normalize Spline** modifier. This could take a few moments to add because of the large amount of vertices, but when it's completed, notice that a new array of vertices are distributed per the default segment distance of 20 units. This creates far too many vertices so we need to increase the segment length.

9. Increase the **Seg Length** value to **200**. This results in 1/10th of the previous number of vertices. More importantly, it will allow us to use other tools to smooth out the terrain while maintaining sufficient detail and accuracy.

10. Reapply the **Terrain** feature to the object. The terrain now appears to be structured much better than before, as shown in the following illustration. Toggle **Edged Faces** mode on and off to help see the object with and without edges displayed. Notice that the terrain stills lacks smoothness in many areas, as shown in the left image. It would be impossible to remove this smoothness by just adding the MeshSmooth or TurboSmooth modifiers because there are too many vertices in positions that can't be adjusted. These modifiers only add vertices but cannot add them in a way their names imply. When character modelers create models, they have to create a basic structure with a very chiseled appearance. Adding too much detail too soon simply restricts the modifications that can be made later. You can see this if you try applying either of these modifiers right now. If you want smooth terrain, you will need to start with additional topographical lines around the problematic areas or create terrain with minimal polygons.

This next exercise demonstrates the need for precision and accuracy in 3D terrain creation.

Creating small 3D terrain with topographical lines

1. Reset 3ds Max.

2. Use the **Legacy AutoCAD** format to import the drawing **ch08-01.dwg**. Ensure that objects are derived by layer and that the **Convert to single objects** option is enabled. This drawing contains the linework shown in the left image of the following illustration, which is part of the more complete site drawing shown in the right image. There is one layer of topographical linework, one layer representing pavers, and a third layer representing the curbs. The paver and curb linework will be used later, so for now we can hide these 2 objects.

3. Perform a **Zoom Extents All** and hide the objects **0-Site-Curbs.01** and **0-Site-Pavers.01**.

There are 6 splines making up the topographical object, each of which needs to be placed at the proper elevation.

4. Change the **Perspective** view to an **Orthographic** view and switch to a single viewport configuration.

5. Zoom in closely, select the **0-Site-TopoLines.01** object and go to **Spline** subobject mode.

6. Leaving the outer spline at an elevation of **0'**, move each inner spline upward **1'**. The inner most line should be elevated 5 feet above the home grid.

7. Enter **Vertex** sub-object mode and weld all of the vertices in the object together. This should be something you should do every time you work on imported linework.

8. Enable the **Show Vertex Ticks** option from the **Display** panel.

9. Use the **Edit** > **Hold** feature to save this object in its current state.

10. Use the **Terrain** feature to turn the linework into a 3D mesh object. This object contains all of the same problems the terrain in the 1st exercise contained at the start, as shown in the following illustration. This object requires very precise creation because of its surrounding environment.

11. Use the **Edit** > **Fetch** feature to return the object to its spline configuration.

12. Add the **Normalize Spline** modifier with the default **Seg Length** value of **20**.

13. Reapply the **Terrain** feature and the object should appear to be much smoother along the sides. However, it still contains erratic extra polygons along its base and the smoothing on the top is still unacceptable.

14. Switch to a **Left** view and add the Edit Poly modifier.

15. Enter **Polygon** sub-object mode and with the **Window** selection active (not the Crossing), select only the very top and very bottom polygons, as shown from the **Perspective** view in the left image of the next illustration.

16. Return to an **Orthographic** view and delete the selected polygons. The terrain should now look like the image on the right.

17. Enter **Border** subobject mode and click on the very top of the terrain to select the top border of the terrain.

18. Within the **Edit Borders** rollout, click the **Cap** button. This adds a single polygon covering the entire top of the terrain. This new polygon does not have the smoothing issues the deleted polygons had.

As it stands now, the terrain is completely accurate and has sufficient smoothing everywhere except along the border of the top polygon. This hard edge along the top is far too strong and must be smoothed out. Doing so with the terrain in its current form would be more difficult and time con-suming than if the terrain was created strictly from 4-sided polygons. More importantly, making modifications after the basic structure is completed would be far more difficult with triangulated polygons than it would be with 4-sided polygons. Many 3D artists insist on creating their models strictly with 4-sided polygons because of the ease of modifying such an object versus an object created from triangulated faces. Because of the benefits of creating a mesh with 4-sided polygons, this section demonstrates the process of creating this same terrain object in this fashion. The process itself takes slightly longer than the process just used; however, the editing benefits are often worth it in the long run.

19. Use the **Edit > Fetch** feature to return the object to its spline configuration.

20. Select the terrain object and enter **Vertex** subobject mode.

21. Enable the **Show Vertex** numbers option.

22. Switch to a **Top** view.

23. Delete the 6 unnecessary vertices that lie on a straight line between adjacent vertices. These should be the vertices shown in the following illustration. These 6 vertices do nothing to define the shape of the individual splines of this object. You could also save yourself time in the process described in this exercise by deleting other vertices that aren't needed, because they lie in a straight line with their adjacent vertices. However, do not bother deleting any other vertices at this time.

Preparing objects for completely 4-sided polygons requires a very strict arrangement of vertices. Each spline needs to contain the same number of vertices, and vertices with the same number need to be next to each other on the adjacent splines. To do this, we need to pick a starting point along all 6 splines and establish a first vertex. Notice in the top-left image of the following illustration that 4 of the 6 splines have vertices positioned next to each other. We will begin here and add vertices on the other 2 splines.

24. Zoom in to the top-left portion of the terrain object, as shown in the following illustration.

25. Within the **Geometry** rollout, click the **Refine** button and click on the **4th** and **6th** splines, as indicated by the highlighted areas in the top-left image of the following illustration. The result should be two additional vertices as shown in the top-middle image. These will be the 1st vertices of each spline.

26. Select the **6** adjacent vertices shown in the top-right image and click the **Make First** button. The result should look like the bottom-left image.

Now we have to make each spline run in the same direction. Notice that 4 of the 6 splines are currently running counter-counter, but that the 2nd and 6th splines are running in the opposite direction. This is just a result of the order in which the lines were drawn or edited in AutoCAD.

27. Switch to **Spline** sub-object mode and select the **2nd** and **6th** splines as shown in the bottom-middle image.

28. Within the **Geometry** rollout, click the **Reverse** button. All 6 splines should now be running in the same direction; counter-clockwise. This is shown in the bottom-right image.

Notice in the left image of the following illustration that the 4th spline has a 2nd vertex position very close to the 1st vertex. To make this entire process work, we have to leave this vertex where it is, because it is critical to defining the shape of its spline; however, we also have to have the 2nd vertex of each of the other 5 splines be positioned adjacent to it, rather than far away from it as they currently are.

29. Switch to **Vertex** sub-object mode and use the **Refine** tool again to add a row of **#2** vertices just below the **1st** vertex of each spline, as shown in the middle image of the following illustration.

Now we have to repeat this process with the next vertex; the #3 vertices of each spline.

30. Using the 3rd spline as a starting point, add additional #3 vertices on all the other splines, so you create a row of adjacent **#3** vertices, as shown in the right image.

31. Repeat this for the row of #4, #5, and #6 vertices, as shown in the right image. After completing row 6, notice that the 5th spline (2nd from top) contains 2 vertices that serve no purpose because they don't define any curvature. Leaving them in would only mean that we have to create other adjacent vertices on the other 5 splines.

32. Delete these additional 2 vertices found on the 5th spline.

These last few steps must be repeated for the entire object. This process can take 10-20 minutes because you will need to add a couple of hundred vertices to make each vertex be a part of a row of side-by-side vertices. However, once completed, it will be very quick and easy to turn this object into an object made up of 4-sided polygons.

33. Add vertices to each of the **6** splines so that each spline contains the exact same number of vertices and so that each row of vertices is lined up in a straight fashion, as shown in the next illustration.

34. If you want to continue from this point on using an already prepared file, open the file ch**08-05.max**.

35. Add the **Turn to Poly** modifier. This modifier will help us create 4-sided polygons. Notice the large number of vertices that are generated. This happens because of the interpolation in the base spline.

36. Enable **Smooth + Highlights** mode. When you do, you can see that 3 portions of the terrain are renderable and 2 are not. This always happens when you turn a series of closed splines into a renderable object.

37. Change the object's color to something that allows the individual segments to be seen easier, such as a blue-green color.

38. Within the **Turn to Poly** modifier, enable the **Limit Polygon Size** option and set the **Max Size** value to **4**. These changes prevent polygons with more than 4 sides from forming. The difficult part is to make 3ds Max create 4-sided polygons rather than 3-sided. Unfortunately, because of the large number of vertices generated from the interpolation in the base spline, it is too difficult for 4-sided polygons to be generated. You could improve the chances by making the interpolation much lower, but the interpolation will simply change the spacing between vertices in a disproportionate fashion. Therefore, we cannot use interpolation.

39. Go down in the modifier stack to the base spline and change the **Interpolation** value to **0**. This removes all curvature in the spline.

40. Return to the **Turn to Poly** modifier and assuming you created your spline properly, you should now see numerous 4-sided polygons everywhere, as shown in the left image of the following illustration. If you refined your spline in a way that 3ds Max couldn't deal with properly, you will see 3-sided polygons, like the one shown in the left image. If you are working from the file ch08-05.max, there will be 1 individual segment that was not created properly, as shown highlighted in the left image. This edge will be dealt with momentarily.

You could apply the **MeshSmooth** modifier right now and get a nice smooth-looking mesh with 4-sided polygons everywhere; however, the lack of interpolation in the base spline will cause the resulting mesh to be generated slightly off from the location of the original splines. If you do not need great precision in your terrain, this would probably be the best option right now. In this scene, however, we need a very precise model. Therefore, we will need to add vertices in the base spline. We can't do it with interpolation, so the only other option is to manually divide the segments that need extra vertices badly. The more curvature a segment has, the more we will need to add vertices. Just remember though, that the more vertices we add, the less likely we will see 3ds Max generate 4-sided polygons. This means that we want to add just enough to retain the original shape of the splines.

41. Return the interpolation of the base spline to **16**. This will help show what edges need to be divided.

42. Enter **Segment** sub-object mode and select all of the segments that have a significant curve and a large space between the vertices that define the curve. This is demonstrated in the right image of the following illustration. Do not select edges that are very short, as dividing these will not be important and will only make it harder to generate 4-sided polygons. Also, switching to a **Fence Selection Region** and using the **Crossing** selection tool will make selecting multiple segments much easier.

43. If you want to continue using the selected edges shown in the right image of the previous illustration, you can use a named selection set that has already been saved with this file called **curves**. Simply select this from the **Named Selection** set drop-down list.

44. Change the interpolation of the object to **0** to remove all curvature.

45. Enable the **Show end result on/off** option in the modifier stack. This will show you the result of the Turn to Poly modifier even when you are working within the base spline. This is shown in the left image of the following illustration.

46. Divide the selected edges one time and analyze the resulting mesh. The result should look similar to the middle image. Notice that there are a couple of additional problem edges generated as a result of this division.

47. Divide the selected edges a second time. The result should look similar to the right image. This amount of division should be enough to ensure that the final mesh stays close enough to the shape of the original linework. You could divide further, but it would result in more work with negligible improvement.

48. If you want to continue with an already prepared file, open the file **ch08-06.max**.

49. Press the keyboard shortcut **Ctrl+V** to make a clone of the object using the **Copy** option.

50. Enter **Spline** sub-object mode, select the **1st** and **6th** splines (bottom-most and top-most) and delete these **2** splines.

51. Return to the **Turn to Poly** modifier and the 2 missing portions of the terrain should appear as shown in the following illustration.

52. Add the **Edit Poly** modifier and attach the first terrain object to the second.

53. Enter **Vertex** subobject mode and weld all of the vertices of the new object.

54. Enable **Wireframe** mode and zoom in-to any problematic areas of the object, such the one shown in the following illustration.

55. Enter **Edge** sub-object mode and select one of the misaligned edges, such as the one shown in the middle-left image.

56. Within the **Edit Edges** rollout, click the **Remove** button. This removes the selected edge. Unlike the delete command, which deletes the vertices it connects, the remove command does not delete anything else.

57. Enter **Vertex** sub-object mode and select the two vertices that have no edge running between them, as shown in the middle-right image.

58. Within the **Edit Vertices** rollout, click the **Connect** button. A new edge is created between the two vertices.

59. Repeat this process everywhere you have a misaligned edge. You can remove multiple edges at a time and connect multiple vertices (that are part of the same row) at the same time, such as those shown in the following illustration. Only after there are no misaligned edges can you continue with the next step.

60. If you want to continue with an already prepared file, open the file **ch08-07.max**.

61. When you think you have connected the last set of vertices, return to **Edge** sub-object mode and select any edge that runs up and down the slope of the terrain (not one that runs laterally or horizontal to the ground). An example is shown in the left image of the following illustration.

62. Within the **Selection** rollout, click the **Loop** button to select all of the edges that are connected and make up an individual row.

63. Click the **Ring** button to select all the edges that run laterally around the terrain. If all of the edges running up and down the slope of the object are selected, as those shown in the right image, then you know you are finished with the alignment of the edges. If the Ring command did not cause all of these edges to become selected, you have a misaligned edge somewhere in the object.

64. Close **Edge** sub-object mode and switch to an **Orthographic** view as that shown in the next illustration.

65. Enter **Border** sub-object mode and use the **Cap** feature to add a top to the terrain as we did before.

66. Close **Border** sub-object mode.

67. Within the **Edit Geometry** rollout, click the **MSmooth** button. This turn breaks each 4-sided polygon into 4 smaller polygons of equal size, as shown in the middle image. You cannot just add the MeshSmooth modifier to achieve the same effect. Notice that the top polygon has been changed in a negative way.

68. Undo this last command.

69. Enter **Polygon** sub-object mode and select the polygon that makes up the entire top of the terrain object, as shown in the left image of the following illustration.

70. Within the **Edit Polygons** rollout, click the **Settings** icon immediately to the right of the **Inset** button and create an inset **12** inches from the perimeter of the top polygon, as shown in the middle image.

71. Delete the selected polygon that makes up the top of the terrain. Next, we're going to apply the MSmooth feature again; however, we needed to add an inset row of polygons as we just did because we need a horizontal set of polygons to make the smoothing action of the MSmooth feature create a complete bend around the rim of the terrain. Otherwise, we would still be left with an abrupt edge as before.

72. Close **Polygon** sub-object mode and then click the **MSmooth** button inside the **Edit Geometry** rollout. The terrain should appear much smoother, as shown in the left image of the following illustration.

73. Click the **MSmooth** button again and the terrain should be even smoother, as shown in the middle image.

74. Enter **Border** sub-object mode and select the border along the top of the terrain.

75. Within the **Edit Borders** rollout, click on the **Cap** feature to create another top for the terrain.

76. Render a close-up **Perspective** such as that shown in the left image of the following illustration, to see what the terrain looks like at this point. You should see a noticeable facet look to the terrain along the top.

77. Apply the **Smooth** modifier with the **Auto Smooth** option and render the view again. The facets should completely disappear, as shown in the middle image.

78. Render the entire terrain to see what it looks like. It should look similar to the right image.

At this point, we are finished with this phase of the terrain's construction and the only thing that remains to be done is to tweak the somewhat perfect look of the terrain and make it a little more believable by adding some imperfections. This can be done with numerous different modifiers, most of which you should be familiar with. These include the **FFD**, **Edit Poly Soft Selection**, **Edit Poly Paint Deformation**, **Noise**, **Relax**, **Wave**, **Ripple** and many more.

Keep in mind a couple of very important points with any of these tools. If you want to apply these modifiers to the entire object, you will need to detach the top polygon, subdivide it to create sufficient polygons with which to apply the modifiers, and then reattach these polygons and weld endpoints. If you want to apply these modifiers to specific parts of the terrain, don't forget to take advantage of the great sub-object selection tools within the Edit Poly modifier; such as **Loop** and **Ring**, as well as the feature that allows you to translate a selection by holding down the Ctrl key while simultaneously clicking on one of the other sub-object icons (not the word in the modifier

stack but rather the icons below the stack). With these tools, selecting the exact sub-objects you want becomes easy.

Also, don't forget to use the **View Align** and **Grid Align** features once you've applied modifiers to your terrain. For example, if you apply the Noise modifier to the entire object gaps will form along the bottom of the terrain where it meets the surrounding terrain. However, if you then select the entire bottom set of vertices, switch to Top view and click the Grid Align button, all of the disturbed vertices will return to the home grid.

If you want to experiment more with this current scene using an already prepared file, open the file **ch08-08.max**. Also, try practicing the techniques described in the previous chapter on 2D sites and use those to create the other elements depicted in this project's linework. The linework that was hidden at the beginning of the exercise would be a great place to start. When these elements are created, you could have something that looks like the following illustration. If you want to investigate this completed scene, open the file **ch08-09.max**. As a side note, the walkways in this project contain stairs in real life, which is why you see such large and unrealistic inclines on the walkways up to the pool area. Adding this type of element is best once you've already prepared the model as shown in the following illustration.

The remaining two sections of this chapter deal with some additional issues concerning 3D terrain that should help you in a number of different situations not yet addressed.

Adding Site Elements to 3D Terrain

The techniques you use to add site elements to 3D terrain should be very similar to the techniques used for 2D terrain, with a few specific differences. The following section lists some of the major types of site elements and a recommended approach for their creation.

- **Roads** – Use the **Boolean** > **Cut** > **Split** feature to cut your roads out of the terrain just as you do with 2D terrain.

- **Curbs** – Once you create your roads, convert the roads to an Editable Mesh and use the **Select Open Edges** and **Convert to Shape** features to create a spline that exactly follows the sides of the road. You can then use the Loft or Sweep features to create your curbs and have them follow the contour of the terrain.

- **Sidewalks** – Use the **Boolean** > **Cut** > **Split** feature to cut out the sidewalks and then use the **Extrude** feature within the Edit Poly or Edit Mesh modifiers to create thickness to the object.

- **Pavers** – Use the **Boolean** > **Cut** > **Split** feature just as with 2D terrain.

- **Parking Lines** – Unlike 2D terrain, where the parking lines can float slightly above a parking lot, parking lines on 3D terrain must be cut out of a parking lot to prevent them from being buried in it. You do not need to worry about disabling the Shadow Casting feature for parking lines with 3D terrain.

- **Mulch** – As with parking lines, mulch must be cut out of 3D terrain to prevent it from being buried in it.

- **Bodies of Water** – Since water is always going to be flat, it is important to remember that if you decide to cut out your body of water from 3D terrain, you will have to use the **View Align** or **Grid Align** features in **Top** view to make all the affected vertices return to the same plane.

- **Grass** – The grass object is often the first object created from which others are cut out. Therefore, you must always ensure to start with enough polygons to allow for enough accuracy in your cuts and enough detail in your 3D terrain. However, assuming that you will be using smoothing tools with your terrain, you should also be careful not to create too many polygons initially, which would reduce the program's capability to generate larger curvature between vertices.

Controlling the Bumpiness in 3D Site Elements

If you cut an element of out 3D terrain and want to reduce the bumpiness of that object, such as for a road or sidewalk running through rough terrain, you can make the object flatter without negatively affecting the terrain around it. The following exercise demonstrates how to do this.

1. Open the file **ch08-10.max**. This scene contains two objects; a high density plane to simulate a terrain of rolling hills and an object that will be cut out of the terrain to simulate a road running over the hills.

2. Select the plane object and use the **Boolean** > **Cut** > **Split** feature to cut the road out of the plane, as shown in the left image of the following illustration. Once the cut is made, do not detach the road.

3. Add the **Edit Poly** modifier to the compound object and enter **Polygon** sub-object mode. The road polygons should be automatically selected.

4. Within the **Polygon Properties** rollout, change the material ID of the selected polygons to ID #**2**.

5. Enter **Vertex** subobject mode, press **Ctrl+A** to select all the vertices and weld all the vertices of the object back together. This causes the object to return to having just one element.

6. Enter **Polygon** sub-object mode and press **Ctrl+D** to deselect all polygons. Unless you created a unique material ID for the road polygons, there wouldn't be a quick and easy way to select all the road polygons again. It is important to set up material IDs like this, in the event you need to return to sub-objects that have deselected, and cannot benefit from multiple elements due to the welding of vertices.

7. Use the **Polygon Properties** rollout to select all the polygons with material ID #**2**.

8. Enable **Soft Selection** with a **Falloff** value of **5**. If you were to apply a modifier to these selected polygons now, the soft selection would still affect the surrounding polygons. Also, you could switch to Top view right now and use the View Align or Grid Align features to make all the selected polygons align to the same plane. If you did, the soft selection will still affect the surrounding polygons. Instead of doing any of these things, let's do something even easier.

9. Use the transform gizmo to apply a non-uniform scale along the Z axis. You can apply a moderate scale as shown in the middle image of the following illustration, which leaves some deformation in the road, or apply a 100% scale downwards along the Z axis to make the road completely flat, as shown in the right image. Had we not used a soft selection, the change from the road to the surrounding polygons would be quite unrealistic.

Summary

When you know some effective techniques, creating 3D sites can be one of the most enjoyable areas of a 3D visualization project. However, if you aren't familiar with some effective techniques, it can be one of the most frustrating areas. Numerous tools in 3ds Max were developed specifically to aid in the creation of the very objects this chapter is based on. These include things like the ShapeMerge and Conform. Both of these tools might seem at first to be ideal 3D site creation tools, but both have major issues that make working with them more trouble than they are worth. There are far better tools to use that weren't even created specifically for 3D sites, and more so than most areas of 3D visualization, the techniques you develop are probably limited more by your imagination than by the tools available. It probably won't be too many more releases before Autodesk makes 3D site creation even easier with more dedicated tools; but in the meantime, we must rely on our imaginations more than the tools they created specifically for our type of work.

Creating Backgrounds

FEW OTHER SCENE COMPONENTS ARE as simple to create and yet so often compromised as are backgrounds. Often consuming more than half of the area of a visualization, backgrounds are as critical as any other scene component and deserve as much care and attention as any other area of scene creation. Although backgrounds are a relatively simple element to add to a scene, they can just as easily be a source of frustration and problems for 3ds Max users.

There are three primary methods in which 3ds Max artists create backgrounds for a visualization. Sadly, it seems that the best method is also the least ubiquitous. One method is to apply a background through the Environment Map channel. A second is to apply a background with 3rd party software. The third method, and the one I recommend for most visualizations is to apply a background image to a 3D object.

Each of these methods has distinct advantages and disadvantages and neither provides the best solution for every type of scene. The following discussion explains each of these methods and the various ways they can be implemented.

Image Types

Before beginning a discussion on the different ways in which backgrounds can be applied to a visualization, it would be appropriate to cover the different types of images that can be used for backgrounds. All background images can be categorized in one of two ways; **cylindrical** or **spherical**. Cylindrical images are nothing more than undistorted images stitched together to form a panoramic view. These images can be captured and created by specially designed cameras, specially designed software, or manually using photo editing software. They are essentially undistorted images that can be used to create up to a full 360-degrees of background for a scene, and because they are distorted, they are the ideal type of image to use as a background. Figure 9-1 shows an example of a cylindrical image that represents 180 degrees of horizon.

Figure 9-1. An undistorted cylindrical image.

Spherical images are distorted images that provide a complete 360-degree representation of an entire hemisphere or an entire sphere of background. They are captured with special spherical cameras or created with special software and appear distorted in image form and relatively un-distorted when applied as a spherical or hemispherical environment background to a 3D scene. Figure 9-2 shows a spherical image with obvious distortion similar to a Mercator Projection map. This image is a representation of an entire 360-degree full spherical environment and shows everything that could be seen if you were standing in the same spot from which this image was taken.

Figure 9-2. A distorted spherical image.

There are many flavors of spherical and cylindrical images used as backgrounds for 3D scenes. Some cylindrical images show land below the horizon and sky above, while others only provide a view of the sky. Typical FOVs (field-of-views) are 180, 270, and 360 degrees while in terms of image resolution and aspect ratio, there are no typical values. Image resolutions from leading vendors can be found well over 10,000 pixels across and depending on the FOV and your rendering size, you may need every one of these pixels to achieve clear and realistic backgrounds. Later in this chapter we will look closely at how to determine what resolution is needed for any given situation.

As an additional note, almost all of the bitmaps shown in this chapter come from the **Marlin Studios** collection (www.marlinstudios.com). Many years ago, we purchased their entire collection of imagery and even though we use only a small percentage of their product, their collection is wonderful and having such a large variety is important when trying to find the right background.

Other leading vendors include **Dosch Design** (www.doschdesign.com) and **Hyperfocal Design** (www.hyperfocaldesign.com). All three provide very high resolution imagery suitable for backgrounds.

Environment Channel Backgrounds

The first background type we'll look at is a background created with the **Environment Map** channel. This is the simplest type of background to implement, yet often the most difficult to make look good. It is nothing more than a color or a map applied in a fixed orientation, although a video file can be applied as well. By default, 3ds Max uses a black color swatch in the **Environment and Effects** dialog box to provide a black background. This type of background is a poor choice regardless of the color, but black is particularly bad even for test renders because of how it can hide the boundaries of an object. Regardless, using a single color for a background is not realistic, and therefore, maps are really the only acceptable alternative.

Figure 9-3. The Environment and Effects dialog box.

If you load a map into the Environment Map channel, you are telling 3ds Max to override the background color and display the map to the extents of the rendered window, regardless of how large the rendered image may be. The only real advantage of using the Environment Map channel over the other 2 options mentioned is that it's quick and easy to implement. However, this single advantage suddenly becomes the greatest disadvantage whenever you decide to manipulate the mapping, and since maps loaded in the Environment channel are mapped to fit the dimensions of the render window by default, manipulation of their tiling and placement is usually required. For example, without adjusting the placement of a bitmap loaded in the Environment channel, you would have to find a background image whose horizon line closely matched your scene's horizon line. And without adjusting the tiling of a bitmap, you would have to use a bitmap whose aspect ratio closely matched the aspect ratio of the rendered image. Figure 9-4 shows a scene with a background image that lacks both of these qualities, as most would. The background image is squashed to fit the render window and the horizon lines certainly do not match. Finding a suitable bitmap is difficult without editing the original image so the only solution, of course, is to adjust the placement and tiling.

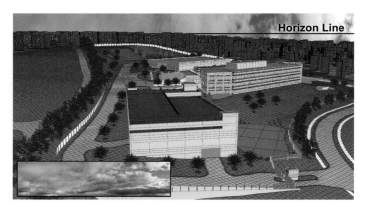

Figure 9-4. A bitmap unsuitable for use as a background with default placement and tiling.

If you want to adjust the placement and tiling of a map loaded in the Environment Map, you have to load an instance of the map in the Material Editor and make the adjustments there. To load an instance, drag the map from the Environment Map channel into any sample slot of the Material Editor and choose the **Instance** option. Doing this causes the sample slot to show a map instead of a material and that map will automatically be using the **Environ** option with **Screen** mapping, as shown in Figure 9-5.

Figure 9-5. The Screen mapping enabled for an Environment based bitmap.

Within the **Mapping** drop-down list are four different options for the mapping of an image that is used as an environment, as shown in Figure 9-6. Each of these options provides a unique way for the map to be placed in the background. Let's look at the differences of each type, but before we do, let's first look at a feature that can significantly improve your ability to work with background images loaded in the Environment Map channel by controlling their display in viewports.

Figure 9-6. The four mapping options for a bitmap used as an enviroment background.

In the **View** menu, there is an option to open the **Viewport Background** dialog box (hotkey=**Alt+B**) shown in Figure 9-7, which allows you to load an image or video into a viewport's background. This can serve as an invaluable visual reference in many different situations, whether you are trying to superimpose 3D models with video (i.e., camera tracking), or simply trying to model a piece of furniture with an image of the furniture in the background.

Inside this dialog box are some additional controls not available through the **Material Editor**. The **Animation Synchronization** section provides controls for implementing animated backgrounds, while the Aspect Ratio section lets you match the background image or animation to the aspect ratio of a viewport, the render window, or to keep the bitmap unchanged. Regardless of which options you use in this dialog, the one that matters most is the **Display Background** option, which enables the background in a viewport.

Figure 9-7. The Viewport Background dialog box.

Screen

The default **Screen** option places the map to the extent of the rendered view. While this option is suitable for single renderings, it's not suitable for multiple views unless you change the map with each new view. In Figure 9-8, for example, the background image alone diminishes the believability of the sequence. It should be noted that the contributor of these images did not actually do this for this project; this background was intentionally used for both perspectives here to illustrate a point.

Figure 9-8. An unrealistic use of the same background image for two different perspectives.

Because the background is a fixed image when the Screen option is enabled, you cannot use this type of background with animations unless the map loaded is an animation itself. Needless to say, with great camera tracking available, this is a futile way to work.

One choice you do have with the Screen option is to use a gradient map. Figure 9-9 shows a gradient map used as a background to simulate a sky just after sunset. Since the image only changes in the vertical direction, you do have the option to make this the background of an animation provided the camera's vertical orientation doesn't change at all. This restriction makes using a Target Camera impossible unless the target stays at the exact same elevation as the camera throughout the entire animation. If this restriction is acceptable, then a gradient map is a possible alternative to the next 3 environment types. There are 3 clear advantages to this type of background. One is that it can be set up in just a few seconds. The 2nd is that you don't have to worry about the resolution of the map as you would if you were using a bitmap. The 3rd is that it renders faster than any other type of background where a bitmap is used.

Figure 9-9 A gradient map used as a background.

Spherical Environment

The **Spherical Environment** option wraps a map around an infinitely large virtual sphere that surrounds your scene. The primary benefit of this option is that if you use a proper spherical map, you can allow your camera to look anywhere in the sky and expect to see a background image without having to worry about distortion or revealing a seam. If you do not use a spherical map, the distortion will be more severe the higher up in the sky the camera looks.

The left image shown in Figure 9-10 is a cylindrical image, meaning that it cannot be used for spherical mapping. The right image shows what the map would look like if the camera were pointed straight up in the sky.

Figure 9-10. An undistorted cylindrical map (left) and a heavily distorted view when looking straight up (right).

The left image in Figure 9-11 is a distorted spherical map, which when used as a background with spherical mapping results in virtually no distortion, even when looking straight up, as shown in the image on the right.

Figure 9-11. A distorted spherical image (left), and an undistorted view of when looking straight up (right).

Cylindrical Environment

The **Cylindrical Environment** option wraps a map around an infinitely large virtual cylinder that surrounds your scene. The problem with this particular type of mapping is that all images are going to have some noticeable distortion because an infinitely large cylinder means that the top of the image will be infinitely far away. Figure 9-12 shows the inside of an extremely long cylinder (with normals flipped) whose top vanishes into infinity. If you imagine an image of any kind mapped onto this cylinder, the top of the image would wrap around to a single point that diverges off to infinity. For this reason, I don't recommend this mapping type. In fact, if you were to use the map shown in Figure 9-10 with cylindrical mapping, the result would be almost identical to the image shown on the right.

Figure 9-12. A view looking straight up when using cylindrical environment mapping.

Shrink-Wrap Environment

The **Shrink-Wrap Environment** option wraps the map around an infinitely large virtual sphere so that all four corners of the map wrap around and meet at the same point. This mapping type creates more distortion than spherical mapping but the one benefit of using it is that it has only one point where a seam is noticeable. If the mapping is adjusted so this point occurs below ground where it won't be seen, then using this mapping type might be an option for you.

Summary of Environment Maps

With the possible exception of the **Screen** option, I believe environment maps are far too difficult and restrictive to even consider as an option for a background. You will find that in order for a bitmap to look good as an environment map, it must be of a high enough resolution or it must be tiled. If you decide to use the **Spherical Mapping** option, which is the best possible option for animations or for projects where multiple rendered views are needed, the bitmap you use should be approximately eight times larger than the final rendered output. The reason for this is that the typical camera used has approximately a 45-degree field of view and sees only one-eighth of the 360-degrees with which the environment has been stretched to. Therefore, that one-eighth segment should be at least as high a resolution as the final rendered output.

The spherical bitmap shown in Figure 9-13 contains 9000 pixels in the horizontal direction and 2300 pixels in the vertical direction. Such a large resolution image is necessary when it is stretched to cover an entire spherical background; or in this case a full hemisphere.

Figure 9-13. A spherical map with a 9000x2300 resolution.

If a bitmap doesn't contain enough pixels in either direction to provide a sharp background your only choice is to tile the map. If you tile a bitmap twice, you are telling 3ds Max to stretch the bitmap through 180 degrees of the environment (both vertically and horizontally) and therefore the bitmap has to only be twice as high in resolution to look as sharp. The problem with tiling, however, is that you have to be careful to keep the seams (caused by tiling) out of view. This will often prevent you from being able to look around very much in a horizontal direction and also prevent you from looking very high in the sky.

Unless you use the perfect type of bitmap image, tiling the background is almost always going to be a necessity. Because tiling and placement of a background map is so much more difficult with only the viewport background image as a guide, I highly discourage the use of maps in the environment channel. Nonetheless, a discussion of why was warranted.

In 3ds Max 2009, the **mr Physical Sky map** is the default map type for the **Daylight** system. This terrific new feature is an environment map and is certainly an exception to our recommendation of not using environment maps within 3ds Max.

Geometry Based Backgrounds

The background types discussed so far have all been those created through the **Environment Map** channel. Geometry-based backgrounds are those where a map used to represent the background is placed on geometry. This type of background is by far the most widely preferred in our industry,

and for good reason. Although it requires more than simply loading a map into the environment channel, it is actually far easier to work on a background using geometry as a guide than it is to use the viewport background image as a guide. Placement and tiling of the map becomes much easier using an object like this, rather than having to do it through the use of a viewport background. Using an object, you can use the viewport navigation controls to quickly move around and see all areas of the map and any problems that may exist.

There are three primary types of geometry used as background objects: hemispherical objects, cylindrical objects, and angular objects. The following discussion describes how each type can be used.

Cylindrical Environment Objects

A cylindrical environment object is nothing more than a cylinder whose top and bottom faces have been removed and whose remaining face normals have been inverted so that the cylinder is visible from the inside. Figure 9-14 shows a cylinder surrounding an entire 3D scene with an image of a background placed on the cylinder so that it's seen behind the other 3D objects.

Figure 9-14. A cylindrical environment object used as a background.

The primary advantage of using this type of geometry object for backgrounds is that there is absolutely no distortion of the map placed on the object if you use a map with an aspect ratio that matches the cylinder. This advantage probably makes it the most commonly used background type. An easy way to make a cylinder with an aspect ratio that matches a bitmap you want to use is to create a plane in **Front** view with a length and width that exactly matches the bitmap. Apply **1** length segment and approximately **50** width segments, and then use the **Bend** modifier to bend the plane 360-degrees. The result will be a perfectly undistorted background every time.

The primary disadvantage of using a cylinder as a background object is that if your camera looks high enough into the sky, it would eventually see the top of the cylinder and the environment channel background color behind it, as shown in Figure 9-15. Obviously, this is not acceptable, but most 3D scenes don't require the camera to look so high up into the sky. When it is necessary to do so, you can move the vertices at the top of the cylinder higher. Of course, you can only do this to a certain point before the distortion becomes too great. If the cylindrical environment option will not work you can use a hemispherical object, as discussed next.

Figure 9-15. The top of a cylinder environment object visible when looking too high in the sky.

Hemispherical Environment Objects

Like the cylinder background object, a hemispherical background object is nothing more than half of a sphere whose face normals have been inverted so the object is visible from the inside. When such an object is scaled large enough to surround an entire scene of objects, it can serve as a great type of background. In Figure 9-16, a hemisphere is placed on a plane representing the ground, thus creating the possibility of a 3D scene, completely sealed from the view or from the effect of the background channel.

Figure 9-16. The hemispherical environment object.

When you place the hemispherical object in your scene, you should ensure that it completely surrounds the objects in your scene, with the one exception of the object that represents the ground stretching out to the horizon. In Figure 9-16, you can see that the ground extends beyond the limits of the hemisphere, and therefore, there should be no gaps between the 2 objects through which the environment background can be seen. This of course assumes that the base of the hemisphere rests on the ground rather than floating above it.

Background objects and the ground do not have to join to form a completely sealed environment. Depending on camera placement and other objects that obscure the background object and background color, you may have your background object floating above, penetrating through, or much larger than the ground object in your scene. The important thing to remember is to keep the environment background color hidden from view at all times. This applies to any geometry type you use as a background.

Just like spherical objects, hemispherical objects require the use of properly constructed bitmaps. When a non-spherical bitmap is used on a spherical object, as shown in the left image of Figure 9-17, severe distortion can result, thereby negating the real benefit of using a spherical object in the first place. However, even when a proper spherical bitmap is used, a curving effect can

appear in the bitmap, as shown in the right image. This effect is difficult to avoid and is more prevalent in bitmaps with more clouds visible. This is one reason why many artists elect to use images with very few clouds in the sky. Notice also that no trees or ground objects are visible in either image. As mentioned, this is because the curving effect would make this part of a bitmap look noticeably bad. It is for these reasons that many in the visualization industry don't use spherical objects as a background object. In just a moment, we will see what the real benefit is of using spherical background objects.

Figure 9-17. The hemispherical environment object.

Angular Environment Objects

Angular environment objects are background object types that only cover a certain angle of the scene. Unlike spherical and cylindrical object types, they do not provide a background for an entire 360-degree view. They can be something as simple as a single polygon, as shown in Figure 9-18, or an extruded arc that covers a larger field of view.

Figure 9-18. The angular environment object.

The primary advantage of this type of background object is that it is very quick and easy to set up. You can create a polygon with the same aspect ratio as the bitmap you want to use on it and then simply scale and position the object so it covers the entire field-of-view for the camera you want to render.

The primary disadvantage is that you cannot easily use a single background object for multiple rendered views or animations. Because of this disadvantage, it would only be practical to use this background object type if you knew beyond any doubt that your final product was going to be a single rendered view. You could actually use more than one of these object types for different rendered views, as long as you use different bitmaps to prevent the same background from being seen in multiple views.

Using Multiple Background Objects

You are not confined to using one background object type to produce a nice background. Sometimes you might find it useful to combine two different bitmaps to provide the look you want to achieve, such as one bitmap for the sky and a second bitmap for the land. In the left image of Figure 9-19, you can clearly see that 2 objects were used in the background of this scene. In the image on the right, you can see that one represented the sky and one represented the land, or more specifically, the trees. To mask the sky in the image showing the trees, an alpha channel had to be used. Two objects were used in this scene because we wanted a certain look for the trees in the background and did not have the appropriate image that contained both the trees and sky we wanted. We could have created such an image in Photoshop using the combination of both bitmaps; however, we find it easier to use this method.

Figure 9-19. Multiple background objects used for scenes.

Illuminating Backgrounds

Just like other objects in your scene, background objects must be illuminated. You can choose to illuminate your backgrounds with the same lights that illuminate your other objects; however, this method is not recommended. The best way to illuminate a background is with a single omni light, centered within the background object and used to only affect the background object and no other objects. There are two advantages of using this method. First, an omni light casts an equal amount of light in all directions and, therefore, all parts of the background object would be illuminated the same, unlike a direct light, a sunlight system, or any other light type you use to illuminate the objects in your scene. The second advantage is that you can control the illumination of your background without affecting other objects in your scene, and vice versa. Both of these advantages are extremely important to creating realistic backgrounds.

Backgrounds in Reflection

It was mentioned earlier that spherical objects are often difficult to use because of distortion and curving that often occurs with the bitmap image. For this reason it is not the preferred background object type. However, there is one very nice benefit of using spherical background objects. Whenever you use a cylindrical or angular background object, you have to be careful not to show the top of the cylinder or the background color beyond. But you have to be just as careful so that they don't show up in the reflections in your scene. Often, you will have a background object that works great as the background, but because of the position of your camera and the direction it looks, the reflections in your scene may make using that object unacceptable. For example, the left image in

Figure 9-20 shows a lake reflecting the cylindrical environment and the top of the cylinder is clearly visible in the lake's reflections.

The simple solution is to use a cylindrical or angular object for the background image and a spherical object for the background reflections. This means that you see a different background object in reflections than you see directly through your camera. This is probably the most preferred type of background setup in visualizations. The image on the right shows the same lake with the cylinder's reflections disabled and a spherical object used for reflections in its place. No matter where you look in the scene, you will never see the sky improperly reflected.

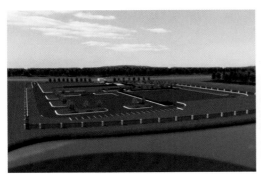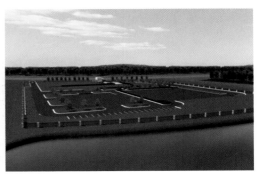

Figure 9-20. Reflecting a cylinder environment (left) and a spherical environment (right).

To use this method follow these 2 simple steps:

1. In the **Object Properties** dialog box of cylindrical / angular background objects, disable the **Visible to Reflection/Refraction** option.

2. In the **Object Properties** dialog box of spherical objects, disable the **Visible to Camera** option.

Figure 9-21. Disabling the visibility options for certain environment objects.

The main reason why this is a good way to set up your background is that you will see undistorted maps directly through your camera and regardless of where you look, you won't see the edges of your cylindrical/angular background objects or scene's background color in reflections. Even if a spherical map appears to be somewhat distorted when applied to a spherical environment object, this effect will almost always be unnoticeable in reflections. This is because when you do see reflections, you usually only see a small area of the sky reflected and what you do see is often obstructed by blurriness applied to the reflections or obstructed by some other object.

The importance of using two background object types like this is also very apparent when you look up at the windows of a building, as shown in Figure 9-22. Here again, the top of a cylinder background object might clearly be visible.

Figure 9-22. Reflections of a spherical environment while looking up at windows.

If you would like to use the background rig shown in Figure 9-23, open the file **typ_background_rig.max**. Remember that whenever you add a light to your scene, especially a light representing the sun, you have to exclude these 3 objects from the light.

Figure 9-23. The typical background rig used at 3DAS.

Applying Backgrounds with 3rd Party Software

An additional method of applying backgrounds to a scene is through the use of 3rd party software; either a plug-in that runs inside of 3ds Max or software that runs outside of the program. This can include image editing software such as **Photoshop** or video compositing software such as **Combustion**.

Image Editing & Video Compositing Software

Many 3ds Max artists prefer to use software like Photoshop to create backgrounds for their visualizations. This is certainly a viable solution and one that provides quick and easy changes to a background. There are a few different ways to set up an image or animation to allow for this type of workflow, but one that is perhaps most widely used is the application of the **Matte/Shadow** material on an object to create an alpha channel. Applying a Matte/Shadow material to the window glass in Figure 9-24 causes an alpha channel to be created automatically, which can be used in other programs to place a background image.

Figure 9-24. Window glass rendered with a Matte/Shadow material to allow background placement outside 3ds Max.

More about the use of these programs will be discussed in the chapters dealing with advanced animation, effects, and Photoshop techniques.

Plug-Ins

There are several choices available that allow 3ds Max users to automatically generate backgrounds based on parametric input. but one stands out from all others. The **Vue xStream** suite of plug-ins from **e-on software** allows you to create amazing 3D atmospheric environments that go well beyond the application of simple background images to a scene. The following description from the www.e-onsoftware.com website is not an advertisement, as the company was not made aware of my mentioning their product. I simply feel that with a discussion about creating backgrounds, and other site objects in other chapters, mentioning this amazing software is appropriate.

"True to its purpose as a complete solution for natural environments, Vue 6 features an elaborate atmosphere engine that does much more than mere backgrounds. Vue's atmospheres provide an accurately simulated environment that affects all the elements of the scene, and behave according to nature's rules. The appearance of an object in a Vue scene is directly affected by the position of the sun, the cloud cover, the amount of dust in the air, or the humidity level.

However, different projects require different approaches to the simulation and rendering of atmospheres. This is why Vue 6 offers no less than four different atmospheric models, ranging from simple background skies to photo-based environments and physically accurate atmospheres. Within this wide choice you will find the solution that best fits your project's needs.

Upon rendering, xStream kicks-in its own render engine, which works in parallel to the native renderer. This assures that the Vue elements will look exactly as if they were rendered inside Vue, and also helps speeding up the rendering of polygon-heavy elements such as terrains and EcoSystems.

However, this is a completely transparent process. There is no need to deal with the xStream renderer. Parameters such as render resolution and anti-aliasing quality need only to be set for the native renderer."

While we have not yet integrated this product into our workflow at 3DAS, through use of a trial version of the software we have determined that integration of the product in certain types of projects is probably in our near future.

Figure 9-25. The Vue xStream plug-in.

Other Considerations

- Whether you use one object for your background or multiple objects, it's important to remember to turn off the **Cast Shadow** option for your background geometry. There is no reason why your background objects need to cast shadows, and doing so will cause them to block your scene from any light placed outside them. Even though the only light that should affect your background objects is the single omni light placed in their center, it is good practice to disable shadows for these types of objects.

- If you use global illumination, be sure to exclude these objects from advanced lighting or global illumination. These objects are the largest objects in any scene and their effect on the light that bounces around a scene is tremendous. Allowing these objects to bounce light will essentially paint your scene with a large amount of blue light.

- Make sure you use enough faces in the creation of your background objects. Using too few will cause facets to appear on your background. Relative to the rest of your scene, the background object has a negligible effect on rendering times and refresh rates so you shouldn't skimp on this object.

- If you have a background image that shows up pixilated in a viewport, try enabling the **Match Bitmap Size As Closely As Possible** option, within the **Preferences** > **Viewports** > **Configure Driver** dialog box.

Summary

Backgrounds are an immensely important part of almost every 3D scene. Whether you just see the background itself, reflections of the background, or the effects of the background through global illumination, this particular part of a 3D scene must be done correctly to achieve a convincing and realistic look. Especially for exterior scenes, where backgrounds can often comprise half of what is seen in a rendering, the importance of an effective background can't be overestimated. This discussion has only brushed the surface of some of the important considerations and methods of implementing great backgrounds. Like all areas of 3D, your ability to explore other methods is limited only by your imagination.

Creating Vegetation

UNLIKE THE CREATION OF MOST object types in visualization, creating vegetation is more an art than a science. When you create walls, roofs, sites, and most other scene elements, you usually do so with the precise guidance of architectural or engineering drawings. Even though we reserve a certain degree of artistic interpretation in the creation of many object types, especially in the absence of information, that degree usually extends much farther with vegetation. For example, when a set of architectural drawings specifies that the roof of a house needs to be a barrel tile roof, it probably doesn't matter if the roof is barrel tile or Spanish tile, but it certainly needs to be some kind of tile, rather than a completely different roofing material such as standing seam or asphalt shingles. On the other hand, when a landscape drawing specifies the placement of an oak tree, you can often substitute a completely different tree, such as an elm. When you place the front door of a house, that door needs to be placed with precision. On the other hand, the location of a tree is often guided less by a landscape drawing and more by where it can block the view of something you don't want the camera to see. These are just a few examples of the added latitude that we are usually afforded in the creation of vegetation as compared to the creation of most other object types. Furthermore, landscape drawings are often never provided, in which case we are sometimes asked to play the role of landscape architect.

Because of the artistic nature of creating vegetation and the myriad issues that challenge our computers' resources, vegetation is one of the most difficult elements of a 3D scene to simulate realistically. This is especially true when your scenes are animated, and your cameras move in and around the vegetation. Whether a scene contains 2D vegetation, 3D vegetation, or a combination of both depends on numerous factors, such as rendering time available, your vegetation libraries, distance of the vegetation from the camera, camera paths, and available RAM. Improperly created vegetation can lead to extremely large file sizes, excessive rendering times, or even system crashes.

So how do you add thousands of trees and plants to your scenes without crashing 3ds Max or without taking weeks to render? Furthermore, how do you even place the vegetation without taking endless hours to do so? The solution can be elusive and is completely scene dependent, but the following is a discussion on some considerations that may make the solution easier to find.

Types of Vegetation

Vegetation in a visualization can be categorized in one of two ways; 2D or 3D. 2D vegetation is represented by imagery and 3D vegetation is represented by a large number of small polygons that together simulate the physical structure of a certain type of vegetation. For each type, there are several methods of implementation and endless tips and tricks to be used. But before jumping into a discussion about effective methods of creation and placement, let's look closely at both vegetation types and the pro and cons of using each.

3D Vegetation

It wasn't many years ago when the idea of using 3D vegetation in a scene was considered ridiculous and impractical. When the 1st version of 3ds Max came out, most top visualization firms relied heavily, if not completely, on 2D vegetation. The few firms that did implement 3D vegetation were usually only able to place just a few examples very close to the camera, and most of those were hand crafted and still relatively low polygon compared to today's standard. Today, 3D vegetation *is* the standard.

Sometimes containing hundreds of thousands of polygons per example, 3D vegetation, like the one shown on the left side of Figure 10-1, provides an undeniable degree of realism over 2D vegetation, like the one shown on the right. Sometimes that realism isn't always needed or justified, such as trees off in the distance, but when it is needed, using 3D vegetation can truly make or break a scene.

Figure 10-1. An example of a 3D vegetation (left) and 2D version (right).

The obvious advantage of 3D vegetation is that it looks 3D. It has depth and looks different at every angle. Not only does it cast great shadows, unlike 2D vegetation it also casts realistic shadows on itself, which is a tremendous advantage that adds to its depth. Another tremendous advantage is that you can view the vegetation from any angle, unlike 2D vegetation, which can look distorted when viewed at high angles and strange when not viewed from the same angle from which the image was captured.

The obvious disadvantage with this type of vegetation is that it significantly increases your refresh rate and render time. 3D vegetation slows render times because of the faces that must be rendered and because of the shadows that must be accounted for.

Unfortunately, 3ds Max presents an extremely meager, and for all practicality, useless selection of 3D vegetation. Fortunately, there are numerous 3D software packages available today that can satisfy your needs in this area.

When we first started implementing 3D vegetation in our scenes at 3DAS, like most firms we were forced to create vegetation from scratch, sometimes spending an entire day to create one tree or plant. Over the years we spent many hundreds of man-hours building our own custom vegetation library, only to abandon most of it for the more realistic vegetation we can produce in a fraction of the time with a software package called **OnyxGarden Suite** for Onyx computing (www.onyxtree.com). This is a series of plant generator programs that run outside 3ds Max and work in conjunction with a plug-in that runs within 3ds Max. The software is relatively easy to learn and we highly recommend its use for anyone in the 3D visualization industry regardless of skill level. It provides great functionality for creating just about any type of vegetation you can imagine and when combined with good materials and lighting, the results are simply amazing. You can even step up the quality of your animations by having the vegetation blow in the wind. All of the vegetation shown in Figure 10-2 was created using Onyx software.

Figure 10-2. 3D vegetation created entirely with software from Onyx Computing.

Virtually all of the 3D vegetation used in our work is created with Onyx, but regardless of which software you choose, you will have to use 3rd party software of some type to create your own 3D vegetation in a reasonable amount of time.

2D Vegetation

There is only one reason I can imagine for which anyone would not want to use highly detailed, well-crafted vegetation models; to reduce the consumption of system resources and to reduce render times. But until computers are able to render in real-time, users will always be looking for ways to do just this. Needless to say, there will probably be a place for 2D vegetation for many years to come, and because of this, part of this chapter is dedicated to implementation of 2D vegetation in a useful and worthwhile manner.

Mesh and Poly Based 2D Vegetation

There are two main types of 2D vegetation; imagery represented by Edit Mesh or Edit Poly objects or imagery created through the use of a plug-in. With the first type, vegetation is usually represented by an image placed on two criss-crossed polygons, and an image in the opacity channel to mask areas of the object where the vegetation does not show. When the left image in Figure 10-3 is placed in the diffuse channel of a material, and the middle image is placed in the opacity channel, you are able to simulate the appearance of 3D vegetation, as shown in the image on the right.

Figure 10-3. Using opacity maps to create 2D vegetation.

The greatest advantage of the criss-cross vegetation type is that it requires only four faces (or two polygons) per object, and therefore it renders quickly. This makes rendering a forest of trees very easy, and although they might not be suitable for close-up views, the ability to populate your terrain stretching to the horizon is invaluable.

Another advantage of this criss-cross vegetation type is that all objects with the same vegetation material can be attached together as a single object. When creating a large amount of vegetation, the importance of this advantage cannot be overstated. As we'll discuss later in this chapter, the number of objects in a scene is a critical factor in the time it takes to render. All of the trees in Figure 10-4 are part of the same object (not to be confused with being part of the same group). Still another advantage is that you can populate your scene extremely fast with this type of vegetation. When done correctly, you can create thousands of trees and all the shrubs and flowers your scene needs in just minutes, regardless of the size of your scene.

Figure 10-4. A forest of 2D trees placed with a few clicks of the mouse.

The greatest disadvantage of using criss-cross vegetation is that the images become distorted when viewed at high perspectives, such as those greater than 45 degrees above the horizon, as shown in Figure 10-5. This makes camera placement critical and accentuates the need for determining placement as early as possible. One of the production tips at the end of the book discusses the need to create an animation script as early as possible. For an animation where cameras move in and around a scene, knowing exactly where a camera will go and where it will see

will help you better decide where to place high polygon 3D vegetation and where you can get away with using 2D vegetation.

Figure 10-5. The negative effect of distortion for 2D trees viewed from high angles.

Another disadvantage of this type of object is that it often casts poor shadows. Most shadow types, such as raytracing and advanced ray-tracing, allow you to take advantage of the image in the opacity channel and cast shadows that mimic the shape of the vegetation. **Ray-traced** shadows are automatically configured to trace opacity maps, while **advanced ray-traced** shadows require you to enable the **Transparent Shadows** option in the **Optimization** rollout. However, shadows cast through the tracing of opacity maps do not always look good, regardless of the shadow type or render engine used. This is especially true when the sun in a scene is placed very high or very low in the sky, but even when placed at the best possible angle (i.e., 45 degrees up in the sky), these shadows usually appear stretched and distorted. This is not to say that you cannot or should not use this type of shadow. It is in fact a very good option for scenes where the sun is not placed too high or too low, as shown in the right image of Figure 10-6, and it is especially good for 3D terrain where some of the other tricks described later in this chapter won't work. When used with 3D terrain, the shadows fall on surrounding objects and conform to the slope of the surrounding terrain, unlike some of the faked shadows that only work well with 2D terrain and without other objects around.

As an additional note, I don't recommend use of the shadow map type for the sun in a scene. Shadow maps, which are already very memory consuming, do not allow the tracing of opacity maps and instead cast shadows of the entire object, as shown in the left image of Figure 10-6.

Figure 10-6. 2D shadows with and without the tracing of opacity maps.

Yet another disadvantage of using 2D vegetation is their tendency to be illuminated very poorly. Without handling this type of vegetation properly, it is usually easy to see one half of the tree illuminated completely different from the other half. Shortly, we'll look at ways to alleviate this particular problem as well as ways to create far better shadows for 2D vegetation. Furthermore, we'll see how to do these things in ways that don't require you or your computer to work too hard.

Plug-in Based 2D Vegetation

Another type of 2D vegetation can be created with a plug-in that uses a dummy object to set the position, rotation, and scale of the object. The most widely used example of this is the **RPC** (Rich Photorealistic Content) plug-in, shown in Figure 10-7. This type of vegetation looks much better than mesh and poly-based vegetation because a different image is generated from different perspectives and because you always see a full image straight-on. Another advantage is that when used in moderation, they render much quicker than 3D vegetation, although not as quickly as the criss-cross vegetation.

Unfortunately, the disadvantages of this type of vegetation are numerous. RPCs are memory hungry because all of the individual images that represent the vegetation from each unique perspective must be loaded into RAM at the start of the rendering process. When too many are used, they can swallow up all of the available RAM in your computer and leave you with nothing left to render. Another disadvantage is that they cannot be attached together, and therefore must remain as individual objects. The result can be much greater rendering times. Still another disadvantage is that they cannot be placed as quickly as the criss-cross vegetation type because they cannot take advantage of some of the great placement tools 3ds Max has to offer, such as the Scatter command.

Figure 10-7. An example of an RPC (Rich Photorealistic Content).

Creating 2D Vegetation

In the first few years we worked on visualizations at 3DAS, no other element in a scene caused more frustration and late nights than vegetation. We tried just about every conceivable approach to creating realistic looking trees, shrubs, and flowers in an efficient and cost-effective manner. Some worked well and some did not. Some methods that used to be great with previous versions of 3ds Max and 3d Studio for DOS have been made obsolete by new program features or new plug-ins. But nevertheless, until computers reach real-time speed regardless of the quality of the rendered output, there will always be a few fundamental procedures that can save you countless hours in the course of a visualization project. In this next section, we will look at some of these procedures.

Creating 2D Trees

When you do decide to use 2D trees, perhaps the most efficient way to create it on a large scale is by using the **Scatter** command. The Scatter command is used to create copies of one object over the surface or within the volume of another object. In this way, it gives you a quick and easy method to create realistic vegetation for an entire project, regardless of size. Creating vegetation this way can produce effective and realistic results with minimal burden on your computer. As mentioned

earlier, it's often unimportant to the clients exactly what type of trees and plants they see in their visualization and since landscape drawings are usually one of the last things created during a project's planning, landscaping will often not even be decided by the time your work begins. When this is the case the client may want you to play landscaper and tell you to simply create something that looks good. This can be a double-edged sword. Although it is nice to not be constrained by placing the exact required vegetation type throughout your scenes, the client may not like what you use. Good communication about landscaping requirements and exactly how you will meet them cannot be overstated. In fact, if anything should be highlighted in your contract, it should be details regarding the landscaping. Whenever possible, we highly recommend gaining flexibility from the client in this area.

When you aren't constrained by creating vegetation of a particular type, I recommend using the Scatter command to create at least a portion of your plants. Doing so can save an enormous amount of time, especially for larger projects. Some projects call for the use of thousands of trees and plants, and placing each of these any other way can take many hours. With the Scatter command, you can create the appearance of a beautifully landscaped scene in a fraction of the time.

Scatter – The 'Area' option

The following 2 exercises illustrate 2 different methods of using the Scatter command to efficiently place a large number of 2D trees in a very short amount of time. In this 1st exercise, we will place the 2D trees shown throughout the background of the images in Figure 10-8. This exercise will not involve the illumination of these nor will it involve the creation of shadows. Both of these will be discussed later in the chapter.

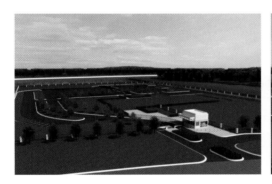

Figure 10-8. A scene with thousands of 2D trees.

Creating 2D Trees – Method #1 (Scatter with the Area option)

1. Open the file **ch10-01.max**. This scene contains six 2D criss-cross trees, an editable spline that represents where the trees will be scattered, and a camera. Incidentally, there are 2 versions of each tree type. Whenever using 2D vegetation, it's helpful to use more than one version of each vegetation type so a repetitive pattern isn't obvious.

2. Select the object **Tree-Area** and add the **Edit Mesh** or **Edit Poly** modifier.

3. Select the object **Site-2D-Tree-Ash-A**.

4. Select **Create** > **Geometry** > **Compound Objects** > **Scatter**.

5. Click the **Pick Distribution Object** button and click on the object **Tree-Area**.

6. Open the **Display** rollout and enable the **Hide Distribution Object** option.

7. In the **Scatter Objects** rollout, change the **Duplicates** value to **5,000**.

8. In the **Distribute Using** section, enable the **Area** option. This provides the best distribution spacing for vegetation.

9. Open the **Transforms** rollout and type a value of **90** for just the **Rotation Z** field. This randomly rotates each face +/- 90 degrees about each tree's Z axis.

10. Render the **Camera** view. Notice that the trees appear to have a white haze around their outer edges. This is because of the white color applied to the **Diffuse** and **Ambient** color channels. 2D criss-cross vegetation should always have a pure black color applied to these channels even when maps are used. The antialiasing applied to the edge of the cutout image picks up and borrows from these colors, so they always need to be set to pure black. As a good rule of thumb, the **Specular** color should also always be set to pure black because if specular highlights are present the vegetation would show these highlights in the masked area of the image.

11. Open the **Material Editor.**

12. Select the material **Site-2D-Tree-Ash-A** and change the **Diffuse** and **Ambient** and **Specular** colors to pure black and render the **Camera** view again. The white haze is removed. Notice also that some trees appear to be very narrow. This is because the tree material is single-sided and some are seen at an angle nearly parallel to the camera's view.

13. Enable the **2-Sided** option for the material **Site-2D-Tree-Ash-A**. This essentially doubles the number of visible trees, although some render engines (such as V-Ray) generate 2-sided materials automatically.

14. Add the **Edit Mesh** or **Edit Poly** modifier to the object. Notice that the trees are now visible in the **Camera** viewport.

15. In the root of the **Site-2D-Tree-Ash-A** material, enable the **Show Map in Viewport** option. The trees are now shown as cutouts from their background. This option has to be enabled in the root of the material rather than within the **Diffuse Color** channel or it will not cut out the background of the tree image.

16. Repeat the previous steps by scattering all 5 trees, each time using a unique **Seed** value so the trees are not scattered in the exact same position.

17. Render the **Camera** view again. The result should look similar to the left image of the next illustration. The right image shows a close-up top view of one area. Rendering 30,000 trees like this should only take a few seconds. If you want to see a completed version of this exercise, open the file **Ch10-02.max**.

Scatter – The 'All Face Centers' option

If you're fortunate enough to have landscape drawings at the time you need to create the vegetation for your project, which seems to be less than half the time for our firm, you might want to take advantage of the CAD linework already in place. Using this method, you replace the landscape symbols inside AutoCAD with a simple triangle, import the triangles into 3ds Max, apply the Edit Mesh or Edit Poly modifier, and use the Scatter command to place a tree at the center of each face (i.e., the triangles you imported).

If you're even luckier to have landscape symbols as blocks, this routine is even more effective. When the symbols are blocks, all you have to do to create the triangles globally inside AutoCAD is replace the linework in a block with a triangle. By resaving the block with new linework, you can change every instance of that block automatically. Once this is done, simply explode all of the blocks and import the linework into AutoCAD by layer.

Figure 10-9 shows an example of this method. The left image shows an AutoCAD drawing with the triangles that were created and the right image shows an aerial view of the finished project including the landscaping that was scattered on these imported triangles. The landscape in this particular project was almost completely 3D because of the need to see aerials like this. This process, however, is identical regardless of whether you use 2D or 3D vegetation. The entire process was very quick and took only a couple of hours. While creating decent 3D vegetation for this scene could actually be accomplished in just a few minutes using other techniques described later in this chapter, the benefit of this particular method is that you can place the precise vegetation called for in their exact locations, which is sometimes very necessary.

Figure 10-9. An example of scattering vegetation using the All Face Centers option.

Creating 2D Vegetation – Method #2 (Scatter with the All Face Centers option)

The following exercise describes the process for using the **Scatter** command with the **All Face Centers** option. AutoCAD is required to use the process described; however, the following is simply a description of the process and does not require the opening of any files.

1. Open the AutoCAD landscaping drawing in which you want to create vegetation.
2. Choose a landscape block you want to turn into a triangle and double-click on the block or select the block and type **RefEdit**.
3. Create a new layer and give it the name of the tree you want to scatter.
4. Make the layer you created the current layer.
5. Create a 3-sided closed pline (not spline) in the center of the block.

6. Delete the existing linework that makes up the block you are editing.

7. Type **RefClose** to save and close the block editing feature. All the blocks with the same name will now appear as triangles.

8. Repeat steps **1** through **5** for all landscaping blocks.

9. Explode all of the landscape blocks.

10. Import the linework into 3ds Max using the option to make all linework on the same layer be part of the same object.

11. Add the **Edit Mesh** of **Edit Poly** modifier to the imported triangles.

12. Use the **Scatter** command as you did in the previous exercise, except this time, use only one duplicate and instead of using the **Area** method for distribution, use the **All Face Centers** option.

Illuminating 2D Trees

Perhaps the biggest drawback users find in creating 2D criss-cross vegetation is the poor illumination that usually plagues its use. The reason for this is because the light in the scene does not evenly illuminate the 2 polygons that make up the tree. To ensure that the illumination is even, you must first ensure that the 2D vegetation does not cast shadows on itself (or on anything else), and that enough lights are used to cast equal illumination in all directions around the perimeter of all trees. The first part of this is simple - just turn off the **Cast Shadows** and **Receive Shadows** option for the trees (in the **Properties** dialog box of each object). The 2nd part requires you to place lights around your scene that only affect the 2D trees and cast light horizontally across the ground.

In the left image of Figure 10-10 are the 30,000 2D trees scattered during the 1st exercise in this chapter. This scene is the one shown in Figure 10-8 but all other objects have been hidden to better show the 2D trees and the lights illuminating them. These 2D trees are being illuminated solely by 4 individual **Direct Target** lights placed in 4 locations around the perimeter of the scene. Notice that these lights are oriented so they project light parallel with the ground. The image on the right shows the **Exclude/Include** dialog box for one of the instanced lights. As you can see, the light is set to include illumination for only the 6 objects shown in the window on the right, which means, of course, that all the other objects in the scene are excluded from illumination.

Figure 10-10. Illuminating 2D trees with 4 direct instanced lights.

The benefit of using this approach is striking. In the left image of Figure 10-11, the 2D tree is illuminated with one light that represents the sun in the scene. Notice how easy it is to tell that the tree is just an image. Even when using global illumination, this variation in illumination will almost always still exist. In the image on the right, the tree is not illuminated by a single light representing the sun, but rather by 4 instanced direct target lights placed evenly around the scene. This 2D tree looks much better because it's illuminated evenly. With a forest of trees, a 3D version might take several hours to render, but the same trees in 2D could render in seconds and still look decent. As stated earlier, whether your vegetation is sufficient as 2D or whether it should be replaced by a 3D version depends on a lot of things, such as rendering time available, distance from the camera, camera movement, available RAM, etc. However, when you do decide to use 2D vegetation, you should always make sure they are evenly illuminated using this type of approach.

Figure 10-11. A 2D tree illuminated by a single shadow casting light (left) and 4 non shadow casting direct lights (right).

Creating Shrubs and Flowers

Another great landscaping application for the Scatter command involves creating the appearance of 3D shrubs and flowers over a large area in a very short amount of time. Besides scattering a tree over a surface, you can also scatter an individual face or a small number of faces over a volume. The face(s) you scatter, such as those shown in Figure 10-12, can be used to represent a leaf or a group of leaves and can be made to appear quite real at just about any distance as long as the leaf (or face) is not too large. Notice that there are three rows of the same images. The top row shows each leaf mapped on an individual face, while the 2nd and 3rd rows show the images mapped on 2 and 6 faces, respectively. Using a smaller number of faces for the scattered object means of course that the 3D vegetation you simulate will contain fewer faces. However, it also means that the shadows will be larger and less realistic. Notice also that mapping the leaves on objects with more faces such as the 3rd row means that the leaves can be shown larger. If the leaves can be shown larger, then you would need to use fewer of them to fill in a volume of space. If you need fewer objects, the result might actually be fewer total faces needed to fill a space. As you can see, choosing the object to scatter may take some experimentation.

Figure 10-12. Faces that can be scattered about a volume to simulate realistic vegetation.

To create shrubs using this method, extrude a closed spline to the height you want to create your vegetation, and scatter the face(s) about this volume. To create the look of flowers among the shrubs, simply create a copy of the scattered leaves, raise the scatter slightly higher than the shrubs, reduce the number of duplicates as necessary to create the desired density, and apply a unique material that gives it a colored appearance as that of a flower. Figure 10-13 shows an image from an animation where this procedure was used to quickly populate a scene with shrubs and flowers. In this particular project, not only were landscape drawings not available, the client had absolutely no idea what they wanted for landscaping. As usual, the client said, 'just make something that looks good', and so this was our attempt to play the role of landscape architect.

Figure 10-13. Shrubs and flowers simulated by scattering faces within a volume.

The following exercise is a demonstration of the usefulness of the Scatter command in creating vegetation on a large scale very quickly. In this exercise, we will create vegetation in the rectangular garden area shown in Figure 10-13.

Creating Shrubs and Flowers

1. Open the file **ch10-03.max**.

2. Select the object **Shrub-Area**. This object consists of 6 closed splines, as shown in the next illustration. This will be the distribution object of the scatter and represents where the shrubs and flowers are going to be created.

3. Extrude the object **2'-0"**. This will be the approximate height of the scattered object.

4. Select the object **Leaf06small**. This will be the leaf that is scattered about the volume just created. Notice that we are using the single faced version of this particular leaf.

5. Select **Create** > **Geometry** > **Compound Objects** > **Scatter**.

6. Click the **Pick Distribution Object** button and click on the object **Shrub-Area**.

7. In the **Display** rollout, enable the **Hide Distribution Object** option.

8. Select and delete the object **Shrubs-Area**.

9. In the **Scatter Objects** rollout, change the **Duplicates** value to **50,000**.

10. Change the **Vertex Chaos** to **10.0**. This helps break up the order of the scattered leaves.

11. In the **Distribute Using** section, enable the **Area** option.

12. In the **Transforms** rollout, use a value of **90** for each of the **Rotation X**, **Y**, and **Z** fields. This randomly rotates each face +/- 90 degrees about each axis. The result at this point should look like the next illustration.

13. Rename this object **Site-Shrubs-Green**.

14. Add the **Edit Mesh** or **Edit Poly** modifier to make the leaves on the faces visible in a shaded viewport.

15. Open the **Material Editor**.

16. Select the material **Leaf06** and enable the **Show Map in Viewport** option. This cuts out the background of the leaf image.

17. Make a clone of this object and name it **Site-Shrubs-Purple**.

18. Change the **Duplicates** value of the Scatter object to **10,000**. This makes the ratio of leaves to flowers, 5 to 1.

19. Move this object upward **12 inches**.

20. Apply the material **Leaf07**. Notice that this material is nothing more than the same **TGA** file applied to the opacity channel but only a color for the **Diffuse Color** channel. Now you can change the color of this object by changing the diffuse color of the material. By doing so you can simulate the look of different flowers.

21. The result should look like the following illustration.

In this first part of the chapter, we looked at the differences between 2D and 3D vegetation and the many advantages and disadvantages of each. Additionally, we looked at a few tips and tricks for creating 2D vegetation. In the second half of this chapter, we will look at how to create realistic and efficient shadows for 2D vegetation, and finish by looking at ways to implement 3D vegetation effectively, without all the undesirable side effects that usually persist with their use.

Shadows for 2D Trees

Most objects you create for a visualization produce realistic shadows naturally. 2D trees, however, usually require additional work because they are nothing more than 2 criss-crossed polygons. Although creating realistic shadows can be quite a challenge, there are several techniques you can apply to vastly improve their appearance. The next portion of this chapter discusses four types of shadows that can be used in conjunction with 2D trees. Each has advantages and disadvantages and which method you use depends greatly on the same things discussed earlier: RAM, rendering time, distance from camera, etc.

Although there is no official title to any of these shadows types, we will use the following terms to delineate the different types:

• Opacity mapped shadows

• Image shadows

• 3D shadows

• Project light shadows

Opacity Mapped Shadows

Most shadow types allow you to use a map in the opacity channel to create the shadow of a tree, as shown in Figure 10-14. This option is automatically enabled for raytraced shadows and is also available for advanced raytraced shadows by enabling the **Transparent Shadows** option. The primary advantage of this particular shadow type is that it is very quick and easy to set up. By simply enabling an appropriate shadow type for a light, you can instantly create decent shadows with accurate placement. Notice in Figure 10-14 that the tree is perfectly aligned and positioned with the 2D trunk. This is often very difficult to achieve with the other shadow types.

Figure 10-14. An example of opacity
mapped shadows.

The primary disadvantage with this shadow type is the reduced shadow quality when lights are placed more directly overhead in a scene. Notice in the far left image of Figure 10-15 that the shadow looks fairly good, but in the other images the shadows become distorted as the sun moves higher and higher in the sky. If the sun were directly overhead, there would be no shadows cast at all (assuming the light was a direct light). When the sun is placed more than 60 degrees above the horizon, I wouldn't even consider this shadow type to be an option. Because 60 degrees is our typical sun angle, this shadow type is our least favorite of the four options.

Figure 10-15. Opacity mapped shadows becoming more distorted with sun moving higher in sky.

Image Shadows

The quickest and least memory-consuming method of creating and rendering shadows for 2D trees is the **Image Shadows** method. You can literally add tens of thousands of these shadows with little more than a few seconds added to your rendering.

To use this method, create a polygon (2 faces), apply the image of a shadow to the polygon and place the polygon at the base of a tree. The grayscale image on the left side of Figure 10-16 is placed in the opacity channel on a material that is applied to a simple polygon.

Figure 10-16. An example of image shadows.

When you render the image, the result appears to be a shadow whose color is determined by the diffuse color. Figure 10-17 shows 3 examples of variations in the diffuse color to simulate shadows of varying darkness.

Figure 10-17. Changing shadow strength by changing the diffuse color.

And if you find that the shadows are too sharp, a simple adjustment of the **Blur** setting within the **Coordinates** rollout of the **Opacity Map** channel will give you the ability to soften the edges to your liking. Figure 10-18 shows some examples of adjustments to this setting. You can also achieve the results with a little more precision by adjusting the actual bitmap that is loaded in the opacity channel. The feather feature in Photoshop works great for making these adjustments.

Figure 10-18. Changing shadow blurring by changing the Blur value in the opacity channel.

Once you have created your polygon and applied the material, place the polygon at the base of a tree, slightly above the ground object (1 inch usually works fine). Unfortunately, this shadow type doesn't work well with 3D terrain because unless the ground around the base of a tree is completely flat, the 2D shadow object is likely to become at least partially buried in the ground. For 3D terrain, any of the other 3 shadow types would suffice.

Since all of your 2D trees that contain similar materials should be attached together (to prevent an unnecessary multitude of objects), image shadows that contain the same material should also be attached together. In fact, a nice trick to place this shadow type effectively is to attach a shadow to a 2D tree before you scatter the 2D tree. The result would be shadows that are always located in the proper place and a multi/sub-object material that controls both the tree and the shadow.

The last step is to turn off the **Cast Shadows** option for the object simulating shadows. When placing the image shadow for individual trees that are relatively close to the camera, it's important to remember that the shadow must encompass the base of the trunk, as shown in Figure 10-19, otherwise the viewers will be left wondering why they can't see the shadow of the trunk. It's really not practical or necessary to worry about including a trunk in the shadow because then you will have to be meticulous in the placement of the shadow. In a forest of trees, you can speed up the process of creating shadows by scattering the polygon over a surface that defines the area where your trees are located. Accurate placement is rarely critical with a large number of randomly placed trees because you are usually viewing the shadows at a distance and/or the shadows of other trees are so close that they obscure any irregularities in placement.

Figure 10-19. Placing a shadow
so it encompasses the trunk
of a tree.

The speed at which these shadow types render is clearly their greatest advantage. But the greatest disadvantage is that they don't cast accurate shadows. In Figure 10-20, the viewer would expect the shadow of the tree to fall on the object next to it, but instead the image shadow is obscured by the box.

Figure 10-20. An image shadow does
not fall on surrounding objects.

Another example of when this might become a problem is when you have a mulch bed with some minor relief. In the left image of Figure 10-21, the mulch bed rises about 6 inches above the ground, and therefore it doesn't appear to receive any shadows by the image shadow object, which is only 1 inch above the ground. You could certainly raise the image shadow above the mulch, but doing so might make it obvious that the shadow is floating above the ground. On the other hand, if you're so close that you can make this kind of distinction, you should probably try to use 3D trees or at least one of the better shadow types.

Figure 10-21. An example of how image shadows do not conform to 3D terrain.

One more important note about this shadow type is that you will almost always have to apply transparency to the shadow material so you can actually see the material of the object it appears to be casting shadows on. In the left image of Figure 10-22, you cannot see the grass through the image shadow. In the image on the right, the shadow is partially transparent, which enables the viewer to see the grass through the shadow. When you adjust the transparency of the image shadow, you will have to adjust the diffuse color of the shadow to account for the apparent change in color of the shadow.

Figure 10-22. An image shadow without transparency (left) and with transparency (right).

For very fast and efficient renders, the image shadow simply can't be beat. It's not an exaggeration to say that the amount of time you save in the course of rendering, loading and saving files, and screen refreshes for a large project can be calculated in dozens of hours. For this reason, it is a great shadow type to implement in many situations.

3D Shadows

The most realistic type of shadow that can be used for a 2D tree is the shadow of a 3D tree. Unfortunately, it's also the least efficient and most time-consuming method. To implement, simply place a 3D tree at the center of a 2D tree, disable the **Visible to Camera** and **Visible to Reflection** options of the 3D tree and disable the **Cast Shadows** option of the 2D tree. Figure 10-23 shows an example of a 2D tree using the shadow of a 3D tree. The 3D tree that was used was the Generic Oak from the 3ds Max Foliage feature. Even with the branches and trunk disabled, this particular tree can have from 5k to 8k faces, depending on which seed value you use. Although this is a relatively small number of faces for a scene with millions of faces, it might not be a good idea to use a large number of these trees to make 3D shadows because as few as 120 could add an additional one million faces to your scene.

Figure 10-23. An example of a 3D shadow with a 2D tree.

The disadvantages of this type of shadow are that it can drastically increase your rendering times and your scene file size, and can decrease your screen refresh rates if not used carefully. If you do decide to use 3D shadows, ensure that you use a tree with the minimum number of faces necessary to achieve the level of shadow detail needed. For example, the tree shown in Figure 10-23 contains over 5k faces and casts very nice shadows, but you can accomplish the same thing with a fraction of these faces. The tree shown in Figure 10-24 looks just as good but contains less than 500 faces. An easy way to create an object like this with fewer faces is to scatter a larger face about the volume of the higher polygon tree, using the higher polygon tree as a distribution object. For scenes with a large number of 3D shadow objects, the difference in rendering time, RAM consumption, and screen refreshes can be dramatic.

Figure 10-24. Scattering a larger face over the surface of a 3D tree to produce a low poly shadow.

Using such a small number of faces for a 3D shadow object might not be suitable for close-up views where a high level of shadow detail is needed; however, when such a high level of detail is needed in the shadows, it will also be needed in the visible tree itself. When this is the case, you shouldn't be using a 2D tree anyway.

Another thing to remember when using 3D shadows with 2D trees is that even though the 3D shadow object has the **Visible to Camera** option disabled, it will still reflect light when you use global illumination. In fact, it will still reflect light when the **Visible to Reflections** option is disabled because this option has nothing to do with global illumination. Since the object still generates global illumination, it will significantly affect the color and highlights of the 2D trees. Therefore, you should consider giving the leaves of your invisible shadow object a particularly useful color. Figure 10-25 shows the effect of using different colors for the leaves of the 3D shadow object. This is a great way to create a varied look to a forest of 2D trees using the same image. You could actually make a significant improvement to a large group of trees by scattering different colored objects around the area of the trees and then making those objects invisible to a camera. The GI reflecting off those scattered objects would essentially paint the tree with different colors.

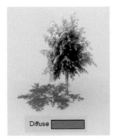
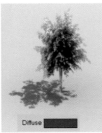
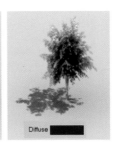

Figure 10-25. Using different colors on a 3D shadow to change the appearance of a 2D tree.

Finally, the reason the 3D shadow is the most realistic shadow type has little to do with the level of detail of the shadow. Other shadow types give you the ability to achieve the same level of detail without the negative side effects already discussed. What makes 3D shadows so great is that they cast correct shadows on surrounding objects, regardless of where the sun is placed in a scene.

Projector Light Shadows

In the **Advanced Effects** rollout of any light is the **Projector Map** feature, which allows you to use a light to project the image of a map or animation onto the surface of objects in your scene, as shown in Figure 10-26. The projector feature works the same way as a projector you would find in a movie theater, in which an image or animation is placed in front of a light and is projected onto a surface. But as you will see, this feature is also a great way to create realistic shadows for 2D trees.

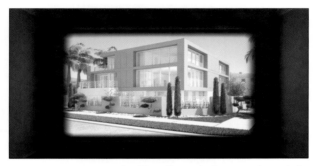

Figure 10-26. An example of how the projector map channel of a light can be used.

Figure 10-27 demonstrates the use of a projector map to create a fake shadow for a 2D tree. The **Cast Shadows** option is disabled for the tree and the black-and-white image of the tree canopy (far-right image) is loaded into the projector map slot of the light, which is positioned just above the image of the tree. The multiplier of the projector light is then changed to **–0.5**, which causes light to be taken out of the area defined by the white portion of the tree canopy image. Negative multiplier values cause light to be removed from the objects hit by the light. The more negative the value, the darker the shadows.

Figure 10-27. Using the projector map slot of a light to create the appearance of a shadow.

Although adding a large number of lights to your scene can drastically increase your render times, these types of lights render quickly because their effect is limited to a relatively small area. The primary advantage of this shadow type is the speed at which it renders and the ability to cast

shadows correctly on 3D terrain and any surrounding objects. In Figure 10-28, you can see that the shadow is cast on the ground surface and on the surfaces of a nearby object. This effect is not possible with **Image Shadows**. In addition, the placement of the light doesn't affect the quality of the shadows, and unlike opacity mapped shadows, you can have shadows created without any distortion; even when the light source is directly overhead.

Figure 10-28. Projector lights casting shadows on a nearby object.

The greatest disadvantage to this shadow type is the multiplied effect of these shadows when they overlap each other. Notice in the left image of Figure 10-29 that there are two shadows and a darker area in the center. If each of these shadows were created using a -0.5 Multiplier value for the intensity the combined effect of both means that the area where the shadows overlap will have twice as much light taken away. So instead of the entire area of shadows having a multiplier value of -0.5, some parts in the center have a -1.0 value applied. In the image on the right, you can actually see three levels of shadow intensity because there are 3 overlapping project lights.

Figure 10-29. The combined effect of multiple shadows overlapping.

2D Trees in Action

To demonstrate the capability of the 2D tree in action, we have included a sample scene you can download and explore, labeled **2D_tree_animation.zip**. A client had asked 3DAS to take their existing scene of a government facility, light it, create a 360 animation path and place trees around the perimeter of the property to give it a more natural and realistic surrounding. Because of the extremely tight deadline, we had no choice but to use 2D trees to speed the rendering process. Figure 10-30 shows two frames from this scene, with the government buildings omitted for privacy concerns. Because the scene was rendered in V-Ray, all V-Ray lights and materials have been removed and all of the vegetation has been converted to standard materials. By examining the scene, you will notice that all trees are 2D, all tree shadows are image shadows, and all the shrubs were created by scattering a single face. Because of the speed of the camera and the video filter used, it's quite difficult for the viewer to discern that the trees are not 3D.

Notice the careful placement of the camera path and how during some parts of the path, trees in the foreground are just barely visible, as shown in the right image of Figure 10-30. Creating and finalizing the camera paths as early as possible is critically important to creating efficient scenes. Until the camera paths were finalized for this scene, we couldn't finalize the placement of the trees. We wanted the tops of the trees in the foreground to be barely visible so the viewer would know that they were there but not see so much of them to know that they were 2D.

Finally, throughout the trees we scattered a single face to create the appearance of underbrush, which really added to the realism. Having a forest of trees can be made much more realistic when there is underbrush to break up the open look of flat terrain with a single texture.

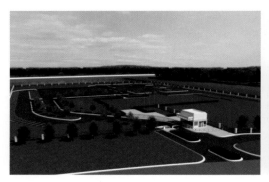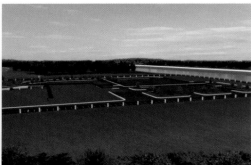

Figure 10-30. A example of 2D trees at work.

Creating 3D Trees

Adding 3D trees to your scene in a care-free manner can burden 3ds Max and your computer beyond their capabilities. Quite often, when you find that your computer runs out of memory or simply can't complete a rendering in a reasonable amount of time, your vegetation is to blame. And the type of vegetation that can overburden your system quicker than any other is 3D vegetation. But fortunately, there are numerous tricks you can use to maximize the number of 3D trees your system will handle and minimize the amount of time it takes your system to render them. Let's look at a few of them.

In the classes we teach at 3DAS, we find that even many experienced 3ds Max users don't understand the significance of some fundamental optimization concepts. Students often ask us to look at their scenes and figure out why their rendering times are so excessive or why they run out of memory so quickly. So many users think that 4 GB of RAM or a top-end video card is needed on a regular basis when, in fact, it is not. So before going any further into a discussion on 3D trees, a little background on scene efficiency is needed.

Parametric vs. Editable

Parametric based objects are objects whose structure and appearance are dictated by parameters. Editable objects, such as the Editable Mesh and Editable Poly, are objects whose structure and appearance are dictated by the X, Y, Z values of location, orientation, and scale of the individual sub-objects that make up the objects. Parametric objects require very little data to store their existence, and therefore have a very small impact on a scene's file size. The following discussion illustrates the important parts. Even when you apply modifiers and create compound objects out of parametric objects, the data for the object(s) is still stored parametrically.

If you save an empty scene with no objects in it, you will find that the file size is approximately 220KB (all of which is used to store system and file attributes). If you drop in a Generic Oak (from the 3ds Max Foliage feature) you will see that the tree contains approximately 25,000 faces. Saving the scene again causes the file size to increase to approximately 250KB. The reason for the small increase is that 3ds Max only has to store a small amount of data to represent this tree; such as X, Y, Z values, height, color, material IDs, etc. Now if you collapse this same tree into an editable mesh or poly and save the scene again, you will see that the file size has increased about six times to approximately 1.5MB. The reason is that this object's geometry is no longer dictated by a small set of parameters, but rather by hundreds of thousands of values for the sub-objects that make up the editable object.

Collapsing an object to an editable mesh or poly should not be confused with simply adding the Edit Mesh or Edit Poly modifier. The differences between the two couldn't be more significant and will be discussed later in Chapter 19. For now, an understanding of the previous two paragraphs is all that is needed.

Now clearly the Foliage feature in 3ds Max leaves a lot to be desired in terms of quality vegetation, but the concept of keeping vegetation parametric based rather than collapsing to an editable object is just as important for the many plug-ins that can be used to create vegetation. As an additional note, keeping plug-in based vegetation in parameter may be necessary just so you can take advantage of features, such as wind.

If you do have to use vegetation in editable form, ensure that duplicates are made as instances rather than copies. A forest of 3D instanced trees will have only a minor effect on file size, but the same forest of copied trees can result in ridiculous file sizes of several hundred megabytes.

Level of Detail

It's always important to determine as early as possible where the final rendered views are going to be. By knowing this, you can determine the level of detail you will need from each view, and therefore, each tree. When creating vegetation, it's critically important that you don't use an excessive amount of indiscernible detail because doing so can quickly lead to excessive render times and memory consumption. To illustrate this, let's look at the Generic Oak again.

As mentioned before, with the default values, the generic oak object contains approximately 25,000 faces, but if you disable just the branches of this object, the face count drops to approximately 7,000. Unless the view of a tree is very close-up, the viewer would most likely not even see a lack of branches. The standard 3ds Max foliage is certainly not something you should be using in production but the concept is still valid - reduce faces whenever possible. Quality vegetation software, such as Onyx, will allow you to turn off certain components such as branches, and set a polygon count limit so you can create very streamlined versions of your vegetation for situations where the vegetation is not so close to the camera.

The Almighty Proxy

A discussion about vegetation wouldn't be complete without some mention of one of the best new features in 3ds Max 2009; the mental ray Proxy. This feature works much like an XRef, storing the data for an object in a separate file, thereby keeping your file sizes to a minimum. When you create a proxy, you are left with a facsimile display of the original object that is less of a burden to display, and therefore allows for easier and quicker viewport navigation. But the real benefit of the proxy lies in the way it allows you to conserve memory. Using proxies, you can render an entire forest of 3D trees without having to worry about running out of memory. The reason is because the proxy objects are treated as dynamic geometry as opposed to static geometry. Dynamic geometry is loaded and unloaded on the fly as needed, unlike static geometry, which is loaded at the start of a

rendering and not unloaded until the rendering is completed. This feature alone makes using mental ray worthwhile. This feature has also been a part of V-Ray for several years and it works much the same way. If you use either mental ray or V-Ray, you should always consider creating proxies out of high-poly objects such as 3D trees.

Summary

Hopefully this chapter shed some light on the importance of creating efficient vegetation and some of the ways to create realistic looking vegetation without going beyond the capabilities of your computer. When done correctly, vegetation can be a simple element to create and not a menacing threat to your project's success. These were just some of the many ways to implement vegetation efficiently and effectively. Your ability to find others is limited only by your imagination.

PART 4

mental ray

As digital artists, we are constantly playing a delicate balancing act between rendering speed and rendering quality. In order to be effective at such a task, we need to understand some theory behind the complex mental ray render engine.

Introduction to mental ray

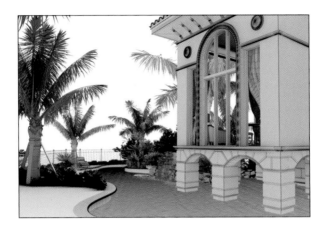

MENTAL RAY HAS MADE RECENT PROGRESS in the architectural arena since its first integration with 3ds Max in 1999. Perhaps in response to the success of Chaos Group's Vray, Autodesk has added mental ray to its premier software programs, and now uses it as the core for materials in both Revit and 3ds Max. It is also the platform for the new iray renderer for 3ds Max 2012, a time-based rendering solution that offers a unique approach to image-making.

The power of mental ray was first acknowledged by Hollywood in 2003 with an Academy award presented to its creator, mental images. Earlier versions of mental ray found its way into visual effect studio pipelines where it was customized and tailored to the various studios' needs. Autodesk saw the potential mental ray had as an alternative to scanline and radiosity, and as a render engine that could compete with new technology like Brazil, Final Render, and V-Ray. Now, with better documentation and a streamlined workflow, mental ray has found a home in many Autodesk products. The mental ray renderer offers powerful tools to create the most demanding visualizations and continues to become more accessible with each release. For many users, switching to a new rendering engine presents its challenges but understanding the basics goes a long way to flatten out the learning curve. We're going to introduce some core concepts in this chapter that will prevent some pitfalls further down the road and get you up and running with mental ray so you can create stunning visualizations in very little time.

It's worthwhile to note that although mental ray appears seamless within the interface, it still remains a separate rendering engine. Files are still translated and passed to mental ray for processing, although this is done transparently and is unnoticeable by the user. The translation process converts the scene into editable meshes, which is the native object type mental ray uses. This is important to know because it is highly beneficial to collapse your objects into editable meshes before you begin rendering as this will cut down the time taken for translation and ultimately allow for faster renderings.

As digital artists, we are constantly playing a delicate balancing act between rendering speed and rendering quality. To be effective at such a task, we need to understand some theory behind the complex mental ray render engine. We won't be examining everything mental ray can do, but we will cover enough so you can feel comfortable with the program and be efficient with your work.

These chapters on mental ray are quite specific and the topics do not get into as much depth as may be needed for certain technical applications. Mental ray can be as complex as you want to make it and I would recommend getting a firm grasp on the concepts presented here as they create a strong foundation, and depict real-world use of the mental ray renderer. The topics discussed here can be applied to many applications that use mental ray and are not just limited to 3ds Max.

Whenever we do a rendering with mental ray, you'll notice that the render proceeds via little white "bracketed" squares within the virtual frame buffer. These bracketed squares are called buckets and depending on how many processors, or the type of processor you have, you will see one or more buckets at a time rendering the final image. What we need to do is understand and optimize what's happening within these buckets.

Image Sampling

The first concept we're going to look at is Image Sampling, referred to in mental ray as **Super Sampling**. Image sampling is the technique of sampling beyond the resolution of the final image. This means that we can subdivide a pixel at render time to give it the proper coloration to avoid things like aliasing and loss of texture detail. This process doesn't miraculously add more pixels, it simply allows the render engine to analyze a pixel more than one time and improve the final pixel color with each sampling pass. Mental ray is a super-sampler and gives us a lot of control over how it conducts the sampling.

In Figure 11-1, notice that the sampling algorithm calculates the appropriate color of each rendered pixel. If we zoom in closely, you can see that the nice crisp edge is really just cleverly shaded pixels that give the illusion of a crisp edge.

Figure 11-1. Example of anti-aliasing due to sampling.

To better understand how image sampling works, let's take a look at a schematic grid of 9 pixels, as shown in Figure 11-2. For simplicity, we'll look at the **Fast Rasterizer** sampling method, which takes samples at the center of each pixel or subpixel. The sampling method used when Fast Rasterizer is not enabled is more complicated but works on the same principles.

The individual squares in Figure 11-2 are representative of the individual pixels of a rendered image. The straight line traveling through the pixels represents an edge of the 3D box shown in Figure 11-1. Above the line is empty space (the white background) and below the line is the blue box. If we conduct one sample at the center of each pixel, as shown with the red dots in the left image of Figure 11-2, you can see that some samples "hit" the box while others miss. If a sample "hits" the box, the resulting pixel will be colored the same color as the box, or blue. If the sample "misses" the box, the resulting pixel will be colored the same as the background, or white.

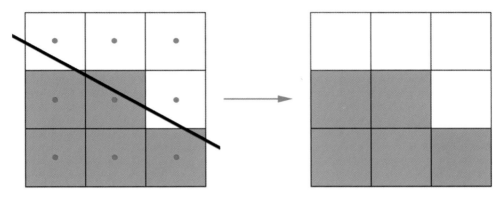

Figure 11-2. Illustrating one sample per pixel and the resulting pixel shading.

Next we'll super-sample the pixels. If we tell mental ray to divide each pixel into four subpixels and then take a sample at the center of each subpixel, it will have to do 4 times the work but will do a much better job at determining what color to assign each pixel to minimize artifacts such as aliasing, flickering, and swimming. To determine what final color a pixel should be, we only have to look at how many samples per pixel actually "hit" the box. If one of the four samples hits the box the resulting shade of the pixel would be a mixture of blue and white. If two of the four samples "hit" the box then the resulting shade of the pixel would be blue and white. The end result would be the right image of Figure 11-3.

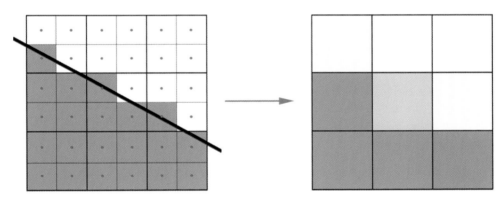

Figure 11-3. Illustrating four samples per pixel and the resulting pixel shading.

If we force mental ray to take 16 samples per pixel, the result would be an even better approximation, as shown in Figure 11-4.

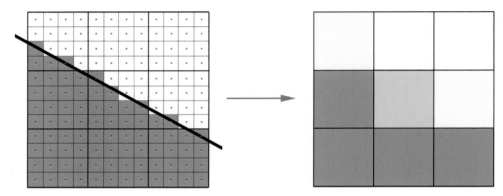

Figure 11-4. Illustrating 16 samples per pixel and the resulting pixel shading.

Keep in mind that we're sub-dividing the pixels to get a better approximation of the final pixel color. Figure 11-4 still only represents 9 pixels, but we've illustrated each pixel undergoing 16 samples. Remember that the result is an averaging of color based on how many samples were blue and how many samples were white. So if 5 samples were white and 11 samples were blue, the resulting pixel color would be a blend of 5/16 white and 11/16 blue.

Obviously, the higher the numbers of samples per pixel, the better the approximation of the pixel color, but many more calculations are needed, which equates to longer render times. So why did we go through all this? We do this because of how mental ray deals with image quality. As mentioned previously, this is a simplified explanation. Mental ray can do intelligent sampling that is adaptive, or intuitive, based on the settings you dictate and the results determined from each pass. This means that mental ray can sample more when accuracy is needed and less when accuracy is not needed. This approach is effective for areas that lack detail or for large areas of smoothly shaded surfaces. This adaptive nature is the exact opposite of the technique known as the **Brute Force** method, by which every pixel is sampled the same amount. The downside to the brute force method is that it is not adaptive, which means you will do excessive calculations in areas of your image that don't require them. By default, mental ray is automatically set to use adaptive sampling.

Image sampling is controlled most noticeably through the second and third rollouts in the **Renderer** tab of the **Render Setup** dialog box; **Sampling Quality** and **Rendering Algorithms**. Let's first take a look at the Sampling rollout, shown in Figure 11-5. Here you can define the minimum and maximum number of samples to be taken per pixel. Whole numbers indicate how many samples will be taken per pixel. Fractional numbers indicate the number of pixels that will be grouped together to share one sample. For example, 1/4 means that only one sample will be taken for every four pixels. This is in essence the exact opposite of super sampling, but allows for very fast renderings when accuracy is not needed.

Figure 11-5. The Sampling Quality rollout.

For the sampling to be adaptive, the minimum and maximum values must differ and the more they differ, the more adaptive the image sampler is capable of being. By default the minimum sampling conducted is one sample for every four pixels and maximum sampling conducted is four samples per pixel. Mental ray will adaptively select how many samples are required based on the Spatial Contrast settings, which we will discuss a little later.

Recall that a higher sampling rate means more calculations and ultimately equates to longer render times. Although you can go as high as 1024 samples per pixel, it doesn't mean you should. There are usually more efficient ways to smooth out aliased areas than using such high sampling. Usually you won't need to go any higher than 16 samples per pixel. Figure 11-6 shows the effect of increased sampling from 1 sample for every 64 pixels (1/64) to 16 samples per pixel (16).

Figure 11-6. A Comparison of sampling rates; Top Left - 1/64, Top Middle - 1/16, Top Right 1/4, Lower Left - 1, Lower Middle - 4, Lower Right - 16.

Notice how each render is progressively more refined and that the increase in image quality starts to become less and less evident. The difference between 16 samples per pixel and 64 samples per pixel for this scene is negligible but rendering times are increased dramatically. As a rule of thumb you can keep the settings at min=1/4 max=4 for draft renders min=1 and max=16 for production renders. Sometimes you'll find that you aren't able to get acceptable results with the suggested production settings and think you can resolve them by choosing higher values. This is the wrong approach and should be avoided unless absolutely necessary. Instead you should try to employ the tools more efficiently to achieve the same improved results with less render time.

The adaptive image sampling process is driven by the parameters found in the **Spatial Contrast** section. The term Spatial Contrast can be reworded as 'pixel variance', which simply means the degree to which adjacent pixels differ in color. Lower values mean that pixels have to be more similar, or less spatially contrasted. If mental ray conducts the first pass of samples at the specified minimum rate and then determines from this first pass that two adjacent pixels are more spatially contrasted than is allowed by the **R**ed, **G**reen, **B**lue, and **A**lpha values another pass will be conducted at a higher sampling rate. Further passes will be conducted until the pixels meet these minimum criteria or until the maximum allowed sampling rate has been conducted. By lowering these values closer to zero, you're forcing mental ray to use more maximum sampling rates, and by setting these values higher you're allowing mental ray to use more of the minimum sampling rates. Essentially, if you use a value of zero, then you are telling mental ray you want perfect image sampling. Since this is not possible, the best it can do is use the maximum sampling allowed for every pixel, and this adaptive sampling method would essentially become a completely brute force method. Typically you should adjust these values together by using the color swatch shown in Figure 11-7 and then adjusting the **Value** setting. This in turn adjusts all the component values at the same time.

Figure 11-7. Spatial contrast settings and the Spatial Contrast color selector.

Jitter is an invaluable option for image sampling. It creates small perturbations in sampling at render time that will aid in smoothing out any aliasing issues that are still prevalent. This is one of the methods mentioned earlier that makes it possible to achieve higher quality renderings without having to rely so much on increasing the maximum image sampling rate. It is usually a good idea to enable this function whenever using mental ray, and Figure 11-8 shows a visual example of this effect.

Figure 11-8. The effect of Jitter disabled (left) and enabled (right).

The last critical setting in this rollout is the **Filter** setting. Filters are basically algorithms that define the weighting for neighboring pixel blending. The filters increase in quality as you move down the list from **Box**, **Gauss**, **Triangle**, **Mitchell**, and **Lanczos**. The Box option is a good choice for draft renderings. Both Mitchell and Lanczos create varying degrees of edge enhancement and provide good choices for production still renderings. The Lanczos filter is much more exaggerated than Mitchell in the edge enhancement effect, but neither is suitable for animation because of the many types of artifacts they are almost guaranteed to create. Again, these include flickering, pixel dancing, pixel swimming, and numerous other terms associated with aliased images. A good choice for animations is the **Gauss** option with a **Height** and **Width** of 3, which would be similar to the Video and Soften filters. As you distribute the algorithm across more and more pixels, you create a softer image that becomes more and more blurred. It's usually not a good idea to lower the default values.

Figure 11-9. Filter settings used to smooth out image sampling results.

mental ray message window and BSP

An important tool to understand what is going on with the mental ray render engine is the **mental ray Message Window**, shown in Figure 11-10. This window gives us important information about our rendering such as render times, the rendering progress, any errors that occurred, etc. One of the most critical pieces of information we can track deals with a raytrace acceleration method known as **BSP** or **Binary Space Partitioning**.

```
RCI  0.3  info :  main bsp tree statistics:
RCI  0.3  info :  max depth           : 27
RCI  0.3  info :  max leaf size       : 21
RCI  0.3  info :  average depth       : 20
RCI  0.3  info :  average leaf size : 8
RCI  0.3  info :  leafnodes           : 697
```

Figure 11-10. An excerpt from the mental ray Message Window showing average leaf depth and size.

Binary Space Partitioning is the method by which mental ray organizes a scene to conduct raytrace calculations. An easy way to think of this is placing a bounding box around your entire scene, and then cutting it up into cubes, or voxels, in such a way that each voxel contains a certain number of geometric triangles, as indicated by the **Size** value in the **Raytrace Acceleration** section of

the **Rendering Algorithms** rollout. If a voxel contains more triangles than is specified by the Size the voxel is further split again. This splitting continues until the limit is reached, as dictated by the **Depth**. So in Figure 11-10 you can see that we continued to subdivide voxels to a maximum of 27 times. The average number of triangles contained in each voxel was 8. The average settings shown in Figure 11-11 are a good starting point to set your BSP leaf **Size** and **Depth** settings.

Figure 11-11. Binary Space Partitioning method.

Another raytrace acceleration method was introduced with 3ds Max 2009 known as **BSP2**. This method, now the default, automatically determines a proper size and depth value to use. This is a nice improvement but there are many situations in which you would benefit from using the older BSP method and adjusting these values manually. If you have the system resources available, you can increase rendering speed by setting your BSP depth to larger values and your size to lower values. Scenes heavily dependent on raytracing will definitely benefit from higher BSP depth settings. It's important to know that if we increase the depth and decrease the size, we will improve render times but we'll also be consuming a lot of additional resources. It's better to start with the settings shown in the Message Window in Figure 11-10 and adjust them as necessary.

You should keep an eye on the **max leaf size** and **average leaf size**, as shown in Figure 11-10. If you see a large change in either of the two values away from the defaults, try increasing your average Depth value by 1. If the value is close to the initial size (in our case 8 and 21 as shown in Figure 11-10), you're close to an optimal solution.

It's worth mentioning here that if you are using 3ds Max 2008, you can often handle large scenes better by using the **Large BSP** option instead of the standard **BSP** method. This option is no longer available with 3ds Max 2009. Large BSP is suited for large scenes that tend to crash when rendered, which incidentally is much more likely on 32-bit computers and 32-bit 3ds Max. Large BSP will dynamically swap files to and from your hard drive, which can have a dramatic savings in RAM. This should be used only if you're unable to render the scene due to memory issues because it is significantly slower than the BSP method. Regardless, the BSP or BSP2 methods are both good options with 3ds Max 2009 and later.

Distributive vs. Network Rendering

Distributive rendering is the ability to use processor cycles of networked machines to aid in the rendering process. This means that you can use multiple computers to generate the final rendered image, as long as they are part of the same local network. Note that this is different from network rendering, which sends out individual frames to networked computers. Network rendering is primarily used for creating animations, while distributed rendering is primarily used for creating stills. It's important to note that network rendering with mental ray works seamlessly with Backburner.

Distributive rendering is enabled through the **Distributed Bucket Rendering** rollout of the **Processing** tab, as shown in Figure 11-12.

Figure 11-12. Distributive Rendering group.

Once distributed rendering is enabled, click the **Add** button and type a computer name or IP address of the computer you want included in the process. Unless you specifically want a special port, use the default port option.

Figure 11-13. Distributive Bucket Rendering host window.

Continue to add up to 8 extra processors as necessary. Note that a dual core processor counts for 2 processor cycles. Additional processors can be purchased, but you don't gain a substantial performance boost unless your network is incredibly fast. Also, depending on your firewall settings, you may have difficulty connecting to the satellite machines. If so, you may need a network administrator to set access for you. Be sure to enable **Use Placeholder Objects** option in the **Translator Options** when doing a distributive render. This will only send the geometry needed to render the view, rather than the entire scene. Once distributed rendering is set up, individual buckets are sent across the network and the final rendering is accomplished by several machines.

Summary

This chapter forms the foundation for establishing image quality and starts to introduce the concept of balancing image quality and rendering speed. This forms a base for us to build on in the following chapters. Many of the parameters we've adjusted in this chapter will need to be adjusted depending on the scene, and what works well for one rendering will not necessarily work well for the next. It is important to understand what the parameters do instead of arbitrarily relying on higher or lower values. Although the process can get quite technical, it's the process that is most important to understand. From here we'll look at how we can apply more technical parameters and use them to generate and tune global illumination within mental ray.

Global Illumination

ALTHOUGH THERE ARE NUMEROUS LIGHTING strategies within mental ray, it all boils down to understanding two essential methods of global illumination; **Photon Mapping** and **Final Gathering**. Each can be used independently of the other, or they can be used together to give even more lighting control. The key to using either of these methods is to understand the process. Once you understand what's happening, you'll understand what you can do to "tune out" the artifacts and "tune in" the solution. We'll start with explaining photon mapping within mental ray.

Photon Maps

In real life, light sources emit infinite amounts of small energy packets called photons. These are the smallest quantifiable bits of energy that interact with their surroundings. Photons lose energy at a rate that is inversely proportional to the distance the photon travels from the light source and this can be expressed in the following equation, where x=distance from the light.

$$Energy = \frac{1}{x^2}$$

Figure 12-1. Inverse square law where x is the distance from the light source.

This decay is further compounded when they reflect and refract through various media further diminishing their energy. Unlike real life, when using mental ray we can discretely specify how many photons a light source will contribute, and define other properties such as how much energy a photon will have initially, how it will decay, and how it will interact with materials. Figure 12-2 illustrates the process.

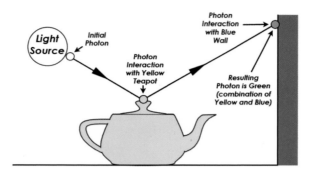

Figure 12-2. Photon schematic diagram.

From the light source a photon is emitted with a specified energy. This photon interacts with a piece of geometry within the scene and leaves an imprint. It is then redirected via reflection or refraction depending on the material. During this interaction the photon has lost some of its energy and "picked up" some of the coloration of the material it interacted with (actually some frequencies are absorbed by the material giving the appearance of the photon picking up the surface color). This newly colored photon eventually interacts with another piece of geometry but since it has been colored from the last interaction, it imprints that color on the new geometry and is further tinted by the color of this new interaction. The new color of the photon is a blend of the first and second material color, which is a true physical phenomenon known as "color bleeding". This process continues until a specified number of bounces are reached, or the photon is lost (no further geometry to interact with).

Let's look at an exercise that demonstrates the use of photon mapping.

Using Photon Maps

1. Open the file **Ch12-01.max**. This is a very simple scene consisting of a white 20'x20'x9' box with no openings, which therefore will prevent any photons from escaping. A light source is supplied by a standard spotlight at a height of 8'10" above the floor.

2. Open the **Render Setup** dialog and ensure that mental ray is your assigned rendering engine. The title of the Render Setup dialog will tell you this.

3. Click on the **Indirect Illumination tab** and scroll down to the **Caustics and Global Illumination (GI)** rollout. You'll see two sections; one for caustic effects and another for global illumination

(GI). We're not generating any caustics for this scene so we don't need to enable them, but we do need global illumination.

4. Enable **Global Illumination (GI)**. The multiplier and color swatch are global settings that influence the initial intensity and color of photons and can be left alone for now. We'll focus on the Trace Depth and Light Properties group and come back to the rest of the settings later.

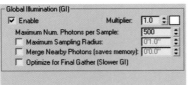 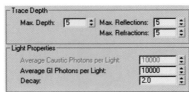

5. Set all the **Trace Depth** parameters to **1** and the **Average GI Photons per Light** to **1**. This tells mental ray that we only want an average of 1 photon contributed by any single light in the scene.

6. Render **Camera01**. The result should look like the following illustration. The spotlight is generating a pool of light on the floor as we would expect; however, you'll notice the addition of another puddle of light that somewhat resembles a single white blood cell on the ceiling. This is mental ray's way of depicting that a photon is being stored in this area of the scene. The photon was shot from the light source and was bounced off the floor to the ceiling where it stopped. This is because the photon was allowed one bounce since we set our Trace Depth to 1 (the lowest allowable setting).

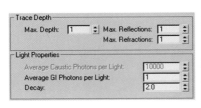 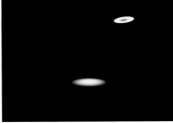

7. Next, set all the parameters in the **Trace Depth** group to 2 and render again. Depending on your scene, you may or may not see another puddle of light. This is because the photon could be stored behind the camera outside our field of view.

8. Increase all the **Trace Depth** values to **4** and render again.

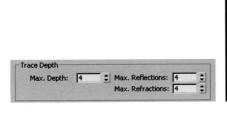

9. Increase all the **Trace Depth** values to **6** and render again.

10. Increase all the **Trace Depth** values back to the default value of **10** and render again.

11. Set the Trace Depth parameters back to 5.

This brings up an important point that photons are view independent. So once we calculate a photon map, we don't need to re-calculate it again should our view change. Because of this, we can save the photon map once and use it whenever we need to. Usually you would keep the Trace Depth numbers between 5 and 7 for most scenes. The only time you need to increase this value is when any single photon will have to travel through multiple transparent objects.

12. Increase the **Average GI Photons per Light** to **500** and render again. The result should look like the following illustration.

There are a couple of important things to note. The photon imprints (puddles of light) have lost their brightness making the rendering quite dark, and there is a lot of noise. The brightness issue is

due to the fact that the photons share the overall initial energy. If we were to add more photons we would see an even darker image.

13. Increase the **Average GI Photons per Light** to **10,000** (the default) and render **Camera01**. The result should look like a darker version of the previous render. We have a couple of options to increase the light level. The first option is to increase the GI multiplier to a higher value, which will increase the photon energy.

14. Increase the GI **Multiplier** to **10.0** and render again.

The second option is to use **Exposure Controls** to tone-map the rendered image using the new **mr Photographic Exposure Control**.

15. Turn the **GI multiplier** back to **1.0**. On the menu bar go to **Rendering** > **Exposure** control, change the exposure control to **mr Photographic Exposure Control**.

16. Enable the **Exposure Value (EV)** option in the **mr Photographic Exposure Control group**, and press Render Preview.

17. Hold down the lower spinner arrow to lower the EV value, while you watch the Preview Render. The image will become visible near a value of **-3**.

18. You can fine tune the number using keyboard entry. Exposure value is a simple way of controlling exposure with a single setting. Alternatively, you could adjust the exposure control via shutter speed, f-stop, and ISO values if you have an understanding of real world photography.

Once you like the illumination in the Render Preview, do the full size render. The noise will be tuned out later in this chapter and we'll come back to the exposure control settings, but for now let's continue with further GI adjustments.

19. Back on the Render Setup dialog Indirect Illumination tab, within the **Global Illumination** section of the **Caustics and Global Illumination (GI)** rollout (not the **Volumes** section), enable the **Maximum Sampling Radius** and render again. This limits the size of the individual photon imprints to whatever radius we specify and with the default value of 1", the result should look like the following image. If you don't see anything, make sure your exposure control is set low enough.

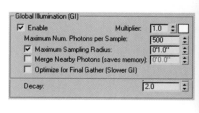

Notice that since the photon imprints are smaller, they've become brighter since the same amount of energy is being distributed over a smaller area, making them appear more intense. If we don't have this checkbox enabled, the photon imprints are defaulted to 1/10 of the overall scene dimensions (which in this scene would be 1/10 of 20' or 2' radius) This works fine for when we use photons in conjunction with final gather, but for photon-only solutions, we need to have enough photons to get detailed illumination within our scene (this can easily be in excess of several million photons). With that many photons, you couldn't effectively have the photon imprints all at 1/10 of the scene size. The goal is to increase the size of the photon imprints to get them to just overlap, and then subsequently smooth out the solution by increasing the **Maximum Number of Photons per Sample** to something higher than the default 500.

20. Change the **Average GI Photons per Light** to 1,000,000 and render again. There is now little chance for any part of the scene to not be covered by a sample, but the image will look quite noisy.

21. Within the **Global Illumination** section (not the **Volume** section), change the **Maximum Sampling Radius** to **3"** and render again.

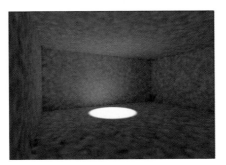

22. By increasing the sampling radius we are filling in the spaces between the illuminated points, and increasing the chance of getting the photon puddles to overlap. By making the pools of illumination larger, we fill in these gaps in the illumination.

23. Change the **Maximum Number of Photons per Sample** to 6000 and then render. We're telling mental ray to use a maximum of 6000 photons per sample, but we've got a small sampling radius. Increase the radius to 1'6" and render again. The result should look like the following illustration. Notice how the samples have been smoothed better than in any previous render.

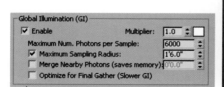

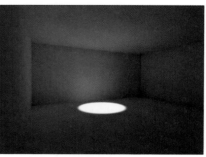

The Maximum Number of Photons per Sample is of no real benefit, unless we have a dense population of photons to begin with. In this case we used approximately 1,000,000 photons so we could get away with a high number of photons per sample (in this case 6000). If we only had the default 10,000 photons we wouldn't gain any benefit to using 6000 photons per sample since that is over half of the total amount of photons stored in the scene. These two values go hand in hand. The number of photons per sample is what we use to "tune out" the noisy artifacts associated with a *photon only* solution. It basically averages out the individual illumination values based on the number of photons sampled.

24. Change the **Maximum Number of Photons per Sample** back to the default **500** and render again. You see that since we're averaging illumination levels across fewer photons, we end up with more noise.

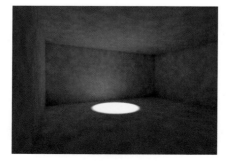

As mentioned before, we can save and reuse a photon map.

25. In the Reuse FG and GI Caching rollout, find the Caustics and Global Illumination Photon Map section. Change the Dropdown menu from Off to Read/Write Photons to Map files. Click on the icon with three dots to the left of the text field, as shown in the following illustration. This will prompt you to store the photon map to a location you determine.

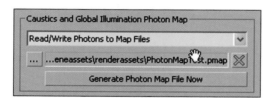

26. Specify a name and location to save the photon map.

27. Render out the scene and wait for the photon emission calculation to finish, or simply click the **Generate Photon Map File Now** button. Once done, your photon map is saved and ready to be re-used automatically. With a saved map, you won't have to wait and go through the emission calculation stage every time you render. If you wish to resave another photon map, you can either specify another file name or click the **Delete** button to the right of the file name, and then recalculate another photon map.

Depending on how many photons you're storing, your file sizes can get quite large. To help with this, mental ray has a new tool that will merge nearby photons. By enabling this tool we can set a radius that mental ray will use to merge nearby photons, thus optimizing the photon map.

28. Set the **Average GI Photons per Light** back down to 500, set the **Maximum Sampling Radius** to **6″** and click Generate Photon Map Now again.

29. Enable **Merge Nearby Photons (saves memory)** and in the field immediately to the right, enter a value of **12″**. The left image of the following illustration shows the photon map without this merge feature while the right shows the resulting map with this feature enabled.

Inverse Square Law

The last parameter to discuss in the **Caustics and Global Illumination (GI)** rollout is the **Decay**. Recall Figure 12-1, the equation for inverse square where the exponent shown in the formula is 2? This corresponds to the Decay value as shown in Figure 12-3.

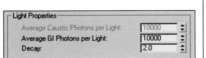

Figure 12-3. Decay is set to the inverse square law exponent (2) by default.

If we were to set this parameter to 1, lights would have a linear falloff to their intensity rather than an exponential. This will allow the photons to lose their energy slowly and as a result, the scene will contain higher illumination values. Likewise, if we set this value to 3 we would have an inverse cube defining the decay. Simply put, values around 2 are physically accurate and anything else would not be. Values between 1 and 2 will allow the light to permeate deeper into the scene while values between 2 and 3 will darken a scene, since light will no longer be able to travel as far.

Another section of the Caustics and Global Illumination (GI) rollout not yet mentioned is the Volumes section. These settings control volumetric effects; however, there are other more practical methods for generating effects of this type and as such will not be covered here.

So why would you use photon mapping? As a rule of thumb, photon mapping is primarily used for interior scenes and usually in combination with final gather. The benefit of using photons to calculate GI is realized anytime you have a somewhat enclosed space with lots of artificial lighting. Photon mapping is typically not used for exterior daylight renderings because the photons will usually only bounce once or twice before being lost. Even if you surround the exterior scene with geometry like a sphere so as to trap the photons, the contribution to the final image quality is usually negligible and exterior GI can easily be accomplished by only using final gather.

Final Gather

Final gather can be looked at as the opposite method to photon mapping. Instead of shooting photons from a light source into the scene, sampling rays are shot from the camera into the scene, to sample the contribution of light on an object's surface. Unlike photon mapping, this method is *view dependent*, meaning a new final gather map would need to be generated, or updated, if your view was to change. The process of incrementally adding samples to a final gather map is useful for creating animations and will be discussed later.

As mentioned, we are sending sampling rays from the camera into the scene. This means that a ray will sample a point on the surface of an object to see how much light is being contributed by its surroundings. The result is that we can use things like HDRIs, self-illuminated materials, photon maps, mr Physical Sky, and areas *lit* by lights to define the surface's illumination. This process is similar to Ambient Occlusion, which will be discussed in the next chapter.

The Final Gather Process

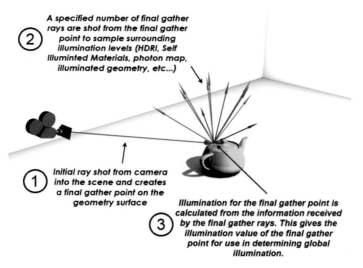

Figure 12-4. Creation of a final gather point.

The following is a summary of the final gather process shown in Figure 12-4:

- A single sampling ray is shot from the camera into the scene.
- This ray comes in contact with a piece of geometry in the scene.
- A final gather point is created on the surface of the geometry, much the same as what happens with a photon imprint.
- This final gather point then sends a specified number of final gather rays into the scene. Some rays will hit the surrounding geometry, some may be lost through a window, and some may hit an environment map (like the mr Physical Sky or HDRI files) or skylight. Either way, there may be a variety of samples taken for each final gather point.
- Mental ray then averages these sampled values to generate the illumination and color value of the final gather point. This information is then used at render time to calculate the illumination in the scene in a similar way to photon mapping. The main difference is we're using final gather points instead of photon imprints.

Let's look at an exercise that demonstrates the final gather process.

Using Final Gather

1. Open the file **Ch12-02.max**. This scene contains a plane, a teapot, and a spot light. The spotlight is intentionally missing the teapot because we're expecting the final gather process to be able to see the puddle of light and determine how much this puddle is contributing to the surface illumination of the teapot.

2. Within the **Indirect Illumination** tab of the **Render Setup** dialog box, open the **Final Gather** rollout and enable **Final Gather**.

3. Using the **Preset** slider, select **Draft** and render **Camera01**. The left image of the following illustration shows the scene with final gather enabled and the right image shows the scene with final gather disabled. Note that the pool of light adds no secondary illumination with final gather disabled, but once final gather is enabled the surfaces of the teapot *see* the pool of light and provide secondary illumination for the teapot.

To better understand what is happening, we'll take a look at what the final gather points look like.

4. Within the **Processing** tab of the **Render Setup** dialog box, open the **Diagnostics** rollout and select the **Enable** option.

5. Select **Final Gather** from the list of diagnostics and render the scene again. The green dots are the individual final gather points. .

6. Return to the **Final Gather** rollout within the **Indirect Illumination** tab, set the **Initial FG Point Density** to **1** and re-render the scene. When we change the density to 1, the preset mode automatically changes to **Custom**. In draft mode we had an initial final gather point density of 0.1, and as shown in the previous illustration, the dots were relatively sporadic compared to what we have now with a density of 1. The denser these final gather points are, the greater the lighting detail will be but at a cost of longer render times.

Keep in mind that each of these final gather points is sampling the surrounding scene's geometry and environment. More importantly, each of these final gather points is using the draft default **Initial FG Point Density** value of **50**. This means that 50 rays are used with each point to sample the surroundings. This presents an opportunity to balance speed versus quality. If we want a higher final gather point density, we can offset the increase in rendering time by lowering the number of final gather rays cast by each point. If we have 100 final gather points in a scene with 50 final gather rays per point, then 5000 samples would be calculated, which is the same number of samples calculated if we have 1000 final gather points casting 5 final gather rays each. Of course the more final gather rays we cast, the better our solution will be, so you need to play with these values on a scene per scene basis.

Now we'll take a closer look at the final gather settings.

7. Open **ch12-3.max**. Note that the following exercise uses a **mr Daylight System**. This type of lighting requires exposure control, so we need to enable this first.

8. Set exposure control to **mr Photographic Exposure Control**, then press Render Preview.

9. Within the **mr Photographic Exposure Control** rollout, click on the preset drop-down list and select **Physically Based Lighting, Outdoor Daylight, Clear Sky**. While watching the Render Preview window, make adjustments to the EV value, and the Image Control settings of Midtones, Shadows, and Highlights to best fit your monitor display.

10. Within the **Indirect Illumination** tab of the **Render Setup** dialog box, open the **Final Gather** rollout and take note of the values used for **Initial FG Point Density**, the **Rays per FG Point**, and **Interpolate Over Num. FG Points**. A very low density of 0.1 is used while only 1 ray per point is calculated and only 1 point is used in the interpolation process.

11. Render **Camera** view. The result should look like the following illustration. The cell-like appearance is mostly a result of the three values mentioned in the previous step. We have a low concentration of final gather points, each final gather point is only sending out one sampling ray, and we are not yet blending the final gather points together. You can see that some spots are black indicating that the single final gather ray wasn't able to sample anything that had a luminance value.

12. Increase the **Initial FG Point Density** to **1** and render again. As you can see from the following illustration, we don't necessarily get a better picture, but we do get more detail since we have a higher density of final gather points. To obtain a better solution we need to smooth out the illumination values. There are essentially two methods we can use. The first, and

most obvious, is to use more final gather rays per sample. This will allow each final gather point to sample *more* of the surroundings, and hence obtain a smoother result.

13. Set the **Initial FG Point Density** back to **0.1**, increase the **Rays per FG Point** to **50** and re-render. As the next illustration shows, this yields a closer approximation of luminance values from final gather point to final gather point, but we still see the individual samples. To get rid of this obvious delineation between final gather points, we'll need to interpolate (or smooth) each sample with the surrounding samples. Before we do this let's look at the other end of the spectrum.

14. Set the **Rays per FG Point** value back to **1** and change the **Interpolate Over Num. FG Points** from **1** to **30**. Notice how the previous illustration and the following illustration both show a generally decent amount of illumination; however, the number of rays used in the previous illustration and the amount of interpolation used in the following illustration have to be used together before a decent solution can be reached.

15. Set the **FG** preset back to **Draft** and render the scene. The following illustration shows how the solution is smoothed out by using 50 rays per FG point and then interpolating each point with the nearest 30 points. Although this gives us good results, you'll notice that we're lacking some detailed shadows. For us to get the detail we need to increase the final gather point density.

16. Increase the **Initial FG Point Density** to 1 and render the scene. This increased the shadow detail substantially, as can be seen in the middle columns and the doorway; however, the render time increased substantially. Even though we now have better shadow detail, we have introduced some noise to contend with. The noise is actually the detail being brought out. Incidentally, if you investigate the FG density values used for the Medium and High pre-set configurations, you would see that the 1.0 value we are using falls in between these presets.

At this point, we could interpolate over more points, but this would remove the shadow detail we gained with the increased FG point density. Instead, we'll increase the number of final gather rays in hopes this will remove this noise.

17. Increase the **Rays per FG Point** to **250** and render again. This removed the bulk of the noise, but there is still a residual amount left. We can continue to increase the Rays per FG Point in an effort to do this, but instead we'll tune out the remaining noise with the interpolation setting.

18. Increase the **Interpolate over Num. of FG Points** to **50** and render again. Keep in mind that interpolation is blending final gather points, and by doing so, details can be lost if it is increased too high. This is similar to the blending method we employed with photon mapping in that if we have enough final gather points, we can have higher interpolation values. If you find that you need high interpolation values to get rid of the noise and as a result lose details, you can increase your density to get them back.

We can use a legacy feature called Use Radius Interpolation Method if we are unable to tune out noise and artifacts with the **Interpolation Over Num. FG Points** option. These are found just below in the **FG Point Interpolation** section.

Figure 12-5. Legacy method of interpolation
as found in earlier versions of mental ray.

Typically, you should keep this to Radii in Pixels since this will then adaptively interpolate the fg points *and* will add any additional fg points at render time if needed. This means that final gather points can be created when needed. Be warned, if you have a low initial final gather point density and use this method, more final gather points will be created at render time, which can give you great results but with long render times. Through experience, I've found that enabling the maximum radius to 30 works well initially. Typically the minimum value should be 1/10 that of the maximum, so for a maximum of 30 pixels, the minimum should be set to 3 pixels.

Noise Filtering

There is another method to remove a noise with final gather; by using **Noise Filtering** within the **Advanced** section of the Final Gather rollout, as shown in Figure 12-6.

Figure 12-6. Noise Filtering dropdown menu.

By default this is set to **Standard** and I recommend that you start with this turned off (**None**) and increase as needed. This filter works in conjunction with the **Rays per Final Gather Point** value by filtering the samples collected from a single final gather point. If any of the final gather rays return a value that is significantly different to neighboring points, it will be rejected from the calculation. This way, the remaining usable samples for each final gather point will be within a defined threshold and will yield more consistent final gather point values. There is a downside, however. As you increase this filter from High to Very High to Extremely High, you remove GI data in the form of light rays and this will cause your scene to get progressively darker. The artifacts this filter removes are usually bright patches, as shown in Figure 12-7. You can easily see these if you turn interpolation off by setting the **Interpolate Over Num. of FG Points** to **1**). If you see white splotches, you will need to use this filter.

Figure 12-7. Example of artifacts that Noise Filtering will aid in removing.

In the **Basic** section of the **Final Gather** rollout is a spinner field called **Diffuse Bounces** that allows the final gather rays to see beyond a single trace. This typically brightens up the image at the expense of greater color bleed, lower contrast, and longer rendering times. The color bleed and contrast can be tempered with the Weight parameter, but the higher render times cannot. The weight parameter will allow you to tell mental ray how much influence the diffuse bounces will have on the solution.

19. Set the final gather settings back to **Draft.**

20. Change the **Diffuse Bounces** to **2** and render the scene. The result should look like the left image in the following illustration.

21. Change the **Weight** to **0.25** and render again. The image on the right shows the apparent increase in illumination, but is then tempered by the weighting to bring back the contrast as shown in the image on the right.

Saving the Final Gather Map for Animations

We can also save the final gather map, which is similar to the photon map; however, it's important to understand that final gather maps are *view dependent*. This means that if our view changes, we'll need to create a new map or when possible add more final gather points to the existing map.

Figure 12-8. The Final Gather Map section.

22. Open up **Ch12-4.max** and render **Camera01**. The result is a diagnostics image as shown in the following illustration.

23. Within the **Final Gather** group of the **Reuse (FG and GI Disk Caching)** rollout of the **Indirect Illumination** tab, click on the icon with three dots, as shown in Figure 12-8, and choose a name and location to save the final gather map.

24. Render the scene to allow the final gather calculation to complete and allow the map to be saved. The result looks like the left image of the following illustration.

25. In the Final Gather Map group, click the dropdown arrow and change it to **Read FG points Only from Existing Map Files**. This prevents the FG map from being overwritten and keeps the previously saved map in place.

26. Switch to **Camera02** and render this camera view. You'll notice that there are no final gather points behind the teapot, as shown in the right image.

Before moving on I'd like to explain what is being seen. mental ray overlays the diagnostic final gather map at render time and does not occlude the fg points with the geometry. This means that the geometry will not hide the green dots that represent final gather points. Thus you're able to see final gather points "through" the geometry in the scene, which can be confusing (such as the final gather points at the base of the teapot). The absence of points in certain regions is due to the creation of final gather points based on our *last view*. If we wish to add these points, we only need to choose Incremental Add FG Points option and render again from this new point of view.

27. From the dropdown list pick Incrementally Add FG Points to Map Files and re-render **Camera02**. You'll notice that there is another final gather calculation phase and more final gather points are added to the existing final gather map.

Notice that new points are *appended* to the original map behind the teapot where none were found before.

So what does this mean to you? This is an important concept when doing architectural animations. Typically a camera is animated to move through the space, and as such 'sees' only select portions of the model. What we need to do is create final gather points on all the geometry the camera sees. Recall that I mentioned the final gather process is view-dependent. So this means that we only need to create final gather points on whatever the camera sees. Obviously, in an animation the view changes from frame to frame. As we've just seen, we can add final gather points to an existing final gather map quite easily. Theoretically, this means we could create a final gather map at frame 1, then add more points at frame 2, and so on. This is not a very economical way of doing it. Usually we can get away with rendering every 5th or 10th frame since there may be very little change from frame to frame. If your animation is slow, you can get away with a wider spacing (say every 30 frames) or if your camera is fast you would need narrower spacing (every second or third frame). For animations, you simply have to "see" all the geometry along your animation path.

It's important to note that when you calculate a final gather map, you don't need to render a production quality image. Thus, you can turn your sampling down to 1/64 for the max and min values to save time. As mentioned earlier, the frame spacing is determined by how fast your camera moves, and if you can "see" all the geometry along your animation path because final gather points are created based on your view. Also, you don't need to save the final rendered image when calculating a Final Gather pass since this pass is only done to create a final gather map.

Once the final gather map is calculated we can render the final image sequence by enabling the **Read FG Points Only from Existing Map Files** option. Set your sampling back to production settings and set the renderer from rendering every **nth** frame to every **1th** frame. This is usually overlooked and causes frustration. Now, render the image sequence as you normally would and mental ray will read the calculated final gather map for illumination levels and create the final rendered image.

If at any time you see some abnormal flickering occurring within your animation, check to see if the final gather map actually "saw" that geometry at that particular frame. If it didn't, you need to

unlock the **Read Only (FG Freeze)** option and append that frame to the final gather map and then re-render the troublesome frames. Note that you can also append final gather points by using the render region option to avoid rendering the entire frame when it wasn't needed.

What it boils down to is that mental ray requires two stages for its GI. The first stage is the calculation of the lighting information via photon and/or final gather maps. Stage two is the rendering of the final image.

A special feature was added in 3ds Max 2009 to compensate for animation flicker caused by moving objects when using Final Gather maps. You can choose to create multiple final gather map files by going to the Mode group and choosing One File per Frame (Best for Animated Objects) and then interpolate between them using the Interpolate over Num Frames setting in the Final Gather Map group.

This addition to the Final Gather workflow provides precise control to eliminate troublesome image sections when animating. I won't delve into it here, so if you need to use it, follow the procedures outlined in the 3ds Max Reference accessed through the Help menu.

Photon Mapping and Final Gather

Both methods of global illumination can be used independently of each other, but we can also use them in conjunction with one another. The order of calculations is first the photon map, then the final gather map. This order is *always* maintained because the Final Gather process uses the information generated by the photon map. When using both methods, it is advantageous to select the **Optimize for Final Gather** option in your photon mapping. This will allow the Final Gather process to be more efficient in reading the photon map.

Figure 12-9. Optimize for Final Gather switch enabled.

If you're wondering why would we want to use both methods, the simple answer is that photon mapping allows us to spray illumination throughout our scene based on the lights, and final gather uses this sprayed light in its calculations of GI. This results in better overall lighting. As stated before, this combination is best suited for interior scenes, scenes lit by artificial lights, or scenes

that have deep niches that need illumination. We'll end this chapter with a few helpful hints when using both methods of global illumination.

- You don't require a large number of photons when using photon mapping *and* final gathering. Your photon map should have just enough photons to cover most of the geometry within your scene and you don't need to specify a sampling radius.

- When rendering exteriors, you do not need a photon map. Final Gather when used in conjunction with a Skylight or mr Daylight System is your best option.

- When calculating your Final Gather map, you can get away with a smaller image size to minimize the render times. If your final output is say 640x480 pixels, you can render your Final Gather map at 400x300 (roughly 75% of the final output size).

- Final Gather can usually be set to Draft for most images. Detailed shadows can be more efficiently calculated using Ambient Occlusion, which will be discussed in the next chapter. If you choose not to use Ambient Occlusion, then higher quality final gather maps would need to be generated, which can add to your rendering time.

- Animations where objects are moving *should not* use photon mapping. Since photon mapping is view independent, if an object were to move, a new photon map would need to be calculated for each frame. A detailed photon map could take a long time to calculate and if this is done for each frame, render times will be unacceptable. Also, discrepancies from frame to frame can occur and give inadequate results. Instead, Final Gather can be used, or better yet, Final Gather *with* Ambient Occlusion should be used for animated objects.

Summary

In this chapter we've begun looking at the technical side of GI in mental ray. The important thing here is to understand the process to better know what needs to be done to eliminate any problems like noise, lack of detail, or artifacts. Knowing mental ray means knowing how to trouble-shoot.

Global illumination allows us to get realistic bounced light in the scenes but only gets us half way to photorealism. The other half comes from the materials we use in conjunction with GI. As just mentioned, ambient occlusion is a fast way to obtain the look of detailed GI solutions in a fraction of the time. Ambient occlusion, when used effectively, can be indistinguishable from detailed GI. We will look at this in the next chapter.

Lighting Strategies

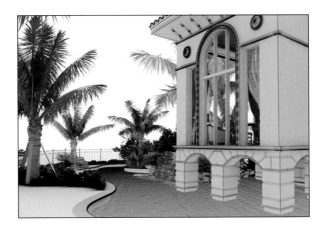

NOW LET'S LOOK AT SOME practical application of the theories discussed thus far. This chapter will discuss lighting methods that will make your visualizations come to life and the strategies introduced here are designed to give you the tools to use mental ray efficiently in production. To simplify our discussions, we'll concentrate on two lighting categories; exterior and interior solutions. Due to the scope of this book, I will intentionally skip studio lighting as this is not a practical application for lighting in architectural visualization. Studio lighting is geared more for things like electronics, cars, and other retail product displays. The strategies discussed here come with specific goals in mind, but as we discovered from the last chapter, global illumination techniques are not entirely discreet from one another, and in fact can be used in conjunction with each other to allow for greater control over scene lighting. Take your time working through the following exercises and continue to revisit them until you fully understand why every step was taken. Be patient and try to extend what you learn here to your own scenes, and when needed, review the theory from the previous two chapters to help remediate any problems that may arise with your scenes.

Using High Dynamic Range Images (HDRI)

We'll start by a simple comparison between low dynamic range (LDR) and high dynamic range (HDR) images. LDR images come in a variety of flavors such as .jpg, .tif, .gif, etc. These image formats all have red, green, and blue channels to define their color information. Some have more channels to include extra information such as an alpha channel. The truth of the matter is that LDR images can only store a finite amount of information for each channel. Typically, most LDR images are 8-bit. This means that we can only store 256 values, or shades of gray, for each channel. So pure red would be Red=255, Green=0, and Blue=0. Notice that I said there were 256 values yet pure red only uses 255 for a maximum value. This is because the range starts at 0 so the maximum is 255 not 256. Without going into a lesson in color theory, pure yellow would be Red=0, Green=255, and Blue=255.

As we can see, there is a finite range of values we can use per channel in LDR. HDR images are the opposite and allow us to use real values to store color information. This means that we can have a wider range, or high dynamic range of values to define an image, and thus, we can have color intensities that are unobtainable in LDR images. For example, the brightest part of a mid-day sun would be displayed as a pure white pixel in an LDR image that corresponds to a color value of R=255, G=255, and B=255. In an HDR image, this can be defined by real numbers such as R=20,483.058, G=23,945.4286, and B=22,563.4. Although we may not see a difference between these images on a monitor, the difference is there. Because of this, we can use High Dynamic Range Images to illuminate a scene with the real-world lighting.

Typically, HDRIs are created so that the illumination they provide matches the illumination shown in the visible image itself. Typically this is called "in situ", which means placing your subject in a situation much like placing a CG building in a photo of an existing street corner. Many users believe that all you need is to apply an HDRI within your scene (as we will do shortly) and render the result. This is only half of the story because HDR images only generate the ambient lighting and 3D lighting still needs to be applied to finish the image. Some production houses have proprietary software that scans the HDRI and places lights according to the image's brightest spots and even sets the light intensity and color based on the HDR image. We won't be as elaborate as this, and instead will just use our eyes to match the light's color, location, and intensity.

1. Open **Ch13-01.max**. This is a simple scene consisting of a teapot and plane. Final gather is enabled with a Draft preset.

2. Render the camera view. The result should look like the left image in the following illustration. At this point, the scene is only illuminated by default lighting. Let's begin the exercise by adding skylight to the scene.

3. Place a standard **Skylight** anywhere in Top view and render the camera view. The result should look like the middle image of the following illustration. Notice that soft shadows are now present, although because of the draft final gather settings, the quality is quite low. The Skylight feature creates an equal amount of illumination from all directions above the horizon.

4. Change the final gather preset to **High** and render again. The result should look like the right image.

5. Return the final gather preset to draft so that test renders for the remainder of this exercise take minimal time.

6. Open the **Environment and Effects** dialog box.

The HDR image we will be using in this exercise is shown in the following illustration. Notice that half of the image is black. This is because skylight should not emanate from anywhere below the horizon, which it would if this half of the image were not pure black. Incidentally, you can down-

load free HDRIs from numerous different vendors such as Dosch Design, Evermotion, and Hyperfocal Design.

7. Click on the **Environment Map** channel, select **Bitmap** from the **Material/Map Browser**, and select the **HDR** image **sunset.hdr**. The **HDRI Load Settings** dialog box appears.

The HDRI Load Settings dialog box is an important feature because it allows us to use an HDRI as is or to use just part of the luminance range. At the top of the HDRI Load Settings dialog box is the image histogram, which is a graphical representation of the luminance range of the image. The farthest left side represents the darkest pixel in the image and the farthest right represents the brightest. When the two red vertical lines are placed at the far extremes of the histogram, as shown in the left image of the following illustration, the entire luminance range is used. When the Black Point and White Point values are adjusted so the two vertical lines are much closer together, such as the right image, a small portion of the luminance range is used. Notice in the right image that everything greater than the white point value is scaled to white and everything less than the black point is scaled to black. This is why so much of the preview image is displayed as pure black and pure white. An easy and suitable way to use this histogram is to either set the white and black point values to the extreme ends of the luminance range, as shown in the left image, or set them to match the Measured Min/Max values, which we will do in this exercise.

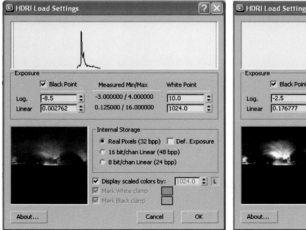 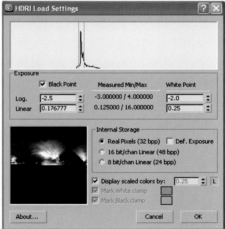

8. In the **HDRI Load Settings** dialog box, set the **White Point Linear** value to **16.0** and the **Black Point Linear** value to **0.125**.

9. In the **Internal Storage** section, enable the **Real Pixels** option (if not enabled), which will allow for the proper storage of the HDR image. Click OK to complete the loading of the HDRI into the environment channel.

If you render right now, nothing will have changed because all you have done is loaded the HDRI as the background image. From the camera's view, the background is not visible. We need to tell

3ds Max to use the HDRI as the skylight rather than the color swatch found in the skylight we just added.

10. Select the skylight you created and within the **Modifier** panel set the skylight to **Use Scene Environment** for its sky color. This will allow the skylight to use the HDRI we placed in the environment channel as the lighting source. In most advanced render engines, using an HDRI within a skylight is the best way to implement image-based lighting.

Once again, if you render right now, nothing will have changed, and you will still see a black rendered image. This is because we haven't mapped the HDRI properly and we don't have enough illumination coming from it.

11. Open the **Material Editor** and drag an instance of the environment bitmap into an empty material slot within the Material Editor. This allows us to adjust additional settings regarding the orientation of the HDRI, as well as intensity values controlled through the Output rollout.

12. Ensure that the HDRI bitmap is set to **Environ** and change the **Mapping** to **Spherical Environment,** as shown in the following illustration. This ensures the spherical HDRI is mapped completely around the scene in a spherical fashion.

13. Render the **Camera** view. Notice that the image is still too dark right now. We could change the white point in the HDRI so it moves to the left in the histogram, thereby making parts of the HDRI that were previously not giving off much illumination, suddenly give off a tremendous amount. Instead of doing this, which would reduce the dynamic range of the HDRI, we simply need to increase the intensity multiplier of the skylight or increase the Output Amount of the HDRI within the Output rollout of the Material Editor. Changing both of these will have the exact same effect on the rendered image; however, I suggest adjusting the Output value so you can see the effect of the change within the sample slot.

14. Change the **Output Amount** to **100** and render the camera view. The result should look like the left image in the following illustration.

15. Increase the **Output Amount** to **300** and render again. The result should look like the middle image in the following illustration. This provides an adequate level of skylight in the scene. Notice how the ground appears to be painted in a blue-purple color. The more you increase the output amount of the HDRI, the whiter the skylight will become until the only thing that prevents it from looking like a mid-day sun image is the lack of strong shadows.

16. Increase the **Output Amount** to **500** and render again. The result should look like the right image. At this point we need to add direct illumination to the scene.

The HDRI we are using has a definitive light source within it; the sun. So when we add a light to the scene, we need to position it so it matches the location of the sun in the HDRI. Because of an

HDRI's soft shadows, it is often impossible to tell where the sun is in the HDRI based on the HDRI shadows. To locate the sun, we could add a fully reflective sphere to our scene and see where the reflection of the sun in the HDRI is located. Since we already have a teapot, we can just make the teapot fully reflective instead.

17. Apply a fully reflective material to the teapot. If you are using 3ds Max 2012, the easiest way to do this is to apply the **Autodesk: Mirror** material. If you are using 3ds Max 2009, you should use **ProMaterials: Mirror** material.

18. Render the **Camera** view and make note of where the sun is located on the teapot, as shown in the left image of the following illustration.

19. Create a standard direct light anywhere in your scene.

20. Use the **Place Highlight** tool to move the new light so its specular highlight occurs in the same location as the reflection of the HDRI's sun. When this is done, the new light will be positioned to match the sun in the HDRI.

21. Enable RayTraced Shadows for the new light and render the camera view. The result should look similar to the middle image of the following illustration. Notice how the areas in direct illumination are completely white and that the shadow of the teapot is actually the same color as the skylight we saw everywhere before the new light was added.

22. Change the direct light Multiplier value to 0.5 to reduce the intensity of the direct illumination.

23. Change the Output Amount for the HDRI to 400 to help reduce the total illumination in the scene.

24. Render the camera view. The result should look like the right image of the following illustration.

25. Adjust the intensity of the direct light and the skylight to achieve an aesthetic balance. If you want to see the final scene as shown in the following illustration, open the file **ch13-02.max**.

Without the direct light source, your rendering is at the mercy of the overshadowing color derived by the HDRI. HDRIs provide a nice way to illuminate a scene. However, their effect becomes diminished as the strength of direct illumination increases. Therefore, they are really most practical and beneficial in scenes with low amounts of illumination, such as dusk or nighttime scenes. The darker a scene, the more difficult it is to set up lighting with regular lights, and since low illumination is less accurate than strong illumination, you often have to use very high render settings to prevent noise from developing. HDRIs provide a nice solution to this problem.

It is worth mentioning that the previous illustration does not use any tone mapping via exposure control. Exposure control will help minimize hotspots and dark areas in an image, but will also reduce the color contribution of the HDRI.

mr Daylight System (part 1 – Exteriors)

The mr Daylight System is similar to HDRI but offers much more power through an extensive set of tools. The mental ray Daylight System is comprised of a mr Sun and mr Physical Sky shader.

1. Open **Ch13-03.max**. You'll notice that it contains a simple white building and a ground plane.

2. Switch to **Top** view and from the **Create** panel select the **Systems** icon.

3. Click the **Daylight** icon. If you are using 3ds Max 2008 or later, you will be asked if you want to use the **mr Photographic Exposure Control**.

4. Select **Yes**, and create a **Daylight System** centered on the house with default time, location, and North direction. You may get a message saying you are placing a mr Sky and "do you want to place a **mr Physical Sky** map into the environment channel?", say yes if you get this message, and skip to step 8.

5. If you didn't get that message you must select the **Modify** panel. Notice that both the Sunlight and Skylight sections have fly-out menus that will allow you to choose different types of sunlight and skylight.

6. From the **Sunlight** drop-down list, select **mr Sun** and from the **Skylight** drop-down list, select **mr Sky**. As soon as you select the mr Sky, you will be asked if you want to place a **mr Physical Sky** map into the environment channel.

7. Select **Yes**.

8. Open the **Environment and Effects** dialog box, and from the **mr Photographic Exposure Control** roll-out, click on the preset drop-down list and select **Physically Based Lighting, Outdoor Daylight, Clear Sky**. Press **Render Preview**. Now you can adjust the EV value spinner while watching the preview thumbnail. If you're familiar with photographic settings, you will probably find it more beneficial to not use a preset and to adjust your exposure control through the three critical components found both in this rollout and the real world. They are shutter speed, film speed, and f-stop. For the sake of simplicity, we will use a preset.

9. On the Render Setup dialog, under Indirect Illumination, make sure **Final Gather** is set to **Draft**.

10. Switch to the **Camera** view and render the scene. The result should look like the left image of the following illustration.

11. Use the **Motion** panel to change the time of day to **6AM** and render the **Camera** view again. The result should look like the middle image of the following illustration. Although the preset we used for exposure control provided a suitable image in the previous rendering with the sun positioned high in the sky, this last rendering appears much too dark with the sun being as far above the horizon as it is; approximately 15 degrees. Rather than correcting this with the more complicated **Photographic Exposure** settings, which requires knowledge of the photography settings just mentioned, we can instead provide a quick fix to the exposure problem by reducing the **Exposure Value**.

12. Change the **Exposure Value** from the default value of 15 to **14** and render again. Notice that the image is twice as bright. This is because when you reduce the Exposure Value by 1, the shutter speed is reduced in half. This means that the shutter of the camera stays open twice as long allowing twice as much light to exposure the image. You can even see the actual Shutter Speed value changing as you change the Exposure Value. Cameras in the real world use these same shutter speeds and when you want to change shutter speed on a real camera, you either double the speed or reduce the speed to half. At this point, the image is still too dark right now so one more change is in order.

13. Reduce the **Exposure Value** from **13** and render again. The result should look like the right image of the following illustration. This image appears to be properly exposed and the amount of illumination in the scene appears to be what we could expect to see with the sun just above the horizon early in the morning.

14. Save your scene using a new name for use in the next exercise. If you want to see the final scene as shown in the following illustration, open the file **ch13-04.max**.

Note how in the previous illustration the skylight color and intensity is driven by the azimuth and altitude of the Daylight Assembly head. This is typically driven by the time of day entered in the **Motion** panel; however, this can be overridden by simply selecting **Manual Override** and positioning the assembly head at any location you like.

The daylight system also provides a sun disc that can be visible within the render. The location is driven by the extrapolated location of the sun's direction vector **not** the physical location of the daylight assembly head. To understand where the sun disc will appear when rendered, it is best to set the daylight's **Orbital Scale** to an exorbitant value.

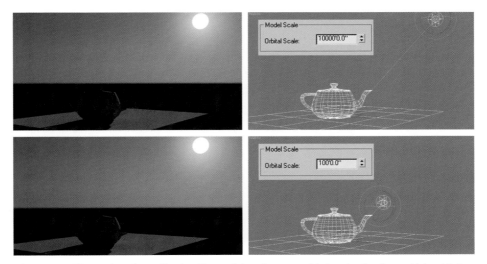

Figure 13-1. The rendered sun disc location matches the assembly head only when a high orbital scale is used.

mr Daylight System Parameters

The Daylight System provides a great way to implement real-world exterior lighting. Although you can use standard or photometric lights with this system, the mental ray Daylight System found in

3ds Max 2009 and later makes the mr Sun, mr Sky, and mr Physical Sky an amazing combination. When used in the way these features were designed, all three are linked together and both the mr Sun and mr Physical Sky include an **Inherit from mr Sky** option, which should be left enabled unless you have a specific reason for them to be disabled. Incidentally, the mr Physical Sky parameters are only accessible by creating an instance of the environment channel within the Material Editor. Fortunately, most of the parameters for these three features are self-explanatory, so here we'll focus on some that are not.

In the Command panel, there is a rollout labeled mr Sky: Haze Driven (mr Sky), and within this rollout is the Haze setting. This setting controls the amount of particulate in the atmosphere, which helps determine the color of the sky and skylight. This value is set to 0, by default, which causes no haze to be generated. Increasing it up to maximum value of 15 simply increases the strength of the haze, while the color of the haze is dictated by the position of the sun. As you can see in Figure 13-2, raising this setting to a maximum value of 15 and changing the position of the sun creates a wide variety of sky and skylight color. In this example, the position of the sun was changed by simply changing the time of day.

Figure 13-2. Haze at full value (from left to right; 6am; 8am; 10am; 12pm; 2pm; 4pm; 6pm).

We can also add a cloud texture to the Haze component to get the look of distant clouds.

15. Continue from the previous exercise or open **Ch13-04.max**.

16. Select the daylight assembly and within the **Modify** panel, change the **Haze** value from 0.0 to **2.0** and render the **Camera** view. A subtle haze is generated.

17. Drag an instance of the **mr Physical Sky** shader from the **Environment and Effects** dialog box to an empty slot in the **Compact Material Editor**.

18. Within the **Material Editor**, deselect the **Inherit from mr Sky** checkbox and render again. The sky returns to showing no haze because you have overridden the haze setting in the Modify panel.

19. Click the Channel button to the right of the **Haze** parameter and add the bitmap **Haze_Clouds.jpg** to this channel. Deselecting the Inherit from mr Sky option overrides the haze setting within the Daylight system and loading a bitmap here overrides the Haze setting within the mr Physical Sky shader.

20. Within the **Output** rollout of the bitmap you just loaded, increase the **RGB Level** of the cloud texture to **10** to compensate for the effect of exposure control. Without doing this, the map would be too faint. As you increase the RGB Level, you also cause the Haze color to be influenced. An alternate to this technique is the **Use Custom Background Map**.

21. Enable the **Use Custom Background Map** within the **mr Physical Sky** shader and copy (not instance) the **Haze_Clouds.jpg** into this map channel.

22. Change the **Output Amount** to a value of **1000**. Also increase the **RGB Level** to **10**. This will compensate for the exposure control and display the cloud image properly in the background. Also make sure the Coordinates rollout shows the Environ button selected, and Mapping set to Screen. The following images show the result of both methods. The left is accomplished by placing a cloud map in the Haze channel, while the right is accomplished by replacing the background image entirely.

The next feature we'll look at is **Night Color**. The Night Color represents the darkest color your sky will change to when your sun goes below the horizon. It's important to note, however, that the color you specify will be the darkest only when exposure control is not allowed to affect the background.

1. Open the file **Ch13-04.max** again to return to the scene we used at the beginning of the last exercise.

2. Render the **Camera** view to remind yourself what the scene looks like right now.

3. Drag an instance of the **mr Physical Sky** shader from the **Environment and Effects** dialog box to an empty slot in the **Material Editor**.

4. Within the **Material Editor**, deselect the **Inherit from mr Sky** checkbox.

5. Select the daylight assembly and within the **Motion** panel, change the time of day to **4AM** so the sun is just below the horizon.

6. Render the **Camera** view. The result should be a very dark scene.

7. Click on the **Night Color** swatch within the **Material Editor** and change the **Blue** component to **0.2**. Click **OK** to close the dialog box. This changes the Night Color to a very dark blue.

8. Render the **Camera** view. Notice that nothing has changed. The reason is because exposure control is affecting the final colors within the image. When the sun is below the horizon as it currently is, we need to adjust exposure control because it's configured for a daytime scene.

9. Remove exposure control entirely and render the **Camera** view again. Notice that the night color you just set is now the dark color in the sky, as shown in the following illustration.

The next feature we need to discuss is **Aerial Perspective**, which contains a setting called Visibility Distance. This setting determines the distance at which a 10% haze is generated. This haze is needed in large exterior scenes where the viewer can see to great distance, because without it there is a diminished sense of scale. This value is set to 32,808'4.781" by default, which is exactly 10 kilometers. The following exercise helps illustrate this important setting.

10. Open the file **Ch13-05.max**. This scene contains a mountain range that spans approximately 10K, which is the same distance the visibility distance is set to by default.

11. Render the **Camera** view. Notice that the image lacks depth and scale, as shown in the left image of the following illustration. This is because there is no haze, even though one would expect to see it for such a view.

12. Select the daylight assembly and open the **mr Sky Advanced Parameters** within the **Modify** panel. Notice that Aerial Perspective is disabled.

13. Enable **Aerial Perspective** and render the **Camera** view again. Nothing has changed because the Visibility Distance is set to 100,000 feet, which is beyond the last mountain in the background.

14. Change the **Visibility Distance** to **30,000'** and render again. The result should look like the middle image of the following illustration.

15. Change the **Visibility Distance** to **10,000'** and render again. The result should look like the right image of the following illustration.

We can also use this as a Lens or Volume shader within the scene.

16. Disable **Aerial Perspective**.

17. Open the **Camera Effects** rollout within the **Renderer** tab of the **Render Setup** dialog box.

18. Within the **Camera Shaders** section of this rollout, click on the **None** button next to **Volume** and load the **mr Physical Sky** map type.

19. Drag an instance of this map into the **Material Editor**.

20. Change the **Visibility Distance** to **10000'** and render the **Camera** view. The image returns to its initial look, as shown in the left image of the following illustration.

21. Change the **Visibility Distance** to **30,000'** and render again. The result should look like the middle image.

22. Change the **Visibility Distance** to **1,000'** and render again. The result should look like the right image.

There is a key difference when using the mr Physical Sky map as a Lens or Volume shader. The Lens shader will not be visible in raytraced reflections but the Volume shader will.

Lastly, we'll look at the **Non Physical Tuning** parameters, accessible in the mr Sky Advanced Parameters rollout of the Modify panel or within the mr Physical Sky map. These parameters will adjust the overall coloration of the render. For example, we could warm or cool the coloration of the rendering by adjusting the **Red/Blue Tint** value. Positive values make the rendered image redder and negative values make the rendered image bluer. Figure 13-3 illustrates the differences between these settings.

Figure 13-3. Various Red/Blue Tint values from left to right; -1, -0.5, 0, 0.5, and 1.

mr Daylight System (part 2 – Interiors)

Having discussed exterior lighting in the first half of this chapter, we now switch the focus to a discussion on interior lighting. We will once again use the daylight system for our interiors, but instead of calculating GI entirely through final gather, we will also have to rely on photo mapping. Photons are the best way to allow light to permeate into a scene, unlike final gather, which on its own does not allow enough light through small areas such as door and window openings. Although sky portals can fill this gap, photons may still be required to spread the illumination throughout the scene. Even sky portals can emit photons for this purpose and we'll look into this later in this chapter. For now, we'll look at using a photon map to bounce light throughout our scene, and then allow final gather to use this 'sprayed' map to obtain a better rendering.

Using photons and final gathering together

1. Open **Ch13-06.max**. This is a simple interior scene illuminated entirely by a daylight system. Materials are already applied but global illumination has not been set up yet. The following image shows what we will produce by the end of the exercise.

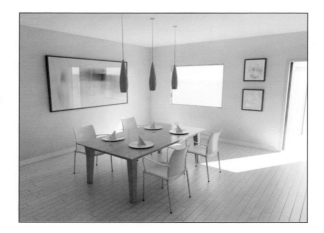

2. Within the **Processing** tab of the **Render Setup** dialog box, enable the **Material Override** option.

3. Load the **Arch & Design** material as the override material. Using a material override during initial lighting setup is useful for reducing test render times and for facilitating the setup process. With only one material, the number of things that must be controlled and understood are reduced and there are far fewer variables involved.

4. Create an instance of the material override in the **Material Editor**.

5. Change the **Reflectivity** of the new material to **0** and set the **Diffuse Color** to 75% gray. To set the color to 75% gray, simply enter a value of **0.75** for the RGB components.

It's important to note that the window glazing has been hidden for the lighting setup because if it were visible, it would receive the override material and stop light from passing through.

6. Switch to Top view and select the daylight system that has already been created for the scene. Notice that when you select the daylight system, pink lines appear. This is the **Photon Target** feature. Essentially, the pink lines represent the tube photons will be shot through and it effectively concentrates the spray so fewer photons are wasted. The target has been adjusted so it's just large enough to cover the openings of our room. You can access the controls for the Photon Target within the **mr Sun Photons** rollout of the Modify panel.

Since we're using a daylight system, we need to use exposure control.

7. Enable **mr Photographic Exposure Control** and use the preset called **Physically Based Lighting, Indoor Daylight**. Right click the **Camera Viewport**, and then press **Render Preview**.

8. Switch to **Camera** view and render the scene. The result should look like the left image of the following illustration. There is no GI in the scene so the only possible result with the daylight system is pure white for direct illumination and pure black for shadows.

9. Within the **Indirect Illumination** tab of the **Render Setup** dialog box, enable **GI** and render the **Camera** view again. The result should look like the middle image of the following illustration. Despite the noise, we're getting good penetration of photons within the scene. The key here is to make sure that most, if not all, of the surfaces receive some illumination from the photon map. Typically you can keep the average number of photons per light set to 10,000. If you were to have more light sources in the scene you would divide the average number of photons by the number of lights. For example, if we had 3 lights in the scene we could get away with an average of 3,333 photons per light since this would total 9,999 photons for the scene. If there are not enough photons to illuminate all of the surfaces in the rendered view, increase the average number of photons per light until there are enough photons to give a good distribution.

10. Enable **Optimize for Final Gather**. This will allow the final gather process to more efficiently read the irradiance values from the photon map.

11. Enable **Final Gather** and set the preset to **Draft**.

12. Within the **Advanced** section of the **Final Gather** rollout, disable **Noise Filtering (Speckle Reduction)** by clicking on the drop down list and selecting **None**. This will enable every final gather ray to be used, which in draft mode is 50 rays per final gather point. This filter should only be used if you see strange bright artifacts when using final gather. Remember that the process will reject any sampled ray that is abnormally different from the rest.

13. Render the **Camera** view. The result should look like the right image of the following illustration.

14. Within the Image Control section of the **mr Photographic Exposure Control** rollout, set the **Highlights (Burn)** value to **0.05**. This will remove most of the overexposed highlights by the door and back wall.

15. Increase the **Shadows** value from 0.2 to **0.5**. This will increase the contrast and depth of the shadows.

16. Render the **Camera** view again. The result should look like the right image of the following illustration.

You'll notice that the scene has a smoother GI quality but is still far from what is desired. There are still some artifacts at the feet of the table and the scene lacks detailed shadows. We can easily adjust our final gather settings to get better connecting shadows and detailed lighting, but this is at the expense of longer render times. A better way is to use **Ambient Occlusion**. Ambient occlusion (AO) is the measure of how much of the surroundings are occluded, or blocked from view, at any given point on a surface. An AO image is always grayscale, and is often referred to as a dirt pass, because it can be used to add a dirty look to what would otherwise be surfaces that are too perfectly clean to be realistic. It can also be used here to add detail and depth to shadows.

17. Within the **Special Effects** rollout of the material you assigned as an override, enable the **Ambient Occlusion** option.

18. Render the **Camera** view. The result should look like the left image of the following illustration.

Ambient Occlusion samples points along the geometry surface to check for any geometry within a specified proximity of that point. If there is, the surface point renders darker depending on the number of sample rays that detect adjacent geometry. We can specify this sampling radius by adjusting the Max Distance value. Increasing this value increases the spread of the shadows.

19. Increase the **Max Distance** value from the default 4" to **2'** and render the **Camera** view again. The result should look like the right image of the following illustration. Notice the increase in depth in shadows everywhere; especially the plates on the table.

 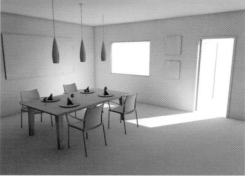

Although ambient occlusion gives us great results, they may not be as accurate as we might like. For example, notice that there is a pronounced shadow in areas like wall corners. This can be

fixed by using the **Use Color From Other Materials (Exact AO)** option. This method will look at adjacent materials and include their properties in the AO calculations. This will take a little longer to render but will give us more accurate results without a huge hit to render times.

20. Enable the **Use Color From Other Materials (Exact AO)** option and render the Camera view. The following illustration shows the before (left) and after (right) images. Notice how the ceiling is still defined without having an over-exaggerated dark crease. Because AO can be applied on a per material basis, we can tailor the shadowing to our needs by adding as much or as little AO as we want. We'll look at this later in this chapter.

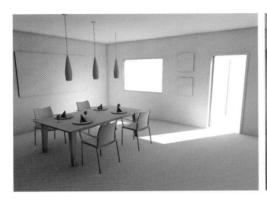 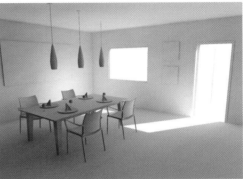

To improve the image quality further, implement some of the strategies discussed in the previous chapter regarding final gather. You can always resort to some of the presets to make this even easier.

At this point we're ready to start texturing and applying materials. The main material we'll be concerned with is the mental ray Arch & Design, which we'll talk about in more detail in the next chapter. Because we had a universal material assigned with the material override, we didn't have to worry about how photons interact with the scene. For example, material color will have an impact as to how much light is reflected off of every surface. Dark materials will absorb the photon energy and lighter materials will allow the energy to propagate more. Because of this, we may have to play with the exposure control settings to compensate for the addition or loss of light energy.

4. mr Sky Portals

Sky portals were introduced with 3ds Max 2008 and can be used to enhance the effects of final gather without necessarily requiring any photon mapping. Sky portals can be thought of as a conduit for skylight; they derive their information from a skylight, an environment map, or a custom shader. Although they need to derive their lighting source and color from other sources, they act very much like an area light. This means that a sky portal is able to create realistic area shadows. It is important to note that sky portals can also be used to emit photons. Therefore, everything we've done in the previous section is applicable here.

1. Open **Ch13-07.max**. This is the same scene we've been using, except the daylight system has been removed and replaced with a skylight.

2. Switch to a **Front** view, and create the photometric light called **mr Sky Portal** just inside the window opening and just inside the door opening. Position and size the sky portals so they fill the openings as much as possible without touching any geometry. Make sure the light direction arrow points to have the sky portals push light into the room.

3. Switch to **Top** view to place the portals so they are flush with the outside surface of the walls. You could also choose to position the sky portal inside the room so it is not affected by the glass within the windows in any way.

4. Render the **Camera**. There is virtually no illumination because the portals are using the sky-light as the color/light source, as you can see in the **Advanced Parameters** rollout of each sky portal.

5. Select the **Skylight** and set its multiplier to **30,000**. We have to do this because we're still using the exposure settings for the daylight system and the skylight is what the sky portals will use as their luminance source now. An intensity multiplier value of approximately 30,000 is needed to create about the same amount of light as that of a daylight system.

6. Enable **Final Gather** and set it to **Draft** mode.

7. Render the **Camera** view. The result should look like the following illustration.

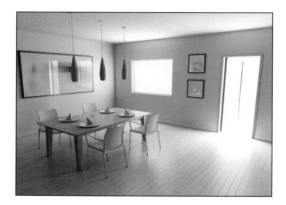

Note that you can simply add the mr Sky Portal like any other light. The only difference is that you need to specify where the illumination is coming from (i.e., skylight, environment channel, or a custom shader). As an additional note, the only shape option currently is the rectangle, so for round windows several smaller sky portals may be needed to fill the shape.

mr Sky Portal Parameters

1. Open **Ch13-08.max**. This scene contains a window opening with a large box just outside of it.

2. Render the **Camera** view. Notice that the pole in the center of the room casts a single shadow, as shown in the left image of the following illustration.

3. Select the **mr Sky Portal** and enable the **Shadows From "Outdoors"** option.

4. Render the **Camera** view. Notice that the pole now casts a double shadow (right image) as if we had two sky portals in two separate windows. This option allows objects behind a sky portal to influence its area shadows. This means that if we have any geometry that is outside the window, area shadow calculations will be calculated based on the amount of occlusion in the opening. The result is a longer rendering time due to the added complexity of area shadow calcula-tions, but realistic occlusion of exterior geometry, such as trees, shutters, or anything else. As an additional note, when this object is enabled and objects are blocking the opening, as in this scene, the result is also a reduced amount of light entering the opening.

Some additional important options include the following:

- **Visible to render** – This option allows you to use the mr Sky Portals as bounce cards to add specular highlights. This option should only be used when sky portals are outside of the view, as they will occlude anything behind them and act as self-illuminated planes.

- **Transparency** – This option is a little confusing for many users. It adjusts the exposure value for objects that are seen through the mr Sky Portal. Typically when balancing exposure, interior scenes are substantially different in light levels compared to the outdoors. This is evident in any interior photograph looking through an exterior window. Either the interior is lit well with the exterior blown out, or the exterior is seen through the window and the interior is very dark. This discrepancy is what transparency compensates for. A transparency value of black will occlude all objects and the environment behind the portal. All other values allow for light balancing. The following illustration demonstrates this with various levels of transparency applied to the sky portal.

5. Self illuminated materials

Self illuminated materials allow you to further exploit the power of final gather. There are many ways to use self illumination; however, the Arch & Design material has quantitative values we can assign for luminance values.

1. Open **Ch13-09.max**. This scene contains a simple teapot on a plane with another plane that will act as an area light. There is also a hidden and disabled omni light, which is used to disable default lighting.

2. Enable **Final Gather** with **Draft** mode.

3. Open the **Material Editor** and notice that there are two materials applied in the scene. One is a basic Arch & Design material assigned to the ground plane and the teapot, while the other is what we're going to use to create our self-illuminated material.

4. Select the **Illumination Material** in the Material Editor. Change the material from a **Standard** material to an **Arch & Design** material.

5. Disable reflections by setting Reflectivity to 0.

6. Enable the Self Illumination option in the rollout of the same name. If you want to establish the self-illumination intensity with physical units that respect the size and scale of your scene, this is certainly an option. However, for this example we'll only concentrate on the Unitless option, which acts like a multiplier. By default, the luminance is set to 1.0, but we can increase or decrease this as necessary to achieve the appropriate amount of illumination.

7. Enable the **Illuminates the Scene (when using FG)** option. This is an important option because without it the material will appear to be self illuminated, but it won't illuminate the scene.

8. Render the **Camera** view. The result should look like the following illustration.

We may need to adjust the final gather settings depending on the size of the self-illuminated geometry. Larger areas can get away with less detailed settings but small areas need a much more detailed final gather map to create acceptable results. If we want to create neon, for example, the size of the illuminated surface is quite small. To allow as many final gather rays to see it, we would need to increase the number of **Rays per FG Point**, and increase the **Initial FG Point Density** and disable **Noise Filtering (Speckle Reduction)**. This way, there is a greater chance that the final gather rays along the surface will see the illuminated tube. In the following illustration, notice how much more illumination detail there is with the image on the right, which uses better final gather settings.

Figure 13-4. Difference between low final gather settings and high settings for small self illuminated material geometry.

There are many applications for this technique and I'll leave you to explore the possibilities. For now we'll look back one more time to the simple dining room scene, only this time we'll illuminate the room using self illuminated planes outside the window and door. Because this scene doesn't use photon mapping we're relying entirely on final gather to generate our illumination. Because of this, we need the final gather process to see further into the scene. This can be accomplished by setting the **Diffuse Bounces** setting to a value of 2 or 3. Higher values will lead to exaggerated color bleeding. If you want to examine this scene with this configuration, open the file **ch13-10.max**.

Figure 13-5. Dining room scene lit entirely by a self-illuminated plane outside the window.

Summary

As you can see, there are many methods by which to illuminate your scenes. Knowing what's available and how to implement it is crucial to being able to meet expectations. At the end of the day, you need to be able to balance rendering speed vs. quality. There is so much more that is available to you within mental ray and this only scratches the surface. Take the information presented in this chapter and research points you may have questions about. The main ideas presented here deal with using photon mapping and final gather when appropriate. Typically, any exterior scene can forego the use of photon mapping since final gather gives more than enough lighting information. Interior scenes, or scenes that use artificial lighting, are better suited to using photon maps. We can then use final gather as a means of smoothing out and refining the GI solution by using the photons'

irradiance values in the final gather calculations. This has been further refined by the use of portal lights that allow us the possibility, depending on the scene of course, of solely using final gather as a method of calculating the bounced light. To this, we can also add self-illuminated materials to the mix to come up with complex architectural lighting.

mental ray Materials

THE **Arch & Design** MATERIAL TYPE HAS BEEN around since mental ray v3.5 and has been a factor in the ease of mental ray's usability. In 3ds Max 2009, this material begat ProMaterials, which were Arch & Design based materials that featured a stripped-down UI. In 3ds Max 2011 and later, the ProMaterials were renamed and redesigned to become Autodesk materials. In 3ds Max 2012 there is now a huge library of **Autodesk** materials that are specifically designed to be even more accurate and easy to use. The Autodesk materials are an attempt to create one set of materials for multiple applications, and are standard for both Revit and 3ds Max. This chapter will focus on the Arch & Design material as it covers concepts that are applicable to any of the new materials. This chapter is not intended to be an in depth guide to all mental ray materials because providing coverage of every material type would require a dedicated book, yet would not be necessary because so many of the thousands of material settings are duplicates and the same concepts explained in this chapter will apply to all material types. This chapter will instead focus on the process of creating and troubleshooting architectural materials, and in doing so, we will learn how to use the new Arch & Design material effectively within architectural scenes.

The first material we will look at is glazing, or glass, and we're going to cover this particular material type thoroughly because this is the perfect material type that allows us to demonstrate two of the most important characteristics of a material; reflection and refraction. In the course of discussing the creation of glass materials, we'll look at how the same concepts discussed can be applied to other materials, such as water. After this, we will briefly look at bump maps, normal maps, displacement, and material exposure control. Each of these will be discussed through the use of the Arch & Design material.

The Arch & Design material

The Arch & Design material comes with a variety of preset templates, all of which are found within the Templates drop-down list in the Material Editor. These are great to use as starting points to see how the parameters differ from template to template. Upon completion of this chapter, I recommend examining each template to see what settings are used, and feel free to examine the new

Autodesk Materials and how these concepts apply to them. We'll start the discussion with an examination of the apparently benign material, Architectural Glazing.

Let's discuss four key points about architectural glazing. These are **Transparency**, **Translucency**, **Glossy Refraction** and **Sub Surface Scattering**. Each of these is quite different from the other and can be used individually or in combination. The reflections will be discussed later in this chapter since they can apply to any material, not just glass.

Transparency

Obviously when you think of a window, you think of transparency. A partially transparent object will partially occlude objects behind it depending on how transparent it is, and it's a misconception to think that window glazing is 100% transparent. Before going further, it is important to note that the Arch & Design material is energy-conserving. This means that if an object is 100% transparent the diffuse properties will have no visible effect, since in theory there will be no absorption of the refracted ray. This is physically accurate in the real world; unfortunately, no material is 100% transparent and the closest thing we have to anything fully transparent is a vacuum. To see any diffuse coloration you would need to have something less than 100% for refraction. The following example shows a glass pane with varying degrees of transparency and a pure blue diffuse color.

1. Open the file **ch14-01.max**. This scene contains a teapot and a thin box on which an Arch & Design material is applied.

2. Render the **Camera** view. Notice that the glass shows 100% transparency, no diffuse coloration and no shadows, as shown in the left image of the following illustration.

3. Open the **Material Editor** and examine the **Refraction** section of the **Main material parameters** rollout of the assigned material. Notice that the **Transparency** is set to **1.0**, which prevents the possibility of diffuse coloration and shadows.

4. Change the **Transparency** to **0.9** and render again. With this change, we see some of the blue diffuse coloration and a shadow vaguely present, as shown in the middle image.

5. Change the **Transparency** to **0.5** and render again. Now we see 50% transparency, a much more pronounced blue diffuse coloration and a darker shadow as well. Notice, however, that the shadow remains gray, as shown in the right image.

The previous example illustrates the correlation between transparency and diffuse coloration. Now, let's examine the correlation between transparency and refractive color. Unlike what we saw in the previous example, the rays that refract through the material will be influenced by the refractive color and will therefore allow for the raytraced shadows to take on the color of the medium. Also, note that the refraction color will also influence the transparency of the material.

6. Change the **Transparency** to **1.0** and set the **Diffuse Color** to **pure black**. This causes the glass to be completely transparent and not cast shadows again. You can also achieve the same result by setting the Diffuse Level to 1.0 while leaving the Diffuse Color as is.

7. Click on the color swatch to the right of **Transparency**, set the colors to **Red=0.9**, **Green=0.95**, **Blue=1.0**, and render again. This slight adjustment has significant impact on the material and we now see a small amount of blue in the glass and in its shadow, as shown in the center image of the following illustration.

8. Change the colors to **Red=0.3**, **Green=0.6**, **Blue=1.0**, and render once again. The glass now shows a more vibrant blue hue than the right image of the previous illustration when the transparency was used to make the glass see-through.

There is typically more color intensity when using refractive coloration, which can be useful with things like stained-glass windows. It's important to note that *any* refractive color other than pure white has a direct impact on the amount of transparency the material has. This means that the color of the diffuse component will start to influence the material. So if your diffuse color was red and the refractive color is blue, the glass would start to look purple.

The following examples show the influence of using a map in the refractive color component of the Arch & Design material and the corresponding diffuse contribution.

1. Open the file **ch14-02.max** and render the **Camera** view. The result is shown in the left image of the following illustration.

2. Open the **Material Editor** and notice that a map is loaded in the **Refraction Color** channel of the assigned material.

3. Click on the **Diffuse Color** swatch and notice that the colors are set to **R=0, G=0, B=0.5**. The center image shows the influence of a white diffuse color while the right image shows the influence of a black diffuse color. Notice that since the refraction color doesn't change, neither does the strength or color of the shadow.

In all three examples there is a nice coloration of the shadows as we would expect from such a panel of colored glass, but this is not a true physical phenomenon although it is a good representation. The true physical phenomenon is the use of caustics and it is important to understand that we're using transparent shadows to fake a caustic effect. Now let's create a real caustic effect.

4. Select the **glass pane**, open the **Object Properties** dialog box for the pane, click on the mental ray tab and select **Generate Caustics**.

5. Within the **Indirect Illumination** tab of the **Render Setup** dialog box, open the **Caustics and Global Illumination (GI)** rollout and enable **Caustics**.

6. Render the **Camera** view. The result should look like the left image of the following illustration. Caustics are a specific type of photon that interacts more intimately with a material than regular photons. In this example, the photons will permeate through the glass pane and take on color in the process to create a realistic effect. Because the pane is flat we will not get any refocusing of light as you would expect through a magnifying glass. The last thing to do is to tell the Arch & Design material to refract light to generate caustic effects.

7. Within the **Advanced Rendering Options** rollout of the Material Editor, enable **Refract light and generate Caustic effects** and render again. The next illustration shows the comparison of the true caustic phenomenon (left) and use of transparent shadows (right).

There is another method to color the color of transparent mediums and it is found under the **Advanced Rendering Options** rollout of the Material Editor and shown in Figure 14-1. Here we can set the maximum distance a ray will travel into the medium before reaching the color defined by the **Color at Max Distance** swatch. This technique is based on the concept of persistence distance, which has been prevalent in the mental ray Glass material for years.

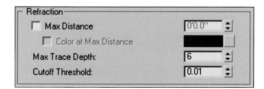

Figure 14-1. Settings to control the color of refraction according to depth of a material.

The concept is seen best in colored transparent objects that have varying thickness, such the teapot shown in Figure 14-2. You would expect a colored transparent object to have more, or less, color depending on the object's thickness. In Figure 14-2, you can see the teapot on the left uses only the refractive color, which doesn't give us accurate results. The teapot on the right uses persistence distance to correctly depict the colored glass. Notice that the handles and spout are

lighter in color and less saturated than the body as we would expect in real life. When you create a new Arch & Design material, this option needs to be set manually, otherwise the material will render a solid color as illustrated in the left image. In a moment, we'll experiment with the Max Distance, but first let's look a little closer at what this is all about.

Figure 14-2. No max distance defined (left) and a max distance defined (right).

The radius of the teapot is 4" (approximately 8" at its widest). In theory, a sampling ray that enters the body of the teapot will have to travel about 8" before exiting the other side. The handle is only a fraction of this distance at its thickest (approximately 1/2" in thickness). This means that a sampling ray will only need to travel 1/2" before exiting the other side. So if we were to enter a value of 1/2" for the max distance, a sampling ray will reach the other side of the handle, yet a ray passing through the body will not. So the ray passing through the handle will reach its max distance and return the color specified at max distance, while the ray traveling through the body will not, and it will subsequently be forced to the color at maximum distance at only 1/2" depth. As the ray continues through the object, the color continues to darken since the effect is compounded. Likewise, any point on the geometry that is less than 1/2" in dimension will return a fraction of the color at max distance and will appear more transparent. Figure 14-3 shows the same teapot with differing max distance values. Note that as you increase the depth, less saturation occurs. So for highly colored glass, you would want to set the value lower, and for a more subtle effect you would want higher values.

Figure 14-3. Various values of Max Distance for refraction.

1. Open the file **ch14-03.max** and experiment with different persistence distances to see the results as found in Figure 14-3. Notice that reflections have been disabled to see the effect better.

One great architectural use for this feature is water. Using the persistence distance enables nice depth coloration for things like pools. The depth of the pool in Figure 14-4 is approximately 4' so the Max Distance would be set to 4' and the color a nice rich lapis lazuli blue. This phenomenon is found in many tropical island settings where you see the aerial color of the ocean increase in richness the deeper the water gets.

Figure 14-4. Lapis Lazuli blue for maximum depth used to depict the rich coloration of the pool.

Translucency

The next material characteristic we'll look at is translucency, which is different from transparency and sub-surface scattering. It's different from transparency in that it allows for rear illumination and shadow casting, and it is different from sub surface scattering in that it doesn't scatter light rays through the medium. Below is a simple progression illustrating the difference between transparency and translucency.

1. Open the file **ch14-04.max** and render the **Camera** view. The result is shown in the top-left image of the following illustration.

2. Open the **Material Editor** and within the **Main material parameters** rollout, change the **Transparency** to **0.5** and render the scene again to obtain the image found in the top right of the following image. Although the material has become more opaque, we don't see an expected shadow of the teapot on the plane. To correct this, we need to use translucency.

3. Set the **Transparency** back to **1.0** and enable the **Translucency** option found directly under the transparency settings.

4. Change the color to **Pure White** and render the scene again. The result should look like the bottom-left image in the following illustration.

5. Change the **Weight** from 0.5 to **1** and render the scene. Notice that this will totally occlude any objects behind the pane. Weight essentially sets the bias between full transparency (a weight of 0) and full translucency (a weight of 1).

There are some key things to note with the above comparisons. First, a reduction in transparency brings an increase in GI on adjacent geometry. Notice in the top-right image of the previous illustration, that the teapot receives indirect illumination from the glass panel when the transparency is less than 1.0 but it doesn't when transparency equals 1.0 or when translucency is used. Second, even though translucency gives the appearance of a semi-opaque material, we don't get a scattered refraction as what we would expect from something like frosted glass. To get a true frosted glass, we will have to employ translucency and transparency, and glossy refraction as well.

Glossy Refraction

In 3ds Max, you can make the generalization that any blurry effect adds additional rendering time to a visualization. Blurry effects include a wide variety of things such as depth of field, motion blur, image sampling, GI, soft shadows, and in the case of this chapter, blurry reflections and refractions. Blurry effects are essentially the opposite of glossy effects, and the two different terms are often used to refer to the same thing.

A perfectly glossy reflection is what you see with a perfect mirror. The surface is so smooth that it creates an infinitely small specular reflection. As the surface of an object becomes rougher, the object (or material) becomes less glossy and the reflection begins to disperse due to small imperfections on the surface that are difficult or impossible to see with the naked eye. As a surface becomes more blurry, only those portions of the reflected image that have enough light intensity are immediately perceived. Thus we really only end up seeing light sources reflected in surfaces that have a low glossiness since the rest of the reflection lacks the intensity to be easily seen. This effect is simulated through the use of shaders, which are algorithms designed to recreate the look of this blurry dispersed reflection.

Historically these shaders were created and named after the mathematicians who created them. Those who are familiar with standard shaders such as Phong, Blinn, Strauss, Lambert, and the like, have been using these synthetic methods of creating a specular highlight. The truth of the matter is that in order to get a true specular highlight, you'll need to have a true reflection and blur it based on how many reflected rays are redirected at a microscopic level. This is achieved by sampling many times at a point on the reflected surface. The more samples, the better quality the blurred reflection will be. We'll also see that reflected areas, like light source reflections, will appear to grow in size and create broader highlights the less glossy a surface becomes.

In this chapter, we will look closely at blurry refractions and then move on to blurry reflections. It is important to note, however, that for the purpose of this chapter, the word blurry will usually be substituted with the term glossy, because in mental ray, settings are usually labeled with the word glossy or glossiness. In reality, the two words blurry and glossy are antonyms, although they are used interchangeably to refer to same concept.

1. Open the file **ch14-05.max** and render the **Camera02** view. Notice that the glass casts a shadow because the glass isn't totally transparent.

2. Open the **Material Editor** and within the **Refraction** section of the **Main material parameters** roll-out, change the **Refraction Glossiness** to **0.5**. Notice that the **Glossy Samples** spinner becomes active.

3. Render the **Camera** view again. Notice that there is no difference in the render even though we have a glossiness of 0.5. This is because the quality of the glossiness will be driven by the number of glossy samples, and no glossy samples effectively turns this feature off.

4. Increase the **Glossy Samples** to **1**. The result should look like the following illustration.

Notice how grainy the result is. If we increase the number of glossy samples, we increase the quality but at a cost of longer render times. The next illustration shows the result of increasing glossy samples to 8, 32, and 64 samples, from left to right. As we can see, there is no real improvement in quality, yet if you use higher values like these you could see much longer render times. The **Fast Interpolation** feature allows us to get similar results in a fraction of the time.

5. Enable the **Fast Interpolation** option, set the **Glossy Samples** back to **0** and render the scene again. Notice that there is now a blurring of the teapot and that this blurring becomes more apparent with lower glossiness settings. We can control the blurring through the Fast Glossy Interpolation rollout of the Arch & Design material.

6. Open the **Fast Glossy Interpolation** rollout. This interpolation works through an algorithm that blurs a lower resolution of the refracted image. By default, it is set to 1/2 the resolution of the final image and is made to blur over 2 pixels because of the **Neighboring points to look up** value, as shown in the following illustration.

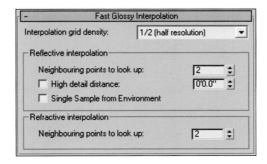

7. In the **Refractive Interpolation** section (not reflective) of this rollout, set the **Neighboring points to look up** to **0** and render again. The result is an image with a slightly smaller degree of blurring. A value of 0 provides the smallest amount of blurring and if you want less you will simply have to disable interpolation.

8. Try rendering with several different **Interpolation grid density** settings. Reducing the resolution of the grid results in an image with the same blurring but a more pixilated appearance. The benefit of this reduction is faster renderings and less RAM consumption; however, values lower than resolution are often unacceptable for production renderings. The following image progression clockwise from the top-left shows a grid density of 1/5, 1/4, 1/3, 1/2, 1 and 2 (double). Notice that the reflection interpolation uses the same resolution as the refraction interpolation, but its own look up value. The concepts mentioned here for refraction interpolation work the same way for reflection interpolation.

All of the previous examples show no interpolation values, meaning the **Neighboring points to look up** are set to 0. Fast interpolation will blur the refracted image by blending neighboring points. The lower the resolution of the refracted image, the more pronounced the blur effect will be. This means that the level of blur will decrease as we use higher resolution interpolation grids.

9. Set the **Interpolation grid density** to **1/5**, and set the **Neighboring points to look up** to **1**. Notice how the refracted image starts to blur and smooth out.

10. Increase the **Neighboring points to look** up to **2** (the default) and render again. The image continues to blur and become smoother. The following image series shows an interpolation grid density of 1/5 and increasing values 0, 1, 2, 3, and 4 Neighboring points to look up.

We can further define the look of the fast glossy interpolation by using it in conjunction with the **Glossiness** and **Glossy Samples** values in the **Main material parameters** rollout.

11. With the interpolation grid still set to **1/5** and the **Neighboring points to look up** still at **2**, set the **Glossiness** to **0.5**, and the **Glossy Samples** to **0** and render again. The result should look like the left image of the following illustration. Remember that without any glossy samples the result will be an image that is not blurred – at least not because of the Glossiness value; however, there is blurriness here because of interpolation. But you could set the **Glossiness** to **1.0** and **Glossy Samples** to **0** and you will still always have blurriness if interpolation is enabled.

12. Increase the **Glossy Samples** to **1** and render again. Notice that there is a very noticeable amount of noise in the glossy refraction.

13. Increase the **Glossy Samples** to **8** and render again. Notice that there is almost no noise now, as shown in the right image of the following illustration. Even though we're using more Glossy Samples, we don't increase our render time but definitely increase quality.

14. Disable Fast (interpolate) and render again. There is a noticeable difference in appearance to materials with and without interpolation. With interpolation you can achieve much faster glossiness; however, you cannot achieve the fine grainy noise that is typical with frosted glass. Whether you should use interpolation is just as much about the look you want as it is about the increase in speed.

Self Illumination

Next we'll need to look at self illumination since this is a perceivable trait found in a variety of materials that exhibit internal light scattering like frosted glass. Self illumination is a way to effectively fake this effect and save on rendering times.

1. Open the file **Ch14-06.max** and render the **Camera01** view. The glass pane contains a slightly transparent material with interpolated glossiness.

2. Within the **Self Illumination (Glow)** rollout enable the **Self Illumination (Glow)** option. The result should look like the following illustration, where the glass pane now uses a small amount of self illumination because it would essentially act as a light source in the real world when lit from behind as it is. We can easily use the same settings to create things like drapes or shear fabrics. It's also important to note that the material doesn't have any reflection yet as we will be talking about this next.

One last thing to examine is the difference between what we've created and a **Sub Surface Scatter** material. Sub surface scattering is a true physical phenomenon that scatters light rays within the medium, and while some get absorbed, others bounce back out giving the appearance of illumination from within. To accomplish this using photons and participating media can get complex. Luckily there are shaders that allow us to get similar results but with an easier workflow. That being said, the SSS materials are not without technical problems and shortcomings

Sub Surface Scattering

We will briefly introduce the SSS Fast material here as the complexity can be cumbersome to tackle within a brief architectural overview of mental ray.

1. Open the file **Ch14-07.max**.

2. Open the **Material Editor** and notice that a **SSS Fast Material** has been applied to the pane.

3. Render **Camera01** view. The result should look like the following illustration. If you were to create a SSS Fast Material, you would notice that the material is set by default to emulate skin. To see this, create a new SSS Fast Material and notice that the color of the swatches resembles that of computer generated skin. For our purpose, we set both scatter colors to a Jade green for our pane material. Most importantly, look for the **Scale Conversion Factor** located in the materials' **Advanced** options. Set **the Scale Conversion Factor** to 1 and render. Then set it to 0.5, and 0.05 rendering each to see the results. The Scale Conversion Factor is what sets the overall influence of the effect. You can play with this value to create the look you want.

For most architectural purposes you would change both the Front Surface Scatter color and the Back Surface Scatter color to the color of the media we're trying to mimic. These front and back surface scatter colors can be set independently of each other if you want to create a more complex material.

One very important note with regard to SSS and global illumination is that there is one option that needs to be checked for the effect to be seen in scenes that use global illumination. In the **Advanced Options** rollout is a switch for **'Screen' (soft) compositing of layers**, which will need to be enabled or disabled depending on your scene.

Figure 14-5. The 'Screen' (soft) compositing of layers option.

Reflection

Reflections are critical for *any* material to achieve photorealism. Everything casts a reflection and it all depends on the characteristics of the surface, material, and the angle at which we view the surface as to how much reflection we see. You may be surprised to learn that elements like concrete, stone, stucco, wood, and even fabric all reflect light and benefit from glossy reflections. The trick is to know how glossy they should each be and how to control the reflections based on things like viewing angle.

Recall that there were templates that acted as presets for some architectural materials? Take a look and see what templates use reflections by default. Materials like masonry have a reflectivity of 0.3 and glossiness of 0.1. Even rough concrete has a reflectivity of 0.3 and glossiness of 0.5.

With technology advancing so quickly and computers becoming more powerful, we can use computationally expensive glossy refractions and reflections to accurately define materials within our scenes. But before we create things like stainless steel, wood, leather, fabric, etc..., we need to understand how reflections work within mental ray's Arch & Design material.

As mentioned previously, the Arch & Design material is energy conserving. So by definition, if a material is 100% reflective we shouldn't be allowed to see the diffuse component, yet we do. This is due to the **BRDF** or **Bi-Directional Reflection Distribution Function**. Simply put, this is falloff. The amount of reflection you see depends on the angle from which you view the surface of a 3D object.

Figure 14-6. BRDF in action as seen in the reflection intensity at various viewing angles.

Notice how faint the reflection in Figure 14-6 is at the start of the sequence (left), and how it progressively gets stronger the more our view becomes perpendicular to the surface normal. To better understand what is happening, let's examine the graphical representation within the BRDF rollout shown in Figure 14-7.

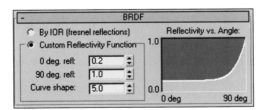

Figure 14-7. The BRDF rollout.

There are essentially two options available here. The first option is true **Fresnel** reflections, and the second is a custom option that allows you to define the reflection function manually using the function curve. True Fresnel reflections occur on every material in the real world and simply put, they are reflections that become more prominent and defined as the angle of a surface normal becomes more perpendicular to one's view. Unfortunately, what is real and what we want to see are usually two different things. For that reason, we can fine-tune the reflection function by manually adjusting the BRDF function curve.

The first two settings are for the amount of reflection the material will have at 0 and 90 degrees to the line of sight, and the third setting dictates how we transition between them (the overall shape of the graph). By default, the **0 deg. refl.** is set to 0.2, or 20%, and the **90 deg. refl.** is set to 1.0, or 100%. The curve shape determines the reflection distribution. By default we maintain 20% reflection until the surface normal reaches 45 degrees to our line of sight (depicted halfway between 0 and 90 on the graph). Reflection then exponentially increases to 100% reflection as the surface normal is between 45 and 90 degrees to our line of sight. To get an object to be 100% reflective, like a mirror, we need to increase both the **0 deg. refl.** and the **90 deg. refl.** to **100%** so that no matter which way the surface normal is oriented, we'll see 100% reflection.

Glossy Reflections

Glossy reflections are a critical component of any material but often come at a huge cost in rendering time. We've already spent a lot of time examining glossy refraction and a lot of what we've learned thus far is applicable to reflections. The following section covers a few peculiarities of glossy reflections.

We've seen that higher quality glossy settings come at a cost of longer render times and need to be set appropriately for the scene to render efficiently. For example, if we had a material with solid color, we would more likely have to adjust our glossy settings quite high since a solid material is less forgiving than that of a texture in revealing artifacts. With a texture we could get away setting a lesser quality since the texture would essentially *hide* the artifacts from a lower sampling rate.

When we deal with materials that have a very low glossy value we can get away with a couple of optimizations. These are found in the **Reflection** group of the Arch & Design material. Materials, such as stone or fabric, that do not require the use of high sample values will benefit from these optimizations. I'll present a couple of options for you to use on materials of these types:

- Use the **Fast (Interpolate)** option to create broad glossy effects, especially on flat surfaces like the floor shown in Figure 14-8. Notice that when using this option the reflection is blurred throughout the entire reflection as shown in the right image of Figure 14-8. We saw previously that lower **Interpolation Grid Densities** will result in more exaggerated blurriness and that the **Neighboring Points to Look Up** will improve the quality but also increase the blurriness.

- Use the **Highlights+FG Only** option to essentially turn your material into a standard shader. This means that it will only reflect light sources and/or use final gather points to produce specular highlights. This method is quick but does not create acceptable glossy reflections. This would be better suited to materials that have very subtle glossy reflections.

- Use the **Metal Material** to recreate metal materials where the specular reflection (or highlight) is influenced by the diffuse color. This is seen on the gold torus knot in each image. Notice that the specular highlights are yellow, not pure white. This is true for all metal surfaces.

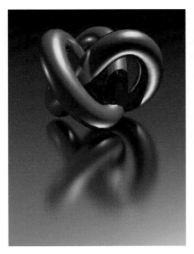

Figure 14-8. True glossy reflection (left) and Fast Interpolated reflection (right).

Notice the shallow reflections closest to the torus knot in true glossy reflections are crisper than those in the fast interpolate option.

1. Open **ch14-08.max** and render the **Camera01** view. This is the scene used to render the images in Figure 14-8.

2. Examine the difference in render times and appearance with and without the use of the options just mentioned; **Fast (interpolate)**, **Highlights+FG only**, and **Metal material.** Note that you can use **Fast (interpolate)** and **Metal material** together, but if you use **Highlights+FG only** with **Fast (interpolate),** the **Fast (interpolate)** option will be ignored.

Since the Fast (interpolate) glossy effect blurs the entire reflection, it may be less than believable in some circumstances. This is remedied by using the **High detail distance** option in the **Fast Glossy Interpolation** rollout. When enabled this will allow you to have the illusion of true glossy reflections by casting more rays to sample the shallow reflections and give them more detail. This works well for textures but still blurs the reflection of the geometry.

In the left image of Figure 14-9, you can see the entire reflection is blurred because of interpolation but this is remedied in the right image where the High detail distance option is used to show the appearance of true glossy reflection falloff. Note the edges of the cylinder have the same amount of blur for both images.

Figure 14-9. Blurry reflections with the High Detail Distance option disabled (left) and enabled (right).

30. Right-click over any empty part of the **Work Area**, and from the menu that appears, select the **Force Source Tile Pictures**. The Work Area icons change to display a thumbnail view of the various sequences, as shown in the right image of the following illustration.

Now it's a time to make some color correction of our image and explore masks.

31. Click the **Merge1** icon. It should turn tan.

32. With the **Merge1** icon selected, click on the **CC** icon in the **Tools Toolbar**. Rather than placing the CC icon yourself and having to manually link it to the Merge1 icon, selecting the Merge1 icon before creating the CC icon makes the process a little easier. Color correction is a powerful tool that let's you change gamma, brightness, contrast, saturation, levels, and much more. Let's start by making an adjustment to the levels in the animation.

33. From the **Controls Area**, click the **Levels** button and enter a value of 0.7 in the field shown in the following illustration. This should increase the contrast of our animation, but in the Display View nothing has changed. The reason why is because we have not yet loaded ColorCorrector1 into either channel A or B.

34. Drag and drop the **ColorCorrector1** icon from the **Work Area** into **channel B** of the **Display View**. When you do, the total combined result of everything coming into ColorCorrector1 and the result of ColorCorrector1 itself should be displayed in channel B.

Special Application of Reflections

One could argue that reflections are a product of their environment, meaning that a reflection is only as good as the environment it reflects. The more reflective a material is, the more that material requires a decent environment to define its appearance. Materials such as water, steel, and glass are all just a few examples of reflective materials that require an environment to be displayed properly. Without the environment, the materials will lack depth and subtle details can be lost.

As mentioned in Chapter 9, you should always create a 3D background rig rather than relying on the **Environment** channel within the **Environment and Effects** dialog box. However, the Arch & Design material (as well as many others) has an environment channel of its own that acts to enhance whatever is used as the true background in the scene; either the 3D background rig or the one loaded in the Environment and Effects dialog box. This environment channel within the material is a handy way to create a quick background reflection in a specific material or to improve on the reflection of the real background. In the case of reflections, where you load a background is not as important as whether or not you do.

The following exercise illustrates how we can add more realism by simply adding a spherical environment map in the **Environment** channel of the Arch & Design material.

1. Open **Ch14-09.max** and render the **Camera** view. This scene has a simple building facade with Alucabond and glazing and is illuminated by a **mr Daylight system**. The materials look sterile and lack depth because no environment map was used.

2. Open the **Material Editor**, select the **White Alucabond** material and open the **Special Purpose Maps** rollout. Notice that a bitmap is loaded in the **Environment** channel of this material but the map is disabled.

3. Enable the **Environment** channel map and render the scene again. The result should look like the right image of the following illustration. The materials look very dark due to the exposure control. To compensate for this we need to boost the **RGB Level** of the bitmap.

4. Within the **Output** rollout of the bitmap you just enabled for the environment channel, increase the **RGB Level** to its maximum of 9,999 and render the scene. The result should look like the left image of the following illustration.

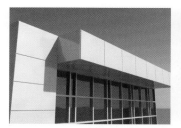 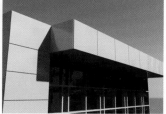

Bump Maps and Normal Maps

Bump maps are fairly self-explanatory and work well for adding an apparent distortion in the reflective surface. Any map type can be used to generate a bump in the Arch & Design material. You simply need to add a map and adjust the bump intensity with the associated amount value, as seen

in Figure 14-10, where a standard Cellular map was used. However, there is a particular flavor of bump found within the **Special Purpose Maps** rollout. **Do not apply bumps to the diffuse shading** is the new flavor and warrants some discussion.

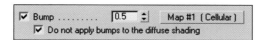

Figure 14-10. The option to prevent an applied bump map from affecting diffuse shading.

As you can see in Figure 14-11, the bump is much more subtle and looks detached from the diffuse component. This allows for a more subtle bump effect that can be beneficial for wet surfaces or shellac/clear coat finishes.

Figure 14-11. A standard bump (left) and **Do not apply bumps to the diffuse shading** (right).

The map type that bridges the gap between bump and displacement is the normal map. This uses a RGB color-coded map to generate bump map effects that are more convincing than traditional bump maps. There are several ways to generate a normal map but the easiest way is to simply use an existing texture and generate a normal map using software like Crazy Bump (www.crazybump.com). The only difference between using a bump map and a normal map is the shader you use. In the Arch & Design material, we can simply apply a **Normal Bump** map shader in the **Bump** slot found in the **Special Purpose Maps** of the Arch & Design material and choose the **Normal Bump** map as our bump map (as the left image of Figure 14-12 depicts).

Figure 14-12. The Normal Bump Parameters

The result of using this bump type is subtle in stills and best illustrated through animated lighting. I only mention it here as an alternative to regular bump mapping and leave the experimentation up to you.

Displacement

Displacement is a little more complicated than bump or normal mapping. We'll only discuss displacement as it is found in the Arch & Design material since there are other displacement shaders available that are outside the scope of this book. It's very straight-forward to apply a texture for displacement, but the trick is to properly prepare the geometry and adjust the displacement global settings to achieve the look you need. Displacement tessellates geometry to produce a mesh with enough resolution to effectively add the geometric detail needed. We need to control this tessellation by first having enough detail in the geometry.

1. Open the file **ch14-10.max** and render the scene. This scene contains just a simple plane with 1 length and width segment. All you see rendered is this ordinary plane.

2. Open the **Special Purpose Maps** rollout of the applied Arch & Design material within the **Material Editor** and enable a basic Cellular map loaded in the **Displacement** channel. Adjust the displacement spinner to 3 to emphasize the effect.

3. Render the scene again and you should see the displacement in the object as shown in the left image of the following illustration. Notice the lack of displacement detail compared to the image on the right.

4. Increase the length and width segments of the plane object from **1** to **20** and render again. The result is the right image.

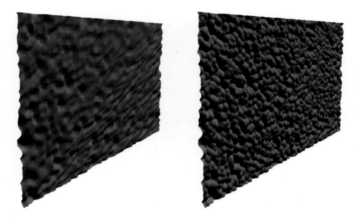

5. Open the **Render Setup** dialog box and within the **Renderer** tab open the **Shadows and Displacement** rollout. The **Displacement** section of this rollout, shown in the following illustration, controls global settings for displacement within mental ray.

By default, displacement is set to **View**, which will adaptively subdivide the mesh for displacement. Polygons that are further away from the camera will not be subdivided as much as those that are closer. This is good but may cause some artifacts in highly detailed displacements, especially if you have a large surface that extends deep into your scene. You can turn off **View** to have the geometry tessellated globally. You'll notice that when you do this, **Edge Length** is no longer defined in pixels but in real world units.

We can also define a maximum global displacement value. This essentially clips the displacement so it can never exceed the global height. One of the most important parameters here is the **Max. Subdiv.** fly-out. This value specifies the maximum number of triangles any polygon will be divided into. By default it is set to 16,000 triangles. This can be as low as 4 or as high as 64,000. If your geometry is of high enough resolution, you can get away with lower values, which can ultimately save your render times since not as many tessellations are required at render time. Typically when using displacement, it is good practice to have a dense mesh to do displacement on. Otherwise, if your mesh has a low face count, you won't get very detailed displacement even with the **Max. Subdiv.** set high. So you may need to add a tessellation modifier if your geometry is too low a resolution.

Lastly, you can force mental ray to produce better displacement detail by lowering the **Edge Length** parameter. Lower values force more detail but with longer render times. Higher values relax the tessellation process and result in quicker render times but at a cost of lower detail.

Material and Exposure Control

There have been countless arguments about gamma correction and exposure controls. Typically using one or the other, or even both in combination, have been adopted by numerous users and studios. I prefer using exposure controls without any gamma correction. So because of this I wish to convey a couple of tips with regard to getting materials to render accurately when using exposure control. Typically, exposure control can lighten the material considerably and give it the appearance of being washed out. While this seems problematic, there is a simple way to bring them back. The first method applies to textures. Simply apply a curve correction within the texture itself. The following image shows a proper compensational curve adjustment. Note you will have to change the control point to a Bezier type by right clicking on it and selecting Bezier from the list.

Figure 14-13. Adjustment needed for bitmap textures to render properly with exposure control.

The second method of color correction with exposure control deals with solid colors. For example, if you were given a specific color to reproduce in your rendering and you use exposure control, you would need to adjust the color by using the square value of each of the R, G, B color components. If the tan color shown in the left image of Figure 14-14 is what you want depicted in a rendering, then when exposure control is used you will need to use the altered color shown on the right, which is achieved by taking the square of each R, G, B value. The color will be darker in the color swatch but will yield the desired color when exposure control is used. Notice that 0.859 x 0.859 =0.738, 0.761 x 0.761 = 0.579, and 0.529 x 0.529 = 0.28. Here is a rendered comparison between these two colors.

Figure 14-14. An intended color (left) and the adjusted color by the intended color, Right; The adjusted color by squaring the values.

Figure 14-15 shows an example of this technique in action using the colors shown in Figure 14-14.

Figure 14-15. Color correcting by squaring the RGB values when using exposure controls.

A quick tip to find the square value is to use the **Numerical Expression Evaluator** by selecting the numerical field and pressing **Ctrl+N** on the keyboard. Then you can enter the value and square it. For example if the value for Red is 0.5, we can click on the value spinner and press Ctrl+N and enter 0.5^2, which will yield 0.25.

Autodesk Material Libraries

The most recent evolution of the Arch & Design material is now called the Autodesk Material. In the 2012 release of 3ds Max, Autodesk ships hundreds of mental ray based materials - shared materials used by AutoCAD, Inventor, Revit, and 3ds Max. These materials represent industry standard paints, finishes, and surfaces so CAD designers can apply materials without having to worry about understanding the material parameters.

These materials allow you to design in Revit or Inventor, and then export those files complete with materials into 3ds Max for rendering via fbx. These materials are actually Arch & Design based materials, with a simplified UI, so that the casual user will not be intimidated by the overwhelming complexity found in the Arch & Design material type. By making 22 individual material types out of the various Arch & Design Templates, the developers have been able to simplify the choices they give you to manipulate any particular material. Be forewarned, the downside of this idea is that if you tinker with the material in 3ds Max you've destroyed the connection with the original library. Autodesk recommends you use the materials as they are to preserve the concept of a universal material library that can be shared by users everywhere.

If you want to customize the materials you can change any material into an Autodesk Generic Material, in fact a new Copy to Generic feature is now part of 3ds Max 2012. Simply right-click on the Material Type button in the material editor and select Copy to Generic.

One other new feature in 2012 Generic Material is the Color by Object option. In the Generic rollout you can easily force the diffuse color to match the object color using this new option.

If you examine the Autodesk Generic material you will find that it has a comprehensive set of parameters, nearly comparable to the Arch & Design material. Years ago Autodesk took the Standard material and repackaged it as the Architectural material, it appears the same thing has happened here with the Autodesk Generic material type.

If you take the time to go through all these rollouts you will find most of the features and functions of the Arch & Design material, with only a few omissions such as the ability for Self Illumination materials to actual generate light in a scene. The promise of seamlessly interaction with CAD programs like Revit and Inventor should excuse those shortcomings. Autodesk seems very serious about trying to make its various products work together, and this appears to be a strong start in that direction.

iray renderer

New to 3ds Max 2012 is the iray renderer, which is a time-based mental ray renderer. Perhaps because people complained about long render times, this type of rendering lets you set how much time you want to spend, and then you know the rendering will only take that long. If the quality is not sufficient, you render for a longer period of time to achieve the desired result.

Once you have assigned the iray renderer using the Assign Renderer rollout of the Render Setup Dialog, you can access the iray rollout. Enter the amount of time you want to spend on the render and then press Render and that is how much time will be used. If you select Unlimited the rendering will go on for as long as you let it. To stop the render press Cancel on the Render dialog when the rendering is of satisfactory quality.

Instead of the bucket rendering you've seen with mental ray, iray slowly refines the entire image at once, sort of gradually bringing the entire image into focus as time progresses.

1. If you want to give iray rendering a try, open **ch14-11.max**.

2. On the Render setup dialog, choose the iray tab and set the time to 3 minutes, then render the camera view.

3. When the rendering is complete, change to Unlimited and render again. Press Cancel to stop the rendering when you have seen enough.

In the illustration that follows the image on the left represents the iray rendering after 10 seconds, the image on the right is the rendering after 5 minutes.

Figure 14-16. 5 seconds into iray on left, 5 minutes into iray on right.

The iray renderer takes advantage of nVidia trademarked CUDA technology, which allows offloading computational work to the graphics device, accelerating the rendering. If you have access to this hardware, your render times will be cut significantly.

The iray renderer doesn't supportable programmable mental ray shaders, it has limitations only understanding a subset of the mental ray features. Review the iray renderer topic in the help system for a complete list of what is and isn't iray compatible. If an object lacks the correct material, iray will render the object in a neutral gray.

It takes a while to get used to the fact that you can't use all the mental ray tricks you've developed when rendering using iray. There is no final gather, no photons. Similar to the thinking with the Autodesk Materials, the iray renderer should be rendering made simple.

The iray Advanced Parameters rollout gives you only a few of the choices compared to what you are used to using in mental ray, such as Maximum number of Light Bounces, Image Filtering, Displacement and Material Override. The lack of Render Region is probably the most common complaint regarding missing functionality. Anticipate more tools in the next release.

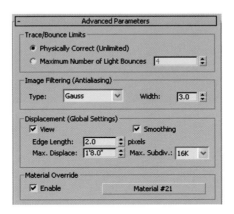

While I have not used iray extensively in production, I have gathered comments from Jennifer O'Conner, mental ray guru, who is using iray for her visualization work now. Here are her suggestions:

- If you are rendering animation, you should probably stick with mental ray for now; you can't reuse final gather or other cached computations, so every frame will recalculate these in iray.

- iray seems to be especially useful for heavy duty scenes with lots of reflections and tricky lighting. If you have the requisite hardware it will be faster than mental ray. On small scenes, mental ray will be much faster.

- iray doesn't support standard materials, so convert your architectural and standard materials to Arch&Design materials unless you like gray. MasterZap has a script for this, search on Zap's "mr Arch Design Tools".

- iray lets you render without lights, by using self-illuminated objects as light sources. People seem to like this, kind of resembles studio lighting workflow. Use photometric lights AND self-illuminated objects for best results. Watch out Revit users, when you export your lights, you'll be getting lights AND self-illuminated objects upon import, this will give you double illumination.

- Unlike mental ray, iray doesn't care how many lights you throw at it, it doesn't start to crawl when you put in too many lights. Every surface is considered a light source in iray.

- Depth of Field comes free with iray and doesn't slow down your rendering, which is great.

- People ask which CUDA devices - nVIDIA GPUs (Fermi class hardware) are best. You probably want the 3 GB GTX 580 if you work on medium-size projects, if you're visualizing bigger max files, get nVIDIA Quadro. iray expects you have lots of memory. Every object is held in memory as geometry.

- Plugins competing with iray include finalRender 4GPU from cebas, and Bunkspeed.

Summary

This chapter is meant as a springboard to initiate ideas and inspiration to create your own architectural materials and give you the tools needed to create them. The information presented here is just the tip of what can be done, but explains tried and true architectural techniques that are used in production. I've tried to limit the discussion to the Arch & Design material, which is a one-stop shop for almost anything you'd require. The new pro materials can be used to simplify this process but in doing so avoid the details needed to better understand materials. Once you become more comfortable with mental ray, I would suggest seeking out more information on the wide availability of shaders which can open up worlds of possibilities. A separate book can be written on this topic alone. Always remember to have fun, and take it further than where you found it.

PART 5

Advanced Visualization Techniques

Although it is beneficial to create your 3ds Max scenes as complete and finished products, there is no denying the usefulness of compositing software that can do some of the things this chapter illustrated. Like other chapters in this book, we have only brushed the surface of what is possible.

Unwrap UVW

GOOD TEXTURE APPLICATION IS AT the heart of any great 3D scene, and far too often, 3D artists do not spend enough time in this area of the design process. As with any project, time becomes an issue and everyone looks for fast and effective ways to get the job done. In the area of texture application, the Unwrap UVW modifier is certainly a tool with enough power and versatility to produce amazing results in minimal time. In this chapter, we'll learn how we can exploit the power of this modifier for architectural visualizations and ultimately increase productivity and efficiency.

Standard UVW maps come in a variety of flavors and are typically planar, cylindrical, spherical, box, or face in nature. While easy to apply, they fall short when faced with complex or organic geometry. The Unwrap UVW modifier provides a unique way of placing a texture; based on the geometry of an object rather than through a predefined gizmo. To better understand how this modifier works, we'll start by looking at a simple cube and then move on to more complex methods.

Texturing a Die

1. Open the file **ch15-01.max**. This scene contains a simple box with the texture of a die applied to each side, as shown in the next illustration. We'll use the Unwrap UVW map to apply unique portions of the texture to each face of the box.

2. Apply the **Unwrap UVW** modifier to the box.

3. Within the **Parameters** rollout, click the **Open UV Editor** button. This opens the Edit UVWs dialog box. This window will allow you to select pieces of the geometry and position them over unique portions of our texture map.

4. In the **Selection Modes** section of the dialog box, select the **Face Sub-object Mode** icon (third from left). This allows us to select faces directly on the object within the viewport or within this dialog box. You can also switch sub-object modes by opening the modifier in the modifier stack.

5. Move the **Edit UVW** dialog box off to the side so you can see an unobstructed view of the geometry.

6. In the **Modify** panel, disable the **Ignore Backfacing** option.

7. Select all faces of the geometry within the viewport. When using Unwrap UVW you can select sub-objects level either within the viewport or within the Edit UVW dialog box. We'll do so with the dialog box shortly.

8. From the **Mapping** menu of the **Unwrap UVW** dialog box, select **Flatten Mapping**. The **Flatten Mapping** dialog box opens.

For square geometry such as cabinets, desks, or any other type of rectilinear furniture, we wouldn't need to adjust any of the parameters in the Flatten Mapping dialog box and could just click **OK**. If the geometry was more organic, we would need to experiment with the **Face Angle Threshold** to obtain better results. This looks at the angular difference between normals of adjacent faces. If the difference exceeds 45 degrees a new mapping group is created. I would recommend coming back to this setting once you've finished the chapter and experiment with different values on a simple teapot to get a better understanding of this parameter.

9. Click **OK** to complete the command. Notice that 3ds Max has separated each side of the box in the Edit UVW dialog box for easy manipulation, yet you can clearly see in Perspective view that your geometry is intact.

10. Click inside any viewport to deselect the faces that are currently selected. The Edit UVW dialog box should look like the left image in the next illustration.

11. At the top-right of the Edit UVW dialog box, click the **Show Map** icon to disable this feature. This feature is enabled by default but it was disabled here to show you how you can make it easier to see the 6 green rectangles (representing the 6 polygons of the box) and the blue grid system that serves as a guide for using the Unwrap UVW feature. What we need to do now is load the texture into the Edit UVW dialog box and position each of the green rectangles over its respective portion of the texture.

12. Click on the **Show Map** icon again to enable it again.

13. Click on the drop-down menu to the right of the Show Map icon and select **Map#1**. The image of the die is shown as the background of the dialog box, as shown on the right side of the next illustration. Notice that the texture is loaded within the dark blue rectangle. This blue rectangle defines the texture space. This means that anything within the blue rectangle is our entire texture. Before we get into positioning each face of the box, we'll need to get used to some navigation.

14. Save the file for use in the next part of this exercise.

Navigating the Edit UVW dialog box

The following is a list of navigational items you should learn to maximize speed and efficiency within the Edit UVW dialog box. These shortcuts will help you work faster with the Unwrap UVW's modifier.

- Use the middle mouse wheel to interactively pan around and zoom in and out of the Edit UVWs window the same way you would inside a viewport.
- You can select geometry at the sub-object level by simply clicking it within the Edit UVWs dialog box or within an active viewport.

- You can transform the represented geometry within the Edit UVWs dialog box by selecting any of the transform modes in the upper left corner. These are **Move**, **Rotate**, **Scale**, **Freeform**, and **Mirror Horizontal**, respectively. I suggest familiarizing yourself with the **Freeform** mode as this will be the most efficient mode to operate in. The following are a few suggestions when using this tool:

 - While in vertex sub-object mode, hovering over different handles of selected vertices will invoke different transform tools. The center handle invokes the **Move** transform, the corner handles invoke the **Scale** transform, and the middle handles invoke the **Rotate** transform. Hold down the **Ctrl** key while dragging with the **Scale** transform to maintain the aspect ratio and hold down the **Shift** key to restrict scaling to either the X or Y axis. Hold down the **Ctrl** key while dragging with the **Move** transform to restrict movement to the X or Y axis as well. Hold down the **Ctrl** key with the **Rotate** transform to rotate selections in 5-degree increments.

 - You can select multiple faces, edges, or vertices the same way you can in the main 3ds Max interface by creating a window selection or by holding down the **Ctrl** key while making additional selections.

 - Right-clicking inside the dialog box opens a quad menu that gives you quick access to numerous commands.

As stated earlier, we need to position and scale these green rectangles over their respective place in texture space. We can do this one by one, but the Flatten Mapping tool has already arranged everything to be in proportion to one another. If we were to start scaling each face individually we could create difficulties by having one face mapped at a different resolution than the other. To avoid this, let's simply select all of the geometry and scale it based on the size of one of the faces of the die.

15. Create a window selection of all faces, either in the Edit UVW dialog box or within a viewport.

16. Use the **Scale** and **Move** transforms to scale and move all of the faces so the top-left face is scaled and positioned to fit the side of the die image with one on it, as shown in the next illustration. Make sure that when you scale the faces you maintain the aspect ratio by holding down the Ctrl key.

Now all that's left is to position each of the faces accordingly.

17. Use **Move** transform to position the other **5** faces over the remaining sides of the die. The result of this exercise should look similar to the following illustration. If you want to see a completed version of this exercise, open the file **ch15-02.max**.

This was a very simplistic demonstration of the Unwrap UVW modifier to help illustrate how we can control the precise placement of a texture on geometry. Now we'll apply this feature to an architectural example.

Applying Tileable Textures

There are numerous applications for the Unwrap UVW modifier in an architectural setting. In this next exercise, we'll apply the texture shown on the right side of the next illustration to produce the rendering of the furniture shown on the left.

We'll start with a schematic texture for this exercise to make it easy to identify the various parts of the texture when it's applied to furniture. Later, we can switch the schematic texture with a real wood texture. The texture shown in the following illustration will represent a typical wood pattern where the direction of the arrows indicates the wood grain and the numbers represent imperfections such as knots or blemishes. Using an image like this is not a suggested workflow for using Unwrap UVW; rather, this texture is used for illustrative purposes.

1. Open the file **ch15-03.max**. This scene contains a cabinet with the texture shown in the previous illustration applied.

2. Render the **Camera** view. The result should be the cabinet shown in the left image of the next illustration. The right image shows what the cabinet would look like with the wood texture applied. The large wood grain is intentional so you can see how the same grain continues across several surfaces, which is not desirable. Also, the doors would have a different grain direction on the door panel compared to the door border. Let's follow a similar workflow as before.

3. Apply the **Unwrap UVW** modifier to the cabinet.

4. Click the **Edit** button within the **Parameters** rollout.

5. In the **Selection Modes** section of the **Edit UVWs** dialog box, click on the **Face Sub-object Mode** icon.

6. In the **Selection Parameters** rollout of the **Modify** panel, disable **Ignore Backfacing**.

7. Press **Ctrl+A** to select all the faces of the object.

8. From the **Mapping** menu of the **Edit UVWs** dialog box, select **Flatten Mapping** and accept the default values. The result should look like the following illustration. Note that the illustration has the background texture disabled. The toggle for this is the blue and white checkered cube in the top toolbar. Depending on your preference this can be enabled or disabled.

To better understand what the Unwrap modifier has done to our texture so far, let's render the scene again without adjusting anything more.

9. Render the scene. The result should look like the following illustration.

Scaling and Orienting the Texture

Obviously things don't look right yet. The texture in the previous illustration appears too large and in some areas is not oriented correctly. Let's deal with the scale issue first. Look at the left image of the following illustration and notice that every face is packed neatly into the texture space of the Edit UVWs dialog box.

10. Select every face in the **Edit UVWs** window and scale them approximately **300%**. You can scale over and over again until the texture resolution in the viewport appears the way you want it.

11. Render the scene. We can see that by scaling up the faces in the Edit UVWs dialog box, each face is allowed to see more of the texture, effectively making the texture smaller on every face. The difficulty we have now is that the orientation of the arrows is wrong in some areas. The door panels should have the grain run vertically instead of horizontally.

12. With the **Edit UVWs** dialog box open, select each of the **4** door panels in the **Camera** view. Notice that the 4 faces become highlighted in the Edit UVWs dialog box, as shown in the left image of the following illustration.

13. Click the **Rot. +90** button in the bottom right corner of the dialog box. Now the four door panels will be oriented 90 degrees from their original orientation, as shown in the right image.

Notice that the faces in the Edit UVWs window overlap other faces. This is perfectly fine since the faces are independent of each other. This means that we can move them wherever we want to position them on the texture. So if we wanted to place numbers on each door, we can move and scale only those faces we want to adjust. The next illustration shows a simplified Edit UVWs window with a texture, so you can see the resulting render based on the placement of the faces. Notice in the left image of the following illustration that the door panels have been centered over the numbers in the texture and the resulting rendered image on the right. We can adjust any face this way.

14. Deselect the **4** door panel faces you currently have selected and reselect just one of them.

15. Move the selected face so it's positioned over any number **1** shown in the background of the dialog box.

16. Repeat the previous step with the other **3** door panels so each door panel is positioned over a different number, as shown in the left image of the following illustration.

17. Render the **Camera** view. The result should now look similar to the right image of the following illustration.

The only thing we need to adjust now is a few of the edges of the doors. The wood grain should run vertically for the left and right edges of each door and horizontally for the top and bottom edges. If you look closely in the viewport or the previously rendered image, you will see that the top and bottom edges of the each door show that the wood grains are oriented horizontally, as they should be. The left and right edges of each door, however, show the grains oriented horizontally when they should be vertical. We simply need to select the left and right edges of each door panel and rotate them 90 degrees in the Edit UVWs dialog box.

18. In the **Camera** view, select the faces that make up the left and right edges of the 4 doors. You can also just select them in the **Edit UVWs** dialog box if you want.

19. Right-click the mouse inside the **Edit UVWs** dialog box and from the quad menu select **Detach Edge Verts**. This separates the left and right edges of each door panel from the top and bottom edges. Now you can move the selected faces elsewhere without bringing the other faces along in the process.

20. Click the **Rot. +90** button to rotate the selected faces 90 degrees. You could also move them to another location on the background image; however, that is not really necessary here.

21. Render the **Camera** view. The following illustration shows a before and after result of this adjustment with a proper wood texture applied. If you would like to see a completed version of this exercise shown in the next two illustrations, open the file **ch15-04.max**.

By going through and adjusting the scale and position of the faces within the Edit UVWs window we can take a simple texture and make it go a long way.

As an additional note, this previous exercise required a tileable texture. If we didn't have a tileable texture we would see noticeable and usually distracting seams in many of the faces of the furniture. Textures that don't tile should follow the steps we discussed previously when we textured the die. Run through this procedure a few times on your own to make sure you get acquainted with the process before trying to map complex organic shapes with curvature. The next exercise demonstrates this kind of mapping and provides a good introduction with a simple sphere.

Mapping Complex Geometry

The Unwrap UVW modifier contains numerous tools to allow the mapping of complex geometry with numerous convex and concave surfaces. Some are outside the scope of this book but I would urge you to look deeper into the **Pelt**, **UVW Unfold**, and **Sketch Vertices** tools. In the following exercise, we look at mapping a sphere to introduce the process of mapping curved surfaces.

1. Reset 3ds Max.

2. Create a sphere of any size in the **Perspective** view and convert it to an **Editable Mesh**. Converting to an editable mesh is necessary for one of the next steps.

3. Within the **Utilities** panel, click on the **More** button to open a list of available utilities.

4. Select the **UVW Remove** command. This loads a utility that can strip geometry of both its material and UVW mapping. The stripping of UVWs only works on collapsed editable meshes, which is why collapsing to an editable mesh was necessary. When primitives are created, mapping coordinates are automatically created. In the case of this sphere, a spherical mapping type is applied. Because of this, when a Unwrap UVW modifier is applied, the way the faces are spread out in the Edit UVWs dialog box will be different from the way they would be spread out if no mapping were applied. Stripping the sphere of its mapping coordinates will make it easier to perform the remainder of this exercise.

5. Click the **UVW** button.

6. Apply the **Unwrap UVW** modifier to the sphere and open the **Edit UVWs** dialog box. You will see the sphere has a simple planar map evident from the top down view in the Edit UVWs window. What we need to do is select a group of adjacent faces.

7. Switch to **Face Sub-object Mode** and make a selection similar to the one shown in the next illustration. Notice that as you select the faces, a planar gizmo appears and orients itself to the average of all the normals of the selection. This gizmo is the **Quick Planar Map** gizmo and allows you to take a planar "snapshot" for mapping at any time. This will make a little more sense in just a moment.

8. Scroll down within the **Unwrap UVW** modifier and open the **Map Parameters** rollout. Here you'll find the Quick Planar Map button. Once you click this, it will create a planar map based on your selection.

9. Click on the **Quick Planar Map** button. Note that if the **Preview Quick Map Gizmo** is not selected you will not see the gizmo but it will still function. Notice also that there is an Averaged Normals switch automatically selected. This is what causes the gizmo to be created based on the average normal of all the selected faces. By clicking one of the X, Y, or Z options above this, you can disable that option to create a gizmo as we did, and instead create one projected along the X, Y, or Z axis. To see what this really means, try enabling the **X** option and then switching your view to a **Right** view. When you do, you will see the selected faces appear the same in the Edit UVWs dialog box as you see them from a Right view. Regardless, for difficult geometry, it is a good idea to leave this option enabled.

Now once the button is pressed, you'll see the selected faces become mapped as per the gizmo.

Continue selecting faces and making planar maps until all the faces have been mapped. Notice that the individual maps are delineated by the green lines, as shown in the next illustration. These are called map seams. The mappings in the left image have been moved around in the Edit UVWs window to display how many separate maps were created. We will now pack these nice and neat in the Edit UVWs window.

10. Select all the faces in the **Edit UVWs** window.

11. From the **Tools** menu in the **Edit UVWs** dialog box, select **Pack UVs**. Accept the defaults and watch how 3ds Max neatly arranges all the mappings into the defined texture space.

12. Maximize the **Edit UVWs** dialog box so it takes up as much of your screen as possible.

At this point we can take a screen capture and load it into a photo editing program like Photoshop and start painting or editing a custom texture using the various mappings we created as a perfect guide. Or we can use any existing texture and move and align the elements within the Edit UVWs window to place the texture as we see fit. To create a custom texture in Photoshop, do the following:

- Make sure the dark blue rectangle in the Edit UVWs dialog box is completely visible.

- Press **Alt+Printscreen** on the keyboard.

- Create a new document in Photoshop and paste the screen capture (**Ctrl+V**) into the new Photoshop document.

- Change the image size and resolution to a desired size.

- Create a new layer and start painting using the faces represented in the Edit UVWs screen capture as a guide.

- Save the texture to an image format you like, create a material using the new texture you've created, and apply it to the geometry.

One last thing to look at is welding UVW mappings together. As you see in the previous illustration, we have 20 individually mapped entities in the Edit UVWs dialog box. This can be problematic since they are all mutually disjointed and we will definitely see a seam in the mapping. We can weld these together by entering **Edge Sub-object Mode** and selecting the edges of one mapping.

13. Make sure the **Select Element** option is turned off and select the **Edge Sub-object Mode** icon.

14. Select an edge on any of the mappings in the Edit UVWs dialog box, as shown in the next illustration.

15. From the **Tools** menu in the **Edit UVWs** dialog box, select **Stitch Selected** and accept the defaults. Likewise, we can separate these by choosing **Tools** > **Break**, which will break the mappings apart.

Summary

The Unwrap UVW modifier is an amazing and robust tool that allows us to create the most complex of texture mappings. This chapter only scratched the surface but introduced some key concepts you can carry forward to learn upon. I would recommend looking at some tutorials on texturing characters since these will delve deeper into the toolset. Often, inspiration comes from the most unlikely sources, and texturing characters can give you practice in texturing the most demanding geometric shapes. For continued self-help with this modifier, try to start using the Unwrap UVW modifier in the course of your normal work or training, instead of always relying on the UVW Map modifier. Using the Unwrap UVW modifier on simple geometry that you would normally apply a standard UVW Map modifier to will force you to think of the process and get your hands dirty.

Compositing

COMPOSITING IS A POST-PRODUCTION process critical to the workflow of many artists creating complex animations in any industry. The main purpose of compositing is to save time and simplify work in the creation of an animation. Rather than spending an enormous amount of time setting up complex effects and rendering animations in a brute-force method where the entire animation is rendered as a whole, compositing involves the rendering of layers, or elements, which are later combined, or composited, in special software that runs outside of 3ds Max.

During the planning of this book, it was decided that compositing is such an important part of the workflow of the typical veteran 3ds Max user, that not including some guidance in an advanced-level book would be a mistake. There are numerous software packages that are all capable of the same basic functions, although some shine better in very specific ways. Some examples are **Shake** by Apple, **Combustion** by Autodesk, and **After Effects** by Adobe. It was decided that the software used in this demonstration would be **Fusion** from **eyeon Software** because this is the software that 3DAS and its partners use in production and only a demonstration with this software would be possible. It is important to understand that everything discussed in this demonstration can be performed by any other major compositing software, although the settings themselves will obviously vary in name. If you want to follow along with Fusion, you can download a watermarked version of this software with no timeout at www.eyeonline.com and by selecting **Learning Edition** from the **Downloads** page.

If you prepare your 3ds Max scene properly, compositing software affords you the opportunity to implement an endless variety of visual effects and design changes with minimal work. Once you've finished rendering your animation, you can quickly and easily change the appearance of individual objects in your scene with or without affecting other objects. You can adjust things such as color, brightness, saturation, and specular highlights. You can animate lights and materials and add great effects such as fog, depth-of-field, motion blur, and much more. Best of all, you can do all these things to an entire animation just as easily as you could a single image in Photoshop. Things you often don't have the ability or expertise to create in 3ds Max can become 2nd nature in compositing software.

Although this chapter is dedicated to compositing, it is necessary to discuss a few things about the rendering process for this scene, to include how things were set up in 3ds Max and why.

For this scene, we are using the V-Ray render engine, because of its impressive speed and ease of use, but also to serve as a demonstration of a 2nd rendering solution to mental ray. It is not necessary to follow along with V-Ray, because the larger picture can be applied to mental ray or just about any other render engine, and the render phase of this chapter is intended to only serve as an introduction to the more important discussion within Fusion. However, if you do wish to render the example scene using V-Ray, you can install a demo version of this software as well, which is included with the support files for this book. Installation of the program is extremely quick and simple and can be done in literally 20 seconds or less. The results of the rendering process are shown both in images within this chapter and as movies found in the support files of this book.

The Rendering Phase

Let's jump right into a discussion on the rendering phase of the project that we will deal with shortly in Fusion. Along the way, there will be multiple files you can use to continue with if you are unable to follow along at any point, either because of the difficulty level or because you chose to not install the demo software needed.

1. Play the movie file **bridge_final.wmv** to get a feel for what the final product is that we will try to produce in this chapter. This animation is 640x480 and runs at 25 frames per second. It uses the DivX codec, which you may need to install, depending on the age of your computer.

2. Open the file **ch16-01.max**. This scene consists of a bridge with several cars traveling along it and an animated camera passing from one end of the bridge to the other. The cars are presently hidden and need to remain hidden at this time. If you are familiar with the difficulties in rendering animations with moving objects you will be probably appreciate the importance of being able to render the cars as a separate layer from the rest of the static objects in the scene. If we were to render the cars in this scene along with all of the other objects the cars would leave behind a trail of bounced light, almost like a GI signature. There are ways to mitigate this effect, and you could certainly render with a brute-force method, but in many situations it is highly beneficial to render objects like this in a separate pass and composite them later in a program like Fusion. Yet, as we will see, being able to handle animated objects in this way is only one of the many benefits of compositing.

Unless you choose to create an animation using a brute-force approach, where the GI for every pixel of every frame is calculated independently of every other pixel and every other frame, the first step in the creation of an animation using global illumination is to calculate a saved GI map. In V-Ray there is really only one reasonable option; using the irradiance map and light cache combination. Thankfully, this is a great option.

If you do not want to create your own GI map, skip steps 3 and 4 and continue on from step 5 using the file **ch16-02.max**, which is the same scene configured to render with an already prepared irradiance map.

3. If you want to create a saved GI map using the irradiance/lightcache configuration, follow the steps outlined in Appendix K for creating an animation for a static scene. Currently the scene is static, so the same steps apply at this point. Once we unhide the moving cars, the scene will no longer be static. When you calculate your own GI map, be sure to use the following critical values for the light cache and irradiance map. All other settings not listed here or in this document should be set to default values:

 - **Light Cache settings: Subdivs = 3000**

 - **Irradiance Map settings: Preset = Medium, H.Sph Subdivs=20, Interp. Samples=100, Nth Frame = 5**

4. Once an irradiance map is created, continue with steps **17-22**, shown in **Appendix K**. Once these steps are complete it's time to render the entire animation using that saved irradiance map.

5. You should have a scene that is now prepared to render the complete animation. However, the complete animation includes the cars, which are presently hidden.

6. Unhide the layer **Cars**. This layer contains 9 cars and a VRayLight. The VRayLight is used to illuminate the cars and only the cars. It is set to serve as a dome light, which is nothing more than skylight coming in equal amounts from all areas above the horizon. We can illuminate the cars with this light during the rendering process without seeing a GI signature left behind, as it would if the cars were included in the GI map calculation.

7. Create a new folder on your computer to save the sequence of images we are about to render.

8. Go to the **Frame buffer** rollout of the **V-Ray** tab and enable the **Save separate render channels** option. This option will allow us to save separate image files for all the different layers of the rendering.

9. Click the **Browse** button, and navigate to the folder you just created.

10. Change the file type to **OpenEXR**, give the sequence of images a name, and click the **Save** button. The **OpenEXR Configuration** dialog box appears.

11. Change the **Format** type to **Half Float – 16 bits per channel** and leave all other settings as is. We are using the OpenEXR image format because of its many advantages, such as a high-dynamic range pixel format, good compression, numerous sub-channels, and more.

12. Go to the **Render Elements** tab. Here you can see we have numerous render elements listed. These represent all the different channels of information that will be rendered out as separate EXR files to the location you just specified. These channels include things such as motion blur, depth-of-field, global illumination, and many others. Later we'll explore these channels in greater depth when they're used in Fusion. Although they are presently listed here, they are not yet activated.

13. Enable the **Elements Active** option.

14. Render the animation, or just a portion of it if you only want to render a small test sequence. Rendering all 250 frames of this animation will take approximately 12-24 hours, or 3-6 minutes per frame, depending on your computer's speed. The next illustration is an example of what the various render elements of frame 150 should look like. To see what the compiled raw animation looks like at this point now, play the movie **bridge_01_day_raw.mov**.

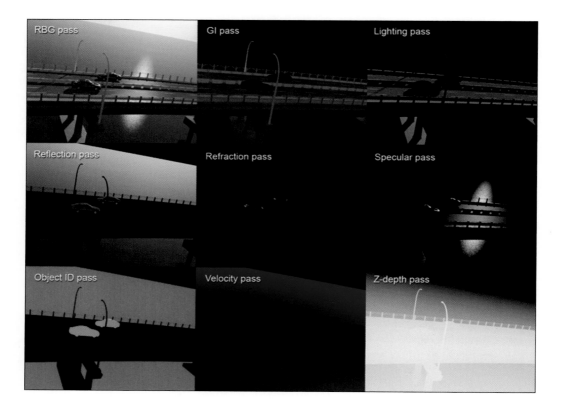

At the bottom of the V-Ray frame buffer (i.e., V-Ray version of the rendered window) is a button labeled sRGB. This button changes an image's gamma from 1.0 to 2.2. The next illustration shows what both versions look like, and later we will explore the difference between these 2 values.

The final step of the rendering process is to calculate an ambient occlusion pass to bring more realism to our animation. Ambient occlusion (AO) is the measure of how much of the sky is occluded, or blocked from view, at any given point on a surface. An AO image is always grayscale, and an example is shown in the following illustration. As you will see shortly, creating an AO pass will do wonders for our final animation because it will be used within Fusion to multiply the colors of the animation, which will add depth and contrast and create a weathered look to surfaces that would otherwise look too perfectly clean.

To make an AO pass in V-Ray, we need to apply a special material to all of the objects in the scene. Specifically, we need to create a **VRayLightMtl**, which is a material that casts illumination. The strength and color of the illumination is dictated by the color or color channel shown in the following illustration. By loading a special map type, the **VRayDirt** map, we can use the map to control the strength of the VRayLightMtl. The VRayDirt map wants to generate a grayscale image where pure black areas represent completely occluded points blocked from view of the sky, and pure white areas represent completely unoccluded points. In between pure black and pure white are areas that are partially occluded. By using this map in the Color channel of the VRayLightMtl, we can create a nice AO pass, like the one shown in the previous illustration. Incidentally, it should be no surprise that an AO pass is also known as a *dirt* pass since its greatest benefit is the way it creates a weathered look to objects in a scene.

15. Open scene **ch16-03.max**. In this scene, the following changes were made to prepare an AO pass for render:

 - A new **VRayLightMtl** was created and the **VRayDirt** map was added to the **Color** channel, as shown in the previous image. Within the VRayDirt map, two settings were changed from their default value. First, a **Radius** value of **0.3m** was used instead of 10m, to make the occlusion not spread out so far, as shown in the left image of the following illustration. Second, a subdivs value of 16 was used instead of 8. This helps reduce noise in the rendering.

 - An instance of this new **VRayLightMtl** was dragged into the **Override mtl** channel as shown in the right image of the following illustration.

 - Indirect Illumination was turned off because it's not needed in the calculation of an AO pass.

 - **Render Elements** were turned off in the **Render Elements** tab.

 - In the **Global switches** rollout, the **Shadows** and **Lights** options were disabled, as shown in the right image of the following illustration, because we don't want these lights or shadows affecting the AO rendering.

- In the **Environment and Effects** dialog box, the **VRaySky** map used as the background was removed and the background color was changed to pure white.

- In the **Frame buffer** rollout, the saved file name was changed.

- Render the AO version of the animation. This type of rendering should take very little time to render because it doesn't use GI, textures, reflections, etc. The left image of the following illustration shows what frame 0 should look like. Notice the difference between this image and the previous AO image. The difference in the two images is a result of using a smaller radius value.

The Compositing Phase

Before we start an exercise on compositing with Fusion, a brief overview of its interface is in order. Fusion can be divided into the following main areas:

- **Tools Toolbar** - This displays shortcuts to some of the critical tools available in Fusion.

- **View Toolbar** - This displays additional commands for polylines, text, and motion paths.

- **Display View** - The Display View is used to view the images produced by tools in the flow. The view can be configured as a single view or two separate views located side by side, using the layout buttons in the view toolbar. Additional floating views can be created on demand from the view menu.

- **Work Area** - The Work Area displays the Flow, Console, Comments Tab and Timeline and Spline Editors. For more information, see the chapters on Flow Editor, Timeline Editor, and Spline Editor.

- **Controls Area** - The Controls Area displays controls for the tools in the flow. Additional tabs in this area reveal controls for any masks or modifiers attached to the currently selected tool.

- **Time Ruler** - The Time Ruler displays controls global to the project, such as the current frame, render range, proxy and quality modes, and so forth. Buttons for playing, navigating, and rendering the flow are also located here.

- **Status Bar** - The Status Bar displays various bits of information about whatever is beneath the mouse pointer, the time to render completion and render status, and memory in use.

1. Start **Fusion** with a new composition. *Composition* is the word used to describe a working Fusion file, and appropriately enough, the files are saved with the extension .comp.

2. Within the **Tools Toolbar**, click the **LD** icon. This activates the Loader tool, which automatically opens a window in which a sequence of image files can be selected. Instead of listing every individual file within a folder, Fusion will display a sequence of files with a single name and a suffix showing the sequence range involved.

3. Select the sequence **1.RGB_color.0125-0150.exr** and click **Open** to load this sequence of images. For simplicity, we will only use 1 second of the animation; however, you can render the entire sequence as previously described if you desire.

The only thing you see at this point is a single icon in the Work Area, as shown in the left image of the following illustration. If you put your cursor over the icon, a flyout appears containing two black dots. These dots represent the two display views above the Work Area.

4. Click the black dot on the left, as shown in the right image. This causes the sequence of images to be displayed in the left window of the Display View. We don't need two windows open at the same time so let's make it a single view.

5. In the **Tools Toolbar**, click the icon representing a single display view, as shown in the following illustration. The two display views should change to a single display view.

6. From the **File** menu (above the Tools Toolbar), select **Preferences** and then click on **Frame Format**, as shown in the following illustration.

7. Click on the **Default Format** drop-down list and select **NTSC (Square Pixel)**, and within the **Settings** section, enter a **Frame** value of **25**. This change causes the default frame resolution to be 640x480 and the frames per second rate to be 25. Click the Save button to complete the configuration.

At the bottom of the Work Area is the Time Ruler, where we should set the frame count to match the sequence of images loaded. There is a quick and easy way to do this.

8. Click and drag the loader icon from the **Work Area** to the **Time Ruler**. Release the mouse and the **Time Ruler** should change to reflect the total number of frames you loaded a moment ago. Some versions of the software may require you to simultaneously hold the **Shift** key while you drag the loader.

The image loader in the Display View looks like the original image before we used the option in the VRay frame buffer to display the image with a gamma value of 2.2. Let's do the same thing here that was done in the VRay frame buffer. As mentioned before, we are going to use linear color space for compositing, and a little later we'll see why.

9. Within the **View Toolbar**, click the **LUT** icon, as shown in the following illustration, and then click Edit. The **LUT Editor** appears.

10. Set the **Color Gamma** to **2.2** and close the window. The image shown in the Display View changes to reflect a gamma value of 2.2. This is the same change made within the VRay frame buffer using the sRGB icon.

11. Within the **Time Ruler**, click the **Play** icon to play the sequence of images.

12. Save this composition. If you want to continue on from this point with an already saved file, load the composition **ch16-01.comp**.

The first composite we will make is to add the ambient occlusion pass to the sequence.

13. Click on the 1st icon you created in the Work Area. If you do not have this icon selected, it is displayed as a green icon. If you do select it, it's displayed as a tan icon and its name (Loader1) is displayed in the Controls Area, where you can do things like change the files used and change the number of frames loaded.

With the Loader1 selected, as shown in the left image of the following illustration, click the LD icon in the Tools Toolbar. Select the sequence 1.ao.RGB_color.0125.exr and click Open to load the sequence. Notice that when you created this new loader, two new icons appear in the Work Area. One is the new loader icon and the other is a merge icon. This icon represents the Merge Tool. Had you not had the Loader1 icon selected when you clicked on the LD icon, this merge icon would not have been created. But since you did have it selected, Fusion assumes that you want to merge the two loader sequences together. You could have clicked on the Mrg icon instead, followed by the LD icon, and could have then created the linking you see in the right image manually. It is critical to know how to do this, so instead of continuing on from here, let's revert back to a moment ago.

14. Undo the Add Loader command you just executed. The Work Area returns to displaying Loader1 only.

15. Click and drag on the **Mrg** icon in the **Tools Toolbar** and place it directly to the right of **Loader 1** in the **Work Area**, as shown in the left image of the following illustration.

16. Place your cursor over the **red square** on **Loader1**. Notice that in the Status Bar, it says that this is Loader1 Output.

17. Place your cursor over the **yellow arrow** of **Merge1**. Notice that in the Status Bar, it says that this is Merge1 Background.

18. Click and drag from the **Loader1 Output** to the **Merge1 Background** and release the mouse. When you do, a link is drawn between the two icons. You have just told Fusion to load the sequence of images in Loader1 as the background of Merge1.

19. Click and drag on the **LD** icon in the **Tools Toolbar** and place it directly above the **Merge1** icon in the **Work Area**, as shown in the left image of the following illustration.

20. Click and drag from the **red square** of **Loader2** to the **green arrow** of **Merge1**, as shown in the middle image. When you do, a link is drawn between the two icons, and Fusion changes the positioning of the square to the bottom of the loader (right image). By doing this, you have just told Fusion to set the ambient occlusion sequence as the foreground of the merge tool.

At this point, we should view the composite we just created. We can split the current window into 2 windows, so we can compare a before and after view side-by-side.

21. Click the **Switch to A/B split view** icon in the **View Toolbar**, as shown in the following illustration. The image that is loaded is split vertically and we can only see the left side in channel A.

22. Carefully click and drag the **Loader2** icon (AO pass) from the **Work Area** to the right side of the vertical green line in the **Display View**. When you do, the AO pass is loaded in channel B. You could press the play button now to play both sequences of images.

23. Click the **LUD** icon in the **View Toolbar**, select **Edit**, and change the **Gamma Color** from **1.0** to **2.2**.

24. Drag the **Merge1** icon from the **Work Area** to channel **B** of the **Display View**. When you do, nothing changes. The reason nothing changes is because we have set Loader1 as the background of Merge1 and Loader2 as the foreground. Since the foreground covers and hides the background, we don't see the original rendered sequence. The whole purpose of creating the AO pass was to use it to multiply the colors of the original animation, not to hide the original animation.

25. Click on **Merge1** and within the **Control Area**, click on the **Apply Mode** drop-down list, shown in the following illustration, and then select **Multiply**. This causes channel B to show the effect of multipling the original animation color by the AO pass. You can consider pure white to represent a value of 1 and pure black to represent a value of 0. So in all of the pure white areas of the AO pass, the original animation is unaffected. In areas of the AO sequence where you see gray, the result will be a reduction in color value, with greater reductions being applied to darker AO areas.

26. Click and hold on the green vertical line and drag around the Display View. Notice that you can rotate the green line, as shown in the following illustration. Notice also that there is a square in the center of the green line. You can move the entire line by dragging from this square.

27. Position the green line as shown in the right image of the following illustration. When you do, you can see quite clearly the effect of the AO pass on the white concrete barriers. Without the AO, the concrete looks too flat and clean. By adding the AO, we add a layer of dirt, which adds depth and realism to the animation.

28. Save your composition. If you want to continue from this point on, open the file ch**16-02.comp**.

Up to now, the three icons we have been working with in the Work Area have been displayed without the benefit of any visual aid in what they represent. We can change that.

29. Right-click over any empty part of the **Work Area**, and from the menu that appears, select the **Force Source Tile Pictures**. The Work Area icons change to display a thumbnail view of the various sequences, as shown in the right image of the following illustration. You may have to reposition the thumbnails slightly if they are positioned too close to each other.

Now let's really make some ingenious adjustments.

35. Select **ColorCorrector1** and click the **CC** icon again in the **Tools Toolbar**. A second color correction icon is loaded and connected to the first.

36. With **ColorCorrector2** selected, click the **Bmp** icon in the **Tools Toolbar**. This is the BitmapMask Mask tool and once loaded, it is automatically linked to feed into ColorCorrector2.

Rather than using the method we've been using, where we select an icon in the Work Area and then click on an icon in the Tools Toolbar, we will have to manually link the next tool.

37. Click and drag a new loader icon from the **Tools Toolbar** into the **Work Area** directly above the **Bitmap1** icon. When the explorer window opens, select **1.pass_obj_id.0125-0150.exr**. This is the rendering element we created by establishing different material IDs for the various objects. In this scene, we set the water object to material ID 1 and the car object to material ID 2 (green color).

38. Click and drag this new loader icon (**Loader3**) into **channel B** of the **Display Area**.

39. Click and drag from the **red square** of **Loader3** (Output) to the **yellow arrow** of **Bitmap1** (Background). The result of the flow thus far should look like the following image. The work flow is often used because this sequence of inputs and outputs is basically a flowchart of information.

40. Load **ColorCorrector2** into **channel B** of the **Display View**.

41. Select **ColorCorrector2** in the **Work Area** and then select the **Colors** button in the **Controls Area** (if not already selected).

42. Click and drag from the center of the color wheel out and to the right until channel B changes to a red hue as shown in the following illustration.

The intent in creating a material pass and loading it into the flow is so we could use it to apply color correction to very precise areas of the animation. Let's make the color correction change we just made apply only to the water in the scene. The water was given a red material ID, so we can use this to isolate the effect of the color correction.

43. Select the **Bitmap1** icon and in the **Controls Area**, select **Red** from the **Channel** drop-down list, as shown in the following illustration.

44. Drag and drop **Bitmap1** to **channel B** view to see the mask. You'll see a black and white image, where only the white area is allowed to be affected by the color correction applied.

45. Drag and drop **ColorCorrector2** to **channel B** again so we can fix the color of the water.

46. Select **ColorCorrector2** in the **Work Area** and within the **Color** tab of the **Controls Area**, change the color of the water so it's a fairly rich blue color, as shown in the following illustration. Be careful not to add so much Strength that the water is unrealistic. Notice that the Strength value changes as you drag around within the color wheel.

47. Save your composition. If you want to continue from this point on, open the file ch**16-03.comp**.

Now let's add some glows and highlights to the animation.

48. With **ColorCorrector2** selected, click on the **LD** icon once again in the **Tools Toolbar**. Merge2 is automatically generated with CorrectCorrect2 linked to the background and the new loader linked to its foreground.

49. Select the **1.pass_specular.0125-0150.exr** sequence. This is represents the specular highlights channel. As before, it's helpful to select the icon you want the new loader to link to, because the new loader is automatically placed in a suitable location in the Work Area and aligined in an aesthetically pleasing fashion. This can be seen in the left image of the following illustration.

50. Drag and drop the new loader (**Loader4**) into **channel B** of the **Display Area**.

51. Select **Loader4** and from the **Tools** menu select **Matte** > **Luma Keyer**. The Luma Keyer Tool uses the black and white specular channel to create an alpha channel. This alpha channel can then be used as a mask for other effects so we can adjust the specular highlights without affecting any other part of the image.

52. Drag **Lumakeyer1** to **channel B** of the **Display View** to see what this layer of information looks like, and within the **Controls Area** turn off the **Post multiply image** option. In the following illustration, we can see only bright pixels.

53. Drag and drop the **Merge2** icon into **channel B** to see the combined effect of all flow elements at this point.

54. Select **LumaKeyer1** and from the **Tools** menu, select **Blur** > **Soft Glow**. Notice that a glow is applied to only the areas that were already bright in the scene, as determined by the specular channel we just added.

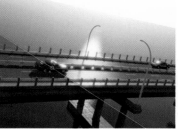

55. Within the **Controls Area**, change the **Blend** amount to **0.5**.

Now let's make some highlights on the cars. To do this, we need to isolate the cars' specular channel from other objects.

56. Drag and drop a new **BitmapMask Mask** icon directly to the right of **Bitmap1**, as shown in the left image of the following illustration.

57. Connect the **Output** of **Loader3** to the **Input** (background) of **Bitmpa2**, as shown in the middle image.

58. Drag and drop **Bitmap2** into **channel B** of the **Display Area**. All you should see is solid white because Bitmap2 is set to display its alpha channel by default. Since Bitmap2 is fed by Loader3, which has no alpha channel, white is the only thing it can display.

59. In the **Controls Area**, change the **Channel** to **Green**. When you do, you should see the cars in white and everything else in black, as shown in the right image of the following illustration.

60. Within the **Controls Area** just above the **Channel** setting, enable the **Invert** option.

Since we want to adjust the specular highlights on just the cars, we need to create an alpha channel of just the cars' specular highlights. To do this, we need to combine the alpha channel of the entire scene's specular highlights (LumaKeyer1) with the alpha channel of the cars (Bitmap2). This is what the Matte Control tool allows us to do.

61. With **Bitmap2** selected, click on the **Mat** icon in the **Tools Toolbar**. This loads the Matte Control tool.

62. Create a link from the **LumaKeyer Output** to the **MatteControl1 Input**, as shown in the left image of the following illustration.

63. Drag **MatteControl1** to **channel B** of the **Display View**. The result is just an alpha channel created from the specular highlights (right image), which is all the work of LumaKeyer1. This is not what we want. We want to create an alpha channel of just the cars' specular highlights. By default, when we created MatteControl1, the link from Bitmap2 was to the wrong place.

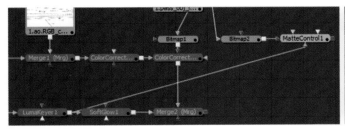

64. Click and drag the **blue arrow** leaving **Bitmap2** and place it on the **white arrow** of **MatteControl1**, as shown in the left image of the following illustration. The white arrow is called the Garbage Matte. As its name implies, the Garbage Matte allows you to throw away that part of LumaKeyer1 that is not part of Bitmap2. The result is an alpha channel of just the cars' specular highlights, as shown in the right image.

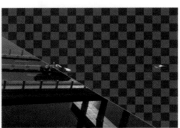

65. Select **MatteControl1** and from the Tools menu, select **Effect** > **Highlight**, and reposition the new highlight tool directly below MatteControl1, as shown in the left image of the following illustration.

66. Drag **Highlight1** to **channel B**.

67. In the **Controls Area**, change the **Low** value to **0.75**, change the **Length** value to **0.65**, and change the **Number of points** value to **6**. The result is a nice streak to the cars' highlights, as shown in the right image.

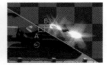

Now let's add color to the highlights.

68. With **Highlight1** selected, add a **color correction** tool and reposition it just below the **Highlight1**, as shown in the left image of the following illustration.

69. Drag **ColorCorrector3** to **channel B**.

70. Adjust the color of the cars' specular highlights using the color wheel in the **Tools Area**, as shown in the following illustration.

Now we need to show the result of all the work performed thus far.

71. Drag and drop a new **merge** tool from the **Tools Toolbar** and place it below **ColorCorrector3**, as shown in the left image of the following illustration.

72. Create a link from the **Output** of **Merge2** to the **background** of **Merge3**.

73. Drag **Merge3** to **channel B**.

74. Create a link from the **Output** of **ColorCorrector3** to the foreground of **Merge3**, as shown in the right image.

At this point we are finished with this portion of the composite process and we need to save the output. You can also play the final sequence of images to see the result.

75. Select **Merge3** and click the **SV** icon in the **Tools Toolbar** and select a file type and save location. You can save your file type as JPG to keep file sizes down with no negligible loss in quality.

76. Click the green **Render** button to start the process of creating each individually composited frame. The finished result should look similar to the following illustration. If you want to explore the final composition file, open **ch16-04.comp**.

Summary

The goal of this chapter was to introduce you to the power and utility of compositing with professional 3rd party software. We hope you agree that compositing with great software like Fusion is really quite simple in comparison to a program like 3ds Max. Although it is beneficial to create your 3ds Max scenes as complete and finished products, there is no denying the usefulness of software that can do some of the things this chapter illustrated. Like other chapters in this book, we have only brushed the surface of what is possible. As we alluded to earlier, we can make adjustments to objects based on their distance from the camera, their speed, or any number of things that could fill a book by itself. The tools are in the program to do more things than you can probably imagine.

Photoshop Techniques
for Visualization

FIRST RELEASED IN 1990, Adobe Photoshop continues to be the market leader for commercial image manipulation. It seems that no one in the 3D visualization industry can do without this program, so we felt it appropriate to illustrate some of our best techniques for integrating Photoshop into our workflow at 3DAS. Realistically, you could fill a book with all of the things you can do with the program to benefit our type of work, but rather than try to do that, we are presenting some of our most widely used techniques we simply couldn't do without from day to day.

A few times throughout the book, we mention that it is our preference to minimize the amount of post production work in Photoshop, Fusion, or any other program, when that work can be just as easily done in 3ds Max. We prefer to have completely independent scenes whenever possible and minimize our reliance on having to touch-up or edit our work in post production. While this is true, there are numerous reasons why we are forced to rely on Photoshop and other programs from time to time. The previous chapter is a testament to the power and usefulness of post production work outside of 3ds Max and when the need to perform post production in Photoshop arises, the following techniques are just a few of the tools you should have at your disposal to get your work done as efficiently as possible. They do not, in any way, represent all the things you should know or need to know about Photoshop. Instead, they are presented to help illustrate the usefulness of post production software and some of the ways you can use other software besides 3ds Max to save time with a project. They are presented in no particular order of usefulness and require a basic understanding of Photoshop. The Photoshop version used in this chapter is CS5.

- Paste-Into
- Ready...Set...Action Script!
- Cloning Done Fast and Effective
- Using 2D Images in 3D Scenes

- Printing Resolution
- Photoshop Masking
- Photoshop Depth of Field
- Adding Effects

Before We Begin

- Although this chapter focuses on CS5, most of these tools can be used in earlier versions of Photoshop.
- Photoshop CS5 has multiple workspaces available. If you have not done so, make sure to set your workspace to the default settings. To do this, go to **Windows > Workspace > Essentials (Default)**.

Paste-Into

The paste-into feature allows a user to paste one image into a very specific area of another image. When this command is used, the pasted image is confined to that area and will not extend beyond the limits of the predefined selection area. Some examples of when you might want to use this technique include:

- Adding an background image into a particular area of another image
- Superimposing a 3D rendering with a real aerial photo
- Duplicating objects in a very specific area (i.e., trees, shrubs, cars, etc.)
- Restricting your image manipulation to specific areas without needing an active selection

In this exercise, we will load the right image of the following illustration into the left image while allowing it to only be displayed through the windows.

1. Open **Photoshop** and load the file **Alaska.jpg**.
2. Press the keyboard shortcut **Ctrl+A** to select the entire image. Keyboard shortcuts are just as practical in Photoshop as they are in 3ds Max.
3. Press **Ctrl+C** to copy the image to your computer's clipboard.
4. Load the file **study.psd**.

5. From the **Select** menu, click on **Load Selection** command. The **Load Selection** dialog box opens.

6. From the **Channel** drop-down list, select **Alpha 1** and click **OK** to complete the command. This causes the single alpha channel embedded in the file to be turned into a selection.

7. Press **Alt+Shift+Ctrl+V**. This executes the **Paste Into** command, which simply pastes the contents of the clipboard into whatever selection is currently loaded. In this case, a background image is added to the area seen through the windows. You could have also selected the **Paste Into** command from the **Edit** menu; however, keyboard shortcuts usually make the same tasks quicker to perform. The result should look like the following illustration. The real benefit of this technique is that you can move the background image around without worrying about it leaving the predefined selection area.

Ready...Set...Action Script

The Action Script feature allows a user to execute a series of commands with one click of the mouse. If you need to execute the same steps over and over again, action scripts can save you a lot of time, and some examples of when you might want to use this technique include:

- Applying filters to a series of images to change the look of each image in the same way

- Reapplying the same procedures from one layer/document to another

- Converting a series of images from one file type to another

In this example, we will apply the Auto Levels feature to a sequence of images, followed by a blur filter, and then we'll scale down each image to a different size. Of course, you can do all of this in video editing software, and to some degree in 3ds Max. However, if you or your company does not use video editing in-house, or does not want to spend the time or money to send it to a professional video editing firm, the ease and speed of being able to do this in Photoshop can be very appealing. The only way this can be done in Photoshop efficiently is through the use of action scripts.

Before you can automate the steps, though, you will need to first create the action.

1. Open Photoshop and open the file **Kids\kids0001.jpg** shown in the following illustration.

2. Click on the **Actions** palette (on right side of screen next to **Masks** palette) and then click on the **Create new action** icon (1st icon to the left of the trash icon). The **New Action** dialog box opens.

3. Name the new action **Levels-Blur-Scale** and click **Record** to complete the command. Notice that the sphere icon at the bottom of the palette turns red, which indicates that any command you use will now be recorded. The next time you open the New Action dialog box, notice that you can assign a function key to execute the script with one press of the key.

4. Press the keyboard shortcut **Shift+Ctrl+L** to execute the **Auto Levels** command. This feature effectively increases the contrast in an image by clipping the darkest pixels (pure black) and the brightest pixels (pure white) and redistributing all other pixels over the 0 to 255 color range.

5. From the **Filter** menu select **Blur > Blur**. This could be used to reduce the antialiasing side effects that often plague animations. Sometimes, it's not until after you've created and played an animation that you realize there are too many artifacts due to the antialiasing filter used.

6. Press the keyboard shortcut **Alt+Ctrl+I**. The **Image Size** dialog box opens.

7. Enable the **Constrain Proportions** and **Resample Image** options (if not already enabled).

8. Change the **Width** from **720** to **320**. Click **OK** to complete the command. Since the image aspect ratio is constrained, the image height will automatically change. The images are currently at NTSC resolution and 320X__ is a common size used for sending clients previews and posting on the Internet.

9. Create a new folder anywhere on your computer where the new images will be saved.

10. Press the keyboard shortcut **Ctrl+Shift+S** and save the image to the new folder you created.

11. Press the keyboard shortcut **Ctrl+W** to close the image.

12. In the **Actions** palette, click the **Stop recording** icon at the bottom of the palette (far left). When you do, commands will no longer be recorded.

13. From the **File** menu, select **Automate > Batch**. The **Batch** dialog box appears.

14. From the **Action** drop-down menu select **Level-Blur-Scale** and with the **Source** drop-down set to **Folder**, click the **Choose** button and navigate to the folder that contains all of the images you want to convert. Click **OK** twice to complete the command. When you do, the 30 images stored in the folder are converted.

Using action scripts can greatly reduce the many mundane tasks of an animation. So, when you need to convert file formats, optimize graphics, adjust colors, resize, and/or add effects to an animation, automating with action scripts is a quick and easy way to do it without having to use expensive and complicated video editing software. For other creative ways to action script, conduct an online search for **Photoshop action scripts**. Not only will you find some clever ideas, they are usually free.

Cloning Done Fast and Effective

When people tell you, "I Photoshop'd that out", their work probably involved the use of the **Clone Stamp** tool. The Clone Stamp tool is useful for duplicating an object or removing a defect in an image. It is wildly popular, but there are ways to make the process much faster than the traditional **Clone** tool. Traditional versions of Photoshop have included the **Spot Healing Brush**, **Healing Brush Tool**, and the **Patch Tool**. Introduced in CS5, the **Content Aware** tool seamlessly fills the selection with similar image content nearby. There are other tools, but are not as effective in the 3D architectural visualization production environment.

Clone Stamp Tool

The Clone Stamp tool takes a sample of an image, which you can then apply over another image or part of the same image. Some examples of when you might want to use this technique include:

- Removing an area like an oil patch on a road
- Duplicating objects in an image, such as cars, trees, people, etc.
- Replacing an object with another

1. Open the file called **aerial.psd**. This file contains 2 layers. Notice on the road that runs along the right side of the development that there seems to be parts of trees erratically located in the middle of the road. These are actually just the tops of trees in the original image on which the 3D image was superimposed. Therefore, a 3D road was also modeled and is also superimposed. The 3D road, however, is on a separate layer that is currently turned off.

2. Turn on the **road_and_car** layer. We placed the road on a separate layer to make this exercise a bit easier to perform.

3. Zoom into the area shown in the following illustration.

4. Create an empty layer just above the layer **road_and_car** and call it **red car**. You can double-click the name of a layer to rename it.

5. Click on the layer **road_and_car**. Choose the **Clone Stamp Tool** located in the toolbar just above the **History Brush** tool, or press the keyboard shortcut **S** to activate the tool.

6. Hold the **Alt** key and click once on the blue car, as shown in the left image of the following illustration.

7. Click on the **red car** layer you created and then, with the **Clone Stamp Tool** still active, paint your duplicate car somewhere else on the same road. In the right image, you can see a duplicate created just behind the blue car, with an additional step added to change the car to red. You can use the blending features described elsewhere in this chapter to change the color of duplicate objects like this.

8. Keep this file open for use in the next exercise.

Spot Healing Brush Tool

The Spot Healing Brush tool quickly removes blemishes and other imperfections in your photos. It does this by using samples around the imperfection, and some examples of when you might want to use this tool include:

- Removing dirt on roads, birds in the sky, or any other small object in an image
- Blurring noise out of a small area

9. Select the **Spot Healing Brush Tool** (just above the Brush Tool) or press the keyboard shortcut **J** to activate the tool. In this file, we are going to use the tool to remove the small red dot shown just below the blue car.

10. In the top-left corner of the screen just under the **Image** menu, adjust the size of the brush so it is larger than the blemish.

11. Click on the layer called **Background**.

12. Click once on the red dot. The dot should disappear.

13. Keep this file open for use in the next exercise.

Patch Tool

Another great tool for cloning is the Patch Tool. This tool allows you to create a selection area around the area you want to edit, and then drag that selection to another place on your image from which to borrow pixels. Those borrowed pixels are then placed in the original selection area to cover what was there. Some examples of when you might want to use this technique include:

- When you want to add objects into a scene like a row of trees or cars
- To duplicate objects and have them blend seamlessly with their surroundings

14. Zoom into the area shown in the following illustration.

15. Click and hold on the **Spot Healing Brush Tool** to reveal a flyout and then select the **Patch Tool** icon.

16. If not already set, enable the **Destination** and **Transparent** options for the Patch Tool. The effect of these options will be apparent in a moment.

17. Create a circular shaped selection around the left tree as shown in the left image of the following illustration.

18. Click and hold inside the selection you just created and drag that to the area between the left and right tree, as shown in the middle image. Do not release until you have moved the tree to the final location where you want the duplicate to be created.

19. Release the left mouse button and the duplicate is made, as shown in the right image. Not only is the duplicate made, it is blended in with the background. Notice in the middle image that the selection that is dragged over is actually covering a small area of the parking lot, yet when the mouse button is released, the parking lot is not clipped out; it is instead blended with the duplicate tree. Even more, a small shadow is visible on the parking lot because of the blend. The Transparent option allowed the parking lot to be shown through the copied tree, which prevented the tree from appearing to grow out of the concrete. If the Destination option were not used, you would have had to create your selection in the open space and then drag it to the tree; just the opposite of what you did.

Content Aware

Introduced in CS5, the **Content Aware** tool easily removes image elements and replaces them with similar content close to the area you removed. For the best results, create a selection that extends slightly into the area you want to replicate. (A quick lasso or marquee selection is often sufficient.) Some examples of when you might want to use this technique include:

- Removing an image but wanting to fill it in with the background
- Fill in the edges of your document with similar content instead of cropping them

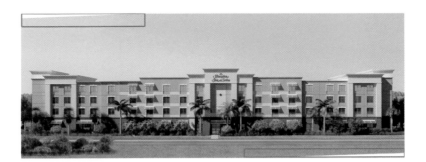

1. Open the file **Hotel.jpg**.

2. Sometimes when you rotate images, there are areas that show up as the background color. As shown in the figure above, we will concentrate on fixing those two areas – the sky and the grass.

3. With your rectangular marquee tool, select the white area around the sky. Press **Delete**.

4. A dialog box will come up and ask you what you would like to replace it with. Under **Contents**, use **Content Aware**. The sky area will now be filled in.

5. Sometimes Content Aware does not do such a good job. Select the grass area as shown in the illustration above. Repeat steps 3 and 4.

6. As you can see, Content Aware does fill in the area with grass. But it is repeated too much. In this case, it is suggested that you use the clone brush and/or spot healing brush to remove the repeating patterns.

7. Content Aware can remove images and replace them with the background. As an example, select the bushes in the foreground area located in the lower-left corner. To select those bushes, use the lasso tool but try not to select any of the building. Repeat steps 3 and 4. As you can see, the bushes are gone and replaced with the grass and road areas.

Using 2D Images in 3D Scenes

Have you ever tried using 2D images (mapped on a plane) in a 3D scene, only to find out that you see white/colored edges around it? This is caused by antialiasing, which in this case is the borrowing and blending of pixels between the edge of a foreground object and the white/colored background that it's cut out of.

In the left image of the following illustration, the image of a tree lies on a white background. If the tree is cut out from this white background and set against a colored background, as shown in the middle image, the result would be a very noticeable white halo around the entire tree, as shown close-up in the right image.

 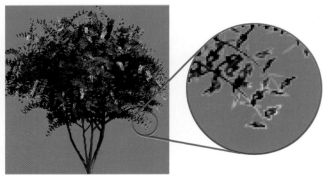

To avoid this, you should always make sure that your backgrounds are similar in color to the foreground object being cut out. There are dozens of ways to do this, but perhaps the easiest way is to create your selection to be cut out, inverse the selection, and fill that selection with a solid or gradient color that closely matches the average shade of color found around the perimeter of the foreground object. In the case of the tree shown in the previous illustration, a soft muted green color would do the trick. Unfortunately, when you create your fill, you will still see this halo shown in the right image because the selection you filled will also employ antialiasing.

The solution to complete the transition to a colored background would be to slightly alter the light colored pixels around the edge of the tree. There are several different ways to do this but the best tool is **Refine Edge**. This tool is found in the **Select** menu and serves one basic purpose; as the menu name implies, to help you select the pixels you need to perform a certain task. In this case, the task is to alter the color of the white pixels around the edge of a tree. Included are the major components of Refine Edge:

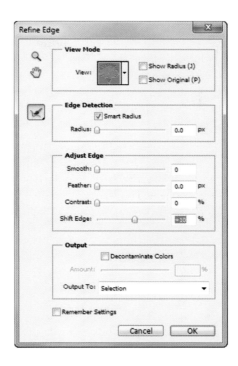

- **View Mode** – Click the thumbnail to view your selection as a mask, marching ants and other display types. **Show Radius** only displays your selection. **Show Original** displays your selection without any adjustments.

- **Edge Detection** > **Smart Radius** – Automatically adjusts the radius for hard and soft edges found in the border region. This option is usually used when your edges are soft and hard throughout your entire selection (Ex. Hair and vegetation).

- **Adjust Edge** > **Smooth** – Reduces irregular areas in your selection. If your selection is defined to many parts, smoothing out the edges can help.

- **Adjust Edge** > **Feather** – Makes hard edges into soft edges. Feathering is often used for faking anti-aliasing and vignette photos.

- **Adjust Edge** > **Contrast** – Hardens the soft-edge or feathered borders.

- **Adjust Edge** > **Shift Edge** – Adjust the edges and amount of your selection.

- **Output** > **Output to** – In most cases you will leave the output to **Selection**. However, it does come in handy for making masks on a new layer if you plan to use it later.

In the following exercise, we'll look at the **Refine Edge** tool in action.

1. Open the file **crape_myrtle.tga**.

2. From the **Select** menu, click on **Color Range**. The **Color Range** dialog box opens and your cursor turns into the eye dropper tool.

3. Adjust the **Fuzziness** to **100** and click on the whitest pixel you can find, such as the one indicated in the following illustration. The Color Range window should indicate which pixels lay within the fuzziness range of the selected pixel, and therefore, which will be selected.

4. Click **OK** to complete the command. When you do, all the similarly colored pixels will be selected. Note that because of antialiasing running behind the scenes, the pixels you see selected are not the only pixels that will be affected by a color change you apply. The next step illustrates this point.

5. Set the foreground color to pure red and use the **Edit > Fill** command to fill the selected pixels with the red foreground color. This will help show you the true effect of the selected pixels. You should see the entire boundary of the tree surrounded by red-shaded pixels.

6. Undo the previous **Fill** command and repeat the previous step using a light muted green color as the fill color for the selected pixels. This will effectively remove any appearance of brightly colored pixels around the boundary of your tree.

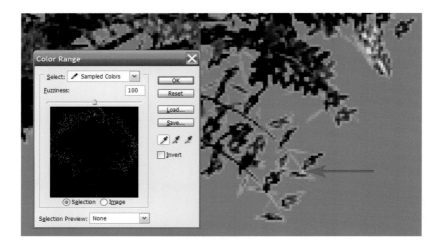

Be careful with the **Color Range Fuzziness**. Too little fuzziness can show too much of the background. Too much and you will lose details in the leaves and branches. You can also make adjustments, by using the **Refine Edge** command just before the fill command, and you can further adjust the select pixels (before or after the fill) using tools found in the **Image > Adjustments** menu. Also make sure to use the highest resolution version of the image.

Converting for Printing Purposes

Two very common questions asked within the visualization industry sound something like 'Why do my renderings look so different on a computer than when printed?' and 'What image resolution should I render to if I want to print my renderings?' The first question highlights some of the problems of color space between computer monitors and printed ink. The second question highlights some of the problems of printing images at too low a resolution. This next section in the chapter aims to address these problems and some solutions.

CMYK vs. RGB

Professional printing firms traditionally use **CMYK** colors (Cyan, Magenta, Yellow, and Black) rather than **RGB** (Red, Green, and Blue) colors used by most consumer printers. RGB has a larger color spectrum than CMYK does, which means it can produce colors CMYK cannot. When you convert to CMYK, you will notice that some of the colors will change because Photoshop is finding the next-closest color to match in the CMYK spectrum, or **gamut**.

The following illustration shows the **Color Picker** dialog box. With it, you can see which colors are in **gamut** and which ones are not. Select a color and see if there is a triangle with an exclamation mark inside in the upper right corner of the dialog box. If there is, you are in the RGB spectrum (out of gamut). If it is not there, you are in the CMYK spectrum (in gamut) and can typically print that color.

If you look carefully at the individual C, M, Y, and K values in the dialog box, you'll notice that a selected color falls out of gamut when just one of the 4 colors reaches 0% or 100%. This indicates that in order to produce the color you have selected, you will need more than 100% or less than 0% of the individual color component, which of course is not possible and is why the selected color is out of gamut.

To ensure that your printed products closely match your monitor's display, you should convert your images to CMYK before sending to print. Although every monitor is different, the RGB to CMYK conversion will show you, through your monitor, the closest match to what will be printed by most commercial printing firms. Converting an image also allows you to tweak any colors before sending a project to print.

To really see the effect of this conversion, perform the following exercise.

1. Click on the foreground or background color in Photoshop. This opens the **Color Picker** dialog box, shown in the previous illustration.

2. Click anywhere inside the dialog box to activate it as the active window and press **Alt+PrintScreen** to copy that dialog box to the clipboard. Close the dialog box.

3. Create a new file, making sure to select **RGB Color** mode while doing so, and paste the dialog box from your clipboard into the new file. Before completing the next step, pay close attention to the rainbow of colors that run vertically in the window.

4. From the **Image** menu, select **Mode** > **CMYK Color**. You can click either **Flatten** or **Don't Flatten** to complete the conversion. Notice how the colors in the vertical spectrum completely change in appearance. The colors now visible are all part of the CMYK spectrum and can be printed by commercial printers.

As a final note about RGB vs. CMYK, try pressing the keyboard shortcut toggle **Shift+Ctrl+Y** to toggle on the **Gamut Warning** feature. When enabled, this feature will show you just how much of your image falls out of gamut by replacing all non-CMYK colors with gray.

Printing Resolution

Rendering a 3D image in high resolution is usually necessary whenever you want to print your image for professional display in a magazine, on a billboard, or in any media of substantial size. Knowing what size to render your image is critical for producing a proper end-product for your client.

To determine the size that you need to render an image, determine the actual size of the printed final product in inches, and multiply the length of each side by the dpi you want. For example, if your image is going to be a 36-inch-wide and 24-inch-high print, and you need 300 dpi, your file output size should be 36x300 by 24x300, or 10,800 pixels wide by 7,200 pixels high. If you do not have the great deal of RAM required to render such a high-resolution image, you can render the image in segments and splice the segments together in Photoshop.

Many inexperienced users, and their clients, mistakenly think that 300dpi is necessary for even large billboard prints. Usually, this could not be further from the truth. From our experience, most billboards are not going to be viewed from less than a foot away like most magazine images would, and therefore, you usually don't need anything even close to 300dpi. In most cases, 150dpi would be excessive and 75dpi closer to the norm. At just 75dpi, an 8'x4' billboard image would still require a whopping 7200x3600 rendering, which might still require printing in segments.

If you need to print a 3X3-inch image for a magazine advertisement or a brochure, 300dpi would be the minimum resolution you should use, but ideally you should try to produce at 600dpi, since RAM and time should not be as big a factor. This is the maximum resolution the average human eye can detect and anything larger would be a complete waste. Some additional tips are:

- When you save your file, choose JPEG and make sure the compression is set on Maximum (this range is usually 10-12). Although this is a subjective manner for many, JPEG compression has the most benefits to printing. First, and most importantly, it is universal. Not only can printers read this format it can be reviewed by almost everyone. Second, this compression algorithm has much more overall efficiency and is much smaller than the other traditional file types (such as TIFF, PICT, and EPS). Lastly, it has great longevity. Since JPEG is known as a universal format, most computers should be able to recognize it many years from now.

- Make sure to remove any paths and alpha channels. You can do this by accessing the **Path Palette** and/or the **Channels Palette**. To remove the additional path/channel, drag it to the trash icon. If you save as a JPEG, the alpha channel will be discarded automatically.

- Always flatten your image. To do this, select **Flatten Image** from the **Layer** menu.

- Talk with your printing company. Many printers have their own guidelines not discussed above. Always check with your printing company and make sure they know exactly what you are sending them. As with most businesses, communication is the key to delivering your projects on time and on budget.

Pricing can vary quite a bit when dealing with printing companies. Local printers will usually cost more than large, national printers. But, if you have quick deadlines and more of a budget, go with a local printer. Just make sure to send your local printer a few smaller jobs before you send them a big one. It is always good to test out vendors before you rely on them with a large project. As for the national companies, they are great if you want printing done cheap and with reasonable quality.

Photoshop Masking

Would you like an easy way to show your clients some different color schemes for your 3D interiors and exteriors, without having to create a new rendering for each new color? Photoshop masking allows you to modify colors (among other things) of very specific areas of an image without affecting other areas. Because of this, you can change the colors of a particular object (or many different objects) in a 3D image with one click of the mouse while your client watches. Furthermore, you can do this without negatively affecting GI, shadows, reflections, or anything else.

The following exercise demonstrates how to create your own exterior masking system so you can change colors for your clients quickly and efficiently. The file that will be used in this demonstration is a rendering of one of the buildings for a large condominium development. The client wanted to test multiple colors for different parts of the building in real time and the best way to do this is with the use of masks. For the purpose of simplicity, we are only going to demonstrate the masking and color changing of just one area of the building.

1. Open the file called **sample_mask1.psd**.

2. Notice in the **Layers** palette that the main rendering is on the base layer and there are two additional layers. The base rendering is currently visible, as shown in the left image of the following illustration.

3. Turn off the base layer and turn on the layer called **siding mask**. The result should look like the right image. This is the area of the building covered with vinyl siding and this is the material whose color we want to change. The black portion of this layer will serve as the masking area.

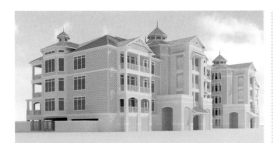

Incidentally, to create a layer like the one shown in the right image of the previous illustration, you can apply a **Matte/Shadow** material within 3ds Max to the selected object whose color you want to change in Photoshop. Render the image out a second time and save the image as a **TGA** with the **32-bit** option, which forces the alpha channel to be saved as well. In the case of this building, the alpha channel will look like the right image of the previous illustration. Next, load the TGA file in Photoshop, go to the **Channels** palette, select the alpha channel and click the **Load channel as selection** icon. This causes the alpha channel (the white pixels) to be selected. Delete the white pixels of the alpha channel and you are left with just black pixels on a transparent background.

4. Continuing with the exercise, turn on all three layers. The top layer is nothing more than a layer filled in with a red/pink color. This is the color we want the siding to become initially.

5. Select the **siding mask** layer and change its blending mode from **Normal** to **Color**. This is done through the drop-down list directly below the word **Layers** inside the **Layers** palette.

6. Right-click the layer called **Red/Jovial** and select **Create Clipping Mask**. The result is a re-coloring of the mask layer, as shown in the following illustration.

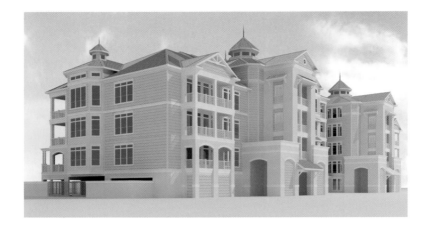

7. By creating multiple layers, each with different colors, you can quickly switch from one layer to another and show your client a series of pre-selected colors. However, you can take this one step further. If you want to change colors on the fly and not have to rely on pre-selected colors, you can do a few additional steps.

8. Right-click the layer called **Red/Jovial** and select **Blending Options**. The **Layer Style** dialog box appears.

9. From the **Styles** list on the left-hand side, select **Color Overlay**. Rather than just clicking on the checkbox to enable it, make sure you actually go to the Color Overlay style by clicking on the words. When you do, a color swatch should appear at the top of the dialog box, which you can click to open the Color Picker dialog box. Inside the dialog box, you can change the colors of the siding in real-time. Notice in the following illustration that a fairly dark green color has been selected. This represents the darkest color you would find anywhere in the material. In the following illustration, this area is found in the darkest shadows, as shown by the area highlighted by the red circle.

This technique can be invaluable in providing your clients the ability to see any possible range of colors they have in mind for their project. Because it's so quick and simple to set up, it's arguably the best way to provide such flexibility. It is sometimes still helpful to create a series of pre-selected colors on individual layers, and if you want to see such an example, open the file **sample_mask2.psd**.

Depth of Field

Depth of field can provide a wonderful touch of realism to your work when applied in moderation. It can also help viewers focus in on a certain area of an image or animation. Applying depth of field in 3ds Max can dramatically increase render times; however, you can often accomplish the same results in a fraction of the time using Photoshop.

1. Open the file called **corridor.jpg**.

2. Using the **Elliptical Marquee Tool**, create an elliptical selection around the names **SMITH** and **ZAJAC**, similar to that shown in the left image of the following illustration.

3. Press the keyboard shortcut **Shift+F6 (Select > Modify > Feather)** to activate the **Feather** command.

4. Type a value of **30** and click **OK** to continue. Although you can't see it, the selection edge has just been softened by being spread over 30 pixels.

5. To see the area you now have selected, press the keyboard shortcut **Q**. This is a toggle button that allows you to switch back and forth from **Standard Mode** to **Mask Mode**. It is also the same as clicking the **Edit in Quick Mask Mode** icon shown highlighted in the right image of the following illustration. The red area is the area unaffected by the selection.

6. Press **Q** to leave the mask mode.

7. Press **Shift+Ctrl+I** to invert the selection.

8. From the **Filter** menu, select **Blur > Gaussian Blur**.

9. Enter a **Radius** value of **0.7** and click **OK** to complete the blur. The amount of blurring is simply a matter of taste; however, it's just best to add such effects in a subtle fashion.

You can also use these same methods to create a vignette effect whereby the focal point of an image, such as the house in the following illustration, is made to stand out dramatically by having everything else around it blurred heavily. This effect can be seen in the right image.

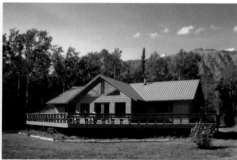

10. Open the file **house.psd**. There are two layers in this file. The hidden layer is the original image and the visible layer is a copy of the house. Notice that the visible layer has the background removed with a soft edge, as shown in the following illustration. This was accomplished with the **Feather** command and was done so the transition from sharp to blur wouldn't cause an aliased look.

11. Turn on the background image and apply a **Gaussian Blur** to it using the default **0.5** radius.

12. Press the keyboard shortcut **Ctrl+F** to repeat the command and keep repeating until you have the desired vignette effect. Repeating the command about 10 times provides a nice effect.

Adding Effects

The true power of Photoshop is sometimes not apparent until you start adding effects to your work that would take tremendous time and skill to add in 3ds Max. Photoshop can often accomplish in seconds what it takes you several hours to set up and what it takes 3ds Max just as long to render. Examples of these types of effects are caustics, motion blur, depth of field, fog, displacement, and volume light, to name a few. Sometimes, the time it takes to render these effects is not worthwhile and sometimes the sheer effort it can take to set up the effects along with all the added experimentation is not worthwhile.

There are seemingly endless ways to add effects to an image with Photoshop, but two different areas of the program seem to stand out above the rest in terms of utility; filters and brushes. The exercise in this section of the chapter will help illustrate the power of both of these areas of Photoshop.

With each release of the program, Adobe adds more and more filters to extend our creative abilities. There are so many filters these days that it's difficult to remember what all of them do; perhaps, even if you make a living out of photo editing. As we'll see in a moment, they can really speed up your 3D workflow and allow you to do things you simply might not have the time or skill to do in 3ds Max.

Anyone who has ever used Photoshop has undoubtedly spent a good portion of the time using the brush tool. However, it's likely that most users don't take advantage of one of the best characteristics of the brush tool; its capability to be created from scratch. There are hundreds of brush styles available after the program is installed and tens of thousands more available for free online. Once downloaded, you can load these free brushes by clicking the **Options** arrow highlighted in the following illustration and then selecting **Load Brushes**.

Using free brushes certainly extends the possibilities of what you can do with the default brushes; however, the real power of the brush tool comes when you make your own brushes to accomplish a specific task. The following exercise demonstrates the power and usefulness of a custom-made brush and adds to that a demonstration of the usefulness of filters.

Before we begin, most effects done in post production require an artistic approach. And, many of these effects should be barely noticeable in your scene. Remember the saying "the best effects are the ones you never see"? This quote should apply to most of your 3D architectural visualization effects.

With that being said, let's look at a great way to add caustics to an image using the brush tool, and a great way to add ripples to water using a filter.

1. Open the file **caustics3.jpg**. This is a rendered image of refracted caustics, as shown in the middle image of the following illustration. The image was created quite simply using the scene shown in the left image. The scene created in 3ds Max contains a single light that shines through a high-polygon plane object with a **Noise** modifier applied. The light shines through the plane and the refracted caustics fall onto the black box. Because there is no other light in the scene, you can capture the **Caustics** component of the rendered image using the **Render Elements** tab within the **Render Setup** dialog box. When you do, the result is a nice black and white image that can be easily used to create a Photoshop paint brush. Creating nice Photoshop brushes is often best accomplished by rendering images like this.

2. Press the keyboard shortcut **Ctrl+I** to invert the black and white colors in the image.

3. From the **Edit** menu, select **Define Brush Preset**.

4. Name your new brush **Caustics3** and select **OK** to continue. You can now use this brush to paint.

5. Open the file **pool.psd**. This file contains three layers. The first is the initial image, shown in the left image of the following illustration, and the other two layers are copies of the pool water and the objects on which caustics are going to be applied, as shown in the right image. The layer called **Caustics_Copy** has a mask applied. This was accomplished using the Paste Into feature mentioned elsewhere in this chapter. With the image of the wall copied onto the clipboard, a selection was made around the wall and the copy of the wall was pasted into the selection. Therefore, whatever you do, this layer will be confined to the limits of the wall.

6. Turn on the **Base_Image** layer.

7. Press the keyboard shortcut **B** to enable the **Brush Tool**. If the **Caustics3** brush you made earlier isn't currently loaded, load it now. In most cases, it will be the last brush in your brush presets.

8. Change the **Foreground** color to **white**.

9. Select the **Caustics_Copy** layer and change the **Opacity** to **25%**. This ensures that the caustics you paint aren't too strong. If you determine at any time that they need to be reduced in strength, simply decrease the opacity of this layer.

10. With the **Caustics3** brush active and without dragging the mouse, click a few times around the various objects where you think caustics should be placed. If you feel that the caustics are too strong everywhere you can reduce the opacity of the caustics layer. If you feel that the caustics are too strong in one particular area, you can use the Eraser Tool to remove caustics gradually in precise locations. Once you are finished, you can achieve a decent looking caustics effect in just a few seconds, as shown in the following illustration.

Remember to think about what surfaces the caustics should and shouldn't be able to strike. Simply erase the caustics from those surfaces on which they shouldn't be found.

11. Select the **Pool_Water_Copy** layer.

12. From the **Filters** menu, select **Distort > Ripple**.

13. Set the **Amount** to **150%** and the **Size** to **Small**. Click **OK** to complete the command. The water should now have a nice rippled appearance, as shown in the following illustration. You could make minor adjustments now, such as cutting off the few pixels on the bottom and right edges of the pool water that get pushed too far out of their normal position.

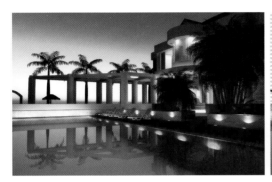

By creating unique paint brushes, you can create wonderful effects like the caustic effect demonstrated here. Anytime you create a unique brush like this, you might want to create a few different versions of it while you're at it. For example, three different images were rendered for the caustic brush, as shown in the following illustration. This was accomplished by simply changing the scale of the Noise modifier and the intensity of the light. All three of these images are available for you to use if you like (**caustics1-3.jpg**) as well as the scene used to create them (**caustics.max**). The scene used was rendered with V-Ray, but can easily be made to work with mental ray.

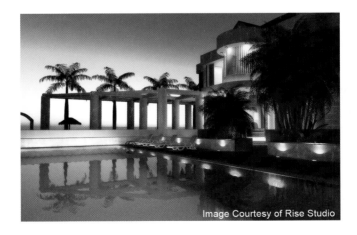

Image Courtesy of Rise Studio

Summary

The goal of this chapter was to illustrate some useful Photoshop techniques that can improve your 3D workflow by reducing the amount of time you need to spend in 3ds Max. In some cases, Photoshop can completely replace some of the phases of scene creation in 3ds Max, and allow you to spend more time on the artistic side of your work and less time on the technical side.

With Photoshop there is essentially no limit to the number of new techniques yet to be invented to improve our work. There were only 8 techniques outlined in this chapter and it would be foolish to argue that these are all you need to maximize your efficiency. Nevertheless, they each have something significant to offer for the typical visualization user, and are a good foundation for further experimentation.

Efficient 3D Workflow

In the ideal 3D world, you could build all your scenes without regard to file size, available RAM, CPU speed, rendering times, or any number of things that complicate the design process. However, since most of us have to be aware of our computers' limitations, we have to manage the way we build objects and assemble our scenes.

The Animation Process

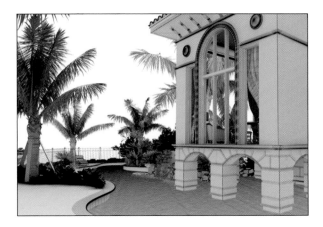

EVERY VISUALIZATION PROJECT IS UNIQUE and every firm takes its own approach to producing the end product. Regardless, most firms tend to execute many of the same major steps along the way, although not always in a logical progression or with the same prudence of veteran firms that have learned a proper execution the hard way. For example, many firms learn the hard way the importance of inspecting architectural drawings before pricing a project.

Most firms seem to experience the same general problems and pitfalls that plague our industry and many eventually employ the same general techniques to mitigate these problems. With this in mind, the intent of this chapter is to provide some insight to some of the major steps of a typical animation project from the first meeting with a client, through post production and delivery of the final product. The goal is to identify the major steps and outline a logical order in which those steps should be executed and to present some tips and tricks that can aid in their execution.

Whether the end product is a still rendering(s) or an animation, the production process is often the same up until the time the rendering phase begins. So, the following is a list of some of the major steps of a typical animation and some of the strategies you can employ to avoid the problems that are likely to arise.

1. Market your services
2. Talk/meet with client
3. Do not disclose price
4. Determine end product
5. Learn as much about project as possible
6. Request drawings
7. Make contact with other companies
8. Receive and inspect drawings
9. Question poor designs

10. Determine what will be seen and the level of detail

11. Create production timeline

12. Write proposal / PSA

13. Receive signed contract and deposit

14. Create project folders

15. Ensure you have latest drawings

16. Break up project

17. Clean and prepare CAD linework

18. Import linework

19. Model building elements

20. Model site elements

21. Create an assembly line work flow

22. Save incrementally and save often

23. Merge background rig

24. Use material libraries

25. Merge scene elements

26. Load lighting preset

27. Create animation paths

28. Create copy of maps in project folder

29. Create test renders

30. Fix / change animation

31. Create production render

32. Post production

1. Market your services

For detailed insight to numerous marketing strategies, refer to Appendix E.

2. Talk/meet with client

A big decision freelancers and small business owners struggle with in their first few years of operation is whether to lease or buy office space and move their business out of their home. Such a decision cannot possibly be made lightly and by anyone else but the individual(s) involved, but if a majority of your clients are locally based, there is a decisive advantage in having office space clients can walk into. Landing large projects from big name developers is an enormous challenge without such an office space. Although many clients will understand that good work is simply good work, regardless of where your business is based, many clients will not see past the fact that you have not obtained the financial means necessary to secure an office, and interpret your company as a here today, gone tomorrow business. Even worse, they may expect you to charge less for your work because of your smaller overhead costs and might believe they can take greater advantage of your position during the negotiation process.

When you market your services to a potential client, something you should have ready to present at any time is a detailed slideshow of what you do and how you do it. Demo DVDs are obviously a great form of marketing media, but nothing can replace the simplicity and effectiveness of a PDF or PPT document to showcase some of your best work while simultaneously presenting an overview of the 3D process and the range of your services. This becomes even more important when you conduct your presentation in person or need to send the potential client something by email. When a potential client calls or emails and you can instantly direct them to a webpage that contains such a presentation, you don't run the risk of losing the client to someone else while your DVD or brochure is being mailed. And unlike a DVD, which can be very time consuming and expensive to update, a PDF or PPT document can be updated in just minutes.

A few sample slides of the presentation 3DAS uses are shown in Figure 18-1. For more information about this type of marketing media, see Appendix J.

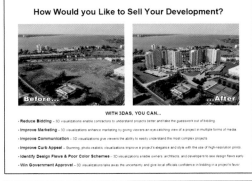
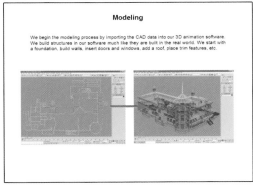

Figure 18-1. A few pages from our 3D CAD brief.

3. Do not disclose price

One of the very first things a potential client will ask is, "How much does a rendering or an animation cost?" It is generally in your best interest to avoid directly answering this type of question until you have a thorough understanding of every detail involved. Obviously, if the client is persistent and demands a 'rough idea', then a range of prices would be appropriate, but only after you have been provided answers to some basic questions, such as:

- What is the final product?
- When is the final product due?
- Is custom furniture needed?
- Are there CAD files?
- Are the drawings finalized?
- Is there a landscape plan?

4. Determine end product

It may seem to go without saying that both you and the client should know what the final product is, but this is truly a step of the 3D animation process that is continually neglected by many new businesses. Knowing that the client wants an animation is not enough. You should know as many details about the final product as the situation allows. You should know answers to questions like, 'What is the length of the animation in raw form and in edited form? Who is editing the video? Are stills needed? If so, how many and what resolution? What kind of music or narration will the video need?' The list can be endless and to find the real answer to some of these questions, you might have to do some digging. Take the following question, for example – 'When do you need the animation?' Clients will often see this question as a way to expedite your work and give you an answer that really doesn't tell you what you want to know. When presented with this type of question, your client may simply throw out a date or timeline on the spot without really telling you that the timeline is flexible. If you instead ask, 'What is the drop-dead date?', a client is far more likely to give you the answer you're looking for, or at least an answer that won't lead you into an unnecessary position.

Likewise, the client should have as thorough an understanding as you do about what will be provided. As mentioned several places in this book, a contract is most valuable not for the legal protection it provides, but rather for the clarity it provides both you and the client as to each person's responsibilities. By listing the details of what the client must provide you and what you will provide for the client and when, both you and the client can be comfortable in the knowledge that each of you understands what the end product is, and when it is due. Finally, when the details are presented in a contract, it is much better to assume that your client knows as little as possible about the process and you should over explain what you will be providing.

5. Learn as much about project as possible

Try to gain as much insight about your project as you possibly can. Doing so makes other steps of the animation process much easier, such as pricing the project, determining timelines, etc. This step, like all others, should also be factored into the final price you provide.

6. Request drawings

Some clients take excessive lengths of time to obtain the latest set of drawings, so request them at the earliest opportunity. When you do, you should make the process as painless for your clients as possible, so as to not discourage them from coming to you with future projects. So rather than requesting an entire set of drawings, which can often make architects and engineers leery, request only those drawings you really need. Do not overlook important drawings such as the landscape plan, furniture plan, cabinet elevations, etc. These are examples of drawings that are commonly overlooked during the initial request that can cause major delays down the road.

7. Make contact with other companies

During the course of just about any project, you usually have access to each of the companies involved in the creation of the project, and hence, a great marketing opportunity. Take advantage of every opportunity to communicate with these new potential clients as it may be your best chance to gain their attention. For a typical project, you might have the opportunity to work with several architects, landscape architects, civil engineers, interior designers, real estate agents, investors, and many others. Each of these individuals might sell your services to others in their network, so meeting or speaking to as many of these individuals as possible is invaluable.

8. Receive and inspect drawings

Most architectural visualizations begin with what I consider the foundation of 3D - the 2D line work. Sometimes, you may need to produce a visualization from nothing more than some simple hand-drawn elevations, in which case your best course of action is to trace the sketch in a 2D CAD program to produce the necessary 2D linework. In most cases, however, you will begin a project with 2D CAD drawings already in hand, even when their creation is not finalized. These CAD drawings may be produced solely by the architect, by a freelance CAD drafter, or by numerous different firms working to complete their part of the final set of construction documents. Whatever the case may be, all involved have their own style for creating drawings and leave their own mark on their drawings. If you're lucky, you will receive a complete set of perfectly created drawings, but most of the time there are things in the drawings that, while not apparent on paper, may cause you hours of time to fix before the linework can be used in the creation of 3D models. These imperfections in the drawing process can eat away valuable production time and significantly impact your profits. For these reasons, you should always try to avoid giving your clients a price until you've had a chance to inspect the drawings you're going to be working with.

For more insight on the inspection of drawings, refer to Chapter 2 and Appendix A.

9. Question poor designs

One of the most practical uses for a 3D visualization for a client is being able to see their project before it's built and change a poor design before construction begins. Your work may begin while a project is still in its design development stage, in which case its design is not set in stone and construction documents have not been produced. In this situation, you may find yourself modeling a portion of the project that appears poorly designed. Sometimes architects or drafters will create drawings based on their interpretation of what their client wants or what their client's sketches show. However, these drawings do not always represent what their clients have in mind. Sometimes their clients don't even know what they want.

You may be asked to model a poor design when your client, whether it's an architect, a developer, or the owner himself, jumps the gun and has you begin your work before the design has been thoroughly analyzed by all of the necessary personnel. In any case, whenever you come across a drawing that appears to be a poor design or a design that simply doesn't make sense, you should question it and stop working until a resolution is found.

You should also question drawings that contain contradictory information before continuing work. This problem is very common, especially with drawings that haven't been completely finalized. An example would be a floor plan that shows a window not shown on the elevations, or vice versa. Another example is when the front elevation shows one roof height, and a side elevation shows a much different roof height. These types of problems should be questioned before continuing work, and if you manage to find numerous problems like these before you accept a job or quote

a certain price, you should cover yourself by not accepting the drawings from your client, or by explaining that you will have to charge more to account for these problems. You will probably regret not doing so later.

10. Determine what will be seen and the level of detail

A critical part of efficient workflow is determining as early as possible what in your scene will be visible by the camera and the level of detail you need to maintain. Doing so helps you avoid modeling features that won't be visible to the camera and placing excessive detail in objects that are farther away from the camera. Creating a detailed script with camera paths as early as possible is a great tool that makes your entire project much easier to manage.

11. Create production timeline

This is probably one of the most poorly addressed steps in the animation process. We have all been guilty at one time or another of establishing an unrealistic production timeline and underestimating the amount of time it takes to create an animation. For some, this is more of a norm than an exception. There are so many reasons why production can drag on beyond our expectations, and no matter how much we think we have learned from the previous project, we often find ourselves in the same position over and over again – continuous late nights trying to meet a deadline.

12. Write a proposal / PSA

Writing a good PSA (professional services agreement) is a crucial step in most visualization projects. You might feel the urge to do away with a contract for certain clients, but caution should be taken in these situations. Obviously, if you've known your client for a long time and trust in their way of doing business, doing without a contract is a reasonable option for most small projects. However, even for these clients, large projects with large price tags should usually include a contract.

When working with new clients, contracts should be used for even small projects, because sometimes only when the details of the scope of services are laid out in writing will the client truly understand what you are going to produce for them. Good contracts prevent you from incurring the cost of additional services not explicitly set forth in writing and also explain in detail what is expected from each party and the limitations of your services. You do not need to have a lawyer write or review your contracts to have them upheld in court, but they should be well-written to avoid any chance of misinterpretation.

A sample contract is available in the support files and is discussed in greater detail in Appendix H. This contract covers all the bases and should help give you an idea of some of the ways a contract can protect you.

13. Receive signed contract and deposit

No matter how good you feel with a particular project or the companies involved, it is always a good idea to wait on a signed contract and deposit before beginning work. Additionally, we recommend always building the project's timeline, as specified in the contract, based on events rather than specific dates. For example, Figure 18-2 shows a project timeline from a PSA in which the first draft

renderings were guaranteed to be provided not by a specific date, but rather by a specific number of days from the time a signed contract, deposit, and all project information are provided. Further events are specified in days from the previous step in the timeline. This prevents you from failing to meet your obligations in the event of a delay that is out of your hands, and have to explain why you're not at fault.

Figure 18-2. A typical project schedule from a PSA.

14. Create project folders

Create a simple and efficient project folder structure. Below is an example of one.

- Docs
- Dwgs
- Images
- Maps
- Max
- Renders
- Videos

15. Ensure you have latest drawings

Never assume that a project's drawings haven't changed without your knowledge. Continuously ask if revisions or changes have been made that would affect your work; especially if there have been long delays in between different stages of the process. It is not unusual for clients to provide architectural drawings right from the start, take excessive lengths of time to sign a contract and provide the initial deposit, and not tell you that the drawings have changed once you are ready to begin work.

16. Break up project

Large 3D projects can be difficult to manage and complete on schedule. The further you get into a project, the more harrowing the adventure gets, and with deadlines looming, you can easily begin to wonder how it's all going to be finished in time. Breaking your projects into smaller jobs can help you manage them and keep production on schedule. Regardless of the project size, and whether you work on it by yourself or with the help of others, a project should be broken up into several smaller and more manageable jobs. Doing so helps you keep track of what's finished and what remains to be finished. Breaking up a project can also help you better estimate the time and staff that will be needed to complete it and aid in the development of a contract.

17. Clean and prepare CAD linework

The importance of adequate attention to this step cannot be overemphasized. Many peers we speak to are surprised to learn how much time our company spends on this step of the production process, which for the typical project is approximately 25% of the total time we spend on a project. As mentioned before, we consider 2D linework to be the foundation of efficient 3D workflow and by spending the appropriate amount of time preparing the 2D linework, we minimize our 3D work.

 More information about the cleaning and preparing of files can be found in Chapter 2.

18. Import linework

How you import your linework is a matter a personal preference. Rather than linking 2D drawings to 3D scenes, our preferred method is importing linework a few elements at a time. For example, if we are building a 3D site, we will import the linework representing the curbs, model the curbs, import the linework representing the mulch beds, model the mulch beds, etc. This allows us to build scene elements with minimal screen clutter and allows us to identify problems on one element before working simultaneously on other elements. For very small scenes, such as the one developed in Chapter 7, importing all the linework at one time is certainly reasonable. When done properly, importing linework only takes a few seconds.

19. Model building elements

Everyone has his or her own style of work and own way of modeling the various objects that make up a 3D scene. However, one of the most asked modeling questions is, 'What is the best way to model walls?' Like most areas of scene creation, it's a matter of personal preference and what method works best for you. Regardless, most veteran users seem to rely on one of two methods for modeling this critical scene element. Some choose to use the 'box modeling' method made possible with the Edit Poly command. Our preferred method is the loft, which allows us to create trim features, reveals, soffits, and fascia at the same time the walls themselves are generated. It also allows us to embed material IDs into the loft and since the loft object is linked to a shape, we can update the individual wall lofts at any time during the creation process by updating their individual shapes.

 Some users rely on parametric modeling features in programs like Revit to create building elements outside of 3ds Max. This approach has come a long way in recent years; however, it is still hindered by two important factors. First, the modeling capability of such programs is often not powerful enough to enable the creation of complex building elements, such as intricate trim features or

windows details. Second, even when the programs allow for such creation, the time needed to create the individual wall, window, door, and trim styles, etc. does not usually justify their use.

For more information on techniques for creating building elements, refer to Chapters 3-6.

20. Model site elements

Creating realistic site elements usually presents far greater challenges to the typical 3ds Max user than creating building elements. Unlike most buildings, 3D sites can quickly grow out of control and beyond the capability of 3ds Max or your computer to handle when not built efficiently. For more information on techniques for creating site elements, refer to Chapters 7-10.

21. Create an assembly line work flow

When creating multiple types of the same building or site elements, you should utilize an assembly line approach. This approach works well for the creation of doors and windows as well as furniture, vegetation, and countless other object types. It worked for Henry Ford in the production of automobiles, and it can work just as well in the creation of 3D objects.

For instance, by using an assembly line to create doors and windows, you can reduce the creation time per door and window type to a fraction of what it would take to create each using other methods. If you decide to try this method, the first thing you need to do is line up a single copy of each door and window type in a row, as shown in Figure 18-3. If your linework originates in AutoCAD or another 2D CAD program, simply make the copies somewhere off to the side and import the linework. If you don't have 2D CAD linework, and instead have to create the windows and doors from scratch in 3ds Max, create the linework off to the side in your 3ds Max file. Figure 18-3 shows a project that contained 14 different styles, which would have been extremely time-consuming to create one by one.

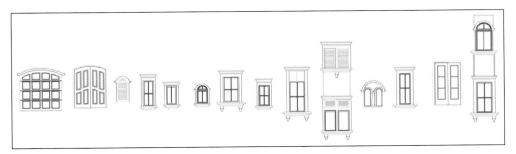

Figure 18-3. An assembly line of windows.

22. Save incrementally and save often

Few things in the animation process can be more frustrating than losing your work when your computer or 3ds Max crashes, or when your files become corrupt in some way. Restarting the computer and interrupting your workflow is bad enough, but having to backtrack and redo work can be downright painful. Equally bad is going back to a certain point in your work to retrieve a scene (or objects) in a previous state, only to find that you didn't save a copy of the scene at the right time. The solution here is to save incrementally and save often.

Before performing a critical procedure that cannot be undone, you should always save your work. Figure 18-4 shows an example of the incremental saves made during a past project. Notice the numerous versions of different scene elements. Notice also the names of the files: **clubhouse**, **entry_signage**, **room**, **site**, and **vegetation**. As previously suggested in the step regarding breaking up a project into smaller sub-projects, each of these elements was created separately and merged together at the end.

Figure 18-4. An example of the many files of a typical project.

Good file management is critical to efficient production and nonexistent in many 3D firms. Saving incrementally and saving often are two good practices that can go long way toward improving your production output.

23. Merge background rig

Nearly every 3D scene requires the use of a background image. Whether creating an interior still rendering or an exterior animation, we recommend using a model based background. When doing so, you should avoid recreating the same objects over and over again. Instead, simply merge the same background rig (such as the one shown below) into your scene and make adjustments to the image and the mapping as necessary.

Figure 18-5. Use of a cylinder object for a background.

For more insight on the creation and use of backgrounds, refer to Chapter 9.

24. Use material libraries

Working with materials in 3ds Max can be a long and arduous process, made more difficult if you don't use material libraries. Material libraries allow you to store and retrieve your favorite and most frequently used materials in easy-to-access files. Creating the same materials over and over again for each project would be a waste of time. Hopefully, your image library, which you use for materials, contains tens of thousands of images. However, if this is the case, the simple act of locating an image to apply to a map channel can end up being not so quick and simple. For scenes with dozens of materials, this can translate to large amounts of wasted time.

The solution is to create and maintain good libraries. If you create a material you think you will want to use again in the future, take a moment to give the material a relevant name and add it to the proper library. If you've never spent much time creating libraries, try opening some of your best scenes, reviewing the materials you applied, and putting the best ones in your library. Like other areas in 3ds Max, a little bit of time spent in program maintenance can save you a tremendous amount of production time and help you meet your deadlines.

25. Merge scene elements

Like the application of materials to your scene, placing common and everyday scene elements can be a laborious and time-consuming process if not done wisely. Most scenes contain ordinary elements such as lampposts, street signs, houseplants, TVs, and so on. Creating these objects for each project is not a viable option for you or your client, and therefore using objects from libraries or earlier projects is usually the only reasonable alternative. Since the focus of a visualization is usually other elements such as buildings, interior or site design, clients will often not care one way or another how you populate your scenes with ordinary objects, as long as they do not distract the viewer from the focus of the scene. For these reasons, I highly recommend using objects from past projects to populate your scene with ordinary scene elements.

26. Load lighting preset

Although the need for experimentation is all but guaranteed in every project, most veteran users still rely on a typical lighting configuration or preset as a starting point. Most advanced render engines provide you the capability to save such a preset, like the one shown in Figure 18-6 used with V-Ray.

Figure 18-6. Examples of lighting presets.

27. Create animation paths

Although the complexities of camera movements in visualizations do not usually compare to those found in the entertainment industry, the need for precise control of cameras is just as important to our work. The creation of animation paths can occur at any time during the animation process, although the sooner the better. Even if you can only create a very rough draft of camera movements, the sooner you determine what is going to be seen through your cameras, the better you can determine which areas of your scene need more detail than others. However, it's usually not possible to finalize camera movements until every piece of geometry is in place.

As a rule, I always inform the client that he or she has the option of specifying the exact camera paths to be used in the final animation. The client often declines this opportunity but it is a useful way of safeguarding the choices you make. The wording from our contracts regarding this matter reads as follows:

The CLIENT shall be allowed to provide a detailed script for camera movements throughout the project. If the CLIENT fails to provide a detailed script of camera movements within 30 days of contract signing, then 3DAS, LLC will use its best judgment to provide a pleasing script for camera movement and will not be responsible for changes which may be reasonably considered unnecessary.

For an example of an interior animation sequence, download a sample scene contains numerous cameras animated along the same active time segment. This file can be found in the scene files for this article. All materials and lights have been removed.

Figure 18-7. Various camera paths for an interior project.

28. Create copy of maps in project folder

If you render to a network of computers, you can improve the overall speed of the rendering process by making a copy of all maps used in a project and placing them on each computer involved in the rendering. This reduces the time required to transfer maps from a central server location to each individual computer. It can also facilitate archiving scenes and ensuring the integrity of a scene is not disturbed by the loss of network connection or the renaming or removing of maps in your maps library down the road.

The easiest way to create a copy of the maps in a project is to archive a scene, unzip the archive, search for all files within the archive, and copy all the bitmaps to a new folder.

29. Create test renders

Test renders should be created throughout the entire course of a project, but there are a few critical points at which you should and shouldn't send test renders to your clients. Naturally, when a client hires you, they want to see the final product as soon as possible. The longer a project takes to complete, the more anxious clients can become in wanting to see and inspect your progress. Many firms make the mistake of sending test renders to their clients too early in the process, when doing so does absolutely nothing to appease the clients and everything to question the progress made. Many clients do not understand enough about the production process to know how some portions of the process take a very long time to complete and others a relatively short time. The very first test renders you send to a client makes a tremendous first impression, and sending the client renderings too soon can create difficult situations, regardless of what you tell him in advance of the renders.

I recommend sending the client test renders at four distinct stages along the production process: after modeling is completed, after materials and lighting have been perfected, after camera paths have been created, and just prior to final renders being generated.

The first set of renderings should be made in grayscale without materials and with one very specific purpose made perfectly clear to the client; to verify the structural correctness of a scene, and perhaps a secondary purpose of verifying camera angles in the case of still renderings being the final product. If you send the first test renderings with materials or colors applied, two problems can arise. First, the client might focus more on the materials and colors and overlook the more important issue of verifying the physical correctness of the structures in the scene. Second, the client will likely begin critiquing materials and colors before you have even begun a serious application of them, which can lead to the client thinking you are going to be charging for extra work when the changes are made, or that you didn't understand what was asked for.

The second set of test renderings should be sent when all materials and colors have been properly applied to the best of your ability per the information provided. Any sooner and you are likely to be wasting time with little gain.

There are two methods we have found that work great for producing these first two test renders. The first is a QuickTime panorama at critical perspectives that provide the best views of a scene. Figure 18-8 provides such an example, with the left image showing the first panorama sent to the client, after the modeling process was complete, and the right image showing what was sent after the scene was completed to the best of our ability. In both cases, we were looking for client approval of the work completed thus far. These panorama files can be found in the support files and are entitled **Dining_test01.mov** and Dining_test02.mov.

Figure 18-8. QuickTime panoramas created as test renders.

The third test rendering that should be sent, and one that would only apply to animations, is a shaded preview animation whose sole purpose is to allow the client to approve the camera paths you create. For this type of render, the client has already seen the test renders with good materials and lighting applied, yet we still make it perfectly clear that the only thing the client needs to comment on is the path of the cameras. This type of render can be best provided using the **Make Preview** feature.

The fourth and final set of test renderings we provide for an animation are full-sized renderings in finished form at approximately every 50th frame of the animation. Doing so enables the client to see exactly what the animation will look like at about every 1 to 2 seconds along the path. Since the renderings are in finished form, with materials and lighting finalized, it also allows the client to see the quality of the final product and to identify last minute changes or revisions.

Changes and revisions are inevitable for most projects and each tends to require new test renders over and over again. Regardless, the four types of test renderings mentioned should serve as a guide in your determination of exactly when it is appropriate to send the client your work.

30. Revise animation

One of the most difficult aspects of running a 3D visualization business is knowing when and how to charge the client for additional work. It may seem a simple matter, but without careful and candid discussions with the client as well as the proper protection built into your contracts, you can easily find yourself persuaded to perform work free of charge. Creating a visualization is as much an art as it is a science and your artistic interpretation of the client's project can easily be viewed by the client as a mistake rather than a matter of artistic interpretation. Furthermore, no matter how much you explain the process and the difficulties in making certain changes, some clients will simply never understand what it takes to make some of the changes they request. To prevent any awkward situations regarding this matter, ensure the client knows from the beginning what can and cannot be changed for free and what types of changes incur additional expenses.

The following two paragraphs are examples of wording that can be used in a contract to help prevent misunderstandings regarding changes to an animation.

3DAS, LLC will provide the CLIENT with a draft version of the 90-100 second animation sequence to review. 3DAS, LLC will revise, within reason, any elements of the sequence which were overlooked or elements which do not conform to the architectural data provided. Colors and textures may be altered after the draft animation submission, at the request of the CLIENT, at no additional charge. The CLIENT may elect to make changes to the design not specified in CAD files at the hourly rate specified in Exhibit B.

Client understands that the 3D visualization process is not perfect, that "gray areas" will exist, and some information may be missing if not clearly and precisely specified in the CAD drawings. For the process to be cost effective for both parties, Client will allow 3DAS, LLC to use its experience and judgment to create the best possible animations and images given time, financial and informational constraints. 3DAS, LLC will also allow Client opportunity to make reasonable changes as long as they significantly improve the presentation.

31. Create production render

For information regarding the creation of final rendered outputs, such as resolution sizes, typical file types used, and tools that can facilitate the rendering process, refer to the file entitled **Rendering.pdf**. This is Chapter 16 from **3ds Max 2008 Architectural Visualization - Beginner to Intermediate**.

32. Post production

If you have never tried post production compositing tools such as Fusion, Combustion, or After Effects, you might not know what you are missing. These types of tools allow you to add things to your animations that would otherwise not be possible without great effort and time. For example, if you wanted to create an animation showing a light changing in intensity over time, you could always render each frame of the sequence showing the light's changing intensity. A far easier way to accomplish the same task would be to render a single lighting pass in 3ds Max that incorporates the light's effect on the rest of the scene and animates the light's intensity in real-time using the post-production software. The difference in time and effort between the two different methods is almost unbelievable.

Unlike the name implies, the process of post-production actually begins well before the rendering process starts, because using the appropriate software (such as Fusion shown in Figure 18-9) requires the user to have a scene set up in a certain way, to have certain types of material applied and to use the Render Elements feature. For more information about how

compositing software is used, refer to Chapter 16. Unfortunately, a proper discussion on the subject of post-production and compositing warrants the dedication of an entire book, but the material presented in Chapter 16 should serve as a guide of what is possible in this final stage of the animation process.

Figure 18-9. Example of the Fusion compositing software in action.

Managing System Resources

A FRUSTRATING REALITY OF WORKING in any 3D program is waiting on the computer to process information. In the ideal 3D world, you could build all your scenes without regard to file size, available RAM, CPU speed, rendering times, or any number of things that complicate the design process. However, since most of us have to be aware of our computers' limitations, we have to manage the way we build objects and assemble our scenes. To work efficiently, we should do whatever we reasonably can to minimize our wait.

At 3DAS, we're often asked what kind of hardware we use to create and render our scenes. Students are often surprised to hear that for many years now we've relied primarily on average speed computers. At the time this book was published, the typical computer in our office is a Core 2 Duo with 2 to 4 GB of RAM. Many new users entering the field of architectural visualization have misconceptions that producing good work requires top-end hardware, and while that may have been true in the early 1990s, today it's simply not the case.

There are several different situations in which the 3ds Max user is forced to wait on the computer. Three of these, in particular, are situations in which good procedures and practices can spare you from long and unnecessary waiting: transferring files, refreshing viewports, and rendering. Most other times, 3ds Max is waiting on the user for input, but for each of these you are forced to spend at least some time waiting on 3ds Max and your computer, depending on how you manage your scenes.

So what are the attributes of a scene that affect each of these three situations, and what can you do to minimize your wait during each of these processes? In this chapter, we're going to take a close look at some tools and procedures that can improve system resource management so your scenes don't become unnecessarily large or consume an unnecessarily large amount of RAM.

After completing this chapter, some fundamental questions you should know the answers to are:

- Should I collapse an object after completing its construction?
- What's the difference in memory consumption between a parametric object, versus an editable mesh object, versus an editable poly object?

- What happens to the operands of a compound object when the final object is created?
- What has a greater impact on file size; the total vertex count or polygon count?
- When should I create copies, instances, XRefs, and proxies?
- Do modifiers increase file size and/or memory consumption? Why or why not?

These are just a few of the many questions you will need to know the answer to if you want to maximize scene efficiency and conserve system resources as much as possible. To illustrate the answers to these and other questions, let's jump right into a simple exercise that illustrates some fundamental concepts of system resource management.

As a supplement to this chapter, you can refer to the file entitled **Scene_Assembly.pdf**. This is Chapter 17 from **3ds Max 2008 Architectural Visualization – Beginner to Intermediate**. In this chapter, you'll find several ways to minimize the time you wait on your computer during each of the 3 situations previously mentioned.

Managing File Size

An immensely important part of good scene management is what you do with individual objects beyond the visual characteristics they display during the rendering process. Looking at a rendering, it's impossible to know how a scene is constructed and what the final configuration of each object is. But a scene where objects are configured properly will always render faster and consume less system resources than objects that are not configured properly; even when the final rendered image is unaffected.

This first exercise illustrates some important concepts about how information is stored in 3ds Max and how you can control a scene's file size. As an indirect result of reducing file size, RAM consumption is reduced, render times tend to be improved and system crashes become less frequent.

Parametric objects vs. Editable Mesh objects vs. Editable Poly objects

The intent of this first exercise is to demonstrate how information is stored for parametric objects, editable mesh objects, and editable poly objects. It should be noted that the same files saved with different versions of 3ds Max will yield slightly different sizes.

1. Reset 3ds Max.
2. With no objects in your scene, save the empty file with the name **empty.max**.
3. In **Windows Explorer**, look at the size of the file. It should be approximately 270KB, although earlier versions of 3ds Max might result in sizes close to 200KB. Even completely empty scenes contain a considerable amount of data, most of which are settings, such as units, viewport levels, time configuration, etc.
4. Create a teapot of any size in **Perspective** view with **4** segments.
5. Press the keyboard shortcut **7** to turn on the **Show Statistics** feature. Notice that there are just over 1000 polygons in the scene.
6. Save the file and name it **teapot-parametric4.max**.
7. In **Windows Explorer**, look at the size of the file again. The size should be approximately 20KB larger.
8. Change the number of segments to the 3ds Maximum value of **64** and save the file with the name **teapot-parametric64.max**. Notice that there are now over 262K polygons.

9. Check the size of the file again and this time it should be unchanged. It is unchanged because the only new information that has to be saved with the scene is the new segment count. No additional information has to be stored because the teapot is parametric based, which means that its structure (the lid, handle, spout, etc.), is controlled and generated through parameters. So 3ds Max doesn't have to store the information for each polygon because the location, size, and orientation of the polygons are all derived from algorithms.

10. From the **Edit** menu, select the **Hold** feature. We will return to the scene in its present form in just a moment.

11. Collapse the object to an **editable poly**. Notice that the Show Statistics feature now shows half the number of polygons, or approximately 131K polygons. As we'll see in a moment, this is misleading data.

12. Save the file with the name **teapot-poly.max**.

13. Check the file size again. The file balloons to a size of approximately 19MB. The reason for the increase is that now 3ds Max can no longer define the teapot's structure by algorithms or formulas. Instead, it must store the X, Y, and Z position value of every individual vertex, such as the one shown in the next illustration. For an object with this many vertices, it shouldn't be hard to see why the file size is now 19MB.

14. Collapse the object to an **editable mesh**. When you do, notice that the total polygon count goes back to 262K faces.

15. Save the file with the name **teapot-mesh.max**.

16. Check the file size again. Strangely enough, even though the Show Statistics feature shows twice the number of polygons, the file size decreases to approximately 11.5MB. How could this be? The reason is that both files have the exact same number of vertices, yet an edit poly object contains far more information than the edit mesh object. The vast majority of file space for both files is used to store the X, Y, and Z position values for every vertex. However, because the Edit Poly object contains far more functionality, it requires far more space to store the default values of that functionality. Incidentally, if you were to save the editable mesh version of this file as a 3ds Max 9 or 2008 file, it would still be 11.5MB. However, if you were to save the editable poly version of this file as a 3ds Max 9 file it would only be 15MB and a 2008 version would be somewhere in between the Max 9 and Max 2009 versions. This could be an indication of how the editable poly is changing and growing in complexity with each new release while the editable mesh remains largely unchanged.

17. From the **Edit** menu, select the **Fetch** feature. This returns the teapot to its pre-collapsed configuration.

18. Add the **Edit Mesh** modifier to the teapot. Notice that the polygon count stays at 262K polygons.

19. Save the file with the name **teapot-mesh_modifier.max**.

20. Check the file size again. The file is the same size as it was before the modifier was added. Adding the Edit Mesh modifier to an object is not the same as collapsing an object to an editable mesh. If you simply add the Edit Mesh modifier, you haven't really added any information because until you start making changes to sub-objects within the added modifier, the vertices won't require new position information. The display of the object will still be completely based on the root object, which in this case is still a parametric object.

21. Remove the **Edit Mesh** modifier and add the **Edit Poly** modifier. Notice that the polygon count is again cut in half to 131K polygons. This is once again, not a legitimate indication of the amount of information stored for the object.

22. Save the file with the name **teapot-poly_modifier.max**.

23. Check the file size again. Notice that it is approximately 100KB larger than the same scene with the Edit Mesh modifier added, as shown in the next illustration. The size increased for the same reasons as mentioned before.

empty	268 KB
teapot-mesh	11,596 KB
teapot-mesh_modifier	288 KB
teapot-parametric4	288 KB
teapot-parametric64	288 KB
teapot-poly	19,044 KB
teapot-poly_modifier	392 KB

Now to see another quality of how information for an object is stored, let's look at another scene.

24. Open the file **oak_tree.max**. This scene contains a single editable mesh object (in the form of a tree) comprised of 262K faces, just like the teapot in the previous exercise.

25. Look at the scene's file size. Notice that the tree creates a file size of 21.3MB. Even though the editable mesh tree has almost exactly the same number of polygons as the editable mesh version of the teapot, the file size here is almost doubled from that of the editable mesh teapot. The reason the two file sizes are so different even though they contain the same number of polygons is that the teapot contains half as many vertices. And the reason it only needs half as many vertices as the tree with the same number of polygons is because almost all of the polygons in the teapot share 4 vertices with adjacent polygons. Notice in the following illustration that the selected vertex is only shared by 2 polygons, as are many vertices in the tree. This doesn't mean that the rendering times will be any different because rendering times are determined more by polygon count. So the vertex count drives a scene's file size and polygon count drives render times. As an additional note, render times are also derived by less noticeable things such as the amount of space the rendered object takes up in the render window. In other words, if you zoom out away from the tree, the render time for the tree will decrease.

Now let's look at one final aspect of the editable mesh and poly objects.

26. Open the file **chandelier.max**. This is a scene containing one object (in the form of a chandelier) whose polygon count is approximately 198K.

27. Look at the scene's file size. Notice that it is 26MB.

28. Add the **Edit Poly** modifier and enter **Element** sub-object mode.

29. Select and delete every part of the chandelier except the wire support, as shown in the right image of the following illustration.

30. Save the file with the name **chandelier-empty.max**.

31. Check the scene's file size. Notice that even though you deleted almost all of the vertices in the scene, the scene actually grew in size, as shown in the following illustration. The reason for this is because you just added the Edit Poly modifier, rather than collapsing to an editable poly. The original editable poly is still stored in its unmodified condition, and adding an Edit Poly modifier only adds to the amount of information 3ds Max has to store with the scene. However, the file size only increased a very small amount because the only thing 3ds Max has do to store the object in this new configuration is assign a deleted notation to each of the deleted vertices. It doesn't have to actually store new vertex locations. Incidentally, the file sizes shown in the next illustration represent those of a 3ds Max 9 version, since all the files for this book are provided in this version. A 3ds Max 2009 version of these files would be about 7MB larger.

chandelier	26,384 KB
chandelier-empty	26,468 KB

32. Delete the current **Edit Poly** modifier and add a new **Edit Poly** modifier.

33. Enter **Vertex** sub-object mode and open the **Move Transform Type-in** dialog box.

34. In the **Offset** section, type **12** for each of the **X**, **Y**, and **Z** fields. This simply moves every vertex 12 units in each direction.

35. Save the file and check the resulting file size. Notice that while adding the Edit Poly modifier doesn't increase the file size much, moving vertices within that modifier does. Approximately 6MB of new information is generated. This time, a completely new set of X, Y, and Z position values must be stored for the object. Because all the vertices were moved in the same fashion, there is some borrowing of information, which is why the file size didn't double.

36. Collapse the object to an editable poly and save the file again. Notice that the file size returns to what it was before, because the information for the vertices' original location has been purged from the file.

This concludes the exercise.

Managing RAM Consumption

While managing file size is clearly an important aspect of good efficient workflow, perhaps an even more important aspect is managing RAM consumption. Unlike the hard drive on a computer, which is capable of handling inefficient scenes of enormous sizes, a computer's RAM is far less forgiving of poor workflow. However, since the amount of RAM consumption is so closely tied to the way individual objects are treated and the file size they generate, it is all but impossible to manage RAM consumption without simultaneously managing file size as well. That being said, the remainder of this chapter discusses some additional concepts that deal directly with RAM consumption while simultaneously affecting file size.

Critical to efficient workflow is an understanding of what is going on behind the scenes within your computer during the times when you are forced to wait on it. No other interface provides a better indication of what's going on than the **Windows Task Manager**, so for the remainder of this chapter we will keep this feature open. Within the Windows Task Manager are several different tabs, one of which displays 3 very important values you should always keep an eye on when working in large, resource hungry scenes: the processor usage, the page file, and the available RAM.

Parametric objects vs. Editable Mesh objects vs. Editable Poly objects

The intent of this first exercise is to illustrate how RAM is used in 3ds Max and to demonstrate some techniques on how to minimize its consumption during critical points in your workflow.

1. Open the file **oak_tree.max**. As we saw before, this scene contains one object with 262K polygons.

2. Change the view to **Top** view.

3. Change the display of the tree to a box. Since the object contains so many polygons, displaying it as a box will make viewport navigation much easier.

4. Make 15 additional instances of the tree and place them in 4x4 grid, as shown in the next illustration. Making copies of an object with this many polygons would not be a good idea unless they absolutely had to be unique.

If you select one individual tree, you'll notice that the Edit Mesh modifier is displayed in **bold**, indicating it is an instance of another object. In a moment, we will collapse each tree to an editable mesh, thereby breaking the connection while greatly increasing the file size and RAM consumption. Before we do this, we need to open Windows Task Manager to keep an eye on RAM consumption.

5. Open **Windows Task Manager** and take note of the available RAM. The computer used in the writing of this chapter contains 2GB of RAM, as shown in the next illustration.

6. Select all 16 instances of the tree and collapse them to an editable mesh. When you do, the link between them is broken and each is stored individually in RAM. The amount of RAM consumed to perform this operation is approximately 450MB.

Before Collapsing		After Collapsing	
Physical Memory (K)		Physical Memory (K)	
Total	2095480	Total	2095480
Available	1237572	Available	782792
System Cache	799196	System Cache	774488

7. Save this file with the name **16-trees-collapsed.max**. Notice that the save take a few moments and consumes an additional 200MB of RAM. This is only temporary and the RAM returns to what it was before the save, but it's important to realize that with large files, the simple act of saving a scene can cause your computer to run out of memory and crash.

8. Look at the scene's current file size. Notice that it has ballooned to approximately 340MB, which not surprisingly is 16 times the file size of one collapsed tree.

Before we render this out, let's look at one more important thing about RAM consumption.

9. Deselect all the trees and reselect just one of them.

10. While taking note of the current amount of RAM available, attach one single tree to the tree you have selected. After the attachment, you should have approximately 120MB less RAM available.

11. Attach an additional tree to the current object. Approximately 140MB more should be consumed. Each time an additional tree is added, a greater amount of RAM is consumed than with the previous attachment.

12. Continue attaching more trees until you have less than 300MB. Do not continuing attaching beyond this point or you will run the risk of crashing 3ds Max. The next illustration indicates the amount of RAM consumed during my execution of these steps.

| Before 1st attachment | After 1st attachment | After 2nd attachment | After 3rd attachment | After 4th attachment |

The attach commands we just executed were extremely memory-hungry because essentially, 3ds Max has to store the original version of all these trees as individual objects and an additional version with some of the objects attached together. Needless to say, more complex operations usually require more memory and can often crash the program if you don't pay attention to the available RAM.

If we were to start rendering these 16 collapsed trees right now, we would be doing ourselves a disservice because we would be giving 3ds Max less memory to work with, and it would almost certainly crash during the render process. We should instead free up this memory that was consumed by the numerous attach commands and then render the scene. If you right-click the **Undo** icon, you would see the last 20 commands you executed. Of course, you can go back to an earlier step before the trees were attached together, but this won't free up any memory because the attach commands you executed would only be moved to the **Redo** list. To free up this memory, you could reset 3ds Max and load the scene again, but since the scene file size is so large, this will take longer than necessary. So instead, let's do something a little easier. All we need to do is create an object and change one of its parameters several times until the memory heavy attach commands are purged from the undo list.

13. Create a sphere of any size anywhere in **Top** view.

14. While monitoring the available RAM displayed in Windows Task Manager, change the **Radius** value **20** times or more until you see the available RAM return to the level it was before the attach commands were used. This helps demonstrate why you should always keep a close watch on your system resources and why you should always purge your RAM prior to render or even before doing something as simple as saving a large file.

Having covered a few fundamental concepts about how 3ds Max stores information, it's time to look at the different ways objects can be handled and the reasons why different objects should be treated differently. Many users simply create the objects they need, apply the necessary modifiers, and give little thought to what those objects do to their workflow and efficiency. For small scenes, you might be able to get away with working this way, but as scenes grow in size, so does the need to consider the following questions for each individual object.

- Should the object be collapsed or left with modifiers intact?
- Should the object exist as an instance, XRef, or neither?
- Should the object be attached to other objects or be left as is?

Let's continue with another exercise that looks at each of these questions closely and the factors that should guide your decision on how to answer them.

1. Reset 3ds Max.

2. Open **Windows Task Manager**.

3. Turn on **Show Statistics**.

4. In **Perspective** view, create a teapot of any size and with **64 segments**.

5. While monitoring the available RAM, apply the **MeshSmooth** modifier. This modifier consumes about 500MB of RAM.

6. Save the file with the name **teapot-highpoly.max**.

7. Look at the size of the file you just saved. It should only be a few KBs more than what an empty scene would be.

8. Reset 3ds Max. Notice that the available RAM returns to what it was before you applied the MeshSmooth modifier.

9. Reopen the scene. Not only does it consume 500MB again during the loading process, it also takes a few moments to load. The file is almost as small as an empty scene, yet it takes far longer to open because 3ds Max has to create the reapply the modifier during the loading process. No matter what you do, you will have about 500MB less RAM available as long as this modifier is left turned on in the modifier stack. The best you can do to reduce the amount of RAM consumed would be to turn off the modifier, which will make approximately 200MB of RAM available again.

10. Convert the object to an **editable poly**. During the conversion, several hundred MBs of additional RAM are consumed.

11. Save the file with the name **teapot-poly.max**.

12. Reset 3ds Max. The available RAM returns to normal.

13. Open the file you just saved. After the RAM stabilizes, which will take a few moments, you should see that the available RAM does not decrease 500MB as it did when you opened the file with the MeshSmooth modifier applied. Instead, it only decreases about 200MB.

14. Convert the object to an **editable mesh**. Once again, several hundred MBs of RAM are consumed.

15. Save the file with the name **teapot-mesh.max**.

16. Reset 3ds Max. The available RAM returns to normal.

17. Open the file you just saved. After the RAM stabilizes, which will again take a few moments, you should see that the editable mesh version of the teapot file consumes about 100MB less memory than the editable poly version. This is despite the fact that the Show Statistics feature says that the editable poly contains half as many polygons as the editable mesh.

18. Look at the size of the two files you just saved. Notice that the editable poly version is approximately 25% larger than the editable mesh version. Despite its greater power and functionality, the editable poly object is more of a strain on your computer's resources than the editable mesh. Because of this, if you determine that you need to collapse or convert your object to one of the two types, it is probably best to choose the editable mesh version. You can always convert an object to an editable poly later in order to use the features unique to this type of object, but when you are finished working on an object, either permanently or temporarily, it is best to store it as an editable mesh.

This concludes the exercise.

Object Management

All of the workflow concepts discussed in this chapter, and many of those discussed throughout this book, can be summarized by answering three simple questions. For any given object you work with or create, you should know the answers to these questions, which can vary from one scene to another.

- Should the object be collapsed or left as is?
- Should the object exist as an instance, XRef, or neither?
- Should the object be attached to other objects or left as is?

The remainder of this chapter looks to answer each of these questions for some of the different situations that apply.

Collapsing Objects

Should the object be collapsed or left as is?

If you collapse an object to an editable mesh or editable poly, all modifiers listed in the modifier stack are lost. The obvious downside to this is that you lose the ability to change parameters within any of the modifiers in the modifier stack. If you know that making further modifications to the object is unlikely or if you decide that you can simply retrieve an original uncollapsed version of the object saved in another file, then collapsing the object isn't a problem. Another downside is that you may significantly increase the scene file size the same way the parametric teapot increased the file size when it was collapsed. For some modifiers this won't be an issue, but for others, such as **MeshSmooth** or **TurboSmooth**, collapsing the object with these modifiers means the object will have a far greater number of vertices to account for individually, rather than through algorithms.

One not so obvious advantage to collapsing objects is the reduced time it takes to load the scene file. When 3ds Max loads a file, every object has to be rebuilt with the modifiers applied to them, meaning that if you apply a modifier to an object and that modifier takes 10 seconds to be computed, that object alone will increase the file load time by 10 seconds because it has to be reapplied during the loading process. To see this clearly, reset 3ds Max, create a simple teapot with the default 4 segments, add the **Tessellate** modifier and change the Iterations to 4. Notice that when you change the iterations to 4, it takes about 10 seconds to tessellate the teapot (depending on the speed of your computer of course). Now save the file and reload it. When you do, you should see that it takes about that same amount of time longer to load the file than it would to load an empty scene. With 4 iterations in the Tessellate modifier, the teapot should contain just over 250,000 faces. If you collapse the teapot now and save the file, you'll have a much larger file size but the file will open in just a second or two. So clearly, some thought should go into how to handle certain objects in your scene, especially the most complex, high-poly objects.

Another type of object that can significantly increase the time it takes to load a file is the **Compound Object**. This type of object includes the **Boolean**, **Scatter**, **ShapeMerge**, etc. Whenever you create a compound object, the original objects are still stored in the file's memory and can be retrieved at any time. What you perhaps didn't know is that every time you load a file with a compound object, that object gets recreated just as an object with a modifier does. Many compound objects can take a good deal of time to calculate, so if your scene contains a large number of them, then be warned your scene may take a long time to load. In most cases, it's better to collapse the compound object and incur a slightly larger file size, than it is to leave the compound object as is and incur a longer load time. So if a scene takes an excessively long time to load, check for these types of situations. In many cases, your file size will actually decrease by collapsing a compound

object, because instead of having to store the information for both of the objects involved, 3ds Max only has to store the result of the operation.

Instances vs XRefs

Should the object exist as an instance, XRef, or neither?

The more complex an object, the more likely it becomes a candidate for an instance or an XRef. If you have 2 high-poly objects, such as 2 of the same kind of tree, it may be desirable to keep them unique so that one can be modified without affecting the other. But remember that file sizes can quickly get out of control when duplicating high-poly objects as copies rather than instances. With XRefs, you don't have to worry so much about the main scene file-size getting out of control, but you will likely run into equally challenging problems, such as longer load times and more difficulty in sharing files over a network.

If you're a mental ray or V-Ray user, you can (and almost certainly should) use the respective proxy features on high-poly objects. With these features, you can literally render a forest of trees like the one shown at the beginning of this chapter. You can render thousands of these trees, consisting of billions of polygons, without having to worry so much about excessive files sizes and load times, or running out of RAM.

In Chapter 17 of *3ds Max 2008 Architectural Visualization – Beginner to Intermediate*, several different scenarios are discussed for when you might choose to make instances rather than copies and vice versa, but one disadvantage to creating instances is that you cannot attach instanced objects with any other object. You can certainly group instanced objects together, which can help in object selection and display, but you cannot attach instanced objects.

Attaching Objects

Should the object be attached to other objects or left as is?

There are two important benefits of attaching objects together. First, by attaching one object to another, you will only have to manage one object instead of two. That can make things like applying materials and mapping much easier and can facilitate selecting and displaying objects. This is especially true when multiple users work on the same project. Few things are as aggravating in 3D as opening a dialog box only to see thousands of objects listed, most of which are labeled as unintelligently as Line01, Box03, Rectang32, etc.

A second advantage is that you reduce the total scene object count, which can help reduce rendering times as well as the total RAM consumed. For large scenes with many objects, you may notice that the very first message that appears when you render says **Preparing Objects**. You might not see this for small scenes if the message only lasts for a fraction of a second but when a scene contains a large number objects, depending on how the objects were created, the Preparing Objects phase of a rendering can take several minutes to process. This is simply an unnecessary aggravation that can be avoided by attaching similar objects with similar materials together. Grouping objects does not change the number of objects in a scene, so other than facilitating management of objects, grouping objects has no bearing on workflow.

32-bit vs. 64-bit

Arguably the best overall improvement in the last several releases of 3ds Max is support of 64-bit operating systems and the **Microsoft DirectX 10** platform. The memory-handling characteristics of the 64-bit version of 3ds Max simply cannot be overstated, and even though it is likely that all the concepts mentioned in this chapter will be applicable for many years to come, being able to take advantage of a 64-bit version of 3ds Max is simply fantastic.

The 64-bit version of 3ds Max is capable of handling scenes of, for all practical purposes, limitless size. This does not mean that you shouldn't exercise all of the resource conscience techniques described in this chapter or that you shouldn't manage your scenes as you would in a 32-bit version. It simply means that a 64-bit version of 3ds Max is capable of handling larger scenes with more objects and a greater polygon count. Your scenes won't render any faster in 64-bit than they will in 32-bit, except of course in cases where RAM is completely exhausted with 32-bit. They also won't load any faster. The ability to create, assemble, and most importantly, render immensely large scenes is what makes using 64-bit 3ds Max worthwhile.

Another great advancement in the software was its capability to support DirectX 10. Quite simply, DirectX is a Windows-based platform that enables software providers to achieve much greater performance in graphics and sound on a PC. DirectX 10 is only supported by **Windows Vista**, which alone makes Vista worth looking into. Unfortunately, the migration to Vista has been painful for many 3ds Max users, so some caution should be taken when the jump is made. Nonetheless, DirectX 10 on Vista is likely what we will all find ourselves using within a few years. Incidentally, 3ds Max 2008 was the first full release of 3ds Max to officially support Windows Vista as well as a 64-bit operating system and DirectX 10.

Summary

This chapter illustrated a few examples of why it's so important to know how to build and assemble a scene without excessive file sizes or polygon counts. Someday, we may no longer have to be concerned with such issues, but for the foreseeable future we should always try to use the tools available to allow for efficient workflow and prevent wasted time. I suspect that no matter how fast computers become, software developers will always fill your plates with more and more processor-hungry and memory-consuming programs and resources. If this is true, then the topics covered in this chapter will always apply.

Appendixes

Top 30 Production Tips

WHEN OUR FIRST TITLE WAS released in 2006, we included a list of our top 20 production tips. They represented the top 20 things we believe anyone in a production environment should be familiar with. This time around we've knocked off a few of those tips that have since been bested by other techniques we've developed and added to those an additional 10. Most of the techniques we presented in 2006 still hold true today as practical and productive, and we are confident that the tips presented here will be equally viable for many years to come.

Students who learn 3ds Max in a classroom environment often believe they have all the tools needed to be viable in a production environment. Unfortunately, many learn the program from training centers that don't dedicate their programs to visualization. This inevitably results in students being familiarized with features that have no place in visualization, and if you believe in the *Law of Diminishing Returns* as we do, you would probably agree that the added material only reduces one's chances of retaining the worthwhile material.

There aren't many computer programs that can rightfully claim to be more complex or more difficult to learn than 3ds Max. Learning the program itself is challenging enough, but learning how to use the program in a production environment can be beyond the reach of many users. Like many technical fields, the visualization industry presents countless challenges that make simple program knowledge insufficient. Our industry is changing and advancing as rapidly as any other and knowing the program well is not enough. Once you jump into a production environment, you soon learn tricks of the trade that you often cannot find in any textbook or classroom discussion. The more 3D visualizers you interact with, the more likely you are to pick up these tricks that would normally take many years to develop on your own. If you manage your own business, the difficulties are even greater, and you must learn creative ways to work within 3ds Max as a user, and ways to improve your production output from a business point of view.

Many of the tips presented here cannot be found in any training document, and they highlight subject matter that we suggest users at all skills levels be familiar with while working in architectural visualization. Although it's difficult to compare the viability of one tip to another, we made our best attempt to list them in order of importance to give added weight to those placed at the top of the list. And while some may seem too simple and obvious to even be placed on anyone's top

30 production tip list, they are too often ignored or overlooked by even experienced users. We should all attempt to learn something new every day and with the speed at which our industry changes, this is for all practical purposes a necessity. By learning each of the following tips, you can implement procedures that normally take years for the typical user to develop in the workplace.

1. Build a network of subcontractors
2. Create a pricing presentation
3. Inspect the architectural drawings
4. Conserve system resources
5. Master the keyboard shortcuts
6. Use the Boolean/Cut/Split feature
7. Use the Loft and Sweep feature
8. Write a good contract
9. Create a mask and use in Photoshop
10. Write a good script as soon as possible
11. Use a professional renderfarm
12. Question poor designs
13. Use deductive reasoning to solve problems with scenes
14. Break up projects
15. Use custom furniture only
16. Save incrementally and save often
17. Model simple elements first
18. Purchase the best available model and material libraries
19. Create an assembly line for doors and windows
20. Use additional input devices
21. Use a standard background rig
22. Use material and model libraries
23. Use the top 3rd-party plug-ins
24. Exclude objects from GI whenever possible
25. Use the Scatter command and Spacing tool to create vegetation
26. Use a 3rd party vegetation solution
27. Use artificial shadows
28. Use simple camera paths to reduce required sampling
29. Render high and convert down
30. Be active in the 3D community

1. Build a network of subcontractors

If you're a freelancer or the owner of a small firm, projects will always come along that are too large or have a deadline too short for you or your firm to handle. Turning away any visualization project can be disheartening, especially when a large amount of money is involved. But because of staffing limitations, freelancers and smaller firms are often forced to turn away large projects with higher profit yields. Likewise, clients will be hesitant to give a large project to a small outfit without some clear and visible assurance that the project can be completed on time.

Hiring employees can be a risky move for small firms. Even more difficult might be the task of finding qualified employees who live locally. The solution is to build a network of subcontractors. By subcontracting your work out to others, you can accept larger jobs and complete any job in a shorter amount of time. Even as a freelancer, you can accept the largest of projects and complete them in a reasonable amount of time. In this way, you can compete with the larger visualization firms and win contracts at which you would otherwise have no chance.

Because of the unique nature of our industry, we can subcontract work out to anyone in the world while communicating completely through e-mail. Quality subcontractors can complete an entire visualization project with minimal guidance, turning the finished product over and leaving you with nothing more to do but bill the client. Depending on where your subcontractors are located, you may find that they charge much lower hourly rates than what you charge your clients, leaving you with a potentially large profit margin. 3ds Max is used worldwide and quality subcontractors can be found in any corner of the world.

To find a quality subcontractor, you can start by exploring the galleries of some of the top visualization websites such as www.cgarchitect.com, www.vismasters.com, or the official Autodesk 3ds Max discussion forum, located at http://area.autodesk.com/. At these and other websites, you can see who does great work and simply send a message asking if they are interested in doing any subcontracting work. Another way is to post a message on a classified message board stating that you're looking for freelancers or firms interested in subcontracting work.

When dealing with subcontractors outside your home country, you always risk business dealings going bad and not having any legal recourse. However, by doing good research and communicating your needs clearly, the risk is minimal. Before engaging subcontractors in any large project, we highly recommend giving them a very small job to determine how well they can live up to your expectations. Some can produce fantastic work but have poor communication skills that make working by e-mail alone difficult. Others may display a great portfolio but be disgruntled employees of firms that produced the images and lack the skills needed to complete the work to the level of quality their images imply. You may also find that they cannot work with AutoCAD drawings.

One of the best ways to employ subcontractors initially is to give them the sole task of modeling a project. To model an architectural scene, a 3ds Max user should need nothing more than the architectural CAD files and some basic instructions. Hiring a subcontractor to complete the materials, lighting, or animation portion of a project can present many challenges you may want to avoid until both of you are familiar with working and communicating with each other.

Until you make the leap of hiring full-time employees, subcontracting your work is the only way to compete with large firms and win the big visualization projects. Even if you only work on small projects that can be completed in just a few days, subcontracting your projects, even just the modeling portion, means that you can take in more work, turn around your work quicker, and keep your clients happier by not turning away work.

2. Create a pricing presentation

When trying to decide where to place this tip in the list of 30 tips presented here, it was suggested that a pricing presentation has to be at the top of the list, at least for business owners, because without landing work, none of the other tips means much. And since price is one of the first things potential clients inquire about, it is often your first (and sometimes only) chance to make a great first impression. Every business owner should have a presentation ready at all times to present to anyone who inquires because without it, you run the risk of looking unprepared, indecisive, and as an opportunist who might attempt to exploit clients when the opportunity presents itself.

It will not always be to your advantage to disclose your prices to those whom you present your work. If you are asked to give a presentation to a more public audience or to a firm whose employees are present, then showing a presentation without pricing is more appropriate. In this situation, it would be to your advantage to make a second version of your presentation, which could be identical except for the prices being removed.

Appendix J provides a discussion on these presentations and presents a sample presentation you can use as a starting point for developing your own. Appendix F also provides a thorough discussion on ways to develop your own pricing and things to consider when trying to navigate this critical subject.

3. Inspect the architectural drawings

Most architectural visualizations begin with what we consider to be the foundation of 3D—the 2D line work. Sometimes, you may need to produce a visualization from nothing more than some simple hand-drawn elevations, in which case your best course of action is to trace the sketch in a 2D CAD program to produce some rough 2D line work. In most cases, however, you will begin a project with 2D CAD drawings already in hand, even when their creation is not finalized. These CAD drawings may be produced solely by the architect, by a freelance CAD drafter, or by numerous different firms working to complete their part of the final set of construction documents. Whatever the case may be, all have their own style for creating drawings and leave their own mark on their drawings. If you're lucky, you will receive a complete set of perfectly created drawings, but most of the time there are things in the drawings that, while not apparent on paper, may cause you hours of time to fix before the linework can be used in the creation of 3D models. These imperfections in the drawing process can eat away valuable production time and significantly impact your profits.

Preparing architectural drawings for use in a 3D visualization can be a very time-consuming process, and until you explore the drawings you're given, you can never be sure how much time you're going to have to spend on preparation. Before quoting the cost of a visualization, you should either insist on seeing the drawings or let the client know you have to bid high to account for the possibility of poor drawings. Not doing so can be a costly and time-consuming mistake. Before becoming wise to these problems and covering ourselves during the bidding or contracting process, we often found ourselves spending endless hours fixing problems with the drawings. On a few occasions, the drawings we received were missing entire elevations and the clients expected us to deal with it at no additional cost to them, believing we should have accounted for that in the bid or contract.

The bottom line is that you must cover yourself by either refusing to start the visualization without good drawings or by pricing your work higher to account for the worst-case scenario. For a thorough discussion of what some of these scenarios might be, refer to Chapter 2.

4. Conserve system resources

Few technical issues are more important for a 3D artist than conserving one's system resources. Without using good workflow procedures that allow you to do things such as minimizing RAM consumption and maximizing viewport refresh rates, you are bound to take much longer to complete your work than your more trained peers and your render times are bound to be longer.

Chapter 19 illustrates the answers to some very common questions you simply must know the answer to, if you want to work at the highest level of speed and efficiency. Some of these include:

- Should I collapse an object after completing its construction?
- What's the difference in memory consumption between a parametric object, versus an editable mesh object, versus an editable poly object?
- What happens to the operands of a compound object when the final object is created?
- What has a greater impact on file size; the total vertex count or polygon count?
- When should I create copies, instances, XRefs, and proxies?
- Do modifiers increase file size and/or memory consumption? Why or why not?

If you do not know the answer to all of these questions, you should invest some time in learning their answers, and a good place to start would be a thorough reading of Chapter 19.

5. Master the keyboard shortcuts

Keyboard shortcuts are the single most important interface element for efficient work in a 3D program. Veteran 3ds Max users, many of whom started 3D in the pre-Max days of DOS, will usually agree that keyboard shortcuts are a critical part of their work. In the days of 3D Studio for DOS, users depended more heavily on inputting commands from the keyboard. Keeping one hand on the mouse and the other hand on the keyboard was common practice, and as stated in numerous places throughout this book, it's a good practice to get into if you haven't already. Proper use of the keyboard can shave many hours off your larger projects and a significant amount of time off even your smallest.

6. Use the Boolean > Cut > Split feature

Most of the tips and tricks listed in this appendix deal more with workflow and technique than simply identifying features that even fundamental level users should be familiar with. There aren't many features in 3ds Max we would feel the need to highlight in this way, but the **Boolean** > **Cut** > **Split** feature would certainly be one of those. This feature is simply invaluable in the creation of 2D and 3D sites, and as of this latest release of 3ds Max, there is nothing that can do what it can do as well as it does, which as its name implies, is cut and split polygons.

The Shape Merge feature is very unreliable unlike the Boolean, which will always work when used properly. The ProBoolean also fails to yield the same great results of the Boolean when it comes to site creation. For all its advances over the Boolean, the ProBoolean does not allow you to cut and split polygons. The best the ProBoolean feature can do to simulate the cutting and splitting of polygons is to imprint new edges in them. However, this doesn't generate new elements within an object and the user is left without a practical way to select the polygons lying within the imprinted edges.

Perhaps in a future release of 3ds Max, Autodesk may incorporate this power into the Pro-Boolean, but until then the Boolean > Cut > Split feature remains at the top of our list of most valued 3ds Max features. This does not mean that it should be used in lieu of the ProBoolean for other operations, such as subtracting a volume of area from a wall in which to place a window, because in many other operations like this, the ProBoolean will always be the better choice. If you want to read more about why this feature is so great, refer to Chapter 7.

7. Use the Loft and Sweep features

Like the previous tip, we've included use of the **Loft** and **Sweep** features to highlight what we consider two of the very best features in 3ds Max. The reason they are both mentioned as part of the same tip is because they are so similar in function and used to basically do the same thing; to project the profile of a spline along the path of another spline. In the area of modeling, we have found the Loft and Sweep to be two of the most productive and useful features.

In visualization, both features can be used to model numerous object types, such as curbs, columns, trim, and furniture, just to name a few. However, each has a distinct advantage over the other in certain situations. Perhaps the most valuable use of a loft is in the creation of a wall. With a loft you can quickly and easily create complex and highly detailed walls from two shapes or splines, and you can modify the loft by making changes to either. You can also apply Multi/Subobject materials to a loft using material IDs. The sweep can create the same end product, but because it doesn't respect the pivot point of the projected shape, it makes precise creation far more tedious. The one downside to the loft is that you cannot use a path that contains multiple, non-continuous splines. This is where the sweep comes in.

The only thing the sweep can do that the loft cannot is work with multiple, non-continuous splines. So if you want to create hundreds of individual parking stops using the loft, you would have to create hundreds of individual lofts, which would obviously be a waste of time. With the Sweep modifier, however, you can do this in just a few seconds.

Chapters 3, 4, and 7 explain the use of lofts and sweeps in great detail. We highly recommend taking advantage of these tremendous features and exploring some of the many ways they can save you valuable production time.

8. Write a good contract

This tip ties into tip 4, in which it's suggested that you cover yourself with higher prices to account for the possibility of working with poor drawings. Writing a good contract is a crucial step in most visualization projects. You might feel the urge to do away with a contract for certain clients, but caution should be taken in these situations. Obviously, if you've known your client for a long time and trust their way of doing business, doing without a contract is a reasonable option for most projects. However, even for these clients, large projects with large price tags should usually include a contract.

When working with new clients, contracts should be used for even small projects, because sometimes only when the details of the scope of services are laid out in writing will the client truly understand what you are going to produce for them. Good contracts prevent you from incurring the cost of additional services not explicitly set forth in writing. They also explain in detail what is expected from each party and the limitations of your services. You do not need to have a lawyer write or review your contracts to have them upheld in court, but they should be well written to avoid any chance of misinterpretation.

A sample contract is available with the support files for this book, and Appendix H discusses this sample contract at length. This contract covers all the bases and should help give you an idea

of some of the ways a contract can protect you. Feel free to use this as a template for your own work.

9. Create a mask for use in Photoshop

Perhaps the best tip we can provide that deals with software outside of 3ds Max is the creation of a mask that allows you to change the colors of a visualization in real-time within **Photoshop**. In a nutshell, you can use the **Matte/Shadow** material to create an alpha channel for a particular object(s) and turn that alpha channel into a mask in Photoshop that allows you to change the color of just the object for which an alpha was created.

The benefits of being able to change colors of select objects in real-time, without negatively affecting the GI, shadows, or detail, are quite far-reaching. To learn how to use this procedure, refer to Chapter 17.

10. Write a good script as soon as possible

Clients will often not know what they want the final product to look like. When they see the final product before them, they will always know if they like it or not; however, it's not viable to keep making changes and reproducing the final product until they decide it's acceptable. By following tip 8, writing a good contract, you can minimize your risk of redoing work for free until the client accepts it, but a better approach would be to give the client a good final product the first time. When the final product is an animation, writing a good script is critical to ensuring you can do so.

A script is a play-by-play account of an animation sequence that tells the reader exactly what the viewer will be seeing and hearing every step of the way, as shown in Figure A-1. To be able to write a script, you or your client must know exactly what the final product should look like and sound like. By insisting on a script before proceeding to the animation phase of a project, you can force the client to give you all the information you need to produce exactly what he or she wants. Consider a script mandatory before the animation phase of a project and never proceed with setting up camera paths until you have it in hand. Failing to get a script ironed out will almost always lead to wasted time and reworking.

Figure A-1. A simple animation script.

Instead of waiting until the animation phase of a project, you would be wise to try to obtain a script early on in the project. Having a script before doing any work at all is the ideal situation,

because by knowing exactly what the viewer should see at every step in the animation, you can also know exactly what objects should receive more detail and the objects where the detail can be left out.

With a script, you can even determine if objects need to be created or inserted in the scene at all. Take, for example, a sequence in which a camera captures the view from only the front of a house. If the camera never views the back of the house, there's no reason to model those features and place objects in the scene that won't be viewable. Doing so will only waste time and increase your file sizes.

The earlier you obtain a script, the less time you will spend performing the same work over and over again and the less time you will waste working on parts of your scene that will never be viewed.

11. Use a professional render-farm

We learned long ago that keeping hardware within a 3D visualization company up-to-date is a difficult, time-consuming, and expensive way of life. But at the same time, if you're in the business of creating animations, you know how difficult it can be to produce them with a small number of computers. Rather than spending so much of your resources on maintaining an internal render-farm, we suggest a different approach; using your company's computers to conduct small test renders of animations but conducting large scale production renders with the use of a render-farm.

Render-farm services provide you an opportunity to send your complete 3ds Max scene to a third party, tap the resources of several hundred computers and render your animations in a fraction of the time. Although using a render service is not always the best option, being able to render long and complex animations when time is short can be invaluable. There are several companies that provide such a service, but ResPower (www.respower.com) is the company we like to mention because they have proven to us to be a reliable company that provides great service at a great price. At the beginning of 2006, they began a new program called 'Unlimited Rendering', whereby users can pay a flat fee for unlimited rendering each month. For a smaller fee, you can use unlimited rendering during a four-day period each month.

12. Question poor designs

One of the most practical uses a client has for 3D visualization is being able to see their project before it's built and change a poor design before construction begins. Your work may begin while a project is still in its design development stage, in which case its design is not set in stone and construction documents have not been produced. In this situation, you may find yourself modeling a portion of the project that appears poorly designed. Sometimes architects or drafters will create drawings based on their interpretation of what their client wants or what their client's sketches show. These drawings do not always represent what their clients have in mind. Sometimes their clients don't even know what they want.

You may be asked to model a poor design when your client, whether it's an architect, a developer, or the owner himself, jumps the gun and has you begin your work before the design has been thoroughly analyzed by all the necessary personnel. In any case, whenever you come across a drawing that appears to be a poor design or a design that simply doesn't make sense, you should question it and stop working until a resolution is found.

Before continuing work, you should also question drawings in which different parts conflict. This problem is very common especially with drawings that haven't been completely finalized. An example would be a floor plan that shows a window not shown on the elevations, or vice versa. Another example is when the front elevation shows one roof height, and a side elevation shows a

much different roof height. These types of problems should be questioned before continuing work, and if you manage to find numerous problems like these before you accept a job or quote a certain price, you should cover yourself by not accepting the drawings from your client or by explaining that you will have to charge more to account for these problems. You will probably regret not doing so later.

13. Use deductive reasoning to solve problems with scenes

To know 3ds Max well, you have to know how to trouble-shoot a scene and be able to figure out what the cause of any particular problem is. It doesn't take much time on any of the many community forums to see that many users don't use a deductive approach to solving problems that arise. On any of these forums, you can see users discussing a problem they are having with a scene and some of the things they have tried to fix the problem. Far too often, however, their approach is to tackle a problem the hard way. By taking a deductive approach instead, you are far more likely to solve a problem when computer software is involved.

For example, if you are trying to determine what is causing noise in your scene, you'll probably want to start your search with materials or lighting. However, you shouldn't be testing material settings at the same time you're testing light settings. Unless you are confident you know the source of the problem, you should try to eliminate all of the possible things that could be causing the problem, and by the process of elimination, you can eventually determine the source. So in this example, you should either eliminate materials or lighting altogether as the cause, and to do that, you simply need to take them out of the equation. If you want to see if materials are the cause, simply apply the same generic material to every object in your scene and if the noise remains, then it cannot be because of the materials. If you suspect the lighting is to blame, you could try removing all the lights in your scene and illuminating your scene with default lighting or with environment lighting. If you determine that lights are to blame, simply turn off lights one at a time to see if the noise still remains after each is turned off.

It may seem to go without saying that everyone should be using this approach when trouble-shooting, but it's clear that it is too often ignored.

14. Break up projects

Large 3D projects can be difficult to manage and complete on schedule. The further you get into a project, the more harrowing the adventure gets, and with deadlines looming, you can easily begin to wonder how it's all going to be finished in time. Breaking your projects into smaller jobs can help you manage them and keep production on schedule. Regardless of the project size, and whether you work on it by yourself or with the help of others, a project should be broken up into several smaller and more manageable jobs. Doing so helps you keep track of what's finished and what remains to be finished. Breaking up a project can also help you better estimate the time and staff that will be needed to complete it, and aid in the development of a contract.

You can start the process by breaking up a project into the major areas of 3D work such as drawing preparation, modeling, materials, lighting, animation, and post production. Some firms assign specialists to perform work solely in these specific areas, and in this way, projects can be easier to manage. Modeling should be broken up further because of the large amount of time this area requires. When we begin the modeling phase of a project, we usually break the work into major scene elements, save the files separately, and merge them together later when all of the modeling is complete. In Figure A-2, for example, the building was modeled in one file and in a completely

separate file the site elements were modeled, which included terrain, streets, sidewalks, curbs, and so forth. The entry signage was created in a separate file as was the vegetation. Lastly, miscellaneous objects, such as cars and people, were created and all of these elements were merged together to finish the modeling phase of the project. At any point along the way, we could have determined that we were falling behind and needed help to get back on schedule. In this situation, we could have subcontracted part of the modeling, such as the site, to another person or firm. Had we tried working on all of the elements at the same time, subcontracting out work would not be a practical option.

Figure A-2. A finished scene built as separate smaller elements.

By breaking up your projects, you can better gauge how much time is required for each component and for the project as a whole, and at any point along the way, you can determine how well production is staying on schedule. Finally, by breaking up your project, you can send work out to others the same way a network manager sends out work to servers during a network rendering.

15. Use custom furniture only

For many years, the most agonizing aspect of any of our interior projects was working with clients to populate a scene with suitable stock furniture. Getting clients to take the time to look through thousands of stock images and see past the generic colors or materials applied to the furniture was something many of them were not willing or able to do. Furthermore, as the quality of 3D has progressed from the early days of scanline, the need for custom furniture has also increased. Today, we make every attempt possible to steer the client clear of using stock furniture and use it only as a last ditch effort to reduce a project's pricing when the client is simply unable to afford the higher cost associated with creating custom furniture.

When we present work to a potential client, we always highlight the fact that we produce custom furniture and don't even present the use of stock furniture as an option. Our contracts reflect this as does our pricing. If, however, a client is simply unwilling to budge on the price we have set forth, and we can go no lower in our pricing, we will offer stock furniture as a way of making the project a reality that both sides can afford.

If you would like to learn more about the use of custom furniture, please refer to the introduction of Chapter 6.

16. Save incrementally and save often

We all hate to lose work when our computers or 3ds Max crashes or when your files become corrupted in some way. Restarting the computer and interrupting your workflow is bad enough, but having to backtrack and redo work can be downright painful. Equally as bad is having to go back to a certain point in your work to retrieve a scene (or objects) in a previous state, only to find that you

didn't save a copy of the scene at the right time. The solution here is to save incrementally and save often.

When you click the **Save As** command in the **File** menu, the **Save As** dialog box opens and displays a + symbol to the left of the **Save** button. Clicking this button saves a copy of the file and places a number at the end. The first time you save a file with this button, the number **01** will be placed at the end of the file name (unless a number is already used at the end of the name). Each additional click of the + button will cause an additional file to be saved with the next number: 02, 03, and so on. In the course of any project, we make dozens of incremental saves, which allows us to go back to just about any point in the creation process and retrieve objects in a previous state, such as before being collapsed or before Boolean operations are performed. Before performing a critical procedure that cannot be undone, we always save our work. Figure A-3 shows an example of the incremental saves made during a past project. Notice the numerous versions of different scene elements. Notice also the names of the files: clubhouse, entry_signage, room, site, and vegetation. As suggested in tip 14, each of these elements was created separately and merged together at the end.

Figure A-3. Incremental saves made throughout the course of a 3D project.

Good file management is critical to efficient production and is nonexistent in a large percentage of the 3D firms with which we have worked. Saving incrementally and saving often are two good practices that can go a long way toward improving your production output.

17. Model simple elements first

Anyone who has ever taken a test in school has probably heard at one time or another to answer the easiest questions first. There are some very good reasons for this. It helps build confidence in the harder questions, it gives you time to access that part of your brain that is for some reason hiding the answer you may know, and it ensures that you don't compromise your opportunity to answer the questions for which you definitely know the answers.

The same basic approach holds true in the creation of 3D visualizations. Modeling is usually the most time-consuming phase in a project and the more complex the structure, the more this holds true. It is wise to put some thought into how to build an object before you actually start and it's probably wise to have a complete understanding of every step you will need to take to complete a model. However, there are numerous things that can make modeling objects difficult even when you know the exact path you need to follow. The biggest problems you are bound to run into include inaccurate drawings and complex designs. Regardless of how well you know 3ds Max and how

familiar you are with the techniques you will eventually use, these things won't help you understand what you're looking at when inaccurate drawings or complex designs are involved. This is where experience in architecture comes in handy and when calls to the architect may be necessary.

When experience escapes you and no one is available to help with your understanding of a project's drawings, your best choice is to work on the simple elements first. Perhaps this might mean to work on the site before tackling the building(s), or to work on the furniture before tackling the interior walls. Regardless, the same approach you heard teachers tell you in school can help you in the world of 3D visualization.

18. Purchase the best available model and material libraries

The importance of a good model and material library cannot be overstated. Like so many other components of a 3D scene, good models and materials are critical to the final product. Being able to populate your interior scene with knick-knacks or your exterior scenes with common elements such as cars, people, lamp posts, or street signs is critical to making your work believable and the projects look lived in. Owning good model libraries is especially critical when you have to rely on populating an interior scene with stock furniture.

The quality of your libraries is dependent on the quality of the individual models or materials, and the quantity of each. If you have a very small number of either, you are bound to spend more time than you care producing models or materials that your project's budget doesn't allow for. Without an extensive selection to choose from, it's difficult to provide the exact look your client desires.

It is not enough to have good materials and models. You must have an easy and efficient way for you or your clients to find what's needed. If you spend an extensive amount of time looking for a specific piece of content, you are usually wasting time. Adding content to any scene can be simple if your libraries are arranged and labeled in a logical and easy-to-understand manner. On the other hand, if your content is not categorized logically and labeled correctly, you can easily spend days adding models and materials to your scenes.

To develop great model and material libraries, you will probably have to make a sizeable investment in the purchase of each. Avoid relying on free content, as it is often of questionable quality and quantity. The following two companies sell some of the best content available on the market, and we have purchased most of our model and material content from these two companies alone; **Marlin Studios** (www.marlinstudios.com) and **Evermotion** (www.evermotion.org).

19. Create an assembly line for doors and windows

Windows and doors comprise a significant portion of the modeling required for most buildings and homes. Many 3ds Max users choose to create these two building elements separately in CAD programs such as **Revit** or using the **Doors** or **Windows** feature within 3ds Max; however, both methods have big downsides.

The main problem with the Doors and Windows features in 3ds Max is that the available types are very limited and rarely provide the flexibility to create all the types needed for even the simplest building or home. The main problem with modeling these elements in other programs such as

Revit is the amount of time needed to initially set up all the different window and door types needed for your projects. If you used the same standard types for each project and didn't need to create any custom types, then modeling in other programs might be an option. If you work in an architectural office and need to create construction drawings anyway, then perhaps creating your windows and doors in these other programs is the best option. If you don't need to produce CDs, then we suggest modeling doors and windows (along with the walls they rest in) in 3ds Max, using the imported 2D line work.

After years of trying countless ways of creating these critical building elements, we have found one way that stands out above all the other methods we have tried; the assembly line. It worked for Henry Ford in the production of automobiles, and it can work just as well in the creation of windows and doors in 3ds Max. The best part about this method of creation is that you can create all of the window and door types at once. After positioning the line work for each window and door type side by side, and importing into 3ds Max if necessary, you can isolate the linework needed to create each component (Boolean, frame, glass, and so on) and create each component at the same time. You can even attach all of the lines together for each type, use the Extrude, Edit Mesh, or Edit Poly commands to create the mesh or poly objects, attach each finished object type together, and then detach the entire window or door as an individual object (comprised of the individual elements).

20. Use additional input devices

In recent years, several great input devices have been developed that can significantly increase your speed and improve your efficiency in 3ds Max. Two of our favorites are the keypad and 3D motion controller. Both of these have streamlined our inputs to the program, and we highly recommend investigating their potential with your work.

The keypad, shown in the left image of Figure A-4, is a device similar to the keyboard with keys that can be programmed to execute a command or display text with a single key press. As outspoken supporters of keyboard shortcuts, we believe that programming and learning a keypad can significantly improve anyone's speed and efficiency. Efficiency in 3ds Max requires rapid input and few devices compare to the input capability a programmable keypad has. Hot keys offer the shortest path to action, and the keypad provides a clearly labeled, physical location for these complex or redundant functions, so you don't have to think about them. Keypads come in many different shapes and sizes, but should you decide to purchase one, make sure you choose one that contains enough keys for all the commands you wish to use with it. Two added benefits of the keypad over the keyboard are the ability to write the names of the commands on the keys and to input text with a key.

The second input device that can be a tremendous asset is the 3D motion controller, shown in the right image of Figure A-4. With six degrees of freedom, you can navigate comfortably with one hand while editing with your mouse in your other hand. This device gives you unparalleled view navigation control, allowing you to zoom in and out and rotate your view with an easy-to-use controller cap. View navigation commands are, for many 3ds Max users, the most commonly used commands. Anything that can aid in their execution can save a tremendous amount of production time and should be considered for use.

The keypad can be purchased at `www.xkeys.com` and the 3D motion controller at `www.3dconnexion.com`.

Figure A-4. The keypad (left) and 3D motion controller (right)

21. Use a standard background rig

One of the most common scene elements 3ds Max users make unnecessarily difficult for themselves is the background. In actuality, it should be one of the most simplistic things to add to a scene and often requires nothing more than merging objects in from another scene and deciding which background image to use. There are numerous reasons why you shouldn't use the Environment channel as the source of your background, and why you should instead use what we call the 'background rig'.

The background is so critically important to scene that we decided to dedicate a chapter to it. For more information on the subject, refer to Chapter 9.

22. Use material and model libraries

Creating the same materials and models over and over again for each project would be a complete waste of time. Rather than doing this, you should borrow objects and materials from other scenes whenever possible.

Working with materials in 3ds Max can be a long and arduous process, made more difficult if you don't use material libraries. Material libraries allow you to store and retrieve your favorite and most frequently used materials in easy-to-access files. Hopefully, your image library, which you use as maps for materials, contains tens of thousands of images. However, if this is the case, the simple act of locating an image to apply to a map channel can end up being not so quick and simple. For scenes with dozens of materials, this can translate to large amounts of wasted time.

The solution is to create and maintain good libraries. If you create a material that you think you will want to use again in the future, take a moment to give the material a relevant name and add it to a library. If you've never spent much time creating libraries, try opening some of your best scenes, reviewing the materials you applied, and putting the best ones in your library.

Like the application of materials to your scene, placing common and everyday scene elements can be a laborious and time-consuming process if not done wisely. Using objects from past projects, can be time-consuming if you must open numerous large or hard-to-find files to locate the objects you're looking for. Just as with material libraries, you should create and maintain object libraries containing these common and ordinary objects. Your libraries should not, however, be limited to just the ordinary objects you tend to use for all your projects; rather, they should include virtually all well-created objects you would be proud to display in future projects. These can be furniture, vegetation, picture frames, or kitchen accessories, as shown in Figure A-5. How you organize the files that contain your objects is not important as long as you can keep track of them and locate them in the future.

Figure A-5. A library of kitchen accessories saved as individual files for later use.

As in other areas of 3ds Max, a little time spent in program maintenance can save you a tremendous amount of production time and help you meet your deadlines.

23. Use the top third-party plug-ins

Another great characteristic of 3ds Max is its ability to allow the use of plug-ins, which offer expanded or specialized functions, such as advanced rendering or the creation of trees. While 3ds Max provides tremendous power and capability through a seemingly endless list of features, some plug-ins provide unequalled power and capability in select areas of 3D.

Over the years that 3ds Max has been around, some plug-ins have become so ubiquitous and so successful, that they have been acquired by Autodesk and fully integrated into the program. Freelancers or small firms should take caution and conduct research to ensure a particular plug-in is truly needed. Purchasing plug-ins can quickly become expensive, and if you don't perform adequate research beforehand, you may regret making a purchase. However, if a plug-in can shave enough time off the production process or significantly improve the quality of your work, then the price should not stop you.

Be sure to check out Appendixes B and C for a list of free and commercial plug-ins.

24. Exclude objects from GI whenever possible

The calculation of global illumination is an immense part of the typical rendering process that uses advanced lighting and whenever you exclude objects from that calculation, you will reduce render times. Good candidates for this technique are usually high-polygon objects whose aesthetic contribution to the GI in a scene is minimal, as is the need for the objects to be illuminated with GI. These can include 3D trees, furniture, cars, people, and many other object types that can often contain a large number of polygons. Ideally, this exclusion from GI should be kept at a minimum and used primarily with objects relatively far away from the camera's view, but when used properly, it can greatly reduce your render times without any discernible reduction in image quality.

After you exclude an object from GI, you will have to light it in another way that fakes the look of GI. The best way to do this is to use four direct lights positioned around your scene and pointing inward. Three of these lights should be instanced and set to about 1/3 of the strength of a fourth light, which should be positioned in the same general area as the sunlight in your scene. Having one light stronger than the other 3 will keep the proper balance of illumination and using a total of 4 lights positioned around a scene will ensure that all sides of the object will be illuminated properly.

Also, when using this technique, you have to be careful to have the 4 lights only create illumination for the objects you excluded from GI and no other objects.

25. Use the Scatter command and Spacing tool to create vegetation

In a 3D scene, one of the most difficult elements to simulate realistically is vegetation. This is especially true when your scenes are animated, and your cameras move in and around the vegetation. Whether a scene contains 2D vegetation, 3D vegetation, or a combination of both depends on numerous factors, such as rendering time available, your vegetation libraries, distance of the vegetation from the camera, camera paths, and available RAM. Too many 3D plants or trees can lead to extremely large files sizes and rendering times, which is why we recommend using a combination of 2D and 3D vegetation in most scenes. When you do decide to use 3D vegetation, one of the ways you might want to create your plants is with the **Scatter** command.

Using the Scatter command to create copies of one object over the surface or within the volume of another object gives you a quick and easy method to create realistic 3D plants for an entire project, regardless of size. Creating plants this way can produce effective and realistic results with minimal burden on your computer.

It's often unimportant to the client exactly what type of plants they see in their visualization, and since landscape drawings are usually one of the last things created during a project's planning, landscaping will often not even be decided by the time your work begins. When this is the case, the client may want you to play landscaper and tell you to simply create something that looks good. This can be a double-edged sword. Although it is nice to not be constrained by placing the exact required vegetation type throughout your scenes, the client may not like what you use. Good communication about landscaping requirements and exactly how you will meet them cannot be overstated. In fact, if anything should be highlighted in your contract, it should be details regarding the landscaping. Whenever possible, try gaining flexibility from the client in this area.

Regardless of the landscaping constraints detailed in your contract, another great tool that facilitates the placement of landscaping throughout your scenes is the **Spacing** tool. You can use a spline (path) or two points separated by a certain distance to specify exactly where your vegetation is placed.

26. Use a third-party vegetation solution

As just mentioned, vegetation is usually not the focus of most 3D visualizations; however, when created improperly it can often be the only thing the viewer focuses on. For years, 3D vegetation was the most difficult type of object to use in a scene because of its extremely high polygon count relative to other objects in scene. Oftentimes, an entire building might contain fewer polygons than a single tree, and it wasn't long ago that this was too large of a problem for most users to deal with.

With the increase in computer power in recent years, 3D vegetation has become the norm rather than the exception, and you should attempt to use it over 2D vegetation whenever possible. However, not all 3D vegetation is created equal. There are numerous software packages that give you the ability to create beautiful vegetation and while we must admit that we have only experimented with a few of them, the **Onyx** and **Bionatics** plug-ins provide arguably the best solutions. Whichever software you use, make sure it gives you all the realism and flexibility you want. If it does not, you haven't chosen the right software because there are several that provide everything top visualization firms need. Above all, don't rely completely on free models, 2D vegetation, or 3D vegetation you create from scratch. Those days are long gone.

27. Use artificial shadows

Another one of the things that makes vegetation difficult to work with is the creation of realistic shadows. Vegetation can be simulated in 2D through the use of photographs and alpha channels, or it can be modeled with a wide variety of detail. Regardless of which method you use, each has pros and cons and tricks that can make working with it easier.

Tip 25 made the suggestion of creating vegetation using the Scatter command. By creating shrubs and plants this way, you can create fairly accurate shadows, depending on the size of the leaf object being scattered. When using 2D shrubs and plants, the shadows are not completely accurate but will suffice in most situations if the camera is not too close, because the shadows are usually small and closely surrounded by other shadows.

The real difficulty in shadow creation comes with the use of 2D trees. Because trees are larger and more sparsely placed, their shadows stand out more and their detail, or lack thereof, is more noticeable. The advantage of using a 2D tree is clear because it requires only a few faces, or polygons, per tree object, and therefore it renders quickly. This type of 2D object, however, casts poor shadows. By creating artificial shadows, you can dramatically improve render times as well as reduce RAM consumption. Creating artificial shadows can be beneficial for 2D trees and 3D trees. Rather than having a high-polygon tree create its own shadows, you can disable the shadow-casting ability of a tree, and create a fake shadow for the tree and save system resources in the process.

Vegetation is a vital component of most 3D scenes. Poor vegetation can ruin an otherwise great scene, and when not used wisely can be a tremendous burden on your computer. For more information regarding the use of artificial shadows, refer to Chapter 10.

28. Use simple camera paths to reduce required sampling

There are two primary methods of implementing GI in an animation. One is a brute-force approach that involves calculating the GI of each frame independently of every other frame. This method is very accurate but also very slow. In most cases, a much better approach is to calculate GI completely for one frame, conduct a small amount of samples in subsequent frames, and then after a certain number of frames have passed, create another complete GI calculation with more samples added in subsequent frames, and so on. This approach can greatly reduce the total time needed to calculate GI in a scene.

The biggest determining factor in just how many frames you can skip before creating another complete GI map, and therefore, how much time you can ultimately save, is the movement of your camera. If your camera moves very little, such as a slow sideways motion, then your view doesn't change much and you don't need to update your map with GI samples as often. You don't need to keep taking samples on surfaces you have already sampled sufficiently in previous frames. However, if your camera moves fast and moves in and around your scene quickly, then you need to update your GI map more often to account for all the new surfaces you see. The faster you move and the more new surfaces you see, the more often you need to update your GI map, and therefore, the longer it will take to create your animation.

With all of this said, you should try to avoid sacrificing quality for the sake of speeding up your GI calculation; however, when push comes to shove and deadlines loom, this is a handy way to shave valuable time off the rendering process.

29. Render high and convert down

In the 3D world, render engines use a process known as image sampling to improve the quality of rendered output by decreasing the effect of aliasing. Aliasing is a term to describe imperfections in the rendering process caused by color changes that are too drastic, and occur over too small an area of screen space to be adequately depicted by the pixels that define that space. In a single still image, aliasing is certainly noticeable and can reduce realism, but if the same scene is set in motion, the results can be downright distracting and can ruin what would otherwise be a great animation. Two examples of these antialiasing side effects are flickering and texture crawling.

Flickering occurs during animations when materials have a speckled appearance with drastic changes in color occurring over a small number of pixels. In these cases, the computer cannot accurately determine which color to assign a given pixel, because the edge of two colors exists in the middle of a pixel. When scenes with these textures are animated, the difference between the two can be dramatic.

Texture crawling occurs in animations in areas along the edges of thin lines. This undesirable effect happens because there are not enough pixels available on a typical monitor to properly display mathematically smooth lines and polygon edges. When a 3D scene is transposed onto a monitor's pixel grid, or raster, each pixel is colored according to whether it is covered by an object in the scene. Aliasing occurs because the raster system does not properly handle the case in which a pixel is only partially covered. Partially covered pixels occur along the edges of objects and are referred to as edge pixels or fragment pixels. The mishandling of fragment pixels results in harsh, jagged color transitions between an object's edge and the background. Examples of materials in which texture crawling is prevalent are bricks in a wall, pavers in a walkway, and fascia on a roof. In animations, these edges appear to crawl, whether they are the edges of an object or the edges within a material applied to an object.

Using higher image sampling settings can greatly reduce the effect of flickering and texture crawling, but often come at an expensive price. Another entirely different way to improve image sampling, and one we use at 3DAS when time and budget allow for it, is to render a scene at a higher resolution than what the final output is actually going to be, and then scale it down to that final output. This is, in effect, increasing your image sampler settings without having to do anything but increase your resolution. Movie studios use this same process to deliver unbeatable quality with absolutely minimal antialiasing side effects. If you've ever wondered how fully animated movies appear so stunning and so free from artifacts despite being broadcast at standard DVD quality (640x480), it's because the final color assigned to every pixel is near perfect. And the reason it's near perfect is because they render their animations at a much higher resolution, 2K (2048x1080) or 4K (4096x2160), and convert down to the final output.

You can use this same technique to deliver stunning, artifact-free animations to your clients as well. However, these resolutions are impractical for most of us, and the low end of the high definition spectrum (1280x720) would be a good place to start.

30. Be active in the 3D community

Many of us in the 3ds Max community, new and experienced, fix some of our most difficult 3D problems with the help of others in the 3D community. To find this help, we often post our questions in 3ds Max online forums and review the replies at a later time. Because of the expertise of the readers in these forums, few problems go unsolved. As long as the question is relevant and posted in a professional manner, it will almost always be answered by one or more readers.

Online forums and chat rooms offer all of us a limitless pool of knowledge from which to draw information, and they are often the only places users can turn to for answers to difficult problems. This is especially true for freelancers or sole proprietors who work on projects alone and don't have other experts working by their side.

Two of the best forums in the 3ds Max community are the official 3ds Max forum administered by Autodesk at www.autodesk.com and the forum hosted by CGarchitect at www.cgarchitect.com. Both sites are monitored by industry experts.

This tip simply highlights the fact that website forums should play an important role in the work of the 3ds Max user, especially the less-experienced user. When a deadline is fast approaching, and you have a problem affecting your production, turn to the experts of a 3ds Max online forum or chat room.

In addition to participation in online communities, it is highly beneficial to participate in live community events. On several occasions each year, the 3D community gathers together to participate in trade shows to display and learn about the latest technological advancements in 3D. Vendors of all types of 3D software, hardware, and media exhibit their most advanced products, while others explore and seek out the products that can aid their production. To maximize your production capabilities, you usually need to use the latest and greatest, and by attending trade shows, you can stay informed and know what that is. Otherwise, you may take quite some time to stumble upon the newest products that can help your production.

Seminars and classes offer all of us the opportunity to improve our work practices and increase our productivity. Generally, the more experienced 3ds Max users are, the less willing and able they are to change their habitual ways of doing things. But the fact remains that everyone will always have room for improvement, and with the way 3D technology advances, you have to be willing to learn new things or eventually you will fall behind your peers. Even certified instructors and specialists learn new tips and tricks when attending seminars and classes taught by other experts. When you have the opportunity, you should give some of these a try. The largest 3D gathering in the United States is **SIGGRAPH**, a weeklong trade show held each summer in one of a number of different metropolitan cities. While SIGGRAPH is the largest gathering of 3D users, the densest gathering of architectural visualizers is the annual **VisMaster's Design Modeling and Visualization Conference**.

Figure A-6. DMVC 2007.

Summary

Our business demands innovation and creativity. Every year that goes by, the software we use makes creating stunning visualizations easier and easier. But at the same time, our clients expect a better product. That combined with increasing competition, refusing to learn innovative ways to improve our own business will eventually lead to lower profits or even business failure.

The tips and tricks presented here are the result of many years of trial and error by numerous individuals, often at great expense and grief. Hopefully these ideas will help you avoid some unnecessary expense and grief of your own.

Top Twenty 3D Vendors

To DO GREAT 3D VISUALIZATIONS, you need great tools, and although 3ds Max is brimming with a fantastic collection of commands and features, it is not by any means a complete package for most of us in the industry. To provide a wide range of 3D services and produce your work efficiently, it is necessary to expand your 3D toolset beyond the limits and capabilities of 3ds Max. Some of the best features in 3ds Max actually started out as third-party plugins that Autodesk (or formerly Discreet) purchased for inclusion in the program, and while some of the tools highlighted here are likely to be incorporated in 3ds Max someday, for now they are only available through purchase.

This appendix contains a great list of tools that can expand the power and versatility of 3ds Max, as well as your entire workflow. Some of these links direct you to plugins that run inside 3ds Max and some to external programs that run outside of the program. Some direct you to great content-providers while others highlight some of the best equipment you could incorporate into your workflow. Each provides something unique to the industry and each improves either the quality or efficiency of our work. Additionally, some programs such as V-Ray, Photoshop, and a few others were considered unnecessary to mention in this list because of their already extreme popularity.

It should be mentioned that these are not advertisements. 3DATS has not benefited in any way from the companies mentioned in this list and only a couple of these companies know that they are being mentioned here. These vendors are listed only because we endorse their products and one or more of our members use them in production.

www.2d3.com – Here's a place you can go to get an amazing program that let's you integrate CG with real-life footage at the touch of a button. With their premier software package, Boujou, you can track even the most difficult of footage, and superimpose your 3D scene with almost no effort. Without such software, combining real video with CG is almost impossible. At last check, Boujou sold for $10,000 and is, therefore, not a viable option for many smaller companies or freelancers. However, a much more affordable option is Boujou Bullet, which at $2,500 provides most of the same features at a greatly reduced cost.

www.3dconnexion.com – As an outspoken advocate of fast and efficient work, I am listing 3D Connexion in this list because of how much their products have improved my speed and efficiency in all of my 3D projects. Every single command used in 3ds Max has to first go through an input device, and it only makes sense to use the best available equipment when it comes to something used as much as an input device. For me, the SpacePilot has made viewport navigation completely effortless has saved time on every project.

www.archvision.com – Archvision has long been recognized as an industry leader in providing, as their plug-in acronym 'RPC' implies, Rich-Photorealistic Content. Their content includes cars, vegetation, people, and much more. One of the things that most impresses my clients about the animations I create is how I integrate moving people in my scenes. With the RPC plug-in, doing so couldn't be easier.

www.artbeats.com – Artbeats provides what I believe to be the finest collection of royalty-free stock video and imagery available on the market. They maintain a seemingly endless list of video and imagery and no matter what kind of subject matter you need for your visualizations, they are sure to have it. With the coming of high definition DVD players, their high definition collections provide a great solution for future projects.

www.axyz-design.com – Metropoly models can be viewed from any angle and break from the limitations of traditional characters. Designed for medium-viewing distances and perfect interaction with rendered images, each collection is optimized for perfect shadowing and little to no image retouching!

www.doschdesign.com – Dosch Design creates some of the finest 3D content, with a large collection of furniture, textures, 2D vegetation, people, HDRI maps, and my personal favorite, a wonderful collection of highly detailed 3D cars.

www.emagin.com – eMagin is a leader in OLED (organic light emitting diode) micro displays and virtual imaging technologies. They produce fantastic 3D visors that can be used in conjunction with Immersive Media's software, to produce a complete 360 virtual-environment complete with stereovision and head-tracking. This technology is just in its infancy and already amazes clients.

www.evermotion.org – Evermotion provides some of the best 3D models available anywhere on the market and at very affordable prices. Their site contains dozens of collections, each containing an enormous variety of highly detailed models or materials.

www.eyeonline.com – Fusion 5 is a full-featured, node-based compositing system with built-in backend tools via a powerful scripting engine with ODBC support. A perfect balance between a backroom-power-tool and a front-room-client station, Fusion 5 has it all. Not only does Fusion 5 have a real 3D environment with camera/lights support for leading 3D packages, it is also one of the most powerful and intuitive 3D particle systems on the market. With hardware-accelerated 3D capabilities, you can now migrate from pre-vis to finals within the same application. eyeon's Fusion is a true synergy of 2D and 3D tools for ultimate compositing.

www.immersivemedia.com – Immersive Media Corp is an advanced digital-video-imaging company that will change your perspective. Using a 360-spherical camera, IMC's proprietary software allows the view to play back videos while changing the view in real time. Combined with a head-mounted visor display from eMagin, the experience is one that will leave your clients in awe.

www.lbrush.com – A sophisticated poly modeling plugin that enables you to take the Edit Poly modifier tool to an entirely new level.

www.marlinstudios.com – Marlin Studios, of Arlington, Texas, is a graphics publisher and studio founded in 1993 by Company President Tom Marlin. The company takes pride in offering high-quality digital content for computer graphics artists at affordable prices, and views itself as a service company, with emphasis on one-on-one customer support.

www.nodejoe.com – NodeJoe is a schematic material editor plugin for 3ds Max that provides a quick, easy, and unique way of working with textures and materials. The plugin provides an intuitive and clearly arranged flow chart interface to create, analyze, and modify materials and textures within 3ds Max.

www.onyxtree.com – This site is home to what I believe to be the finest 3D procedural-modeling software for vegetation. With just a few clicks of the mouse, you can create realistic, custom vegetation for export to 3ds Max. You can even animate your vegetation with wind.

www.polyboost.com – PolyBoost is an extensive set of easy-to-use but advanced tools for 3d artists working in 3ds Max. The focus of the PolyBoost tools is at speeding up and streamlining workflow for the artist. PolyBoost offers a wide range of tools for creating various types of subobject selections as well as a set of modeling tools that will make many tasks in everyday modeling much easier. Included is also a Viewport texture painting tool, UVW editing tools, and a set of useful transform tools. The tools have been developed with the end-user very much in mind to enable tools that are user-friendly, fast, stable, and above all useful. Autodesk 3ds Max contains an existing set of robust modeling tools. Combining these base tools with over 100 PolyBoost tools greatly enhances the users' ability, giving them the most fully featured model-ing package on the market with uses that stretch over all of the different areas of 3d.

www.quest3d.com – Quest3D is perhaps the best tool available for creating photorealistic, inter-active, and real-time 3D visualizations at an affordable price. While not as advanced as the Crytek engine, Quest3D is inexpensive enough to be practical for very small firms.

www.respower.com – If you're in the business of creating animations, you know how difficult it can be to produce them with a small number of computers from which to render. Render-farm services provide you an opportunity to send your complete 3ds Max scene to a third party, tap the resources of several hundred computers, and render your animations in no time at all. Although using a render service is not always the best option, being able to render long and complex animations when time is short can be invaluable. There are several companies that provide such as service, but ResPower has proven to me to be a reliable company that gives a great service at a great price. At the beginning of 2006, they began a new program called 'Unlimited Rendering', whereby users can pay a flat fee for unlimited rendering each month. For a smaller fee, you can use unlimited rendering during a four-day period each month.

www.shutterstock.com – Shutterstock is the largest subscription-based stock photo agency in the world. Their outstanding collection of premium, royalty-free images grows every day, with photographs, illustrations, and vectors you won't find anywhere else.

www.sugar3d.com – Sugar3D cars each come with 3 polygon versions and represent the most realistic and easy to use image-based vehicles on the market.

www.zcorp.com – While attending SIGGRAPH a couple of years ago, I came across a booth by Z Corp. and was immediately fascinated by their amazing product line of 3D printers. Z Corp. makes the world's fastest 3D printers and, at last glance, the only one that can produce mod-els in multicolor. Although this is probably not a product for new 3D users, this is definitely a product that everyone should keep their eyes on. With every year that goes by, print quality and speed will improve to the point that it will become mainstream. I imagine it won't be long before everyone has a 3D printer sitting on his or her desk as 2D printers are today.

Top 20 Free 3D Resources

YOU CAN SAY NOTHING IN the world is free, but in the 3D world there are endless resources available for all of us to improve our workflow. The following is a compilation of 20 great websites that you can use to download free software or free information. Some of these resources are well known while others are relative unknown. All of them provide something unique and if you haven't investigated each to see how it might be incorporated into your workflow, you would probably be doing yourself a favor to check them out.

www.animoto.com – Animoto Productions is a bunch of techies and film/TV producers who decided to lock themselves in a room together and nerd out. Their first release is Animoto, a web application that automatically generates professionally produced videos using their own patent-pending technology and high-end motion design. Each video is a fully customized orchestration of user-selected images and music. Produced on a widescreen format, Animoto videos have the visual energy of a music video and the emotional impact of a movie trailer. The heart of Animoto is its newly developed Cinematic Artificial Intelligence technology that thinks like an actual director and editor. It analyzes and combines user-selected images and music with the same sophisticated post-production skills & techniques that are used in television and film.

www.autodesk.com – Of course, the list wouldn't be complete without a reference to the company that makes 3ds Max. The official 3ds Max forum (the 2nd link) is a great place to get help and advice from peers for any problem you can't solve on your own. It's also a great place to search for a 3D job or to post an available position.

www.bluevertigo.com.ar – A great source for textures, fonts, Photoshop brushes, sound clips, and much more.

www.blu-ray.com – With the explosion of high-definition over the last few years, a mention is in order regarding the most popular source for everything related to the Blu-ray Disc – the king of high-definition media. This site provides movie and product reviews, news, guides and forums covering Blu-ray movies, players, recorders, drives, media, software and much more. Warning: don't feed the trolls. They bite!

www.ceruleanstudios.com – Trillian is a fully featured, stand-alone, skinnable chat client that supports AIM, ICQ, MSN, Yahoo Messenger, and IRC. It provides capabilities not possible with original network clients, while supporting standard features such as audio chat, file transfers, group chats, chat rooms, buddy icons, multiple simultaneous connections to the same network, server-side contact importing, typing notification, direct connection (AIM), proxy support, encrypted messaging (AIM/ICQ), SMS support, and privacy settings. Trillian provides unique functionality such as contact message history, a powerful skinning language, tabbed messaging, global status changes (set all networks away at once), Instant Lookup (automatic Wikipedia integration), contact alerts, an advanced automation system to trigger events based on anything happening in the client, docking, hundreds of emoticons, emotisounds, shell extensions for file transfers, and systray notifications.

www.cgarchitect.com – In just a few short years, CGarchitect has established itself as the premier visualization website, with over 85,000 active visitors every month. The site contains all of the latest visualization news, fantastic tutorials and discussion groups, product reviews, and more. While numerous websites have come and gone, CGarchitect appears to have the right ingredients to continue to be the industry-leading website indefinitely.

www.cgtextures.com – Perhaps the largest collection of free textures available on the planet.

www.cozimo.com – Say goodbye to scheduling meetings, sitting in traffic jams and waiting in boardrooms. With Cozimo you can collaborate and review images and videos — together in real-time or on your own time. Get feedback from clients and colleagues instantly. Cozimo is the faster, better, simpler way to work.

www.download.com – Download.com offers a huge library of free and legal software downloads. They provide timely, relevant, and credible information about important software updates as they come available. Their editors write unbiased reviews and ratings for thousands of free downloads, and they are committed to maintaining coverage that is objective and accurate. All the downloadable software in their library undergoes a rigorous testing process to ensure it is safe and spyware free.

www.dynamicdrive.com – A great website to obtain free, original DHTML & Javascripts to enhance your 3D website.

www.earth.google.com – Google Earth has established itself as the premier satellite imagery company, providing users with highly detailed imagery and the ability to implement numerous other graphical features not available with any other program. Although you can download Google Earth for free, I highly recommend Google Earth Pro for those users who want to take their work to a new level. With the Pro version, you can create interactive fly-throughs that show aerial tours of a project and its environment, you can create movies in real time, add graphics and blend 3D visualizations into the satellite imagery. Google Earth never fails to impress my clients.

www.engadgethd.com – Perhaps the best Internet source available for entertainment-based technology information. This site is often the first place you would ever find information on emerging technologies.

www.gijsdezwart.nl/tutorials.php - A short and sweet guide to linear work flow and monitor calibration.

http://graphics.uni-konstanz.de/~luft/ivy_generator – An easy-to-use procedural ivy generator that provides amazing realism.

www.materials-world.com – A big challenge in creating visualizations is the ability to use the correct colors on the walls in your scene. If you do not have a good system in place for choosing and applying colors, you may go back and forth with the client numerous times trying to provide the correct color. Clients will often not even know what colors they will be using in their project. Even if they have a paint manufacturer and a paint name selected, that chosen color may not look right to them on their computer screen. This website provides a great solution. Materials-World.com lists virtually every major paint manufacturer and almost all of their available colors. Simply have your client go to this website and pick out or confirm their color selections, and regardless of variations in monitors, when you send them back the final product, it will match the colors they selected.

http://www.maxplugins.de – An immense source of free plug-ins for 3ds Max. This site also includes information about a wide variety of plug-ins for purchase.

www.sba.gov/starting_business – The growth of any business is closely tied to the application of good management skills and techniques. I highly recommend visiting this website to gain some great insight to managing a company, especially for those just starting out. Also worth checking out is the SCORE business toolbox at (**www.score.org/business_toolbox.html**), which contains numerous sample business templates, online counselors available for free advice, and numerous business guides to make running your own business easier. Equally valuable is the U.S. Chamber of Commerce Small Business Center (**www.uschamber.com/sb/toolkits**).

www.scriptspot.com – ScriptSpot is a diverse online community of artists and developers coming together to share and discover scripts for 3ds max and SketchUp. Their users come from a variety of fields - from Visual F/X to Game Developers, Architects or even hobbyists. Come discover. Share. Blog. Comment. ScriptSpot is powered by you.

www.skype.com – Here's a product that I didn't even know existed until the end of 2005. Once I learned about it, I began using it every day. Skype is a program that allows you to call anyone, anywhere in the world at no charge, provided they have Skype also. Since the basic version is free for download, there's no reason why anyone couldn't use it. For myself, the biggest benefit has been the ability to talk to my overseas subs at any time at no cost.

www.vray-materials.de – A website dedicated to the creation and sharing of V-Ray materials. With thousands of donated materials, it's easy to find one for any need.

Common 3D Mistakes

DURING THE PLANNING OF THIS book, we decided that it would be worthwhile to include an appendix dedicated to common 3D mistakes. Rather than provide our own input, which we have done throughout all other areas of this book, we wanted to include input from other veteran artists in an attempt to provide a greater perspective and to help illustrate how common some of the problems are that we face in the industry. Ironically, some of the mistakes and advice mentioned here echo the things we have mentioned in several other places in our own writing. Some of these mistakes apply strictly to business owners and some are generalized for any 3D artist at any skill level. Regardless of your current position in the industry, reading about mistakes made by others may prove helpful at some point in the future when you are pursuing other avenues of work.

As an additional note, we decided not to edit this writing so it would reflect the true views of those who contributed.

Common Business Mistakes

Mistake: Failing to realize that money spent on useful resources is time saved

Solution: Invest in your business! Is there any pride to be gained in spending all day modeling a specific chair, when it could be purchased for a relatively small amount of money? These days, thanks to our wonderful global community, there are countless tools available to make our work easier and better. Weigh the cost of purchasing tools to assist your work versus the time and effort it would take you to produce the same result on your own. Consistently step back from your projects and evaluate where your time, energy, and money would be most wisely spent. You are bound to be more successful when you use better tools.

Mistake: Allowing a client to pressure you for a price on the spot, even if it is "just a ballpark"

Solution: Be firm with clients! Have a thorough knowledge of what you are pricing and review all relevant drawings before providing a proposal. Do not feel strange about refusing to quote a price over the phone or on the spot. One of the most important things you can do to ensure you understand the scope of a project is to retreat to a private corner when you have some spare time, and review the entire set of plans. This will help you discover what is missing, what needs to be fixed, and what is required of you as far as time and effort. When all else fails, pad your proposal.

Mistake: Failing to educate your client about the 3D process

Solution: Explain your work at every available opportunity! Educate your clients about the process and complexity of 3D. Although 3D is becoming more of a norm and clients are becoming better educated with each passing year, most still have little understanding of what we do and how we do it. Educating your clients helps ensure that they understand what you need from them to do your work. This includes the information you need, and the time you need to do your work. Explain how you will need certain information from them to complete your job and help them understand how your schedule is tied to receiving that information.

Demand the same respect from your clients that you show them. If a client respects you, he or she will be less likely to demand unreasonable deadlines and less likely to believe you can be taken advantage of.

Mistake: Not using a contract for certain projects

Solution: Always use a contract! Protect yourself by always specifying in writing, and in great detail, what you and your client are responsible for providing. Specify exactly what each side will receive and when it will be received. The real estate market is dynamic and ever-changing. Even more dynamic is the progress of a typical project. There are often many individuals a client must rely on to see a project through to completion, and if any of these individuals fails to meet his or her own financial responsibilities, a project can collapse. When that happens, your fees can be jeopardized. A project may also be delayed or fail to be approved entirely by a governmental agency. Unscrupulous clients may decide that since they are not going through with their project, they don't have to pay you. Always plan for the worst in your contracts and think a few steps ahead.

Mistake: Never start working without a deposit

Solution: Demand a reasonable deposit upfront! Never begin working on a project until you receive a reasonable deposit, such as 33% or 50%. Anyone who is unwilling or unable to meet this simple and common business practice is probably someone with whom you should avoid doing business. There are countless reasons why it might seem suitable to begin working without a deposit, but it is not sound business. Making a deposit is the same as making a commitment, and clients unwilling to make such a commitment should be avoided.

Mistake: Making unreasonable concessions for clients

Solution: Be professional and consistent! Gaining respect from your clients and associates requires you to run your business professionally in all aspects. One way to lose the respect of others is to make unreasonable concessions for clients, such as not charging for things that are beyond the scope of a project, working ridiculous hours to accommodate a client who doesn't pay you on time, and using informal business documents. Set up professional rules for your

business, abide by them, and train your clients on what to expect each time they work with you. They will appreciate having a consistent experience with you, and feel more confident referring you to others.

Common Artist Mistakes

Mistake: Not devoting time to learn new techniques

Solution: Make time! Whether you are completely new to 3D or a veteran artist, strive to learn something new with each day of work. CAD operators in general seem to have a tendency to be set in their ways and learning new techniques is often a low priority. Take advantage of every available free resource, and as much as your finances allow, invest your own resources in furthering your education. Make the most of online forums, free tutorials, and peer relationships.

Mistake: Ignoring fundamental concepts

Solution: Master the basics! Many 3D artists produce outstanding work but work much harder and longer at it than is often necessary. Just as important as producing great work is knowing how to produce it efficiently. If you have never studied fundamental concepts such as memory management and proper scene assembly, you would probably be doing yourself a favor to invest some time in these areas.

Mistake: Not creating variety in your work

Solution: Create a unique look with each new project! Every project is obviously different, but too often 3D artists make their projects look the same. Many consistently use the same lighting, the same materials, and the same models with each new project. This not only makes your portfolio less diverse, it also hinders creativity and exploration of new ideas and new techniques. Put something unique and special into every project and expand your imagination whenever possible.

Mistake: Not taking advantage of online support

Solution: Create a support network! Create a network of support with others in the industry and solicit advice and constructive criticism on forums and websites dedicated to 3D visualization. Build friendships with people around the world doing the same work, as they are just as interested in hearing about your business as you are about theirs. Having access to a global community in these days of modern technology means that if you are stuck on something, you will have someone to help you at all hours of the night and on weekends. One of the best ways to improve as a 3D artist is through sharing opinions, receiving constructive criticism, and learning new tips and techniques from others.

Mistake: Ignoring useful resources

Solution: Create a collection of resources! Continually scour the Internet for articles, tutorials, news, reviews, and editorials, and make some type of organized record of them. Don't overlook topics that are not relevant to a current project, because they may prove useful in future projects. The tools available for our work changes as much as any other industry, and if you don't spend time looking for the next great tool, you are bound to never learn about it until it's no longer so great.

Marketing Your Services

In an ideal world, your business would grow so successfully that you would not need to focus time, energy, and resources on marketing your services. In the real world, however, such success usually only comes with time. How much time, obviously, depends on such things as the quality of your work and your general business savvy. But equally important is your ability to market yourself. Though good work sells itself, it only sells if someone knows you're selling. The next few pages discuss some of the key elements you should consider when marketing your services and offer some suggestions that can help make you successful in this area of business management.

Your Clients

It seems that with every year that goes by, more people become aware of and fascinated by 3D technology. Everyone knows the success Hollywood studios have had with animated films. Beyond these movies, however, the general public is not keenly aware of how this technology has been integrated into the world of architectural visualizations. One of the most common questions I'm asked when I tell someone what I do is, "Who do you sell to?" Before you market yourself in any business, you should know the answer to this question. Let's discuss some potential clients and some of the keys to successfully marketing to these clients.

Developers

A developer can be a single person, a large firm, or anything in between. A developer's primary goal is to acquire land and build, or develop, on that land, and the 3D visualization services you offer can be an invaluable marketing tool in helping developers make those sales.

You will probably find developers to be the best source of large projects with the greatest profit margin. This is because their projects usually entail more than just a single residence or office building. If you're fortunate enough to land a large developer as a client, you may find yourself working on a large golf course community, a stadium for a metropolitan city, or a skyscraper—any of which may have a $500 million price tag. This type of client may be more inclined to offer payment

for visualization services of this scale, knowing the marketing value of your services and understanding the small drop in the bucket that your service fees are when compared to the overall price tag. Take the $500 million golf course community, for example. A five-minute animation for such a project may require months of work for several people at the cost of $50,000 to the client. Even at $50,000, the total cost for your services would be no more than 1/10,000th or 0.01% of the project's cost. A developer probably understands, more than any other type of client, the ability of your services to produce sales. For these reasons, developers should comprise a good portion of your marketing effort.

As a freelancer or a small business owner, you might find it difficult to complete a large project typically available through a developer, and even more difficult to land such a project. Usually, the only way to do so is to create a good network of sub-contractors, which is my #1 production tip discussed in Appendix B.

Architects

For many 3D visualizers, architects are the most typical type of client, especially for freelancers or small businesses that are not willing or able to work on the large projects possible through developers. Whether or not this is true for you, you should consider a number of things when marketing to architects. First of all, most projects you work on will require the services of an architect. Even though some states and countries don't require construction documents to be certified by a licensed architect (and you should know if yours does), an architect will usually be used for structures of any significant size and complexity. In addition, when hired by any client who is not an architect, you will almost certainly be required to deal with the architect who is designing the project for your client.

Depending on the complexity and scale of your project, you may be required to work closely with the architect for a long period of time. Helping you in any way possible to make your work a success is usually in the architect's best interests. An architect would be unwise to upset his client (who may also be your client), because he or she failed to communicate the design to you either verbally or in drawings. Because of this, the architect is usually willing to give you whatever is necessary for you to complete your work.

During the course of your dealings with the architect, you have the opportunity to win him or her over as a future client. By providing quality work and professional service, you will have made a great impression and given yourself unhindered access to one of the greatest potential clients in our industry.

Continuing education

Many states and countries require architects to undergo a certain amount of continuing education each year to maintain their licenses. In my home state of Florida, for example, architects are required to take 20 hours of instruction in state-certified courses. These courses range from Waterproofing Exterior Walls to Soundproofing a Residence to Changes in the Building Code. The lengths of these courses can range from one hour to 20 hours or longer. Some architects choose to attend formal classes to receive their training while others choose to receive the majority of their training at informal seminars or even in their own office.

If you have ever worked in an architectural office, you have probably witnessed some of these informal courses. Architects will receive a call from a firm asking if the architect would be willing to receive a catered lunch for his office in exchange for allowing the firm to give a presentation on their product. Although an architect might normally want employees to do something more viable than listening to a sales pitch from an unknown company, the architect might be willing to yield the time if the sales pitch is actually a state-certified continuing education course.

This continuing education requirement gives you a great opportunity to get your foot in the door of any architect's office. By becoming a certified architectural continuing education provider, you will be able to establish great relationships with people who will be one of the greatest sources of future work.

One of the first things I did after starting my own business was to apply for such a certification. I was required to create a one-hour course of instruction with a detailed outline and slide-show presentation. I submitted the outline and a copy of the slide-show presentation along with an application (to the Florida Department of Business and Professional Regulation), and two months later, I was given certification to teach a one-hour course entitled 3D CAD for Architectural Visualizations. Upon receiving this certification, I updated all of my marketing tools to make it known that I was a state-certified architectural continuing education provider. This became a great marketing help, because it offered something useful to architects, and lent credibility to my business.

If you would like to receive the certification offered by your state, go to your state's official government website and search for "architecture continuing education." For more information about continuing education, refer to Appendix I.

Individuals

Perhaps your most frequent calls for work will come from individuals who request your services for a one-time project. These can range from a couple who are building a dream home to an entrepreneur who wants to build a small office complex, to a doctor who needs to move his practice into a larger building of his own design. This type of client should be given no less attention than any other, if for no other reason than that they may refer others to you down the road. If one of your long-term goals is to run a 3D visualization business without having to devote much effort to marketing, you will almost certainly have to rely on referrals to procure enough work, and the smallest of clients can refer the largest of clients. The doctor you are providing an animation for may have a brother who runs the largest development firm in your area. Such a situation presents another opportunity in which you are given unrestricted access to a great potential client.

Contractors

Another source of business for those of us in the architectural visualization industry comes from construction companies, or more simply, contractors. Contractors often design and draw plans for structures without the assistance of an architect. Some states and countries don't require an architect to approve the plans of a project. Even when the certification of an architect is required, the contractor may still perform all of the work (including designing and drawing the structure and coordinating with owner and subcontractors) and submit the plans to an architect for review and certification only. In these types of scenarios, contractors are just as likely to require your services as an architect.

Sometimes an architect or contractor will offer the option of your services to a client at an additional charge. The contractor may arrange a meeting with you and the owner, although this usually only happens when all three of you are in the same local area. When a meeting is not possible, you must usually rely on the architect or contractor to sell your services. Utilizing your services is usually in the best interest of architects and contractors, because having your 3D visualization for their project can significantly increase their client's certainty in the design, facilitate the bidding process and reduce the overall bid prices, and provide them a sample project to use as a marketing tool for future projects. Architects or contractors who can offer 3D visualization services to a potential client may gain an edge on their competition; it may ultimately be the factor that separates them from the others.

Real estate agents

For many years after starting my own visualization firm, I did not believe real estate firms to be much of a source for potential business for those of us in the 3D visualization industry. But when I started looking for a new office and contacted a few realtors, it occurred to me that I had stumbled upon possibly the greatest marketing strategy those of us in the visualization industry could employ. I had initially contacted three realtors about three different offices I found while driving around town. While talking to them over the phone, each asked what type of business I was in. After I told them, each seemed enthusiastic about meeting with me to discuss the possibility of me doing work for them. I arranged a face-to-face meeting with each agent, and in each meeting we spent more time talking about my business and what I could do for them than talking about the office I was interested in purchasing.

Although commercial realtors are not in the business of buying and developing property, they usually have long-term partnerships with developers, in which they act as selling agents for the developers' projects. In this situation, the real estate firm may be very willing to support the use of your services, whether you are paid directly by the real estate firm or the developer. In either case, the real estate firm is responsible for selling the developer's property, and anything that helps is worth investigating, especially something as interesting and eye-catching as 3D. Realtors have a vested interest in making their clients happy, and introducing a developer they work for to a great 3D visualization firm can make them very happy. For all of these reasons, real estate firms should never be overlooked as a source for potential business. I highly recommend contacting a few realtors and telling them you're interested in purchasing a new office. You might be amazed at what it leads to!

Your Tools

Now that we've discussed some of your greatest sources of future visualization work, let's look at some of the marketing tools with which you can reach your potential clients. Even on a limited budget, you have numerous tools at your disposal. In the remaining pages of this appendix, we will look at some of the tools available, and some of the tricks to making the most out of them.

Websites

A website is easily your most important and ubiquitous form of marketing media. Unless you are a well-established firm with little need for marketing, an effective and eye-catching website is an absolutely critical tool to your business. With a website, you can show your work to anyone, anywhere in the world, at a minimal cost. But no matter how well-designed, a website will not be a marketing tool that brings in a large number of cold calls that lead to contracts. For this reason, I firmly believe spending a large amount of time and money on specific website marketing is not a good idea. What makes a website highly effective and important is that it serves as an electronic brochure that anyone can access anywhere and anytime. This electronic brochure is the best way to follow up a conversation with a potential client. Whether the potential client is someone you ran into on the street, someone who saw your advertisement in the phone book who calls to investigate your services, or someone you just had a meeting with, your company's website serves as the ultimate marketing tool.

When a potential client calls you to get information about your company, they generally ask the same questions: What do you do? How do you do it? What do you need from me to start? How much does it cost? Rushing the conversation by simply saying, "Check the website; everything you need to know is there," can be a big turnoff for a client. Instead, you should attempt to feel out callers; answer some questions, and ask some of your own. But you can end conversations by

informing the callers that they are welcome to visit your website to view your portfolio and find some additional information about your company and what you do.

What should your website contain, and how should it be designed? Without a doubt, it should contain the best work you have ever created. Your website should be easy to navigate and not contain an enormous number of large graphics or introductions that take excessive amounts of time to load. Your potential clients may be impatient and choose not to sit through fancy graphics or take the time to figure out how to navigate your site. More importantly, your company is being evaluated by the viewers at every moment, and an inability to create an efficient and effective website may give the viewers doubt in your ability to create an efficient and effective product for them.

I suggest creating a navigation menu with as few buttons as possible, just enough so that the viewer doesn't have to go through several pages to get to a particular point. My recommendation for the minimum page navigation buttons you should include follows:

- **Home**: This link, which takes the viewer back to the homepage, is an essential link that any website in any industry should have.

- **About Us**: This is a standard label for a link that takes the viewer to a description about your company. This link is important, because not revealing at least the basic information about your company cannot help but give the viewer doubts as to your company's candidness.

- **Gallery**: Display the best of your company's work here. For each category of content, I suggest creating a separate link. For example, on the gallery page of my website, I created three separate links: one for animations, one for renderings, and another for imagery.

- **Contact Us**: Another standard link, it should include at least one email address and phone number.

Brochures

Brochures are another type of media I consider a must for those of us in the visualization industry. Brochures give you the ability to show your work to others during face-to-face meetings, tradeshows, or anyplace you run into potential clients. Your brochure can serve as your resume and is often the very first look others take at your work. Just like your website, your brochure should show off your best images and make a clear presentation of your company's services. If you offer animation services, state it clearly. If you offer unique services, state each clearly—don't expect the viewer to know about them automatically. Like your website, your brochure is a demonstration of your presentation skills and a poorly designed brochure can kill your chances to receive work from the viewer.

I highly recommend using a professional printing service for your brochure, even for freelancers who only need a small number printed. But when and how should you distribute your brochures? If you believe only one thing in this discussion on marketing, let it be this—do not mass-mail your marketing materials. From my personal experience and that of many others I have spoken to, mass mailings waste time and money. A very small percentage of the brochures will ever make it to the person who actually has the influence to supply you with work. Those few that do make it to the right person, which could be as little as 1%, will likely be treated no better than the mounds of junk-mail you receive at home. This marketing strategy sends the message that whatever you had to say was not important enough for you to say in person or with at least a phone call. You would be better off saving your money, printing fewer brochures, and handing them out as a follow-up to a phone call or a face-to-face meeting.

Phone books

If you can afford to splurge in any marketing area, an advertisement in the phone book would be a good choice. Many cities have more than one phone book, with one often being much more expensive than the others. In this situation, some caution should be taken and some research conducted, to determine which one to advertise in, or whether to advertise in more than one. In my hometown of Sarasota, we have two phone books, the *Verizon Yellow Pages* and the *Yellowbook*. The first year I was in business, I decided to splurge and advertise in both. I placed two ads in both phone books under the headings of "Architectural Illustrators" and "Graphic Design."

In the *Verizon Yellow Pages*, my ads cost three times as much as in the *Yellowbook*, even though their size was half that of the *Yellowbook* ads. I believed at the time that the circulation numbers justified spending more on the Verizon ads, but after more research, I learned that the greater circulation Verizon claimed was in residences. I realized in my second year that my primary focus should be on readers in businesses rather than in residences, and since the *Yellowbook* claimed to deliver to every business in the area, I didn't believe advertising in the more expensive book was justified. During that first year, I made it a point to ask people who called where they heard about my business. I received just as many referrals from the less expensive *Yellowbook* as I did from the more expensive *Verizon Yellow Pages*, which justified my decision to drop the Verizon ads.

Your decision to advertise in your local yellow pages should also depend heavily on your local area. If you live in an area like Sarasota, Florida, which is exploding in growth, advertising in the yellow pages should be a given. In areas with little growth, advertising in your local phone book might be a waste of money. If you decide to advertise in a phone book, I recommend placing an ad in the two separate locations I mentioned before, "Architectural Illustrators" and "Graphic Design." An ad placed under '"Architectural Illustrators" is likely to be seen by all of the architects listed, because their ads will appear right before yours. A listing under "Graphic Design" is a viable choice, because a large percentage of people think of the word "graphic" when looking for someone to provide visualization services. Other terms such as "architectural illustrator" or "visualizations" are not as well known outside the architectural world, but "graphic" is a generic word that describes our type of work better than any other word or term found in a typical phone book.

In addition, a listing under the category "Graphic Design" will draw the attention of those who are not necessarily looking for your type of business but may decide to investigate hoping to find a better product than what they were looking for in the first place. For example, if a developer wants to create a brochure for a condominium being sold and needs a graphic image of each floor plan, he or she might call you to ask if you provide that type of service, and find that you can provide much more than the ordinary floor-plan graphic common in any brochure of that type. That developer may decide to spend a little more to have you create a 3D floor plan from a perspective view and, down the road, possibly an animation.

Finally, I have received many calls over the years from graphic designers who saw my listing next to theirs and called for help producing work for their clients. I received these calls, only because they were checking out their competition.

DVDs

If your company provides animation services, then DVDs are an essential component of your marketing strategy. DVDs provide your potential clients with the only true representation of what your animation services entail. Animation on your website can only provide a small glimpse of your company's capabilities, because even faster-than-normal connection speeds take too much time to download videos shown at DVD quality. Smaller resolutions allow you to put an entire demo DVD on your website, but even they are not as compelling or revealing as the full-size DVD resolution.

Going back to the discussion on mass mailing, DVDs should only be sent when preceded by a phone call, so someone of authority expects to receive it. DVDs take a small amount of time to load

or set up, but sometimes that's too much time for some people. A face-to-face meeting will allow you to combine both the best of what you have to say and the best visual imagery you have to show. A portable DVD player offers a great way to show your DVDs (outside your own office).

Phone calls

Nobody likes receiving a telemarketing phone call, but when done with a certain style, placing a cold-call can yield tremendous results. The main goal is to speak to someone with authority. For small companies, those with approximately 10 staff members, you might try asking to speak to the owner or manager directly regarding visualization services. For larger companies, speaking to the owner will be much more difficult, but you might find a marketing division that is willing to meet with you to discuss your services.

Another approach I have found successful for larger companies is asking to speak to human resources. Employees in human resources tend to be more receptive to meeting with outsiders, because it's their job to do so. Even though human resources personnel are not the decision-makers you need to speak with, they can arrange a meeting with the right ones.

Because of the unique nature of your services, and the fact that a quality visualization is fascinating and entertaining, the people you're meeting with can be hooked the moment they see your work. Above all, arranging a face-to-face meeting with someone in a firm is the critical first step.

E-mails

Under no circumstances should emails be sent when any other form of marketing is a viable option. E-mails should never be used locally, that is, within driving distance, when a phone call or face-to-face meeting is possible. Clearly, if you wish to market to prospective clients at great distances and you cannot afford the time and cost of phone calls or brochures, e-mail is a reasonable option. But e-mails must be exceptionally eye-catching and extremely brief to be considered by the viewer longer than the split-second it takes to find the delete button.

Spam is generally viewed with hostility, so you should be careful not to make a nuisance of yourself. Your e-mails should appear to be written directly to the company you're contacting rather than appearing as spam. Include an image or two of your best work, use a polite introduction and closing such as "Dear Sir" and "Sincerely," and include a link that takes the reader immediately to a page with eye-catching images that beg for more exploration. You should provide an easy mechanism to take addresses off your mailing list if people so desire, and respect their wishes.

As an aside, my best two overseas subcontractors actually contacted me with advertising e-mails. I was impressed with their work and knew immediately that I wanted to work with them in the future.

Summary

Marketing a 3D business can be tricky. You can be the best animator in the business, but if the right people don't know your business exists or aren't introduced to your business in the right way, your business can't be successful. For most of us, building up the right clientele will simply take time, but the concepts discussed in this appendix should help speed up the process and also help you avoid some common marketing pitfalls. With every passing year, your business should only grow stronger.

Pricing Your Services

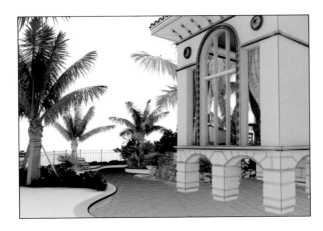

THE PURPOSE OF THIS APPENDIX is to help improve the way you establish the fees you charge for your services. It's geared toward freelancers and small business owners who often have great production skills but lack experience with the business end of the industry. Often in our industry, new companies assume that the quality of their work is enough to be successful. Although great work tends to sell itself, great work alone does not usually suffice for a 3D visualization company.

We decided to include a short discussion on pricing in this book only because this information is requested so often from our students as well as those who participate in the many 3D forums. It is not our intention to dictate how you conduct your business, and more specifically, how you price your services. This document serves only to offer a few suggestions to new business owners who could benefit from some of the hard lessons learned by many of those who contributed to this book. It is quite simple and very general in nature, yet offers some sound advice we see too often overlooked.

To establish a fee for your services, be it an animation, a still image, or modifications to work done in the past, we suggest using the following very simple formula, to which all other discussion will refer back.

daily rate x project days = project fee

Often in our industry, business owners establish their pricing for a project based on a set daily rate, without first putting reasonable thought into how to establish an appropriate daily rate. Until you create a comprehensive budget that factors in all overheads and a realistic number of production days you have in a year, using the above type of formula is a risky strategy.

Although it probably goes without saying, the daily rate listed in the previous formula actually represents the required daily revenue your business must generate on a daily average, plus the profit that you decide to build into your operation. It's important to make this simple distinction because your required daily revenue is what you *must* generate to stay afloat, while the daily rate

you ultimately charge factors in profit that most businesses never even see in the first few years of operation. With this in mind, we can write our daily rate in the following way:

daily rate = required daily revenue + profit

We will discuss profit momentarily, but right now, let's focus on calculating the revenue you have to generate to stay afloat. To do this, we will show one final formula:

required daily revenue = overhead costs / production days

The first step in calculating your required daily revenue is to calculate overhead costs. Once overhead costs are established, we can determine the total number of days in a year that we have to work on projects and add to that a profit margin. With a required daily revenue established, we can determine how much profit we would like to earn, if any, and this becomes our daily rate. We can multiply our daily rate by the number of days needed to complete a project, and this becomes our project fee. Pricing projects in this fashion may seem to be too simple to be applicable to your business, but we would argue that it's one of the most beneficial business strategies you can employ.

Calculating your overhead costs

Overhead costs are all the expenses that are necessary for the continued long-term operation of a business. These should be calculated on a yearly basis and should include everything from office rent to the software you use. It's also important to factor in things like the per year cost of equipment that will need to be replaced at some point in the future, such as computers. If you are a freelancer working out of your home and want to calculate your pricing based on conducting business from an office outside your home, remember to include the future expense of a lease or rent. Some examples of yearly overhead costs that might need to be factored in to create a legitimate daily rate include the following:

- office lease and utilities
- insurance
- travel
- employee education (including your own)
- software and hardware
- marketing
- sub-consultant fees
- salaries (including your own)

The last item on the list is particularly important because freelancers and small business owners often exclude their own salary from their list of overhead expenses, and instead consider it an item that can be sacrificed for the sake of building a profitable business. This way of thinking is usually not sustainable and is one of the reasons some businesses fail before their third year in operation.

Two important questions arise at this point. One is, 'How profitable does the business need to be?' This will be addressed in a moment. But first, another question that should be asked is, 'How many production days will I have in a year?'

Calculating production days

Once you calculate your overhead costs, the next step is to determine how many days in a year you can reasonably expect to work on your projects. It's absolutely critical that you be true to yourself in this area and you accurately determine what time you are willing and able to put into your business. Remember that larger companies have separate departments for marketing and accounting, but as a freelancer or small business owner much of your time will have to be set aside for these and other areas. Give yourself reasonable time to focus on these areas of your business and be sure to allow for some time off during the year for holidays, illnesses, and family matters.

An example of how many available production days you might have is as follows:

365 days a year, less 104 (weekends), less 20 days (holidays), less 5 days (sickness), less 24 days (2 days/month marketing and accounting) = 212 days a year for production.

Once you arrive at a reasonable number of production days available, you will be one step closer to calculating your required daily revenue.

Calculating your profit

The final step in calculating your daily rate is to establish a profit margin. Once you accurately establish your yearly overhead costs and divide this amount by your total production days available, simply add the amount you want to earn as a profit, and you will reach your daily rate.

If you are content with barely making ends meet long enough to become established and reputable, which is the goal of many new business owners, then your business's profit is something that can be legitimately sacrificed. If you consider the fact that many businesses fail before their third year, and those that eventually do succeed fail to be profitable for many more years, then building a business that fails to make a profit in the short-term is not out of the question. However, if you decide to do without profit, your project fees should be unwavering because they become based solely on your overhead costs. It is extremely important, however, to remember to distinguish the difference between doing without your own salary and your business doing without profit. Those who fail to separate the two have little chance for success.

If you decide to sacrifice your business's profit, it's still important to calculate what your daily revenue would be based on the profit of typical businesses that generate a successful profit margin. Many businesses use a long-established rule of thumb for determining what to pay their employees. As a general rule, employers often pay their employees 1/3 of the revenue their employees generate. This leaves 2/3 for the business. Half of this is often allocated for overhead costs, such as those listed earlier, and the other half is set aside for profit. For example, if you are a 3D specialist earning $20/hour, then your employer is probably billing your time out at about $60/hour. With this rule, 1/3 goes to the employee, 1/3 goes to overhead costs, and 1/3 goes toward profit and absorbing unexpected dry spells where production slows or projects fail to materialize.

If you follow this rule as a guide you can assume that at some point in the future, when your business has become truly established, your salary as a sole proprietor should roughly approximate your overhead costs, which in turn should also approximate your business's profit. Likewise, the combined salaries of all employees should roughly approximate all overhead costs and all profits. This is a good rule to plan with because even when profits are crippled by dry spells and unexpected financial burdens, your business can still be successful.

Summary

For some 3D artists, pricing is the most challenging aspect of running a successful visualization business. Clients often understand very little about how your work is produced and a great deal about pricing and negotiating. That by itself can put you at a significant disadvantage when you bid on a project, and the bigger a project is, the more likely it is that your potential client will be a skillful negotiator. Combined with some of the other documents in the appendices of this book that deal with things such as marketing, business plans, and pricing presentations, you can prepare yourself for successful price negotiations.

Additional Information

If you would like some additional information on pricing your services, be sure to check out a fantastic article from Blue Flavor (www.blueflavor.com), web and mobile design, development and consulting company. The following is an example excerpt from an article written by Brian Fling and found at:

> www.blueflavor.com/blog/2006/apr/25/pricing-project

Pricing Poker: Bluffing, Budgets and Trust

One of the great mysteries of pricing a project is budgets... vendors always want them, clients never want to reveal them. We ask every client if they have a budget that they need us to work within, every agency I've ever worked on the other side of the fence with has asked the same. Very, very few clients ever reveal this crucial detail.

Having been the client on many occasions, I usually have a price in mind. The problem is if I say I'm willing to pay $15,000 for something, proposals magically come back with proposals priced at about $14,999. On the other side of that coin, every book on consulting says never ballpark a project, even though the client always asks for it.

I find it funny... in a sad sort of way, that we often start out our partnership with bluffing, no one saying what they are really thinking... how much they are willing to pay and how much it should cost (again using scraps of paper in the car dealership).

The budget reveals a lot about the client and the project. We use it as a barometer of how serious the client is, if they have given their project serious consideration, how much they understand about the project, to evaluate possible return on investment scenarios, to help define scope, whether it is cost-efficient for us to pursue, and to see if we can even do the project within their budget.

Creating A 3D Business Plan

WHETHER YOU START A 3D business as a sole proprietor or as one of several partners, a business plan is arguably the most important document you and your company will ever create. Regrettably, it is also one of the most overlooked and neglected. Many professionals will succeed regardless, and many will fail regardless, but those who take the time to create a plan ahead of time will almost always be more successful and avoid many of the pitfalls and roadblocks they would have otherwise been blind to. Simply put, a business plan is a road map to success for your business. It's a document that summarizes the steps your business needs to take to be successful.

The value of a business plan does not lie in the document itself but rather in the steps one takes to create it. If one 3D visualization company gave their business plan to another visualization company, the plan would be far less valuable to the borrowing company and be best served as a template for their own plan. A business plan is only a worthwhile document when careful thought is put into its creation by each owner of the business because the real value lies in the systematic research, planning, and thinking each owner puts into the plan.

Any veteran 3D visualization business owner will agree that starting a successful 3D business requires an enormous sacrifice in free time. So in the frenzied, hectic beginnings of a startup business, it should be no surprise that most owners are inclined to do more doing than thinking. But the fact is, planning helps you anticipate problems, capitalize on opportunities, and face some tough questions that many often overlook in the midst of all that doing.

When my business partner and I first started our 3D business, we made the mistake of doing too many projects without the aid of a legal contract. This was a decision we finally regretted one too many times and after learning some of the many pitfalls of not doing so, we now require contracts on ALL projects. We always stress the importance of contracts when we teach our 3D courses, but most students are surprised to hear us say that, in our opinion, a contract's greatest value does not lie in the legal protection it provides, but rather in a far less conspicuous quality. When created properly, a contract's greatest quality is its ability to delineate, without question, each party's responsibilities and obligations. If for no other reason, 3D business owners should create a contract so the client knows exactly what the final product is, when it's to be finished, and what their responsibilities are to help you do your job properly. A business plan works the same

way. By creating an effective business plan, there should be no doubt in what lays ahead for your business and the obligation you and any other owner has to making the plan successful.

So what goes into a 3D business plan and what are some critical steps to take along the way? If you look at different sources, you are bound to see the same general steps from each source, but I would prefer a slightly different set of steps for a 3D business – one that mimics the approach I would take with a new client that is looking for 3D. These components and steps are an extremely condensed version of a good plan but can serve as a general guide that can help you navigate the much longer and more complicated plans found online.

Products and Services

Describe in great detail what all of your products and services are: still renderings, animations, branding, websites, interactive virtual reality, 3D printing, etc. When a client inquiries about 3D, the first thing I will always ask is what the final product is. Without knowing this, all other information is almost useless.

Market Analysis and Pricing

List your potential clientele and establish your pricing. By researching who your potential clientele are, you can focus your marketing energy in the right direction and achieve the best return on time and money spent. Critical to this is determining what your customer's needs are, where they are, and how you will reach them. Unfortunately, no area in the 3D business world, or in most businesses for that matter, is more difficult to get right and less forgiving to error as pricing. Within your market analysis include a summary of your competition, profit and loss, cash flow, expenses, and your monthly budget. Always be conservative in your estimates. Just like we tend to underestimate the time it takes to complete a 3D job, business owners underestimate the costs of running a business. . .especially the initial one-time only costs that most never think of, such as liability insurance needed with most commercial leases. Working in 3D, liability was the last expense I would have thought about ahead of time.

Supporting Materials

Determine what materials and documents (besides your business plan) you will need to be successful. Examples of some important materials are: your contract template, marketing presentation (both with and without pricing), printed brochure, website, and demo DVD, to name a few.

Operational Plan

Explain the daily operation of the business and the daily/monthly/yearly responsibilities of each individual involved. Even for sole proprietors, listing these responsibilities is critical.

Marketing Plan

List details for how your business will market itself in all possible business climates. How will your plan change when business slows down? What are your marketing materials and when will you update them? Perhaps no part of the 3D business plan should receive more reviewing and updating

than this area. When you finish a large successful project, will you immediately add the imagery to your portfolio?

Additional Suggestions

Some parting thoughts on a successful plan are:

- Think and plan long-term, but always remember that most business fail in the 1st two years. Determine how long you can go before being profitable and where you want to be after five years.

- The plan is just as important down the road as it is at the start. Review it regularly to make sure you are on course, or so you can adjust to market changes.

- Get help from others who have been through it before. Share your plan with others who can help.

- As the saying goes, garbage-in equals garbage-out. Write the plan yourself or don't even bother making one.

- Use online resources such as SCORE (`www.score.org`), which offers free tools, education, and counseling for small businesses, and Palo Alto (`www.paloalto.com`), a leading software provider for creating business plans.

The Professional Services Agreement

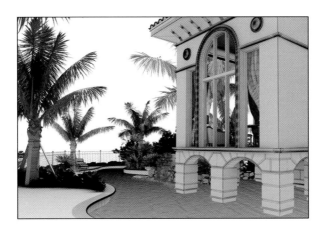

IN THE 3D VISUALIZATION INDUSTRY, few would probably question the importance of a contract between themselves and a client. It doesn't take much time on any of the popular 3D forums to see that most members strongly support the use of a contract of some type, even for projects with which the client is well-known and highly respected. However, the reason why a contract is so important might not be so commonly understood.

Contracts in any industry serve one obvious purpose of providing legal protection, whereby either party can be afforded the opportunity to pursue legal action to recover financial damages. Ironically, this legal protection is not at all what makes a contract so invaluable for most projects in our industry. In an ideal world, having a good contract in place would mean that regardless of a project's size, we can all sleep soundly knowing that if things unravel between us and the client, we can recover our losses with the help of our local legal systems. Unfortunately, we don't live in an ideal world and the reality is that while all of us will be victim to unscrupulous clients from time to time, it is unlikely that many of us will ever recover damages through legal channels.

Except for very large projects where a tremendous amount of money is involved, few of us can afford the legal expenses that arise by taking advantage of laws in place. In most cases, we realize that pursuing legal action is not worth the time, cost, or risk, whether we have a clear case or not. Despite having worked in this business for over ten years and discussing the matter countless times with peers, none of the partners at 3DAS has ever met an individual or company who has successfully recovered damages from a client.

What makes a contract so invaluable is not the legal protection it provides, but rather the information it provides. A well-written contract should make it clear beyond any reasonable doubt, what the responsibilities and expectations are of every party involved in a project. By making this information understood from the start, a properly worded contract should prevent a guilty party from deciding to fight in the wake of legal action, and prevent a project from spiraling out of control and forcing either party to pursue legal action in the first place. By taking the time to word a contract properly and review it with a client early on as necessary, you can avoid learning the hard way how small an amount of legal protection a contract provides.

Sample PSA

Included in the support files of this book is a sample contract, referred to as a **Professional Services Agreement** (PSA), which you can use as a template for the creation of your own contract. This PSA is comprised of 4 main sections; **Authorization to Proceed**, **Scope of Services**, **Professional Fees**, and **Standard Terms and Conditions**. The remainder of this appendix is a brief discussion of some of the most important areas of these three sections.

Introduction and Authorization to Proceed

This section of the PSA serves as an introduction and the location where both parties can sign to acknowledge acceptance and authorization to proceed. Besides the authorization to proceed, the most important highlight of this section is paragraph 1.a. where the client designates one representative as *"the single individual whom has the authority to accept and/or approve services and invoices provided by 3DAS and to direct tasks per contract on behalf of the CLIENT or Owner."* For projects with numerous individuals involved on the client's side, this is a very important designation to make. Without making it clear to everyone involved that one individual should serve as the approving authority for your services, your efforts to solicit information, critiques, and approval may have to be performed over and over again to different individuals. Making this designation early on can save a great deal of time and prevent awkward situations between you and the client.

Scope of Services

Exhibit A, Scope of Services, is without a doubt the most important part of the PSA. This section should answer in great detail the who, what, when, where, how, and why of your project. The information provided in this section should make it clear to the client, without question, exactly what he or she can expect throughout the course of the project. There is no one most important part of this exhibit, because all of it is critical and equally important. It is comprised of 3 parts; **Description of Services**, **Final Product**, and **Project Schedule**.

Description of Services

Many clients understand very little about the 3D design process and exactly what they are getting themselves into. If you do not spell out what you will be providing in great detail, you are likely to see complications arise later on when the client realizes that his or her expectations were not met. Notice in paragraph 1.a.1 of the sample PSA, that precise details regarding animation length are included as well as comments such as *"Virtual elements of the animation will be limited to those elements lying within the boundaries of the property."* It is extremely important that both parties know exactly how long an animation will be or that nothing outside the boundary of the project's property lines will be shown; or, least created in 3D.

Included in the description of services should be details about which rooms will be visible for interior sequences and which areas of the property will be visible for exterior sequences. Without these details, clients will too often ask you to add a bathroom, foyer, lanai, etc. to the animation sequence without really understanding the enormity of what they are asking.

Most of the details outlined in the scope of services should be mentioned to some extent during the first sales pitch you make to a client. One of these details that should be driven home over and over again is mentioned in paragraph 1.a.4. Here we make it clear to the client that every detail shown in the project's elevations will be modeled and shown in 3D. We mention this from the first meeting with a client, informing him that as 3D artists we make the presumption that if an architectural feature is important enough to be seen in an elevation, it is also important enough to be see in 3D. Likewise, if it's not important enough to be drawn in the elevations, then it is not important enough to be modeled in 3D. For example, if the client provides us elevations that don't include door knobs, we cannot be responsible for providing such a detail in 3D and may elect to charge additionally for such details if the client decides later on that it is necessary.

Also discussed in this section are details regarding the resolution of still imagery provided. Many clients don't understand the significance of pixel resolution and may later ask you why their image looks so bad when it's blown up to fit a 8'x4' billboard. Addressing the maximum resolution you are providing may prevent such a question later on.

The last section of the description of services addresses the all-important issue about modifications and post-production. You should use every opportunity available to ensure that the client understands what he or she can change without incurring additional costs and the exact details regarding how draft renderings are presented and how often they are presented. Notice in paragraph 1.c.1 that we inform the client that the very first test render that will be presented will be a black and white image or animation without materials or colors applied. The sole purpose of the initial test-render is to allow the client to identify design issues or modeling errors. By excluding colors and materials, you allow the client to focus on what is really important early on; providing approval of the 3D models.

Final Product

The very first question you should always ask a client during the first discussion of a project, unless the client has already provided the information, is "What is the final product?" Without knowing the answer to this question, everything else discussed is a moot point. This section of the PSA simply addresses this issue in precise detail. If the client wants something more than a standard T.V. resolution or something more than the typical still-image resolution you provide, reading this section should make it clear that he or she needs to ask.

Project Schedule

This section of the PSA serves two purposes. It specifies what you provide the client and when, and identifies what the client needs to provide you before you can begin your work. It is critically important to identify in the contract exactly what the client needs to provide to you in order for you to start and complete your work, because if a project gets off schedule and fingers are pointed, having made your needs clear from the start can keep you from being blamed.

Notice in paragraph 3.b, that completion of the various stages of the production process are not specified in hard dates but rather in days from the completion of a previous phase. This is very important, because if you tell the client for example that you will provide the first draft renderings by a certain calendar date and miss the date because you got a late start as a result of not having all the information you needed, then you might have no one to blame but yourself.

Professional Fees

By listing all fees on one page, as shown in Exhibit B of the sample PSA, you can make it very easy for the client to understand what is being charged and that there are no hidden fees buried elsewhere in the contract. Doing this also makes it possible for you to send your employees or subs the scope of services without revealing the details of the project's finances. Providing copies of the scope of services to all the individuals working on a project makes it just as clear to your production personnel exactly what needs to be done, as it does to your client.

Notice in paragraph 1.c that an hourly fee is billed for additional services not included in the scope of services. Since most of the profit from a project would come from the total fee outlined in paragraph 1.a, it might be beneficial for your hourly fee to reflect a lower value than what you really budget. In other words, if you decide that to be profitable you need to charge X per hour and you determine that 100 hours of work are needed to complete the project, you can simply make your total fee 100X. However, if you state your hourly fee as less than X, you will not make as much on changes but the client will assume that your total cost will be based on the hourly rate, and therefore, that more hours are involved in the project and he or she is receiving a greater value. Since the amount of time spent on changes is usually small relative to the total hours of a project, using this technique is usually beneficial.

Standard Terms and Conditions

Every business that uses contracts should have standard terms and conditions, and in the 3D visualization business, the terms and conditions identified in Exhibit C of the sample contract should provide adequate protection against unforeseen issues.

Two areas of particular importance are mentioned at the beginning of this exhibit; **Client Reviews and Changes** and **Colors and Materials**. They convey to the client that our work is just as much an art as it is a science. As such, they must understand that things like colors, lighting, and interpretation of non-specific data will never be perfect. Specifically it states,

- *3DAS will use its best effort to accurately match color information and materials provided by client. Client recognizes, however, that colors and materials will vary from the supplied information due to lighting conditions and the specific printer and/or display device used to display the image. Reasonable variations from supplied color data material representation are to be expected.*

- *Client understands that the 3D visualization process is not perfect, that "gray areas" will exist, and some information may be missing if not clearly and precisely specified in the CAD drawings. For the process to be cost-effective for both parties, Client will allow 3DAS to use its experience and judgment to create the best possible animations and images given time, financial and informational constraints. 3DAS will also allow Client opportunity to make reasonable changes as long as they significantly improve the presentation.*

3D CAD Brief

IF YOU ARE A SOLE proprietor or small business owner and want an effective technique to get your foot in the door with architectural clients, consider becoming a certified continuing education provider. Many states and countries require architects to complete a certain number of hours of formal education each year, and if yours is one of them, you can take advantage of this by offering a course for which local architects can receive their credits. Figure I-1 shows the website and posted regulations for the State of Florida regarding continuing education for architecture and interior design.

"Both architects and interior designers are required to complete 20 hours of educational instruction or training, in subjects or courses approved by the Board, each biennium prior to the license expiration date. A minimum of 16 hours must be in technical and professional subjects related to safeguarding life, health, property and promoting the public welfare."

Figure I-1. The webpage discussing Florida's continuing education requirements.

Anyone can create a continuing education course of 1 hour or more and submit it to his or her respective government for approval, as the individual in Figure I-2 has done. Doing so can open new doors for your business. For a more in-depth discussion on continuing education and its marketing benefits, see Appendix E.

Course Number:	AR.04.1551	Contact Hours: 1.00	Counterpart Course:	Expiration	Feb 28, 2009
Course Title:	SLIDING DOORS IN MEANS OF EGRESS AN ANALYSIS OF CHANGES TO THE MODEL CODES				
Course Level:			Course Type:	Approved	Feb 01, 2008
Contact Person:	Eric Eiffert		Phone: (941) 223-7279		
Instructors:	Eric Eiffert				
Provider 3060	WON-DOOR CORPORATION				

Figure I-2. An example of a continuing education provider and his course offering.

Visit this book's homepage to download a copy of the 1-hour course taught at 3DAS, entitled **3D CAD for Architectural Visualization**. Figure I-3 shows some of the slides from that presentation found in the file **3D_CAD_Brief.pdf**.

Figure I-3. Example slides from the 3DAS continuing education course.

The 3D Presentation

AN IMPORTANT TYPE OF MEDIA that every 3D business or freelance artist should have ready at all times is a detailed presentation of what they do and how they do it. Whether you present this in person, by mail, or provide over the Internet, a 3D presentation is an invaluable tool that should be continuously updated and reviewed. This product should showcase some of your best work, while simultaneously presenting an overview of the 3D process and the range of your services. A few sample slides of the presentation 3DAS uses are shown in Figure J-1 and the presentation itself is provided in the file entitled **3D_Presentation.pdf**. Feel free to use this as a guide to creating your own.

Figure J-1. Sample slides from the 3D presentation used by 3DAS.

It should be mentioned that while sample DVDs (such as the one shown in Figure J-2) serve as a great tool to showcase one's work, especially when that work is an animation, a DVD should never be the sole type of media you rely on to present your work to potential clients. If you meet with a potential client face-to-face, you should always be prepared to show a slide show of your work, as needed, and the prices you charge. At 3DAS, we have created two versions of the same presentation, one with and one without pricing, and show one of the two as the situation dictates. Leaving a printed version of this presentation can also be helpful in helping a client remember your work.

Quick Reference Guide to Critical V-Ray Settings

V-RAY IS A THIRD-PARTY PLUG-IN that runs within 3ds Max, replacing its default scanline render engine and providing users the ability to achieve greater realism with more speed and less difficulty. Developed by the Chaos Group in Sofia, Bulgaria, V-Ray has become the most widely used render engine for architectural studios around the world and is a top choice of many movies studios as well. Backed by an innovative group of developers and a dedicated user base, V-Ray stands poised to be a leader in render engine software for many years to come.

So what makes V-Ray so special? There are four characteristics that accurately define the suitability of any 3D program; speed, ease of use, quality, and cost. Along with a great marketing strategy, the success of V-Ray in its first few years was due to a great mixture of each of these qualities. Essentially, all advanced render engines are capable of the same level of quality, but what continues to make V-Ray a favorite among many users is its speed and ease of use. And although not free like mental ray, its price of $999 (as of the printing of this book) is worth every penny for many production companies who cherish every hour saved in render time and every hour saved in employee training.

The goal of this document is to provide a quick overview of the most critical V-Ray features of the final 1.5 release and a quick reference for great test and production render settings for both stills and animations. It is important to note that settings that should not usually be changed from their default values will usually not be discussed here. The features in V-Ray we consider most critical, and therefore, the features highlighted here, include the following:

- Image Sampling
- GI Engines
 - Irradiance Maps
 - Light Cache
 - DMC

- Color Mapping
- Environment Lighting

Image sampling

Image sampling is arguably the most important and least understood feature in V-Ray. If you don't conduct good image sampling, having extremely high quality settings in other areas of the program, such as GI and materials, will do you absolutely no good.

Image sampling controls how V-Ray implements antialiasing in your scenes, which is a process used to reduce imperfections in the rendering process caused by color changes that are too drastic, and occur over too small an area of screen space to be adequately depicted by the pixels that define that space. After GI is calculated, V-Ray determines the final color to assign to a pixel by sampling each pixel. This simply means that a test is conducted to determine what object is detected at an infinitely small point lying at the center of each pixel, along with the material and lighting applied to that point. If V-Ray only takes one sample per pixel, then whatever color it detects at the center of a pixel is what the entire pixel will be colored. But because objects, materials and lighting can change over the span of a pixel, the center of a pixel shouldn't dictate how the entire pixel is colored. When it does, the result is a chiseled, aliased look throughout an image.

By conducting subpixel sampling, you can force V-Ray to divide each pixel into smaller subpixels and conduct sampling at the center of each subpixel, with the end goal of determining the best possible color to assign to each pixel. The more subpixel samples that are taken, the better an image sampler can determine what lies within each pixel and what final color to assign.

An important note to remember about image sampling is that when fine granular-like noise appears in an image, the cause is usually image sampling. The exception to this would be the noise caused by the Brute Force render engine, which also produces fine granular-like noise. When large splotchy noise appears in an image, the cause will almost always be the irradiance map or light cache. The one exception to this is usually HDRIs.

Image Samplers

There are three ways in which you can implement image sampling through V-Ray in your scenes. Deciding which method to use usually requires experimenting with small portions of your scene or with high face-count objects hidden.

Fixed rate

This method takes a fixed number of samples per pixel. When **Subdivs** is set to the default value of 1, one sample is taken at the center of each. The benefit of this sampler type is that you know without a doubt that a certain number of samples will be taken for each pixel. The downside, however, is that the sampler is not adaptive and can't speed up a rendering even when higher image sampling isn't needed.

This sampler should only be used for production renders for scenes where a majority of the rendered image is made up of lots of blurry effects or very detailed textures. However, this method is usually a poor choice for animations because of the excessive render times it creates. For production renders, a value of 5 or 6 should be used. In scenes with tremendous detail or blurry effects, values of 4 or less will result in detail being lost and values greater than 6 will usually result in an indiscernible improvement in detail.

Adaptive DMC

As its name implies, this sampler is adaptive, which means it can implement greater sampling when greater sampling is needed and lesser sampling when lesser sampling is acceptable. This image sampler subdivides pixels according to the **Min subdivs** specified, and if it's determined that the color variation in adjacent pixels is not too excessive, no additional subdivisions will be made. However, if the sampler determines that the variation in color between adjacent pixels is too great, it will continue to subdivide pixels during subsequent passes until such time that it determines the pixels are close enough or until the maximum number of subdivisions allowed by the **Max subdivs** value has been reached. And by default, the setting that determines how close pixel colors have to be is the **Noise thresh** value within the **DMC Sampler** rollout.

Unfortunately, the Noise thresh value controls the acceptable noise level in all blurry effects in V-Ray, such as GI, depth-of-field, motion blur, glossy reflection and refraction, and so on. This is not a good thing because if you improve the quality of image sampling using this value, you will be requiring a higher level of quality in all blurry effects, even when that higher quality is unnecessary. Therefore, you should always disable the **Use DMC sampler thresh.** option and specify the acceptable level of color variation using the **Color thresh** value within the **Adaptive DMC image sampler** rollout. When you do, you can control image sampling quality independently of all other blurry effects.

The importance of the Color thresh value cannot be overstated. This value controls how adaptive the image sampler is. If you set this value to 0.0, you are telling V-Ray that you want perfectly noiseless image sampling. This of course isn't possible, so the best V-Ray can do would be to apply the Max subdivs value to every pixel in your image. If this is done, however, the image sampler is no longer adaptive and there is no point in using it. In fact, if you set the Color thresh to 0.0 and use a Min and Max value of 1 and 4, you will get the exact same result as you would with the Fixed image sampler and a Subdivs value of 4.

This is the best sampler to use for most production renders, but it should not be used for test renders over the much faster Adaptive Subdivsion sampler. We suggest that values of 2 and 5 be used for production renders, or 3 and 6 if necessary. Do not use Min values less than 2 because V-Ray will almost always apply inadequate sampling somewhere in your image (because of the Color thresh value specified) and do not use Max values greater than 6 because you will usually see indiscernible improvement at the price of much longer render times.

Adaptive subdivision sampler

This sampler provides another adaptive solution for image sampling, but what makes this tool so great is that you can allow V-Ray to take less than 1 sample per pixel. This simply means that pixels can be grouped together and 1 sample taken for the entire group. That being said, it is important to note that the adaptive subdivision sampler is quite different from the adaptive DMC sampler when values of 0 or less are used. When a **Min rate** of zero is specified, each pixel corner is sampled rather than the center of each pixel. When values less than 0 are used, the adaptive subdivision sampler still takes the samples at the corners of pixels, although it is somewhat vague to define what exactly is the number of samples per pixel. Nevertheless, it can roughly be stated that a value of -1 skips every other corner in the horizontal and vertical directions, and the result is that you get blocks of 2x2=4 pixels. A value of -2 gets you blocks of 4x4=16 pixels, and so on. The actual block size is always a power of 2.

When not using blurry effects or detailed textures and objects, this sampler is a possible alternative. For scenes with large areas of smooth surfaces, such as a large wall with a smooth appearance, the Adaptive subdivision sampler is unbeatable. But if you cannot get away with using a negative Min rate it is somewhat pointless to even be using this sampler for production.

Another disadvantage of this image sampler is that it uses more RAM than the other samplers, and since RAM is most critical during production renders, this is yet another reason why the adaptive subdivision sampler is usually only acceptable for test renders. For test renders, we recommend always using this sampler.

Antialiasing Filters

The very last process applied to a rendering, with the exception of post-render effects, is antialiasing. After image sampling is conducted to determine the best possible color to assign a pixel based on subpixel sampling, antialiasing is applied to blur each pixel with neighboring pixels so that an aliased look can be further avoided. Like any blurry effect in V-Ray, antialiasing filters can increase render times, and generally, render times increase as blurriness increases.

The following are good choices for antialiasing filters:

- **None** – You can disable antialiasing altogether and still achieve great results for test and production renders for both stills and animations. The benefit of not using a filter is typically faster render times. Using no filter provides a look similar to Mitchell-Netravali.
- **Catmull Rom** – This filter provides sharpness that makes it great for still renderings with a large amount of detail. This filter is not appropriate for animations because it generates side effects often referred to as flickering and swimming.
- **Video** – This filter is good for animations because it softens or blurs each image to mitigate the effect of flickering. However, this filter can take about 10% to 20% longer than any of the others listed here.
- **Mitchell-Netravali** – This filter provides a good mixture of sharpness vs. softness and is often used in production stills.

Suggested Render Settings

Test Renders

Adaptive Subdivision with Min/Max = -1/2 and Clr thresh = 0.1 (i.e., default values)

Production Renders

Adpative DMC with Min/Max = 2/5 up to 3/6, Use Noise Thresh = disabled, Clr thresh = 0.005 down to 0.003

GI Engines

All GI calculated by V-Ray is classified as a **Primary Bounce** or a **Secondary Bounce**. When a GI engine is assigned to calculate all primary bounces, its mission is to calculate the effect of light bouncing of all surfaces directly in view or indirectly in view by way of reflections or refractions. This simply means that if you can see a surface, the primary bounce engine is responsible for calculating the GI for that surface. When a GI engine is assigned to calculate all secondary bounces, its mission is to calculate the effect of light bouncing of all surfaces that cannot be seen, directly or indirectly. Any surface whose GI is not calculated by the primary bounce engine assigned is calculated by the assigned secondary bounce engine.

The reason for the two classifications is so different GI engines can be used to calculate the effects of different types of light bouncing off surfaces in a scene. Since a primary bounce surface

is directly visible, it should make sense that the GI for a primary bounce surface needs to be more accurate than the GI calculated for a secondary bounce surface. Just because you can't see a surface that is outside your field-of-view, doesn't mean that the surface doesn't play an important role in the total GI solution for your scene. But it does mean that you can use faster, less accurate calculations for the GI on that surface. By calculating an accurate primary bounce and an approximated secondary bounce, you can achieve accurate GI in an efficient manner.

Irradiance Maps

The **Irradiance map** is the most widely used engine for the primary bounce because it is capable of very accurate GI in a relatively short amount of time. Because it's so accurate, it's not even an option for the secondary bounce.

Resolution

As its name implies, the irradiance map is a map, and just like a bitmap, an irradiance map has a resolution. The resolution of the irradiance map is completely determined by the **Min** and **Max** values found at the top of the Irradiance map rollout. The reason the irradiance map can achieve such accurate results in such a relatively short amount of time is because it is adaptive. As an adaptive solution, V-Ray can apply a higher resolution to parts of an image that need more detail and more accurate GI, and a lower resolution to parts that don't require such accuracy.

When the irradiance map algorithm begins its work, samples are taken on all the primary bounce surfaces at a density defined by the Min Rate value. When the min rate is set to 0, the irradiance map resolution matches the rendered image resolution and a sample is calculated for each pixel. If the min rate is set to -1, the irradiance map resolution is cut in half and 1/4th the number of samples are calculated. When set to -2, the resolution is cut in half again, and the number of samples is reduced again.

After the irradiance map creates samples during its first pass, as defined by the Min Rate, it then looks to the threshold values, which are ghosted out when presets are used, to determine if the samples taken during the 1st pass will be accurate enough to define the GI on all the primary bounce surfaces. If the colors calculated by adjacent samples are too different, or the normals of the surfaces at the samples are too different, or if the distance between samples is too great, V-Ray will force another pass of samples to be taken at a higher resolution. If the samples are determined to be accurate enough in a particular area, no additional samples will be calculated in that area in future passes. This process repeats until the maximum resolution, as defined by the Max Rate, is reached. So if a min rate of -1 and a max rate of 0 is used, 2 passes will be made. The first pass will create a map with a resolution one-half that of the rendered image, and then a second pass will be made to take extra samples as needed at a resolution that matches the rendered image. If a max rate of 1 is used, the final pass will create samples at a resolution twice that of the rendered image.

The irradiance map comes with a nice list of presets that can be relied on for test and production renderings. For test renderings, we recommend using a Very Low preset and for production renderings we recommend using a Medium preset. If the Medium preset does not allow for enough detail to be shown in the final rendered image, you can use a High preset. However, you should understand that when you switch from a Medium to High preset, the Max Rate changes from -1 to 0, which means that the final pass will be created at twice the resolution and take four times as long as the final pass calculated for the Medium preset. Another very important thing to remember about irradiance map resolution is that as you increase the resolution of the map, you will usually make it easier to see noise in the map. If you use a very low irradiance map resolution, such as that which would come with a Very Low preset, the map will be blurred. Since the map is blurred, so too is the noise. If you use a very high resolution, such as that which would come with a Very High

preset, the map will be very detailed and the noise will be much easier to see. The noise will become smaller, but by becoming smaller it will also become more stark and easier to see. When many users encounter noise in their irradiance map, their first instinct is to use a higher resolution; however, this will only make the noise easier to see. Instead of increasing resolution beyond the -1 rate defined by the Medium preset, we recommend improving the two other critical settings in the irradiance map rollout; Hsph. sudivs and/or Interp. samples.

As a final note about irradiance map resolution, you could avoid using presets altogether. However, you should only do this when you understand explicitly what each value controlled by the presets represents. The presets offer great configurations and it should be understood that improving these settings will only make the irradiance map less adaptive, and therefore, less efficient. By reducing the threshold values involved, you are telling V-Ray you want a more accurate irradiance map, and therefore, it will have no choice but to create samples closer to the specified max rate. If you set each threshold to 0, you would be telling V-Ray that you want a perfectly accurate irradiance map. Although that is not possible, it will do the only thing it can do, which is to sample all surfaces at the max rate. Your irradiance map would then be a brute force solution.

Hsph subdivs

This value stands for hemispheric subdivisions. When a sample is calculated, a virtual hemisphere is placed above the sample and rays are shot out in all directions to determine what colors are shown in the various directions. One ray might detect the blue sky, another the green grass, another the gray asphalt. All of those rays are averaged together to create a final sample color. A single ray is shot through each segment of the subdivided hemisphere and the more rays that are shot, the more accurate the final color will be. So increasing this value increases the number of rays and the accuracy of the final color.

This setting has an enormous effect on the time it takes to calculate an irradiance map. You can easily double your irradiance map calculation time by doubling this value, even when the improvement in the final image is indiscernible. Because of this, we highly recommend using the lowest acceptable value that doesn't negatively impact the final image quality. We have found that the default value of 50 is only rarely needed and that the same level of quality can be achieved with a value of 20. When noise develops, rather than automatically increasing this setting, we recommend increasing the third critical setting; Interp. samples.

Interp. Samples

This value stands for interpolation samples. Since a finite amount of samples are taken throughout an image, V-Ray uses interpolation to estimate the GI in the spaces between the samples. If interpolation were not conducted, the irradiance map would take on a very cellular or faceted appearance. To determine the primary bounce GI at a point in between samples, V-Ray uses the Interp. samples value to specify how many surrounding samples to blend together, which in turn determines the final GI color to assign to the point. Increasing this value will cause more blurring in the irradiance map, will reduce the visible noise, and will reduce the visible detail. The default value of 20 works well in many cases, but you will often have to raise this value to something much higher to remove noise in the irradiance map. If you are trying to remove noise, we recommend increasing this value up to 100 before you start testing Hsph. subdivs. values above 20. The impact on rendering time of increasing interpolation samples is very small compared to the impact of increasing hemispheric subdivisions. If you increase this value too much, you may lose detail and you will have no choice but to increase the number of samples (i.e., the irradiance map resolution), or increase the quality of the samples (i.e., hemispheric subdivisions).

As you can see, the three settings discussed for irradiance maps are interconnected and are used to basically do two things; control noise and detail. For each scene, there is an optimal

configuration of these three settings that will yield great image quality in the shortest amount of time possible.

Suggested Render Settings

Test Renders

Preset = Very Low, Hsph. subdivs. = 20, Interp. samp. = 100

Production Renders

Preset = High, Hsph. subdivs. = 20, Interp. samp. = 100

Light Cache

The **Light cache** is another complex algorithm used to approximate indirect illumination. Unlike some of the other GI solution types, the light cache has only been around a few years and was first developed by the makers of V-Ray. It's a fantastic lighting solution and the most widely preferred secondary bounce engine among V-Ray users. There are two main reasons for its continued success. One is that it provides a great mixture of speed and quality, and another is that it's very simple to use, relative to other solution types. One of the things that makes it so easy to use is that it does not have a multitude of variables that control adaptive behavior like the irradiance map, and this alone makes it a much simpler solution to use. Nevertheless, it is still a complex creation that still contains enough variables to confuse and overwhelm many users.

The practicality of the light cache can be best attributed to its speed, which in turn, can be attributed to its ability to compute a very large number of light bounces very quickly. As a side effect to this benefit, it is not as accurate a solution as the irradiance map or, as we'll see in a moment, the DMC solution. And because it's not as accurate as these 2 methods, it's not a good choice for use as the primary bounce unless you perform progressive path tracing. Progressive path tracing is a great technique in which the light cache is used for both the primary and secondary bounces to produce a complete rendering from the moment the rendering process begins. The rendering is simply refined slowly over time and stopped when an acceptable level of noise is reached.

Because the light cache is so good at calculating a large number of light bounces, it's very effective for interiors, where light tends to be trapped more and bounce around more surfaces than it does in exterior scenes. Additionally, the light cache effectively spreads out the light very well, making it even more effective for interiors; smooth lighting is extremely important for nice interior images. This is not meant to take anything away from the use of light cache for exteriors, because we still use it more than any other type for both interiors and exteriors.

There are just a few settings within the light cache rollout that would be considered critical to most scenes. By far, the most critical setting is **Subdivs**, which dictates the number of rays that are shot from the camera onto the primary bounce surfaces. Those rays shot onto the primary bounce surfaces approximate the effect of GI from secondary bounces, and the number of rays used is the square of the Subdivs value. For example, when the default value of 1000 is used, the number of rays sampled is actually 1 million. When a value of 2000 is used, 4 million rays are sampled. So every time you double the Subdivs value, you use four times as many rays and the light cache takes four times as long to calculate.

For test renders of still images, try using a Subdivs value of 100 for large scenes and 250 for small scenes. For production renders, simply multiply this range by ten. Try a value of 1000 for large scenes and 2500 for small scenes. Although these values work well for still images created in **Single Frame** mode, animations must be created in **Fly-through** mode, and in this mode, all of the rays

used are spread throughout all of the frames of the animation. If your camera doesn't move very far or very fast, and if your animation path isn't too long, you can use similar values to those just mentioned. However, if every few seconds you see a completely new set of surfaces and your animation path runs continuously for a long period of time, these values will be far from sufficient. As a general rule, it's not a good idea to have long camera sequences, such as 20 seconds or more. If you keep your sequences to under 20 seconds in length and if your camera does not move so far or so fast that you see completely new surfaces every few seconds, then a good rule to apply to Fly-through mode would be to double the Subdivs value used for a still rendering.

When light cache samples are taken for a single frame, they are spread throughout the entire image. The areas in between samples are shaded based on the information calculated by the closest sample. If interpolation were disabled, you would see the entire image broken into an array of sample cells, where all points within a cell would be shaded the same color as the sample taken at the center of the cell. By increasing the number of rays used, you can break the scene into smaller cells and the smaller the cells, the more accurate your GI will be.

You can specify the size of the sample cells through the **Sample size** setting. When the **Scale** setting is to **Screen**, the sample size is specified as a fraction of the screen size. For example, when set to the default value of 0.02, the Sample size value wants to make each sample 2% of the screen's size. This does not mean that the sample size will necessarily be 2%, because if there aren't enough samples to divide the image into the actual sample size could be much larger. This is a critical thing to understand because the Sample size setting dictates the size of a sample if, and only if, there are enough samples to allow for the size specified with this setting. In other words, if the Subdivs value is too low and there just aren't enough samples being taken, it doesn't matter how small you make the sample size because the image can only be broken down into so many sample cells. Too few sample cells means that you won't be able to achieve the desired sample size, and therefore, detail may be lost.

Once enough samples are taken to allow for the sample size you dictate with the Sample size setting, any additional samples will simply be used to improve the color of the samples. More samples will yield better sample color accuracy.

When the Scale is set to screen, the sample sizes in the foreground of an image will always be more accurate than the samples in the background. For example, when a sample is set to 2% of the screen size, then 2% of the screen size in the foreground might mean 1 foot while 2% of the screen size in the background might mean 10 feet. This simply means that objects in the foreground will have a more accurate light cache applied, which is a good thing. However, when you render an animation and your camera moves into and around a scene in a way that causes the view to constantly change and new surfaces to constantly be seen, you will need to use the **World** option. If you use the Screen option in these situations, objects that are initially in the background will eventually be in the foreground and need just as much accuracy as all other objects.

When you set the Scale to World, the Sample size is no longer set as a percentage of the screen size, but rather as a real-world distance. Unlike the Screen default size value of 0.02, which is an excellent choice for almost all situations, the default World value will almost always need to be adjusted. A good place to start in determining what size to use is to pick some area in the center of your screen and determine what the real-world distance would be on a surface that would be measured as 2% of the screen size. If 2% of your screen size would equate to a distance of 10 feet, then use a sample size of 10 feet. If 2% equates to 100 feet, then use 100 feet. You simply need to find a commonly viewed area that provides a good representation of a surface that is not always seen in the foreground and not always seen in the background.

For animations, the Subdivs value needs to be increased beyond that which you would use for a still image, because all of the samples will have to be spread out through the entire animation. The optimal value is determined by several variables, such as animation length, the speed at which the

camera's perspective changes, the detail in your objects and materials, and much more. As a start, you can try to simply double the value you would use for a still image and this will usually provide good results.

When the irradiance map / light cache combination is used, the secondary bounces are calculated before the primary bounces. The reason for this is that the light cache is not as accurate as the irradiance map, so instead of calculating GI in a very detailed manner with the irradiance map and then calculating GI in a very rough manner with the light cache, V-Ray instead starts with a light cache to roughly approximate the GI and then uses that information to more accurately and more quickly calculate the much more detailed irradiance map. It just wouldn't make sense to do it any other way. When creating an animation of a static scene (i.e., a scene where only the camera moves), the following is the proper procedure. This procedure will not work on scenes with changing lights, changing materials, or changing objects.

1. Set **Primary** and **Secondary** bounces to **Light Cache**
2. In the **Global Switches** rollout, enable the **Don't Render Final Image** option
3. Enable the **Show Calc phase**
4. Change the mode to **Fly-through**
5. Set the **Subdivs** value
6. Auto-save the light cache
7. Render the light cache
8. Change the mode to **From File**
9. Click **Browse** and load the saved light cache
10. In the **Indirect illumination** rollout, switch the **Primary bounce** type to **Irradiance map**
11. Enable the **Show Calc phase**
12. Change the mode to **Increm. Add to Current Map**
13. Auto-save the irradiance map
14. In the **Common** tab, switch to the **Active Time Segment** option
15. Set **Nth** frame value
16. Render the irradiance map
17. Change the mode to **From File**
18. Click **Browse** and load the saved irradiance map
19. Check whether or not to use the **Use Light Cache for Glossy Rays** option and **None** for secondary bounces
20. Turn off the **Don't Render Final Image** option
21. In the **Common** tab, change the **Nth** frame option back to **1**
22. Save the final rendered output to file
23. Render the final output

One final option worth mentioning in the Light cache rollout is the option to **Use Light Cache for Glossy Rays**. This option allows you to drastically reduce the time needed to calculate blurry reflections and refractions by borrowing information stored in the light cache. When this option is used, you must leave the light cache enabled as the secondary bounce.

Suggested Render Settings

Test Renders

Subdivs = 100 for large scenes and 250 for small scenes

Production Renders

Subdivs = 1000 for stills of large scenes, 2500 for stills of small scenes, and approximately twice these values for animations, Scale = Screen for stills and animations with minimal change in viewpoint, Scale = World for animations where camera moves in and around scene and view constantly changes.

Brute Force

The final GI engine discussed in this appendix is the **Brute Force** engine. The brute force engine is neither our favorite primary nor secondary bounce solution, but we do use it on occasion and it is a great choice in certain situations. The term *brute force* is used in mathematics to describe a method of solving an equation by trying all possible solutions. As an example, applied to the field of cryptography, or code breaking, it simply means to break a code by testing every possible permutation. In V-Ray, the name is used because this render engine is potentially capable of computing the GI everywhere in a scene. This method is not adaptive, like the irradiance map and light cache, because samples are taken independently of all other samples and all other frames (for animations). Therefore, no sampling information is borrowed and no samples are blended together. Although the brute force method is theoretically capable of calculating a perfect solution, this is never really feasible or practical. Like other render solutions, this method is simply another way of approximating GI to an 'acceptable' degree of accuracy. Brute force is a great option for calculating GI in a scene for certain situations, but to better understand what those situations might be, you need to know what the advantages and disadvantages are of using the brute force method.

There are four primary advantages for using the brute force method over other GI solutions. The greatest advantage of the brute force method is the ability to produce very accurate GI. The only competition brute force has in this regard is the irradiance map, which because of its adaptive nature leads many to choose the irradiance map as their first choice for the primary bounce. Remember that the primary bounce requires a high level of accuracy. Because the brute force method is referred to as an exact method, it should be no surprise that there are very few controls used to dictate the quality of the image, and this is the second advantage. A third advantage is that because brute force doesn't store sample information for later use, it requires far less memory to use than the adaptive methods. The fourth and final big advantage of using brute force is that when rendering scenes with moving objects (besides the camera), it is the solution that provides the most accurate GI and it is a legitimate alternative to rendering a scene in multiple passes and compositing the separate passes later.

There is really only one main disadvantage of the brute force method for calculating GI and that would be the time it takes to create quality images. This one disadvantage, however, makes this solution method unacceptable for many users in many situations. To achieve high quality GI, either for primary or secondary bounces, a value much greater than the default 8 Subdivs must be used. In most scenes, you will probably find that values above 30 are needed to achieve a noiseless image. Since noise is easiest to see on large, smoothly shaded surfaces, you must usually use a very high Subdivs setting on these types of scenes. However, these are just the type of scenes where the irradiance map and light cache combination shine. Therefore, the brute force method is best suited for scenes with high levels of detail either in materials or in object structure. Incidentally,

because this method is so much slower than the irradiance map and light cache combination, it should never be used for test renders.

There is an additional setting within the Brute force GI rollout; Secondary bounces. This setting controls the number of times light, processed by the secondary bounce solution, is allowed to bounce from one surface to another. When the brute force method is not used as the secondary bounce solution, this setting cannot control the number of secondary bounces. Since the light cache is so much faster than the brute force method, and since a high level of accuracy is not needed for secondary bounces, using the brute force method for secondary bounces should only be used in very specific situations. For those specific situations, increasing this value beyond the default value of 3 can help provide accurate GI in areas where light has a hard time reaching, and in this way can add depth and contrast to dark areas.

Suggested Render Settings

Test Renders

The brute force solution should not be used for test renders.

Production Renders

Subdivs = 30 to 80

DMC Sampler

The **DMC Sampler** plays a critical role in specifying the quality of all blurry effects in V-Ray. A blurry effect in V-Ray is any effect that provides a blurry look, such as motion blur, depth of field, area lights, blurry reflections, and GI, to name a few. DMC stands for deterministic Monte Carlo. Monte Carlo is used in mathematics to describe a method of solving complex mathematical problems through the use of algorithms. The designation was first made in the 1930s and is actually a reference to the casinos in the city of Monte Carlo, Monaco, and was chosen by a group of mathematicians who were relating the 'random' and 'repetitive' nature of the casinos to the similar nature of the algorithms they created. DMC is a variation of this approach. Unlike Monte Carlo sampling, which would result in random sampling and slightly different renderings every time, DMC uses pre-defined sampling sequences so that re-rendering will always produce the exact same image. V-Ray uses DMC sampling for all blurry effects, and because of this, two of the settings within the DMC Sampler rollout are critical to every scene.

In V-Ray, there is a term called *importance sampling* that describes the technique of controlling the number of samples taken for a blurry value based on the importance of the value. Importance sampling is controlled by the **Adaptive amount** setting found in the **DMC Sampler** rollout. By setting this parameter to its lowest possible value of 0.0, you are telling V-Ray that you don't want to conduct importance sampling and therefore, don't want V-Ray to base the number of samples taken for a blurry value on how important that value is. By setting this parameter to its highest possible value of 1.0, you are telling V-Ray that you do want to abbreviate the DMC algorithm for each blurry effect based on their importance. Why would you want to do this? Well, just like any other area of V-Ray, we want to save time.

The **Noise threshold** value only plays a role when importance sampling is conducted and importance sampling only plays a role when a blurry value has enough subdivisions, thereby generating enough samples. But remember that the values in the DMC Sampler rollout affect all blurry values. For this reason, we highly recommend making sure first that each blurry value is set properly. Then

and only then should you experiment with lowering the noise threshold. The smaller your adaptive amount, the less effect your noise value will have. For most situations, we recommend increasing the adaptive amount to its highest value for the best speed vs. quality. The one exception to this would be scenes using HDRIs, in which case reducing the noise threshold to 0.8 or 0.9 will often go a long way to reducing noise.

There are 2 other settings worth mentioning in the DMC Sampler rollout, the **Global Subdivs** multiplier and the **Min Subdivs** value. By doubling the Global Subdivs value, you are telling V-Ray to double every Subdivs value in the program, with the exception of the Subdivs values for light cache, caustics, photon map, and image sampling. Some use this to quickly increase the quality in their scene, but we don't recommend doing so. It would be like putting a cast on both arms and both legs when only one leg is broken. It will definitely improve the quality of a problematic setting but it is likely to improve settings that don't need improvement, and thus, it can lead to dramatic increases in rendering time. The same applies to the Min samples value. It can be hard to specify a min samples value when you don't even know the true number of samples you are working with and even if you did, you might be applying a much higher quality setting to an area of your scene that doesn't need it.

Suggested Render Settings

Test Renders

Adaptive amount = 1.0, Noise threshold = 0.01

Production Renders

Adaptive amount = 1.0, Noise threshold = 0.005

Color Mapping

Color mapping is a term used to describe the way V-Ray changes the final color of your screen's pixels to adapt to the limitations of the typical computer display. It works much like the exposure controls on a real camera or even within 3ds Max. It can also be compared to the way the human eye changes to allow more or less light to enter the retina. Color mapping is a requirement for any rendered image, and fortunately, it's also one of the easiest to understand.

As mentioned, color mapping is a lot like exposure control, and while you could use exposure control in the Environment and Effects dialog box, it's not a good idea to do so because color mapping in V-Ray provides much more power and versatility than the exposure controls native to 3ds Max (mental ray not withstanding) and using both color mapping and exposure control would be like using exposure control twice. The results are difficult to predict and usually not very good.

All color mapping controls are found in the color mapping rollout and in the drop-down list are 7 different options to choose. By default, linear color mapping is employed and all this option does is multiply the final intensity of all pixels within the 0-255 range an equal amount. For any color, an intensity of 0 results in a pure black pixel and an intensity of 255 results in pure white. So all of the pixels from 0 to 128 will be brightened the same degree and all pixels from 129 to 255 will be darkened the same degree. But some pixels actually want to be displayed above the 255 level. If, for example, you look at the sun with the naked eye, you naturally want to squint or shut your eyes to keep them from being damaged. Yet, if you take a picture of a mid-day sun and look at it with the naked eye, all you see is the color white. When you look at the sun with the naked eye, you see pure white, which corresponds to a color of 255, but the sun shines with luminosity or radiation, which is what actually burns your eyes. The color of the sun is captured in a photograph as pure white and

nothing more because the illumination is clipped at this 255 value. The same thing happens automatically with color mapping. Illumination in an image that wants to be a higher value than 255, such as a direct view of a VRay sun, is clipped at this value.

Although there are seven different options for color mapping, I recommend using one of 3 different options; **Exponential**, **HSV exponential**, or **Reinhard**. Let's look at each briefly.

The exponential option will saturate pixels; i.e., add color, based on their intensity. What this means is that pixels that are really intense, or bright white, will be given more color, thereby replacing the white with color, and pixels that are less intense will be given less color. The result of this is that brighter areas in the scene will not appear so bright and darker areas will not appear so dark.

The HSV exponential option is a minor variation of exponential. HSV stands for hue, saturation and value, and this type of color mapping preserves the hue and saturation of a pixel and only allows the value to be altered. The result of this color mapping is similar to exponential except HSV exponential will provide a more vibrant display of colors and keep materials from being washed out so easily.

The final color mapping mentioned is Reinhard. This is a great option to use because it provides a mixture of linear and exponential color mapping. Linear color mapping usually allows too many surfaces to be overexposed while exponential often provides too much change in hue and saturation. The mixture of these two color mapping types is controlled by the Burn value. When Burn is set to 1.0, the result is purely linear color mapping, and when Burn is set to 0.0, the result is an exponential-like color mapping. A good place to start color mapping in any scene is with Reinhard and a Burn value of 0.5. This provides a 50/50 blend of Linear and Exponential and the result is usually a great place to start testing the lighting in a scene. Just like so many other areas of V-Ray, you really need to test different color mapping types and different settings within the various types. So in the case of Reinhard, if you render a scene and determine that there's just too many areas of overly bright highlights, all you need to do is reduce your Burn value and bring it closer to Exponential color mapping.

With the first four color mapping types available in the drop-down menu, you are give the capability of increasing or decreasing the illumination of dark areas of your image separately from bright areas. Raising the Bright multiplier increases illumination in already bright areas of your scene and decreasing the bright multiplier decreases illumination. The dark multiplier works the same way. Therefore, raising the dark multiplier increases illumination in already dark areas of your scene, and decreasing the dark multiplier decreases illumination.

Within the Color mapping rollout are two options that can drastically affect the quality of images; **Clamp output** and **Sub-pixel mapping**. When Clamp output is enabled, the color mapping is applied after the pixel colors have been clamped (or capped) at the maximum value of 255. This simply means that even though some pixels want to be displayed above the maximum color value of 255, such as reflections of high intensity light sources, color mapping is applied to them after their color value has been reduced. If this option is not used, the averaging of dark pixels next to bright pixels can result in an aliased look or in small white dots. Sub-pixel mapping allows color mapping to be applied to sub-pixel samples taken rather than to an entire pixel. Enabling this option is often necessary to remove the same aliased edges and white dots just mentioned with Clamp output. We highly recommend enabling these options by default. Doing so can drastically improve image quality with negligible increase in render times.

The final option that should be addressed in this section of V-Ray is the Affect Background option. Leaving this option enabled will cause the background color or map to be affected by any changes made to color mapping. Although we recommend using a background rig in your scenes, if you decide to take advantage of the VRaySky map as your background, then you should disable this option so your sky map doesn't change just because you need to change the exposure of objects in your scene.

Suggested Render Settings

Test Renders

Reinhard with a Burn value of 0.5, Sub-pixel mapping = enabled, Clamp output = enabled, Affect background = disabled

Production Renders

Exponential, Sub-pixel mapping = enabled, Clamp output = enabled, Affect background = disabled

Environment Lighting

A discussion on environment lighting in V-Ray can lead to lengthy coverage over a wide range of similar topics, such as HDRI lighting. This particular topic and several other topics could fill volumes, but the intent here is to simply introduce the concept so it can be built upon more easily with future study.

Environment lighting is simply illumination of a scene with skylight. However, skylight can be created in a number of different ways. It can be created with images, with a VRay dome light, a VRaySky map, an IES Sky, or it can be controlled right through the environment rollout. This section will focus on illumination through the Environment rollout.

When GI is enabled within V-Ray, the background color assigned within the Environment and Effects dialog box will automatically be used to illuminate a scene. The only way for skylight not to affect a scene with GI would be to make the background color black. With a pure black color, there will be no skylight, and with a pure white color there will be full skylight, or at least as much as the multiplier value will allow. The color controls the strength of the skylight and the color. So if you want to simulate the kind of skylight you would see during a sunset, all you need to do is select the appropriate color.

The Environment rollout within V-Ray contains an environment color override, which when enabled, will override any color assigned within the Environment and Effects dialog box. If no other lights exist in a scene, the color swatch in either area can act as the sole source of illumination. The strength of environment light is controlled by a color swatch, and by the multiplier value. However, if a map is used in the environment channel, the respective color swatch and multiplier are disregarded.

One important thing to note about the Environment rollout is that if you use image-based environment lighting, you should always apply the image to the VRay dome light rather the Environment channel. Applying an HDRI to the VRay dome will always result in superior image-based lighting.

Suggested Render Settings

Not applicable as environment lighting contains no quality-based settings.

Index

The only online store catering to professional architectural visualization artists.

We specialize in content, training, software, plugins, books, entourage and models for visualization.

shop.cgarchitect.com

cgschool

Image Credit: Spine3d

For 3ds Max® with iray®
BOXX IS THE PROFESSIONAL'S CHOICE

The exclusive Autodesk® Subscription Advantage Pack for 3ds Max® & 3ds Max® Design 2011 features one of the world's first physically accurate "point-and-shoot" renderers—the iray® rendering technology from mental images.

And because iray software simultaneously utilizes all the CPUs and CUDA-capable GPUs it finds within your system, it's time to ask yourself: "Is my current workstation up to the task?"

If the answer is no, it's time to go XTREME.

With support for seven GPUs or four dual slot GPUs, 3DBOXX XTREME solutions feature unparalleled acceleration for iray, delivering the fastest desktop rendering experience on the planet.

Retire that "wait" station and get yourself a workstation. Get yourself a BOXX.

BOXX
THE PROFESSIONAL'S CHOICE
WWW.BOXXTECH.COM
512-835-0400 | SALES@BOXXTECH.COM

More BOXX professional solutions include GoBOXX, the mobile workstation built for visualization, design, animation, and more, and renderPRO, the world's first personal dedicated rendering solution.